RUSSIA!

CATALOGUE OF THE EXHIBITION
AT THE SOLOMON R. GUGGENHEIM MUSEUM, NEW YORK,
AND THE GUGGENHEIM HERMITAGE MUSEUM, LAS VEGAS

GuggenheimMUSEUM

RUSSIA!
Solomon R. Guggenheim Museum, New York
September 16, 2005–January 11, 2006

This exhibition has been realized under the patronage of
Vladimir Putin, President of the Russian Federation.

This exhibition has been organized by the Solomon R. Guggenheim
Foundation in collaboration with the Federal Agency for Culture and
Cinematography of the Russian Federation, State Russian Museum,
The State Tretyakov Gallery, State Hermitage Museum, and ROSIZO
State Museum Exhibition Center.

This exhibition is made possible by

Major exhibition sponsorship provided by

This exhibition is further made possible by Lazare Kaplan International,
Thaw Charitable Trust, International Foundation of Russian and Eastern European
Art, Trust for Mutual Understanding, an indemnity from the Federal Council on
the Arts and Humanities, together with the generous support of the *RUSSIA!*
Leadership Committee.

Transportation assistance provided by

Media partner Thirteen/WNET

Special thanks to the Hermitage-Guggenheim Foundation for its assistance with
this exhibition.

RUSSIA! The Majesty of the Tsars:
Treasures from the Kremlin Museum
Guggenheim Hermitage Museum, Las Vegas
September 1, 2005–January 15, 2006

This exhibition is organized by the Solomon R.
Guggenheim Foundation in collaboration with
the Moscow Kremlin State Museum-Preserve of
History and Culture.

RUSSIA!

This companion volume to *RUSSIA! Nine Hundred Years of Masterpieces and Master Collections* and *RUSSIA! The Majesty of the Tsars: Treasures from the Kremlin Museum* documents every object in the exhibition *RUSSIA!* Pages 4–65 include the objects exhibited in New York; pages 66–87 include those exhibited in Las Vegas. The entries are grouped by section in accordance with the installation at each venue. Many of these works are also reproduced on a larger scale in the companion volumes; in the following entries, the references to plate numbers in parentheses correspond to the numbering in those publications.

The authors of the entries are:

AC	Alexander Chubinsky	MM	Marina Martyunova
AK	Angela Kudriavtseva	NA	Natalia Abramova
EM	Elena Morshakova	NB	Natalia Bushuyeva
EY	Elena Yablonskaya	NM	Natalia Markina
IB	Irina Bobrovnitskaya	NR	Natalia Rashkovan
IK	Igor Komarov	OM	Olga Melnikova
IV	Inna Vishnevskaya	SN	Scott Niichel
IZ	Irina Zagorodnyaya	VC	Valentina Chubinskaya
LK	Lubov Kirillova	VF	Valeria Fedotova
MC	Masha Chlenova	VH	Valerie Hillings

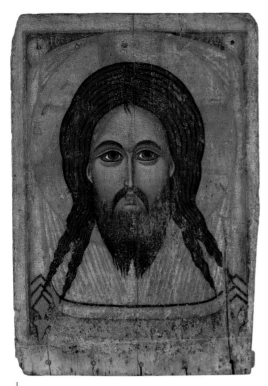

1

RUSSIA!
SOLOMON R. GUGGENHEIM MUSEUM, NEW YORK

THE AGE OF THE ICON: 13TH–17TH CENTURIES

1. *Savior Acheropita*, Village of Novoe near Yaroslavl, last quarter of the 14th century
Tempera on panel, 104 x 74 cm
The State Tretyakov Gallery, Moscow
(plate 9)

One of the most venerated subjects of the Christian world, the Savior Acheropita (or the Savior not made by human hands), emphasizes Christ's disembodied face and long, stylized hair with locks visible on both sides of his monumental head. During Christ's lifetime, Avgar, king of the Syrian city of Edessa, sent his messenger Ananias to Palestine seeking a cure for his leprosy. The Lord answered that he could not travel, as the time of his Passion was upon him. He washed his face in Ananias's presence, leaving behind his holy image on the cloth. When Avgar kissed the cloth, he was cured with the exception of one lesion on his forehead. After Christ's death, the Apostle Thaddeus came to Edessa preaching the Gospel, and Avgar decided to be baptized. The last trace of the disease left him, and the cloth was mounted on wood and displayed above the city gate for the citizens to venerate. When Avgar's idolatrous grandson came to power, the image was hidden in the city walls, only to be discovered years later and used to thwart Persian invaders. In 944, the icon was transferred to Constantinople and enshrined in the Church of Theotokos. At the end of the tenth century, a duplicate was taken to Kievan Rus, where in turn

it was widely copied. The monumental icon of the Most Holy Savior Acheropita continued to be regarded as a protector of cities and the sick. The *Savior Acheropita* shown here represents Christ with customary enlarged eyes, a long, straight nose, and arched eyebrows. The nimbus surrounding his head has an abstract, red cross, and the intense color is echoed in his rosy cheeks. —V H

2. DIONYSII (1440–1503)
Crucifixion, from the Trinity Cathedral at the Pavlo-Obnorskii Monastery, near Vologda, 1500
Tempera on panel, 85 x 52 cm
The State Tretyakov Gallery, Moscow
(plate 18)

Dionysii first gained his reputation as one of the greatest Russian icon painters in 1481, when he worked on the iconostasis for the Dormition Cathedral in the Moscow Kremlin. Consequently, he became a favorite artist of Tsar Ivan III (reign 1462–1505), for whom he completed a number of commissions. While little of his work survives, the frescoes in the Dormition Cathedral, as well as the interior of the Church of the Nativity at the Ferapont Monastery in northern Russia, constitute the models for identifying his work. The *Crucifixion* bears the markers of the work Dionysii did at Ferapont, among them the flat planes of light, yet expressive, colors and simple contours, such as the soft S-curve silhouette of Christ's body. Dionysii consistently elongated his seemingly weightless bodies, even as he reduced the size of the heads, feet, and hands of his figures, and he did not try to create a sense of depth as Andrei Rublev had. An inscription referring to the Trinity Cathedral of the Pavlo-Obnorskii Monastery near Vologda was found on the back of the icon during restoration. This discovery led to the icon's attribution to Dionysii and to the assumption that it was part of the Festive tier of the iconostasis. In the work, the Virgin stands on the left and is comforted by the women of Jerusalem, while John, Christ's favorite disciple, stands on the right alongside Longinus the Centurion. Two mourning angels are above Christ's head. The two angels in the middle left signify the arrival of the Church, while the two on the right, representative of the Old Testament, fly away. —V H

3. *St. Nicholas of Zaraisk with Scenes from His Life*, Village of Pavlovo near Rostov, second half of the 14th century
Tempera on panel, 128 x 75 cm
The State Tretyakov Gallery, Moscow
(plate 2)

Often called Nicholas the Wonder Worker, this saint's cult came to Russia soon after Prince Vladimir of Kievan Rus converted to Eastern Orthodoxy in 988. Nicholas, the famous bishop of Myra in Lycia, was venerated more than any other saint in Russia, and his influence was second only to Christ and the Virgin. In 1225, a miracle-working icon of Nicholas intended for Zaraisk, near Ryazan, was brought from the Greek colony of Cherson to Novgorod, then trying to resist the Tatar invasions. They attributed their success, in part, to the icon, and so it came to be viewed as having the ability to protect cities and assumed particular importance in the north of Russia,

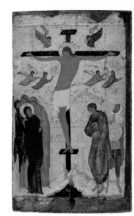

2

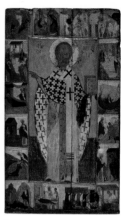

3

where *St. Nicholas of Zaraisk with Scenes from His Life* was made. Nicholas was also regarded as a saint protective of farmers, herders, and travelers. The icon shown here, like most representations of Nicholas, depicts him in the traditional gesture of prayer, or *orans*, with arms bent at the elbow and hands raised. In his left hand, he holds the Gospel. His cloak and cowl have flat, abstract, and stylized black crosses on a white ground. Surrounding him are sixteen scenes from his life, including his miraculous birth to the childless couple Theophanes and Nona, his ordination into the priesthood, and his Dormition. The practice of painting icons of saints surrounded by such scenes reached its maturity only in the early fourteenth century, but became a characteristic mode thereafter. —V H

4. *SS. Boris and Gleb with Scenes from Their Lives*, Moscow, second half of the 14th Century
Tempera on panel, 134 x 89 cm
The State Tretyakov Gallery, Moscow
(plate 3)

Boris and Gleb were the younger sons of Prince Vladimir of Kiev, who brought the Orthodox faith to Kievan Rus. Both had converted to Orthodoxy and received new Christian names, Romanus and David, respectively. The two men reportedly sought to live their lives like saints, and they ruled the territories of Ryazan (Boris) and Murom (Gleb) with mercy and compassion. Upon Vladimir's death in 1015, their half-brother Svyatopolk, who had not converted to the Orthodox faith and harbored jealousy and fear of Boris's potential to become Grand Prince, seized the throne and ordered his brothers' murders. Neither the older Boris (seen here with a beard) nor the younger Gleb resisted their assassins. Five years after their deaths, Boris and Gleb's tomb became a site of veneration and miracles, and they were canonized as the first Russian saints. They were regarded as modern-day passion bearers, who chose to accept suffering and death. In this sense, they fit the Russian Orthodox model of Christ as a sacrificial lamb who did not resist injustice, rather than the stern, powerful judge of Byzantium's Christ Pantokrator. *SS. Boris and Gleb with Scenes from Their Lives* shows Boris and Gleb as military saints dressed in royal regalia of vivid red and green and bearing swords. As in all representations of the pair, Gleb is shown as the younger and gentler brother, a point made in part by his smooth, beardless face, and each holds his left forearm in a different position. Sixteen scenes from the

brothers' lives surround them, providing insight into their tragic story. —V H

5. FOLLOWER OF DIONYSII
St. John the Divine on Patmos with Scenes from His Life and Travels, Moscow, late 15th–early 16th century
Tempera on panel, 132 x 98 cm
The State Tretyakov Gallery, Moscow
(plate 26)

John the Divine was one of the twelve apostles, an evangelist, and the author of the Book of Revelation, which describes the end of the world. This icon represents St. John seated on a bench in a cave on Patmos, dictating to his disciple Prochoros. After surviving flogging, poisoning, and submersion in boiling oil, John was sent into exile on this Greek island by Roman Emperor Dometian. John's head is tilted up and to the left, where three rays of light indicate the presence of the Holy Spirit and the source of his divine inspiration. Sixteen scenes from John's life surround the central image. The scenes chart his journey to spread the word of Jesus in Asia Minor and particularly to the Ephesians—whose pagan leaders sent him to Rome to stand trial as punishment for the success of his evangelism—as well as the miracles he performed up until his death. The source for this and other representations of the theme is the apocryphal text *Travels of St. John*, attributed to Prochoros. By the sixth century, this text had been translated into Slavonic. In Russia, John served as the patron saint of missionaries. *St. John the Divine on Patmos with Scenes from His Life and Travels* closely parallels two other icons on the subject of roughly the same date. In the late fifteenth and early sixteenth centuries, there was a belief that the end of the world described in the Book of Revelation was imminent, and therefore the production of icons of St. John the Divine was in keeping with the tenor of the historical moment. The assignation of the work to a follower of the painter Dionysii is largely based on John's beautiful, tranquil face and the simple silhouettes of the figures. —V H

6. *Assembly of Our Lady*, Pskov, late 14th–early 15th century
Tempera on panel, 81 x 61 cm
The State Tretyakov Gallery, Moscow
(plate 6)

According to Orthodox tradition, the day following the Nativity of Christ calls for giving thanks to the Virgin by celebrating the Synaxis of the Virgin, or the Assembly of Our Lady. In the *Assembly of Our Lady* shown here, Mary sits on an elaborate throne, with a curved backrest, in front of a highly abstract rendition of a cave. Rather than the swaddled baby Jesus asleep to her left and under the watch of an ox and a donkey, she holds an icon of Christ Emmanuel in Glory in an eight-pointed, red-and-green frame suggestive of a star. Thus the icon, or image, of Christ becomes a central focus. In her company are the Magi, angels, shepherds, and the ancient personifications of the Earth and the Desert, all gathered to celebrate the birth of the Savior, humanity's gift to him of a Virgin Mother, and the Madonna's role as intercessor with her newborn son. The intense greens and pearl whites are characteristic of the Pskov school. The illusionism of the work reflects the style developed under the Paleologos Dynasty founded in Byzantium around 1261. This approach also entailed the presentation of scenes of dramatic action and the suggestion of movement within a defined space through the juxtaposition of curves and straight lines. —V H

7. *The Miracle of the Archangel Michael and SS. Florus and Laurus*, Novgorod, early 16th century
Tempera on panel, 67 x 52 cm
The State Tretyakov Gallery, Moscow
(plate 23)

SS. Florus and Laurus were martyred brothers and stonemasons who lived in Byzantium and Illyria in the second century AD and became beloved saints of the Russian Orthodox Church. One day they lost their horses and appealed to Archangel Michael, who is seen at the center of *The Miracle of the Archangel Michael and SS. Florus and Laurus*, with Florus on the left and Laurus on the right. Upon the return of their horses, the pair dedicated themselves to these animals. Michael, who along with the saints occupies the top, or heavenly, realm, holds the reins of two horses—one black and one white—in the middle register of the icon. The horses assume confrontational stances and bear a resemblance to horses found in Eastern miniatures and textiles. The horses and riders at the bottom of the icon impart a sense of vitality, informality, and the everyday that is characteristic of the Novgorod school. The sinuous curves of the horses' necks, coupled with vivid yet harmonious color, make this an outstanding example of this accomplished center of icon painting. —V H

8. *Transfiguration*, from the Transfiguration Church, Spas-Podgorye, near Rostov Velikii, 1395
Tempera on panel, 116 x 87 cm
The State Tretyakov Gallery, Moscow
(plate 4)

Transfiguration formerly belonged to the church dedicated to this subject in the village of Spas-Podgorye in the region of Rostov Velikii in northeastern Russia. The story comes from the Book of Matthew (17:1–9), which recounts Christ's trip into the mountains in the company of his disciples Peter, James, and James's brother John. The icon follows the description in the scripture by representing Christ's robe in a dazzling white, and the burst of light that emanated from him with abstract, golden rays. Both Moses and Elijah, said to have suddenly appeared before the assembled group, are present, the former on the right holding a book, and the latter on the left represented as an old man. Upon seeing them, Peter offered to build three dwellings on the spot—one each for Christ and the two prophets—but he was interrupted by the voice of God who proclaimed, "This is my Son, the Beloved, with him I am well pleased; listen to him!" The disciples fell to the ground in fear, and this is the moment captured in the icon. Peter is represented on the right, kneeling on his left knee and raising his right hand; John, who is on the left, turns back to look upon the scene; and James, dressed in a crimson robe, has fallen headfirst to the ground. Christ is elevated above the schematic mountain in a dark mandorla, while Peter, James, and John seem to have literally fallen off it. The back of *Transfiguration* bears an inscription of 1395, but some scholars have argued that the elongated proportions of the figures and pronounced chromaticism, among other features, suggest it may have been made in the fifteenth or sixteenth century. This argument is further supported by the placement of John on Christ's right and Peter on his left; the mirror image, or reverse, of this subject's standard representation was a format characteristic of early-fifteenth-century Russian icons. —V H

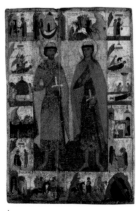
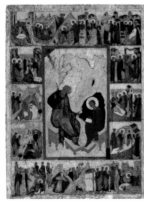
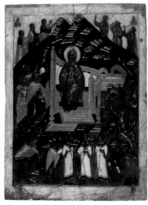
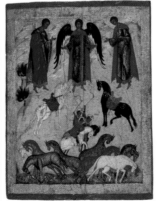
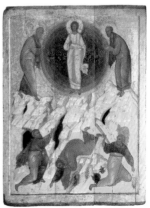

4 5 6 7 8

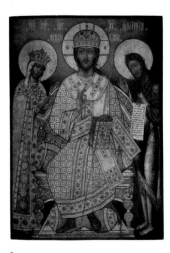

9

9. NIKITA PAVLOVETS (?–1677)
King of Kings or *The Queen Enthroned*, Armory
Chamber School, Moscow, 1676
Tempera on panel, 184 x 130 cm
The State Tretyakov Gallery, Moscow
(plate 25)

This is one of the few ancient Russian icons that was
signed and dated. An inscription indicates that it was
commissioned by Tsar Fedor Alexeevich (reign 1676–82),
son of Alexei Mikhailovich, the second Romanov tsar
and half-brother of Peter the Great, on the occasion of his
coronation in November 1676. Fedor Alexeevich was the
first tsar to include stops at all the Kremlin cathedrals in
his coronation procession. Pavlovets depicts Christ as a
King on a golden throne wearing a crown topped with a
cross. The sumptuous crown and scepter, similar to the
royal regalia of the tsar, visually suggests a link between
Christ and the sovereign Russian king. The commonly
used phrase "God and the Great Sovereign" underscored
the Russians' belief in his divine right to rule. Mary—
here represented as the Queen of Heaven—and St. John
the Baptist complete the traditional core of the Deesis,
and act as intercessors on behalf of humanity. The
extremely large size of the icon adds to its overall sense of
majesty, as does the liberal use of gold and decorative pat-
terning. While Pavlovets rendered the abstract design of
Christ's robe extremely flat, for the faces he employed the
chiaroscuro technique developed in Western religious art;
consequently, the figures appear more lifelike. This reflects
a discernible break in the style of Russian icons beginning
in the 1640s. —VH

10. *Shroud of Christ*, 1565
Silk and gold and silver thread, 168 x 262 cm
State Russian Museum, St. Petersburg

This Easter shroud of the entombed Christ was the last of
four made by the workshop of Princess Euphrosinia
Staritskaya, widow of Prince Andrei Staritsky, son of Ivan
III. The original background no longer exists. Adapted
from the Byzantine *epitaphios*, which covered vessels con-
taining the host and wine for the Eucharist, these shrouds
were used during the Procession of Burial, a central
Orthodox feast held the Saturday before Easter. This and

other, similar shrouds were extremely large, horizontal,
and filled with numerous mourning figures grouped
around the central figure of Christ. The scene in *Shroud of
Christ* is framed on four corners by the symbols of the
evangelists, whose portraits appear in the four corners of
the hem. Portraits of prophets and prelates are also
depicted in round medallions around the hem. The focal
point of the shroud is the lifelike, mourning Virgin on the
left of the principle image, who gently cradles her dead
son's head. Similarly, in the middle of the hem, Christ
stands over his mother's deathbed and holds her soul—
which looks like a baby wrapped in swaddling cloths—in
a scene from the story of the Dormition of the Virgin. The
inclusion of this subject suggests *Shroud of Christ* was
made for the Cathedral of the Dormition at the Kirillo-
Belozersk Monastery, which was in close proximity to the
Goritsk Convent of the Resurrection founded by
Euphrosinia, which she herself entered two years before
this shroud was made. —VH

11. *Deesis: The Savior with the Virgin and
St. John the Baptist*, Vladimir-Suzdal,
first third of the 13th century
Tempera on panel, 61.5 x 146.5 cm
The State Tretyakov Gallery, Moscow

This icon represents Christ, the Virgin, and St. John the
Baptist, the three principle figures of the Deesis. In
Greek, this word denotes an entreaty to God. The repre-
sentation of the Virgin and St. John with their hands
raised in a gesture of prayer in proximity to Christ
Pantokrator (Christ as a bearded, intense figure with one
hand holding the Gospel and the other raised in a ges-
ture of blessing) became a characteristic element of
Byzantine art in the tenth and eleventh centuries and
was adopted by Russian icon painters. The subject
belonged to the cycle of the Last Judgment, and the
Virgin in particular was regarded as an effective interces-
sor on behalf of humanity. In Vladimir-Suzdal, the
region where this icon was produced, this subject was
especially popular, as the Virgin was seen as the "Hope of
the Damned." The Vladimir-Suzdal school made various
alterations to the Deesis model around this time, among
them the frequent replacement of the Virgin and St.
John with two angels. As in this example, the icon
painters in this region also tended to produce single-
panel icons representing the heads of the three subjects,
an approach that contrasted with the typical model,
which depicted the three main figures in half- or full-
length and on three separate panels. Different from the
often older, sterner representation of Christ, this one
shows him as a young man with delicate features. Very
few examples of Vladimir-Suzdalian icons made prior
to the Mongol invasion of this region in February 1238
are extant, so this graceful, elegant example is a rarity of
its kind. —VH

12. *Our Lady of Yaroslavl*, second half of the
15th century
Tempera on panel, 54 x 42 cm
The State Tretyakov Gallery, Moscow
(plate 5)

Our Lady of Yaroslavl follows the model established by
the original *Virgin of Vladimir* (see cat. no. 13). Like that
famous icon, this version emphasizes the tender interac-
tion between mother and child as opposed to the greater
seriousness of the representation known as the Virgin
Hodegetria, in which the Virgin's right hand and the
Christ child's left hand are typically raised in a gesture
of prayer and blessing, respectively. As is characteristic of
fifteenth- and sixteenth-century interpretations of this
subject, the Virgin turns her head to the right instead of
the left, and she does not direct her gaze toward the
viewer. The hint of sorrow in her downcast eyes suggests
inner reflection and turmoil concerning her child's
ultimate fate. Her elegant, beautifully colored *maphorion*,
or veil, is adorned with stars, a symbol of the Mother of
God's eternal virginity. The representation of the gar-
ment's folds is much less linear and stylized than the earlier
Byzantine model. —VH

13. *The Virgin of Vladimir*, Moscow, 1514
Tempera on panel, 107.5 x 69.5 x 3.5 cm
Moscow Kremlin State Museum-Preserve
of Culture and History
(plate 19)

It was believed that the first image, or icon, of the Virgin
and Child was painted by St. Luke the Evangelist. The
version of this subject known as *The Virgin of Vladimir*
came to Russia from Constantinople in 1131, as a gift

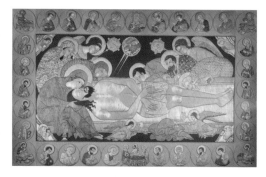

10

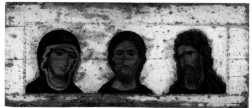

11

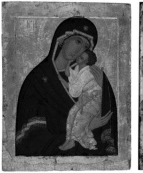

12

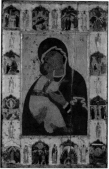

13

from Patriarch Luke Chrysoberges to Grand Duke Yuri Dolgoruky of Kiev, and became Russia's most holy icon. Dolgoruky's son Andrei Bogoliubsky transferred the icon to the city of Vladimir in 1155, where the Assumption Cathedral was erected to house it. In 1395, troops led by Tamerlane, whose empire rivaled that of Genghis Khan, approached Moscow, at which time the miraculous icon was sent there from Vladimir. When Tamerlane's army retreated, the Muscovites credited the icon as a protector of the city; they subsequently kept it, placing it in the Assumption Cathedral in the Moscow Kremlin. In the first third of the fifteenth century, the original *Virgin of Vladimir* was put in a gold filigree cover commissioned in 1410 by Metropolitan Photius of Moscow. The cover included representations of the church festivals in registers around the central image. Two replicas of the original icon, now in the State Tretyakov Gallery, were produced as reserve copies. The second version, made in 1514 under Metropolitan Varlaam (in office 1511–21), followed the expanded iconography of the gold cover and reflects the sixteenth-century emphasis on elongated figures and vivid color. This version remains in the Moscow Assumption Cathedral and is seen outside Russia for the first time in this exhibition. —VH

14. *Dormition of the Virgin*, Tver, 15th century
Tempera on panel, 113 x 88 cm
The State Tretyakov Gallery, Moscow
(plate 8)

The Dormition, also known as the Assumption of the Virgin, is one of the most important subjects in Eastern Orthodoxy. It recounts the death of the Virgin, the ascent of both her body and soul into heaven, and her birth into eternal life, at which time she continued her role as intercessor for humankind. This story does not derive from the canonical biblical texts, but from the apocryphal Homily of St. John the Divine on the Passing Away of the Virgin Mary, complemented by the homilies of John of Thessalonica, Andrew of Crete, and Germanus of Constantinople, and the canons of Cosmas of Maïma and John of Damascus. The Dormition constitutes one of the twelve major church feasts in the Eastern Orthodox Church. In the *Dormition of the Virgin* shown here, as is typical of icons of this subject, Mary is shown on her deathbed surrounded by mourners, among them SS. Peter and Paul, two prelates, and several grieving women of

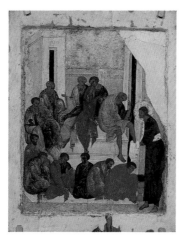

16

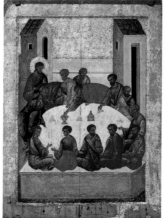

17

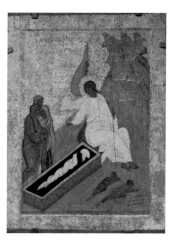

18

Jerusalem. Christ stands behind Mary and holds what appears to be a baby wrapped in swaddling cloths reminiscent of depictions of baby Jesus. In fact, the baby represents the Virgin's soul, which Christ will carry up to heaven. A third stage in this process is included at the top of the icon, which presents the enthroned Virgin in heaven, surrounded by angels bearing the apostles on clouds to greet her, and, unusually, handing over her girdle to the Apostle Thomas. With this act, her Ascension is complete. *Dormition of the Virgin*, a product of the Tver school, is distinguished by the intensity of the blues, which are especially prominent in the field of angels surrounding Christ in the center. Consequently, this icon is often called the *Blue Dormition*. —VH

15. ANDREI RUBLEV (ca. 1370–1430) and DANIIL CHERNYI (ca. 1360–1430)
Ascension, 1408
Tempera on panel, 125 x 92 cm
The State Tretyakov Gallery, Moscow
(plate 7)

Rublev, the most famous icon painter in Russian art history, was a student of the Byzantine icon master Theophanes the Greek, who arrived in Novgorod around 1378. In 1405, Rublev, by then a monk, worked alongside his teacher on the iconostasis for the Annunciation Cathedral in the Moscow Kremlin. Seven extant icons testify to his mastery of the Byzantine tradition. By 1408 Rublev began work with his colleague Chernyi on the Assumption Cathedral in Vladimir, where it is likely they collaborated on *Ascension*. Painted two years before his celebrated *The Holy Trinity* icon, *Ascension* already exhibits the hallmarks of Rublev's mature style. While he crowded numerous figures in the foreground, he nonetheless produced a more realistic representation of recession in space than was previously found in icons. He convincingly portrayed the abstract realm of heaven—which has just received Christ following his Resurrection and visit to his disciples on the Mount of Olives—by contrasting the curved, suspended mandorla (a characteristic aureole, usually either round or almond-shaped, placed around a figure to symbolize the presence of God) with the stable, horizontal line of his followers below. Additionally, Rublev's use of flowing, curved lines not only makes the

image less rigid and angular, but also less static. The range of deep, pure colors distinguishes his work; and the soft, less stylized, and more human features of his subjects convey a sense of gentleness and compassion. —VH

16. *The Washing of Feet*, from the Festive tier in the Cathedral of the Dormition at the Kirillo-Belozersk Monastery, ca. 1497
Tempera on panel, 84.5 x 67.2 x 2.3 cm
State Russian Museum, St. Petersburg

17. *The Last Supper*, from the Festive tier in the Cathedral of the Dormition at the Kirillo-Belozersk Monastery, ca. 1497
Tempera on panel, 83.5 x 63 x 2.5 cm
State Russian Museum, St. Petersburg
(plate 16)

18. *The Myrrh-Bearing Women by the Tomb of Christ*, from the Festive tier in the Cathedral of the Dormition at the Kirillo-Belozersk Monastery, ca. 1497
Tempera on panel, 84.5 x 63 x 3.2 cm
State Russian Museum, St. Petersburg
(plate 17)

These three panels were part of the twenty-five icons of the Church Feast or Festive tier of the iconostasis at the Cathedral of the Dormition at the Kirillo-Belozersk Monastery. This program is one of the most complete, as it includes the twelve major church feasts, twelve scenes of the events from the last weeks of Christ's earthly life, and an icon of St. Alimpii the Stylite. The combination of the twelve festival scenes with the twelve scenes from the end of Christ's life was characteristic of icon painting from Novgorod. The icons seen here tell three key stories of the Passion cycle. The first in the series, *The Washing of the Feet*, recounts the story told in John 13:4–12; this is the subject of the liturgy read on Maundy Thursday. Prior to the Passover feast, Christ performed the ancient ritual of hospitality by washing the feet of his disciples. Through this act, he demonstrated his humility as well as his love and respect for his fellow men, including his elders. In the context of a monastery, which was charged with welcoming wanderers, pilgrims, and beggars, this story had great

14

15

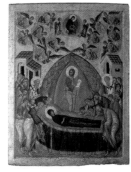
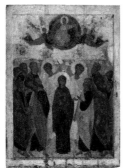

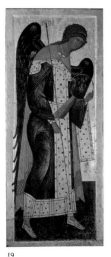
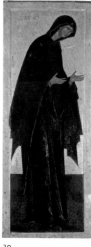
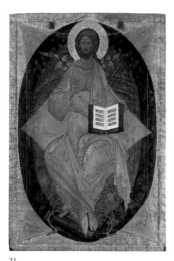
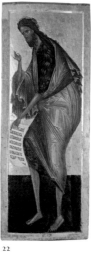
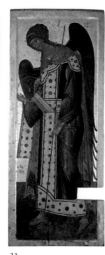

19 20 21 22 23

significance. In the icon, the figure of Christ stands on the far left and is distinguished from his seated disciples both by his elongated body, which makes him appear physically larger than the others, and his halo. Christ is represented in the act of drying the feet of his disciple Peter, who initially refused to let Christ wash his feet. When Peter then asked Christ to wash his head and feet, too, Christ proclaimed that Peter was already clean; however, Jesus told those assembled that "not all of you are clean."

The Last Supper immediately followed *The Washing of the Feet*, and as in that icon, the painter(s) produced an impression of recession within the interior space as well as such clearly delineated architectural details as the arch in a manner reminiscent of Andrei Rublev. The same could be said of the varied palette and the treatment of the chalice that calls to mind Rublev's *Holy Trinity* of around 1410. In this icon, Christ again stands to the far left of the picture and is identified by his halo. The disciples are seated at a large, round table. John, Christ's most beloved disciple, is seen prostrating himself before the Lord, while Judas, right of center in a vivid red cloak, boldly reaches across the table to grab the chalice. This scene takes place prior to Christ's announcement that one of them would betray him before the rooster crowed three times.

The Myrrh-Bearing Women by the Tomb of Christ came after the Crucifixion and is based on a combination of elements from the accounts of the four Evangelists: Matthew (28:1–7), Mark (16:1–7), Luke (24:1–10), and John (20:1). In accordance with Hebrew tradition, the three women—Mary Magdalene, the other Mary, and Salomia—had come three days after the Crucifixion to anoint Christ's body with myrrh. This icon shows the angel of the Lord, here represented nearly three times as large as the women and in a glowing white robe, appearing to them to announce Christ's Resurrection. He gestures toward the empty tomb and in so doing his arm creates a diagonal that formally echoes the sarcophagus. It also draws an imaginary line between the women, associated with Jesus, and the two guards in the lower right, whose earthly authority had no power over Christ. The opposition of the white shroud and the black surface of the sarcophagus is suggestive of the contrast between life and death. The simplicity of the composition, coupled

with the varying shades of color and the expressive faces of the women, make this one of the most outstanding examples of Russian icon painting. —VH

19. *Archangel Michael*, from the Deesis tier in the Cathedral of the Dormition at the Kirillo-Belozersk Monastery, ca. 1497
Tempera on panel, 191 x 78 cm
Museum of History, Architecture, and Art, Kirillo-Belozersk
(plate 13)

20. *The Virgin*, from the Deesis tier in the Cathedral of the Dormition at the Kirillo-Belozersk Monastery, ca. 1497
Tempera on panel, 191 x 72.5 cm
Museum of History, Architecture, and Art, Kirillo-Belozersk
(plate 11)

21. *Christ in Glory*, from the Deesis tier in the Cathedral of the Dormition at the Kirillo-Belozersk Monastery, ca. 1497
Tempera on panel, 192 x 134 cm
Museum of History, Architecture, and Art, Kirillo-Belozersk
(plate 10)

22. *St. John the Baptist*, from the Deesis tier in the Cathedral of the Dormition at the Kirillo-Belozersk Monastery, ca. 1497
Tempera on panel, 191 x 72.5 cm
Museum of History, Architecture, and Art, Kirillo-Belozersk
(plate 12)

23. *Archangel Gabriel*, from the Deesis tier in the Cathedral of the Dormition at the Kirillo-Belozersk Monastery, ca. 1497
Tempera on panel, 191 x 78 cm
Museum of History, Architecture, and Art, Kirillo-Belozersk
(plate 14)

The Cathedral of the Dormition at the Kirillo-Belozersk Monastery is located in the northern region of Russia

known as Belozersk or the White Lake and is dedicated to St. Kirill of Belozersk (1337–1427), one of the most popular Russian saints. Kirill, or Cyril, was a student of St. Sergius of Radonezh, the head and teacher of Russian hermits and founder of the Trinity-Sergius Lavra, also known as the Monastery of the Holy Trinity, which is considered one of the most important spiritual centers in Russia to this day. In 1397, Kirill left the Simonov Monastery in Moscow for the north in the company of his fellow monk Ferapont, who, like Kirill, founded a monastery in Belozersk in the late-fourteenth century. Kirill sought to lead an ascetic, hermetic life, but instead ended up establishing a monastic community. He also played a role in politics by expanding the territory of the Moscow prince through the establishment of his monastery and serving as an advisor to the sons of Dmitry Donskoi (prince of Muscovy 1341–53). His monastery became the first in Russia dedicated to the Virgin. Kirill was canonized in the fifteenth century, and the stone Cathedral of the Dormition, which replaced the original wooden one, was completed in 1497.

The cathedral's four-tiered iconostasis, a format that had become customary in Russian Orthodox churches by the fifteenth century, included a Deesis tier (image of intercession with Christ in the center flanked by the Virgin and St. John the Baptist, sometimes with archangels and additional saints), a row showing the most important events of the liturgical year, a Church Feast or Festive tier, and a Prophets tier. Below these rows were icons of Christ, the Virgin, and the icon known as "In Thee We Rejoiceth." It is thought that embroidered icon cloths hung under these so-called local icons. It is believed that a large team of masters from Moscow, Rostov, Novgorod, and possibly Tver worked on the iconostasis.

The Deesis tier originally had twenty-one panels, and five of them are seen here, including the central three figures of Christ, the Virgin (left of Christ), and St. John the Baptist (right of Christ), as well as those of the two Archangels Michael (far left) and Gabriel (far right) who traditionally flank the Virgin and John. The Deesis tier in the Assumption Cathedral in Vladimir, painted in 1410 by Andrei Rublev, Daniil Chernyi, and members of their workshop, served as a model for this one. In this sense, it reflects the style of icon painting developed in Moscow

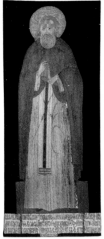
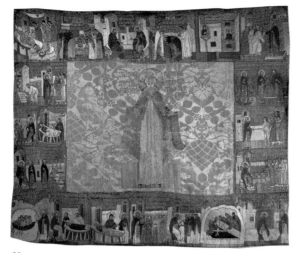

24 25

in the late-fourteenth and fifteenth centuries, characterized by an expressive use of vivid color—in this case the vermillion is particularly prominent—and curved lines, as well as a less stylized, more tender rendering of the faces.

The central figure of Christ in Majesty follows a set iconographic program. Seated on a throne with three intersecting "radiances" represented by a diamond, an oval, and a triangle, he holds the Bible open to Matthew 11:28: "Come unto me, all ye that labor and are heavy laden." The symbols of the Evangelists are represented in the four red triangles surrounding him: an angel (upper left, Matthew); an eagle (upper right, John); a lion (lower left, Mark); and an ox (lower right, Luke). Alongside Christ's head are two golden-winged seraphim.

The Virgin, who has a gentle expression characteristic of the period, appears in her role as intercessor, a point emphasized by her deep bow toward Christ. St. John presents a text from Matthew 3:2–10: "Repent ye: for the kingdom of heaven is at hand. . . . And now also the axe is laid unto the root of the trees." The fingers of his right hand form the Greek initials of Jesus Christ. The Archangels Michael and Gabriel are both attired in brilliantly colored robes in the style worn since antiquity by high church dignitaries close to the Byzantine emperor. Each also bears a staff as well as a round, flat, transparent disk derived from a pagan symbol denoting the sovereignty of the bearer. These elements underscore the archangels' dual role as intercessors at the time of the Last Judgment and as heavenly powers assigned to crown the righteous at the time of their entry into the Kingdom of Heaven. —VH

24. *St. Kirill of Belozersk*, 1514
Taffeta, silk, and gold and silver thread,
198.5 x 84 cm
State Russian Museum, St. Petersburg
(plate 21)

This full-length representation of St. Kirill of Belozersk, shown with his right hand raised in a gesture of blessing and his left hand holding a scroll, was made more than one hundred years after his death. He is depicted as both a monk—evidenced by his monastic cloak with light-blue cowl and four crimson Calvary crosses—and as a haloed saint. St. Kirill's extremely round head and the very simplified rendering of the face as almost a flat silhouette suggest the influence of Dionysii. As indicated by the inscription along the bottom of the pall, it was given to his monastery by Grand Prince Vasily III (1478–1533) and his wife Solomoniia Saburova in the hope that they would be blessed with a child: "The present pall was made in 1514 by the order of Vasily, by the Grace of God the Sovereign of All Russia and Grand Prince of Vladimir and Moscow and Novgorod and Tver and Pskov and all other principalities, the ninth year of his rule and Smolensk." The late addition of "and Smolensk" reflects the fact that it came under the rule of Moscow in the year the pall was made. The original black taffeta background is now lost, as are prayers that were embroidered on the margin and an inscription alongside the saint's head identifying him as St. Kirill the Wonder Worker. This pall was one of the first of many to adorn the tomb of Kirill. —VH

25. *St. Kirill of Belozersk with Scenes from His Life*,
early 16th century
Damask, silk, and gold and silver thread,
99.5 x 118 cm
State Russian Museum, St. Petersburg
(plate 20)

This embroidered icon cloth follows the common icon format of a central image of a saint surrounded by scenes of his life. It is one of the few cloths of this nature still extant. As in the full-length pall, Kirill is shown with his right hand in a gesture of blessing and holding a scroll in his left hand. The inscription identifying him as St. Kirill the Wonder Worker, Abbot of the White Lake, can still be seen in silver embroidery on either side of his head. Nineteen scenes from his life appear—each of them accompanied by lengthy descriptions—covering episodes from his birth, to his taking of the monastic vows, to the giving of instructions on how to administer the monastery, to his burial and post-mortem appearance to an elder visiting his tomb. This is one of the embroidered icon cloths that hung under the lowest tier of the iconostasis of the Cathedral of the Dormition at the Kirillo-Belozersk Monastery, and as a consequence it was made in a format wider than those used for icons. The influence of Dionysii is again apparent in this remarkable work. —VH

26. *The Tsar's Gates*, Moscow, mid-16th century
Tempera on panel, two panels: 169 x 40 cm,
176 x 41 cm
The State Tretyakov Gallery, Moscow
(plate 24)

Also known as the Royal Gates, *The Tsar's Gates* stand at the center of the iconostasis in Russian Orthodox churches, and they separate the space of the congregation from the sacred space of the Sanctuary. This example assumes the standard format, with the subject of the Annunciation in the upper registers and icons of the four Evangelists below. The left side pairs St. John the Evangelist, seen with his scribe Prochoros, with St. Luke. On the right, St. Mark appears on the top and St. Matthew on the bottom. Although these doors do not have additional panels, others might also include depictions of the theologians St. Basil the Great and St. John Chrysostom, the fathers of the liturgy. By the early sixteenth century, the subject of the Last Supper was often placed directly above the doors to indicate the priest's role of continuing Christ's sacerdotal office. The opening of the doors represented the entry into the Kingdom of God, and the closing was seen to evoke the expulsion from the Garden of Eden. The Annunciation served to remind the congregation that Mary had redeemed the sins of Eve, and both she and her son offered humanity the chance to enter into heaven, manifest in an acceptance of the Gospels written by the Evangelists. —VH

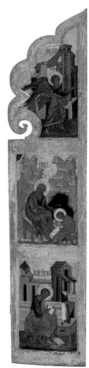
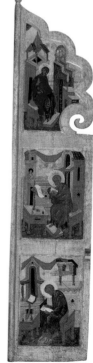

26

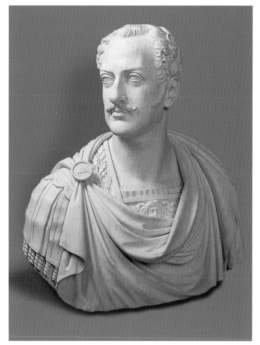

27

WESTERN EUROPEAN MASTERPIECES IN RUSSIA: THE IMPERIAL COLLECTIONS OF PETER I, CATHERINE II, AND NICHOLAS I

27. LUIGI BIENAIME (1795–1878)
Portrait of Nicholas I, ca. 1850
Marble, h. 92 cm
State Hermitage Museum, St. Petersburg
(plate 43)

Bienaime moved from Carrarato to Rome early in his career, where he joined the studio of the Danish sculptor Bertel Thorvaldsen. He adopted Thorvaldsen's style, which featured classical subjects and poses with tight, polished lines influenced by, if not directly copied from, antiquity. *Portrait of Nicholas I* portrays Tsar Nicholas I (1796–1855), the Romanov who ruled Russia from 1825 to 1855. His reign is marked by the Decembrist uprising (resulting from disagreement over his succession to the throne), and also by his significant involvement in the reshaping of the Hermitage collection. Bienaime sculpts Nicholas in classically regal costume, explicitly attributing to him the prestige of the Roman Empire. While faithfully rendering his subject's appearance and Western European grooming, the artist deliberately perfects his features. In omitting the details of the eyes, Bienaime hauntingly blends the tsar's contemporary style with a sense of antiquity, thereby emphasizing Nicholas's imperial status and lasting legacy in Russian history. —SN

28. BON BOULLOGNE (1649–1717)
Jephta's Daughter, second half of the 17th–early 18th century
Oil on canvas, 153.5 x 218 cm
State Hermitage Museum, St. Petersburg
(plate 36)

Boullogne was the most gifted child of a well-known artistic family. He was strongly influenced by the Bolognese school, including Guido Reni. His multifaceted career included decorative painting at Versailles and work on a number of chapels, in addition to his paintings on canvas. In *Jephta's Daughter*, he offers his interpretation of the biblical story of Jephta, who was asked to lead a mercenary Gileadite army against the Ammonites despite being born of a prostitute. Before going to battle, Jephta vowed to God that, in exchange for victory, he would sacrifice the first living thing to approach him upon his return home. Boullogne theatrically renders the tragedy of Jephta's vow when his only daughter, a virgin, greets him on the porch with a joyous dance to music. Jephta's horrified expression and his daughter's naive bewilderment exemplify the artist's keen ability to explore emotional and narrative complexity. —SN

29. ANGELO BRONZINO (1503–1572)
Portrait of Cosimo de Medici I, 1537
Oil on canvas, 117.5 x 87.5 cm
State Hermitage Museum, St. Petersburg
(plate 29)

Bronzino was a pupil of Pontormo and was therefore highly influenced by Italian Mannerism. He devised his own uniquely reserved style in Florence, where he mastered the art of portraiture while painting the intellectual elite. He eventually became the court artist to Cosimo de Medici I (1519–1574), represented here in the year he came to power. Bronzino's portraits are characterized by a disciplined color scheme and a sense of detachment. He distinguished himself from many of his contemporaries by emphasizing his subject's social and political eminence rather than portraying an accurate representation of character. In *Portrait of Cosimo de Medici I*, Bronzino eliminates any sense of emotion from the young face of the Grand Duke of Tuscany, making him impenetrable, like a painted sculpture. The darkness cast on the scene, in addition to de Medici's black clothing, emphasizes the status symbols that are visible, including his regal pleated collar and cuffs, as well as the gold medallion in his hand. The severe shading also draws focus to de Medici's dramatically elongated fingers and the blazing scene beyond, both typical of Bronzino's Mannerist training. —SN

30. JEAN-SIMEON CHARDIN (1699–1779)
The Laundress, 1730s
Oil on canvas, 37.5 x 42.7 cm
State Hermitage Museum, St. Petersburg
(plate 38)

French artist Chardin is best known for his reserved still lifes and domestic genre paintings. He was concerned with social inequality, and he depicted it in an honest, restrained way. Chardin's typical subjects were ordinary people in the poorer areas of Paris, and through painting he imparted a sense of dignity to their lowly occupations. *The Laundress* is suffused with a tempered calm through compositional balance and a limited palette. Chardin's selective use of chiaroscuro focuses foremost on the laundress and her work, and also on the pauper child who sits below and blows a transitory bubble through a straw. Behind them, through the door, the viewer gains access to

28

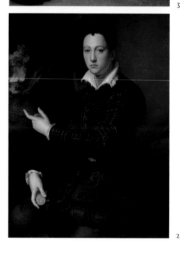

30

29

a secret world, where a second laundress, surrounded by a cloud of steam, hangs fabric to dry. Chardin's methods monumentalize the subjects against the dark background; he captures a beautiful, fleeting moment and holds it, staging their social status in a sympathetic light. —SN

31. GAROFALO (BENVENUTO TISI, 1481–1559)
The Entombment, 1520s
Oil on canvas, 53 x 75.5 cm
State Hermitage Museum, St. Petersburg
(plate 27)

Italian artist Garofalo brought the High Renaissance to Ferrara. Strongly influenced by Raphael and often considered stylistically derivative, Garofalo's unquestionable skill nonetheless brought a unified eloquence to his work. Despite his reputation for productivity, he was hindered by poor vision, and his career ended when he went blind in 1550. *The Entombment* shows Garofalo's ability to render myriad emotional states through an iconographic vocabulary of mannerisms. The viewer sees not only the grieving followers, but also two men carrying the lifeless body. The men appear more focused on the task at hand than on the tragedy of Christ's death. Interestingly, Garofalo bestows the most dramatic pose upon the woman at right, identified by her long red hair as Mary Magdalene; her

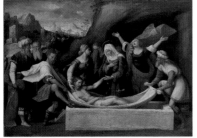

31

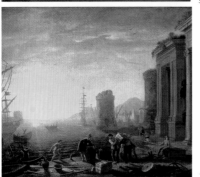

32

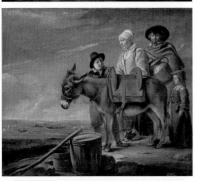

33

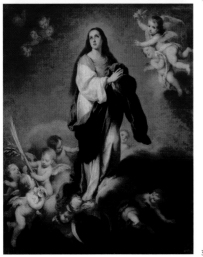

34

32. CLAUDE LORRAIN (CLAUDE GELLÉE, 1600–1682)
Morning in the Harbor, late 1630s
Oil on canvas, 74 x 97 cm
State Hermitage Museum, St. Petersburg
(plate 35) 164

Claude Lorrain, along with fellow artist Nicolas Poussin, is considered one of the greatest French artists to work in Rome during the seventeenth century. Best known for his idealized landscapes of the Italian countryside, Lorrain reveled in the nuances of both the early and late-day Roman sun, and consequently performed extensive studies on the interaction of light and shadow. Because he preferred to depict a soft, golden glow, most of Lorrain's extant works are of transitional moments in the morning and evening. In fact, until 1958 *Morning in the Harbor* was incorrectly titled *Evening*. The work delicately portrays the rising sun over an awakening seaport. Both of these subjects exemplify Lorrain's stylistic innovation—whereas earlier artists had to choose between directly rendering the sun and relying on it as their only light source, Lorrain does both, even as he transformed the harbor scene into an original genre. He creates a contrast between the light background and dark foreground, and thereby broadens the sense of space between them, while the graceful light diffuses forward from its source, resulting in a harmonious sense of unity. —SN

33. LOUIS LE NAIN (1593–1648)
The Milkmaid's Family, ca. 1641
Oil on canvas, 51 x 59 cm
State Hermitage Museum, St. Petersburg
(plate 37)

The Le Nain brothers—Antoine, Louis, and Mathieu—studied and worked together in Laon, Normandy, before sharing a studio in Paris. Because they collaborated closely and only signed their pieces by last name, attributing a single author to their works has been challenging and controversial. Louis is generally credited with large-scale works that consider social status, often representing a group of peasants in a suspended moment, creating a realistic environment of greens, blues, and grays. In *The Milkmaid's Family*, a market-bound peasant family is monumentalized by their size and height above the distant French countryside. Le Nain bestows a sense of dignity on the milkmaid by bathing her in a warm light, highlighting her posture and poignant downward gaze. The painter's typical color scheme creates an elegiac, even sympathetic, setting for the family. Perhaps most eloquent is their stationary position—underscored by the resting dog at the milkmaid's feet and the mule's unarticulated, static legs—that seems to hold them hopelessly still forever. —SN

34. BARTOLOMÉ ESTEBAN MURILLO (1617–1682)
The Esquilache Immaculate Conception, 1645–55
Oil on canvas, 235 x 196 cm
State Hermitage Museum, St. Petersburg
(plate 34)

Murillo worked in Seville, where he painted portraits, as well as internationally acclaimed scenes of children. He also frequently depicted the Immaculate Conception,

responding to seventeenth-century Spain's affinity for the subject. *The Esquilache Immaculate Conception* is laden with iconographic symbols that first appeared in Italy during the early sixteenth century. The Virgin Mary is depicted as the Woman of the Apocalypse—an exquisite beauty in heaven, clothed in white and blue and draped in sunlight (here light emanates outward from her), standing above the clouds and upon the moon. Cherubs surround her and carry emblematic objects, including the olive branch, palm, iris, and lily. Murillo's talent for portraying children brings a heightened realism to the playful angels, while his exaggerated use of light makes the radiant Virgin appear divine. —SN

35. JOSEPH NOLLEKENS (1737–1823)
Charles James Fox, 1791
Marble, h. 56 cm
State Hermitage Museum, St. Petersburg
(plate 42)

Nollekens spent several years living in Rome restoring ancient sculpture before returning to England and joining the Royal Academy, where he refined his neoclassical style. Although he became a wealthy portrait sculptor and tomb-maker, his reputation was plagued by alleged eccentricities and miserly habits. Charles James Fox (1749–1806) was an English statesman and a strong proponent of reform. He was highly regarded in England and also Russia, where he was famous for challenging William Pitt the Younger's proposal to attack Russia and force the Russians to relinquish territories won in the Turko-Russian War. This portrait was purchased in 1791 by Catherine the Great. Nollekens portrays Fox in a boldly noble fashion, dressing him in antique robes that give him the appearance of a Roman senator. His soft, full face exudes a sense of enlightenment, and his elegant wig indicates his social status in the English community. —SN

36. JACQUES-AUGUSTIN PAJOU (1730–1809)
Princess of Hesse-Homburg before the Altar of Immortality, 1759
Marble, h. 100 cm
State Hermitage Museum, St. Petersburg
(plate 41)

Pajou was brought up in a poor Parisian family and was first taught the art of sculpture by his father. He was considered a talented decorator and sculptor, as well as a

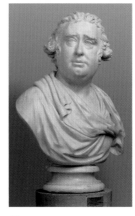

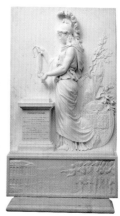

35 36

arms are desperately outstretched in a manner suggestive of Christ's crucifixion, while her brilliantly colored garb soars in a mysterious wind. Furthermore, by placing the Virgin Mary and Christ's hands at the center of the composition, Garofalo emphasizes the connection between mother and son, even after death. The Virgin Mary is saturated with a quiet acceptance, befitting her divine halo. —SN

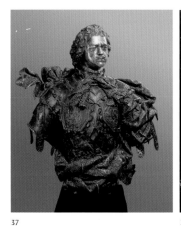

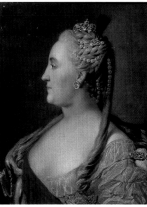

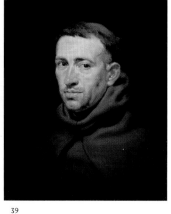

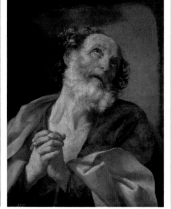

37 38 39

brilliant draughtsman. In *Princess of Hesse-Homburg before the Altar of Immortality*, Pajou monumentalizes the life of Anastasia Ivanovna Trubetskaya (1700–1755), Princess of Hesse-Homburg, and reflects on an eighteenth-century fixation on death and grieving. The predella (below) depicts Elizabeth Petrovna (1709–1762), daughter of Peter the Great, wearing her nightcap and a ribbon— the Order of St. Catherine, a decoration created in honor of her mother, Catherine I—as she leads the Preobrazhensky Guards on a march upon the Winter Palace in a successful coup d'état over the infant Tsar Ivan VI in 1741. On that very night, the enthroned Elizabeth, Empress of Russia, bestowed the Order of St. Catherine upon Anastasia. In the carving's upper portion, Pajou uses a classical motif to represent the recently deceased Anastasia in the guise of Minerva, Roman goddess of Dawn, War, and Wisdom, as she sacrifices the Saint Catherine ribbon at the Altar of Immortality. —SN

37. BARTOLOMEO CARLO RASTRELLI (1675–1744)
Portrait of Peter I, ca. 1723
Bronze, h. 102 cm
State Hermitage Museum, St. Petersburg
(plate 49)

Born and educated in Florence, Rastrelli came to Russia in 1716, on a three-year contract by invitation of Peter I (1672–1725), better known as Peter the Great. He remained in St. Petersburg for the rest of his life, becoming the leading foreign sculptor working in Russia in the first half of the eighteenth century. *Portrait of Peter I* is regarded as Rastrelli's most accomplished work, as well as the finest monumental sculpture of Peter executed during his reign. The sculptor's characteristic baroque style is evident in the emperor's sharp turn of the head, his disheveled hair, and the expressive folds of an ermine mantle thrown over his cuirass. The small shield on the left side of Peter's chest depicts his famous military victory over the Swedes in the battle of Poltava in 1709. A scene on the right shield—an allegory of the new Russia being created by the emperor— shows Peter chiseling out of stone a statue of a woman, clad in armor, crowned and carrying symbols of power: scepter and orb. The portrait's claim to physical likeness is incontestable as Rastrelli used a wax mask taken from Peter's face in 1719. Cast around 1723, the bust was chased and engraved by the engraver Semange under the sculptor's supervision. This portrait

came to stand for the entire epoch, with Peter's resolute figure embodying the advent of a Westernized and modernized Russia. The sculptor's son, Bartolomeo Francesco Rastrelli, became the leading architect who established the Italian baroque style in St. Petersburg, counting among his most celebrated buildings the Winter Palace (1754–62). —MC

38. FEDOR ROKOTOV (1736–1808)
Study for *Portrait of Catherine II*, 1763
Oil on canvas, 59.5 x 46.9 cm
The State Tretyakov Gallery, Moscow

This is a study for the full-length coronation portrait of Catherine II (Catherine the Great) that Rokotov completed in 1763. It was made a year after Catherine (1729–96), born Sophie Augusta Fredericka, a German princess, staged a successful coup d'état, dislodging her unpopular husband Peter III and installing herself on the throne. Widely disseminated through numerous copies and engravings, Rokotov's finished portrait became one of the first images affirming Catherine's new status. The study shown here focuses on the empress's bust, depicting her in profile and emphasizing the linear contour of her face, neck, and shoulders; her figure is given a sharpness that underscores the stately resolve of her character. Although advancing age is betrayed by swollen features and a double chin, Catherine's facial expression exudes self-confidence and power. Rokotov's portrait gives a glimpse of the absolute monarch who popularized the

French Enlightenment in Russia and yet ruled in a ruthless autocratic way. The palette is dominated by silvery gray, which creates a uniform effect of reserved dignity and echoes the diamonds and pearls of the empress's decorations. Traces of traditional Russian rouge on Catherine's cheek show her acceptance of the customs of the country she chose to rule. —MC

39. PETER PAUL RUBENS (1577–1640)
Head of a Franciscan Monk, 1615–17
Oil on canvas, 52 x 44 cm
State Hermitage Museum, St. Petersburg
(plate 31)

Flemish artist Rubens is considered the greatest Baroque artist of the seventeenth century in Northern Europe. Unlike many of his contemporaries, Rubens led a privileged life, which included a first-rate education and ample opportunity for travel. His innovative style was greatly influenced by the Renaissance of Northern Europe and the High Renaissance of Italy, which he encountered firsthand during a stay there (1600–08). The response to his work was remarkably powerful, and his influence spread across the continent during his lifetime. *Head of a Franciscan Monk* represents an early stage in Rubens's stylistic development. A devout Roman Catholic, Rubens imbues his subject with a sense of virtue through the use of a marked chiaroscuro, especially in the figure's face, where light seems to emanate from within. Despite a restrained palette, the skin retains a fleshiness that accentuates its vitality. This fleshiness, in exaggerated form, would become a signature element of Rubens's later works. —SN

40. PETER PAUL RUBENS (1577–1640)
The Arch of Ferdinand, 1634
Oil on panel, 104 x 72.5 cm
State Hermitage Museum, St. Petersburg
(plate 32)

In his last major undertaking, Rubens transformed the city of Antwerp to celebrate the arrival of Cardinal-Infante Ferdinand (1609/10–1641), the newly appointed regent of South Netherlands. The artist designed a series of wooden stages and arches wrapped in painted canvases, and he directed a league of local artists in the execution of his plans. When the festivities began on April 17, 1635, the

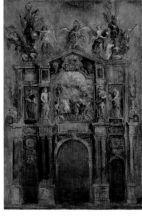

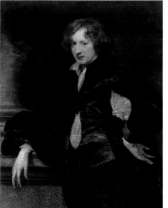

40 41 42

completed structures were brought to life with music and theatrical performances, and the result was a grandiose spectacle that epitomized the Flemish Baroque. In *The Arch of of Ferdinand*, a sketch for this project, Rubens displayed his mastery of the brushstroke as he constructed a lyrical tribute to the Cardinal-Infante's recent victory over the Protestant Swedes. He considered the classical idea of the triumphal arch but used a formal Baroque structure. Abandoning the typical modes associated with war—strength and austerity—Rubens instead implemented soft colors and a rhythmic line, both typical of his late career when his works proved most emotive. —SN

41. GUIDO RENI (1575–1642)
Repentance of the Apostle Peter, ca. 1635
Oil on canvas, 73.5 x 56.5 cm
State Hermitage Museum, St. Petersburg
(plate 33)

Italian artist Reni was greatly influenced by antiquity, as well as Raphael and Parmigianino. Espousing the ideals of the Baroque, his religious works were characterized by their emotional intensity and were infused with pathos and subtle colorism. He produced many accomplished, multiple-figure compositions, but it was portraiture that best demonstrated his gift for psychological character studies. In *Repentance of the Apostle Peter*, Reni represented the depths of misery in his portrait of a close and loyal follower of Christ. By denying his connection to Christ three times in one night before the midnight crowing of the cock, Peter broke his solemn oath. Throughout his remaining days, he remained tortured by the memory of his trespass and is said to have fallen to his knees whenever he heard the sound of the cock. This work characterizes Reni's late career when he moved to lighter tonalities and a silvery palette. While Peter's unruly hair and wrinkled skin heighten the emotional tension of the piece, his twisted neck and imploring, upturned eyes best exemplify Reni's evocation of despair. —SN

42. ANTHONY VAN DYCK (1599–1641)
Self-Portrait, 1622–23
Oil on canvas, 116.5 x 93.5 cm
State Hermitage Museum, St. Petersburg
(plate 30)

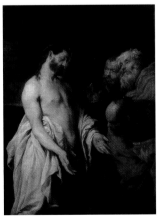

43

Van Dyck studied in Antwerp with Peter Paul Rubens from 1618 to 1620 before accepting a series of commissions in other Western European countries. Apart from Rubens, van Dyck was the only Flemish Baroque artist to win international acclaim. He did so largely as a result of the portraits he produced during the period 1632–1641, when he served as court painter to England's Charles I. One of van Dyck's most outstanding self-portraits, this work was one of several the artist made at the time. It reflects a seventeenth-century fixation with self-portraiture that is best exemplified by Rembrandt. Van Dyck gazes directly at the viewer as he casually leans against a balustrade, thereby projecting his youthful self-confidence. The influence of Rubens is evident in the fleshy pinkness of the skin, the dark, minimal background, and the emphasis on the face and especially the eyes. The attenuated treatment of the fingers, however, is van Dyck's own innovation and is characteristic of his evolving style. This painting in particular exerted an influence on the portraiture and self-portraiture of Russian artists, and of Orest Kiprensky and Karl Briullov in particular. —VH

43. ANTHONY VAN DYCK (1599–1641)
Appearance of Christ to His Disciples, 1625–26
Oil on canvas, 147 x 110.3 cm
State Hermitage Museum, St. Petersburg
(plate 28)

Van Dyck painted *Appearance of Christ to His Disciples* during his six-year stay in Italy. This work depicts the second visit of the resurrected Christ to his disciples. On his first visit, Thomas demanded to see and touch Christ's wounds. In van Dyck's painting, Christ invites "Doubting Thomas" to look upon his injuries, but in accordance with the Gospel and in contrast to many other representations of this subject, Thomas does not actually put his fingers into the gash in Christ's abdomen. This treatment underscores Christ's message to Thomas from the Gospel according to John 20:27: "Do not be faithless, but believing." The overall palette of the work shows not only the influence of the work of Rubens of around 1615, such as *Head of a Franciscan Monk* (1615–17, cat. no. 39), but also the darkened background and dramatic light effects characteristic of Caravaggio, who painted this same subject in 1600. —VH

44. JEAN-ANTOINE WATTEAU (1684–1721)
An Embarrassing Proposal, 1715–16
Oil on canvas, 65 x 84.5 cm
State Hermitage Museum, St. Petersburg
(plate 39)

Considered one of the most important early eighteenth-century painters as well as a pioneer of the Rococo style, French artist Watteau was inspired by the Venetian colorists and particularly by Peter Paul Rubens. He was quick to break from academic tradition, and from 1714 to 1717 he worked within his own genre: the *fête galante*. These small easel paintings were consistent in content: well-dressed gentry caught in a moment of conversation or music making and isolated in a charming park scene. Sometimes Watteau's works coupled contemporary dress with theatrical costume, thereby confusing both the time and place of the painting's action. *An Embarrassing Proposal*

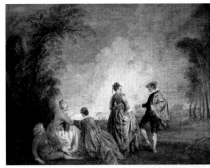

44

45

directs the viewer to interpret the subtle nuances of the standing man and woman; and, in a sense, welcomes the viewer as both voyeur and as the sixth member of the country party. For Watteau's subjects, there appears little distraction or worry from the outside world; they seemingly inhabit a timeless Arcadia. In fact, the seated trio is a precursor of the later, scandalous picnic scene in Edouard Manet's *Le Déjeuner sur l'Herbe* of 1863. —SN

45. PHILIPS WOUWERMAN (1619–1668)
The Horsing Manege in the Open Air, mid-17th century
Oil on canvas, 61.5 x 77 cm
State Hermitage Museum, St. Petersburg
(plate 40)

Dutch artist Philips Wouwerman lived in Haarlem and evidence suggests that he served as Frans Hals's apprentice, although his works show no trace of Hals's style. After a brief period in Hamburg, and through the influence of Pieter van Laer, he developed his own distinct style. Wouwerman's fascination with horses, coupled with his mastery of gray landscapes, earned him the reputation as the greatest and most versatile seventeenth-century Dutch horse painter. *Horsing Manege in the Open Air* is a prototypical early work of the artist: horses fill the foreground, a hill gives a sense of scale to the architecture that dominates the middle plane, and the background recedes to the sky. Whereas his later works emphasized the subject's horizontality and employed a more vibrant color scheme, here Wouwerman infuses the work with a distinct verticality and a somber palette of grays and browns. The unruly horses bring the scene to life and embody the artist's affinity for nature. —SN

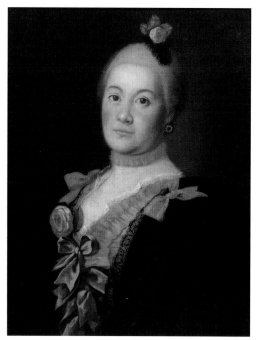

46

ASSIMILATING WESTERN EUROPEAN AESTHETICS: 18TH CENTURY

46. ALEXEI ANTROPOV (1716–1795)
Portrait of Princess Tatiana Trubetskaya, 1761
Oil on canvas, 54 x 42 cm
The State Tretyakov Gallery, Moscow
(plate 50)

Antropov was from the third generation of a family of artists; he began working as an apprentice in the Imperial Chancellery of Construction, which oversaw the decoration of all of St. Petersburg's new architecture. There he studied painting, first under Louis Caravaque and Andrei Matveev, and later under Ivan Vishniakov, who became the head of the painting workshop from 1739. Antropov worked on commissions that included the painting of icons, interior decorations for imperial palaces, and portraits of the Russian nobility. In 1761 he was appointed chief painter of the Holy Synod and an overseer of the icon-copying workshop. Princess Tatiana Trubetskaya, depicted here, was the daughter of Prince Alexei Kozlovsky, the head of the Synod. The austerity of the black background and of the sitter's dress contrasts with the abundant and bright ornamentation of her hair and clothing: the red of the ribbons on her dress is echoed by the roses and the traditional Russian rouge on her cheeks, while the green of the leaves on the flowers is reinforced by that of the fluffy bows on her bosom. —MC

47. VLADIMIR BOROVIKOVSKY (1757–1825)
Portrait of Ekaterina Arsenyeva, mid-1790s
Oil on canvas, 71.5 x 56 cm
State Russian Museum, St. Petersburg
(plate 51)

Often called the most distinguished portrait painter of the 1790s, Borovikovsky made this half-length portrait at the height of his artistic career. It depicts Ekaterina Arsenyeva (1778–?), the oldest daughter of the major general Nikolai Arsenyev—the chief of the headquarters of the famous military commander Alexander Suvorov—and his wife V. Ushakova. Educated at the Smolny Institute for Young Ladies of the Nobility in St. Petersburg, in 1796 she was nominated the maid of honor to the Empress Maria Fedorovna. The young woman is depicted holding an apple, an attribute of Aphrodite, the goddess of beauty. Her hat is decorated with ears of wheat that link her figure to the nature scene in the background. The subdued and light tones of the palette, the soft transitions of shades, and the gradual spatial recession, which is set on a slight diagonal, amount to a gentle portrait in the sentimental style popular in Russian art and literature of the time. —MC

48. VLADIMIR BOROVIKOVSKY (1757–1825)
Portrait of Prince Alexander Kurakin, 1799
Oil on canvas, 178 x 137 cm
State Russian Museum, St. Petersburg
(plate 72)

This is one of Borovikovsky's most successful ceremonial portraits. Prince Alexander Kurakin (1752–1818) rose rapidly in his career under the reign of Emperor Paul I, who in 1796 nominated him vice-chancellor and decorated him with the highest orders of the state. In 1798, however, as a result of power struggles in the court, Kurakin was suddenly dismissed from service. Thus this portrait, completed in 1799, immortalizes the regalia already lost. The bust of Paul I is visible in profile on the left side of the painting, reaffirming the dignitary's alleged proximity to the emperor. A harmonious combination of bright contrasting colors, dominated by red, gold, white, and black, further underscores the high status of the sitter and the solemnity of the occasion. In 1801 Kurakin regained imperial favors, and in 1802 he became the chancellor of Russian orders and a member of the State Council. He spent the following ten years as a Russian ambassador, first in Vienna (1806–08) and then in Paris (1809–12). —MC

49. VLADIMIR BOROVIKOVSKY (1757–1825)
Portrait of the Sisters Princesses Anna and
Varvara Gagarina, 1802
Oil on canvas, 75 x 69.2 cm

The State Tretyakov Gallery, Moscow
(plate 71)

Although the composition and general setting of this portrait is similar to that of the *Portrait of Ekaterina Arsenyeva*, Borovikovsky's painterly style here becomes more linear. The character of the figures, Anna Gagarina and Varvara Gagarina (1784–1808), daughters of the Secret Councilor Prince Gavriil Gagarin from his marriage to Praskovia Voenkova, is more pronounced, and they are set more sharply against the background. This portrait is also less formal and the figures engage the viewer in a more direct way: one of them stares out self-consciously, having lifted her eyes from the music sheet, while the other is leaning forward toward the space of the viewer. The sense of intimacy is further enhanced as the spatial recession on the left is interrupted by a table—a sly compositional device that forces us to remain in a dialogue with the figures rather than simply perceiving them as inhabiting their own space. —MC

50. LOUIS CARAVAQUE (1700–1754)
Portrait of the Tsarevich Peter Alexeevich and Tsarevna
Natalia Alexeevna in Childhood as Apollo and Diana, 1722
Oil on canvas, 92 x 118 cm
The State Tretyakov Gallery, Moscow
(plate 48)

Born into an artistic family in Marseilles, Caravaque was one of the main foreign artists hired by Peter the Great as a court painter in 1716. Caravaque painted the tsar's family on numerous occasions. Here he depicts Peter's grandchildren, Natalia Alexeevna (1714–1728) and Peter Alexeevich (1715–1730), who ruled briefly from 1727 as Peter II. The two children are shown in elaborate classical costumes and endowed with the attributes of Roman gods, the boy holding the lyre of the sun god Apollo and the girl the bow of Apollo's twin sister Diana, the goddess of hunting. The setting is highly theatrical, with contrived gestures and dramatic lighting. The tasks of a court artist at the time were not limited to painting, however; Caravaque also designed the decorations for imperial palaces, staged celebrations and firework displays, painted the interiors of churches and their iconostases, and made designs for coins and medals. In addition, like all foreign artists in Russia, Caravaque was required to take on Russian pupils. He continued to work in Russia for almost forty years, surviving six successive rulers. —MC

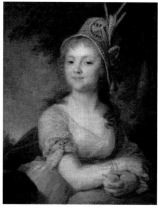

47

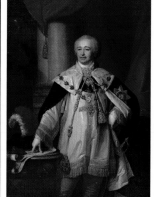

48

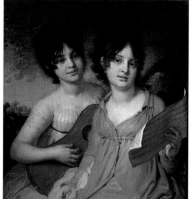

49

51. GÉRARD DELABART (active Russia 1787–1810)
*View of Moscow from the Kremlin Palace Balcony onto the
Moskvoretsky Bridge*, 1797
Oil on canvas, 75 x 143 cm
State Russian Museum, St. Petersburg
(plate 68)

A French landscape painter and a student of Joseph-Marie
Vien (whose other best-known pupil was Jacques-Louis
David), Delabart came to Russia in 1787. He was com-
missioned by Catherine II to make a series of views of the
imperial palace in Tsarskoe Selo. Delabart became well-
known for his series of sixteen views of Moscow, made in
1794–98 and widely disseminated in engraved versions.
These views became especially popular after the
Napoleonic invasion of Moscow in 1812, during which
many of the city's old wooden buildings were destroyed:
Delabart's images thus acquired the status of precious his-
torical records. This particular painting shows Moscow
from the highest point of the Kremlin's hill, with the
Kremlin cathedrals visible on the left, its surrounding
white-stone wall and towers on the right, and the Moskva
River behind it. The architectural ensemble of the
Kremlin, built in the 1330s, was reconstructed a number

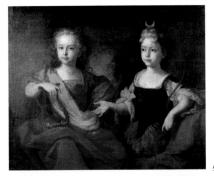

50

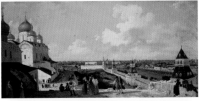

51

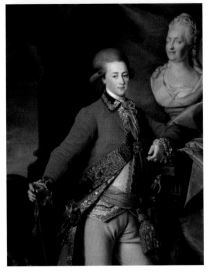

54

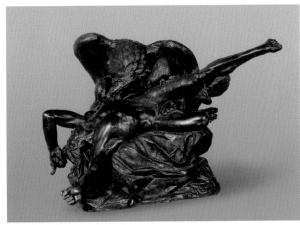

52

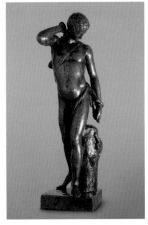

53

of times; this work continued in the late eighteenth cen-
tury, as is evident from the white-stone bricks stacked
near the wall on the right. —MC

52. FEDOR GORDEEV (1744–1810)
Prometheus, 1769
Bronze, h. 63 cm
The State Tretyakov Gallery, Moscow
(plate 61)

Like all the other great Russian sculptors of the second
half of the eighteenth century, Gordeev studied at the
Academy of Arts in St. Petersburg under Nicolas-François
Gillet. Between 1767 and 1769 he studied in Paris at the
Royal Academy of Painting and Sculpture under Jean-
Baptiste Lemoyne. Gordeev made this sculpture during
his time in Paris and four years later it gained him mem-
bership in the St. Petersburg academy. The sculpture
shows the Greek god Prometheus, who rebelled against
Zeus by stealing fire from him and teaching mortals to use
it. As a punishment, Zeus tied Prometheus to the side of a
rock, high in the Caucasus Mountains. Each day a vulture
came to tear at Prometheus's immortal flesh and try to
devour his liver; at night his body healed so that at dawn
the torture could begin anew. Gordeev's classical style is
highly expressive, with its dynamic composition and
detailed naturalistic finish. This bronze version was cast in
1956 from the plaster original, also in the collection of
The State Tretyakov Gallery. —MC

53. MIKHAIL KOZLOVSKY (1753–1802)
Shepherd with a Hare, 1789
Bronze, h. 81 cm
The State Tretyakov Gallery, Moscow
(plate 76

Kozlovsky studied at the Academy of Arts in St.
Petersburg between 1764 and 1773 under the French
sculptor Nicolas-François Gillet. In 1774 he went to
study in Rome, returning to Russia in 1780. In 1788 he
traveled to Paris on a government grant to perfect his
artistic skills and to serve as a resident supervisor of
Russian art students at various Parisian institutions. He
was working on a series of tranquil and idyllic classical
sculptures, like this one, when he witnessed the storming
of the Bastille. There is some dispute among scholars as to

whether the plaster original of this work was made in
Rome in 1775, when Kozlovsky described making a
statue that "represents the month of August or the sum-
mer in the form of a young shepherd," or in Paris in 1789
at the same time as the marble statue of the same subject
(now in the Hermitage). Kozlovsky's classical style com-
bines a sensitivity to antique prototypes with the influ-
ence of French eighteenth-century sculpture. In 1794 he
became a full member of the St. Petersburg academy and
taught there until his death. This bronze version of the
statue was cast in 1909 from the plaster original now in
the collection of the Ivanovo Museum of Art. —MC

54. DMITRY LEVITSKY (1735–1822)
Portrait of Alexander Lanskoi, 1782
Oil on canvas, 151 x 117 cm
State Russian Museum, St. Petersburg
(plate 62)

Levitsky studied under Alexei Antropov. In 1770 he
became a full member of the Academy of Arts in St.
Petersburg where he taught the portraiture class from
1771 until 1787. This painting, executed according to
the highest standards of academic portraiture, was
commissioned by Catherine II, who had fallen in love
with Alexander Lanskoi (1758–1784), a twenty-two-
year-old officer. Lanskoi, the son of a poor nobleman
from Smolensk, was the adjutant of Prince Grigory
Potemkin when he became Catherine's favorite in
1779. In a career move typical of this favored status, by
1784 Lanskoi was made a general as well as the holder
of several Russian and foreign orders. According to
contemporaries, Lanskoi was exceptionally handsome
and intelligent, a man of refinement and taste that
were cultivated to such a degree that he rapidly trans-
formed himself from an utterly provincial nobleman to
an enlightened collector and art lover who was known
to correspond with Voltaire. Catherine was so fond of
Lanskoi that she mourned his early death to the extent
of refusing to leave her private rooms for several days
and kept this portrait of him in her private rooms until
her death. Levitsky depicted the young man dressed as
the major general of the engineering corps, standing
next to the marble portrait bust of Catherine the
Great made by the sculptor Fedot Shubin. —MC

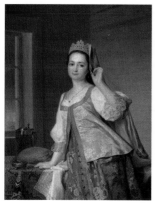 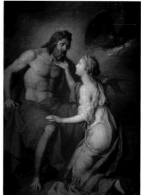 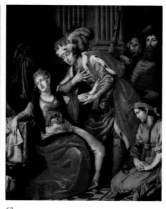 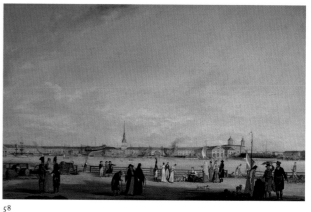

55 56 57 58

55. DMITRY LEVITSKY (1735–1822)
Portrait of Agafia Dmitrievna (Agasha) Levitskaya,
Daughter of the Artist, 1785
Oil on canvas, 118 x 90 cm
The State Tretyakov Gallery, Moscow
(plate 65)

We know very little about Levitsky's private life. He owned a house on Vasilyevsky Island in St. Petersburg, where he lived with his wife Anastasia and their daughter Agafia (also known by her pet name, Agasha). Agafia was born in the 1760s and died not earlier than 1805. She was married to A. Andreev, who worked as a secretary to the director of the senate's printing house. Upon her husband's death in 1805, Agafia returned with her children to the care of her father. This portrait shows her in a traditional Russian costume made of extremely fine fabric. Levitsky's excellent painterly technique is evident in the varied textures and highly detailed decoration of the surfaces of the dress and the tablecloth, and the perfectly smooth finish of the brushwork, all of which anticipate the portraits of Jean-Auguste-Dominique Ingres. Despite its decorative richness, however, this is an intimate portrait, as suggested by the young woman's informal pose and her open and direct gaze. —MC

56. ANTON LOSENKO (1731–1773)
Zeus and Thetis, 1769
Oil on canvas, 172 x 126 cm
State Russian Museum, St. Petersburg
(plate 56)

Losenko was one of the first students of the Academy of Arts in St. Petersburg to be sent to study in Paris. He went there as early as 1760, and stayed intermittently for three years, followed by four more years in Rome. He painted *Zeus and Thetis,* a commission from Count Kirill Razumovsky, during his last year in Rome. It depicts a subject from Homer's *Iliad*: Thetis, a Nereid (sea nymph), is shown begging Zeus, the ruler of Mount Olympus, to avenge her son Achilles, whose beautiful lover Briseis, has been kidnapped by Agamemnon, the commander of the Greek troops. Losenko's mastery of classical academic conventions of composition and figure painting are amply evident in this work. In 1770 he became a full member and professor of the St. Petersburg academy, and in 1772 was made its president—the highest honor for a Russian

artist at the time. Losenko's impact on academic painting in Russia was enormous; it is with him that history painting in Russia began to acquire the high status it already held in the Western European academies of art. —MC

57. ANTON LOSENKO (1731–1773)
Vladimir and Rogneda, 1770
Oil on canvas, 215.5 x 177.5 cm
State Russian Museum, St. Petersburg
(plate 57)

In 1764, the Academy of Arts in St. Petersburg came under the patronage of Catherine the Great, and it was modeled on the Western European and specifically the French academic system. Losenko was among the earliest success stories of the academy. While his predecessors and most of his contemporaries were primarily portrait painters, Losenko took on the elevated genre of history painting in a neoclassical style. In *Vladimir and Rogneda,* he presented the Russian historical subject of Prince Vladimir I of Novgorod, who in 980 rested control of Kiev from his half-brother Yaropolk, the legitimate son of Svyatoslav I. Vladimir asked Prince Rogvold of Polotsk permission to marry his daughter Rogneda. When Rogvold refused (partially because Rogneda was the intended of Yaropolk), Vladimir waged war on Polotsk, killed Rogvold and his two sons, and forcibly married Rogneda. Taking this land played a key role in Vladimir's successful plot to conquer Kiev. Losenko's painting shows the moment when Vladimir sought Rogneda's forgiveness. While the subject matter was Russian, the combination of classical form with a melodramatic scene clearly derives from the work of such Western neoclassical masters as the French artist Nicolas Poussin, whose work Losenko undoubtedly saw when he traveled to Paris and Rome on a stipend from 1760 to 1762. This painting earned Losenko the title of Academician. —VH

58. JOHANN MAYR (1760–1818)
View of the Admiralty from the Vasilevsky Island
Embankment, between 1796 and 1803
Oil on canvas, 76 x 116 cm
State Russian Museum, St. Petersburg
(plate 67)

A Swiss artist, Mayr was born in Germany into a family of artists. He came to Russia in 1778 at the invitation of the Academy of Arts in St. Petersburg and went on to teach painting, drawing, and engraving there until his death. Mayr mainly produced illustrations for scientific treatises, but between 1796 and 1803 he also created a series of cityscapes of the imperial capital, some of which were engraved and published as *Views of St. Petersburg.* This painting from the series shows the embankment of Vasilyevsky Island, one of the biggest in the delta of the Neva River. Across the river is the Admiralty, founded by Peter the Great in 1704 as a shipyard and center of administration for the fleet. The painting shows its stone buildings and the tower with a spire that had been erected in the 1730s, as well as ships under construction in front of it. At the time this painting was made, the Admiralty was a fortress surrounded by ramparts and ditches. Several years after Mayr completed this painting, it became an essentially historical record, as the Admiralty was entirely rebuilt between 1806 and 1823 on the order of Alexander I. —MC

59. IVAN NIKITIN (1688–1741)
Portrait of Tsarevna Natalia Alexeevna, 1715–16
Oil on canvas, 102 x 71 cm
The State Tretyakov Gallery, Moscow
(plate 46)

This is one of the earliest-known portraits by Ivan Nikitin, the most accomplished Russian portraitist of the first half of the eighteenth century. Nikitin was among the first four Russian painters sent by Peter the Great to study painting abroad on a state grant. This portrait was made shortly before he left for Italy in 1716. Tsarevna Natalia Alexeevna (1673–1716), Peter's beloved sister, is shown dressed in the new European style rather than in traditional Russian costume. One of the most educated women of her time, she strongly supported Peter's reforms and contributed to the development of Russian theater. Nikitin's portrait was made shortly before the tsarevna's death. The expressiveness and naturalism of the sitter's face, especially her eyes, and the pronounced three-dimensionality of her dress, stand in contrast to the stylization of the *parsunas* of the turn of the century. Yet the blank background as well as the half-length and three-quarter turn of the figure link this painting to established Russian pictorial conventions. —MC

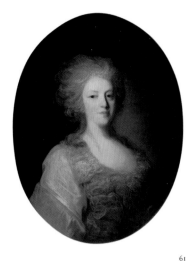

61

63

59

60

60. IVAN NIKITIN (1688–1741)
Portrait of a Field Hetman, 1720s
Oil on canvas, 76 x 60 cm
State Russian Museum, St. Petersburg
(plate 47)

Nikitin spent four years studying painting at the academies of fine arts in Venice and Florence. In 1720, on Peter the Great's request, he returned to Russia, where he was appointed the first court portraitist. He remained close to Peter and enjoyed his patronage until the tsar's death in 1725. Nikitin's best works date from the 1720s. The title of this painting is based on an inscription found on its verso: *"getman napolno,"* that has been tentatively interpreted as *"Napolniy Getman"* (Field Hetman), referring to the commander of Cossack field troops in Malorosiia (Little Russia), Poland, and Lithuania. However, since the figure's costume features no evident native elements, one Russian scholar has recently argued that this is, in fact, Nikitin's self-portrait. The naturalism of the figure stands in striking contrast to that of icon painting and *parsunas*: the man's white eyebrows and moustache, his disheveled hair, and his reddish skin and eyelids betray an old and tired man, whose eyes seem filled with both fear and resolve. Nikitin's loose, expressive brushstrokes and his use of gold are more reminiscent of the painting of Rembrandt than that of the Italian artists he had studied. —MC

61. FEDOR ROKOTOV (1736–1808)
Portrait of Praskovia Lanskaya, early 1790s
Oil on canvas, 74 x 53 cm
The State Tretyakov Gallery, Moscow
(plate 64)

Born into serfdom, Rokotov was freed early in his life (the exact year is unknown) and in the mid-1750s moved to St. Petersburg. In 1760, on the recommendation of Ivan Shuvalov, he was admitted to the recently founded Academy of Arts in St. Petersburg. There he studied under several foreign masters, including Pietro Rotari, the court painter of Empress Elizabeth from 1756 to 1762, who most likely influenced his interest in the rococo. In 1765 he became a full member of the St. Petersburg academy, but chose to move to Moscow where he worked as a free painter from his own studio with assistants and pupils. Rokotov's portraits from the 1770s and 1780s are usually considered his finest, while this work exemplifies his mature style. Painted predominantly in ash-gray, silver, and pink tones, the portrait emphasizes the sitter's noble and reserved qualities. The fine lace on Lanskaya's dress is echoed by her hairstyle, contributing to an enigmatic and romantic image. The oval shape of the painting, a device often used by Rokotov in his later portraits, creates an intimate and introspective effect that serves to emphasize the internal characteristics of the sitters.

Praskovia Nikolaevna Lanskaya (1770–?), born Princess Dolgorukova, was married in 1792 to Colonel Yakov Lanskoi, the brother of Alexander Lanskoi, the favorite of Catherine the Great. —MC

62. FEDOSII SHCHEDRIN (1751–1825)
Marsyas, 1776
Bronze, h. 69 cm
The State Tretyakov Gallery, Moscow
(plate 59)

Shchedrin studied at the Academy of Arts in St. Petersburg between 1764 and 1773 under Nicolas-François Gillet. After he graduated, he won a scholarship from the academy that allowed him to continue his education in Florence, Rome, and Paris. After his period of government-sponsored travel ended in 1777, Shchedrin remained in Paris for another five years, working primarily on private commissions. *Marsyas* is one of the artist's early sculptures, made in a Baroque style evident from the exaggerated expressiveness of the figure and the heightened drama of the event. It depicts the Greek satyr Marsyas, who challenged Apollo, the god of music, in a flute contest. When Marsyas lost, he was punished for his arrogance by being flayed alive. Shchedrin's sculpture shows the torment of a man who dared to challenge a god. —MC

63. FEDOSII SHCHEDRIN (1751–1825)
Sleeping Endymion, 1779
Bronze, h. 58 cm
The State Tretyakov Gallery, Moscow
(plate 60)

This sculpture demonstrates the transition of Shchedrin's work from the exuberance of the Baroque style toward a smoother and more restrained classicism. The subject of *Sleeping Endymion* is well suited to the contained and introspective qualities of the classical style. Selene, the Greek goddess of the moon, fell in love with Endymion, an extremely beautiful—but mortal—shepherd. In one version of the myth, in order to preserve Endymion's youth, Selene casts a spell on him that puts him into eternal sleep. Shchedrin has made Endymion's body appear timeless; the contours of the figure are perfectly smooth with hardly any muscles. However, Endymion's pose and

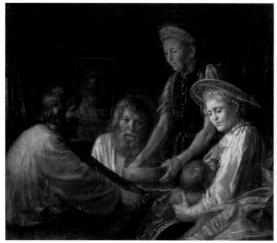

64

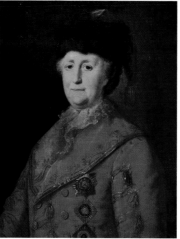

65

Shubin was born in the same northern village near Arkhangelsk as Mikahil Lomonosov. His father, a free and literate peasant, was Lomonosov's first teacher. It was through the scientist's patronage that Shubin was accepted to the Academy of Arts in St. Petersburg, where he studied under Nicolas-François Gillet between 1761 and 1767. In 1767 Shubin won a gold medal from the academy and was sent to study in Italy and France, where he spent the next six years and studied under Jean-Baptiste Pigalle. Upon his return to Russia, he produced a variety of classical sculptures, but became best known for his marble busts of statesmen, military commanders, and members of the nobility under Catherine the Great. During the 1770s and 1780s Shubin produced marble busts at the incredible rate of at least one a month, and made a number of portraits of the empress, whose special favor he enjoyed. This bust precedes Shubin's full-length statue of *Catherine II the Legislator* of 1789, which is considered his most successful work. It depicts the empress with a scepter, the symbol of her power, and the allegorical attributes appropriate to an enlightened monarch: a book of laws, a scale of justice, and a horn of plenty. —MC

67. FEDOT SHUBIN (1740–1805)
Portrait of Prince Platon Zubov, 1795
Bronze, h. 70 cm
The State Tretyakov Gallery, Moscow
(plate 55)

By the 1790s interest in Shubin's work had faded; his financial situation became increasingly difficult as his commissions diminished and his teaching post at the academy remained unpaid. He did not stop working, however, and his portrait-busts from that time demonstrate his ability to describe his insights into his sitters' characters within the medium of marble. This bust depicts Prince Platon Zubov (1767–1822), the last favorite of Catherine II, a man of little intelligence and education, but good-looking and fluent in French. Beginning in 1789, Zubov rose rapidly in his career and by 1795, a year

the cloths under him are still somewhat Baroque in style. The same subject was famously depicted a decade later by one of Jacques-Louis David's favorite students, Anne-Louis Girodet (1793; Musée du Louvre, Paris). It is known from archival documents that Shchedrin made a marble version of this work and gave it to Catherine the Great's collection in the Hermitage. This bronze version was made in 1909 from the original plaster. —MC

64. MIKHAIL SHIBANOV (d. after 1789)
Peasant Lunch, 1774
Oil on canvas, 103 x 120 cm
The State Tretyakov Gallery, Moscow
(plate 58)

Born a serf, Shibanov was later sold to Prince Grigory Potemkin, the favorite of Catherine the Great, who patronized his servant's art. Yet in 1783 Shibanov is mentioned in documents as a free painter. Familiar with peasant life at first hand, Shibanov was the first Russian painter to depict it in genre scenes. The artist's inscription on the back of the work reads: "this painting shows peasants from Suzdal province." Shibanov shows the peasant lunch as a kind of solemn ritual, one that reveals the inner rhythm and dignity of daily peasant existence. The figures' poses are static yet psychologically expressive and historically evocative, with the men shown wearing beards long forbidden by Peter the Great. The women wear traditional Russian costumes and headdresses. The entire scene, and especially the detail of the woman nursing the child, has religious connotations. Shibanov's style is painterly rather than linear, with visible loose brushstrokes and blotches of paint. The color scheme is dominated by red and brown tones, creating a particularly earthy and poetic atmosphere. —MC

65. MIKHAIL SHIBANOV (d. after 1789)
Portrait of Catherine II in a Travel Dress, 1787
Oil on canvas, 70.5 x 56 cm
State Russian Museum, St. Petersburg
(plate 66)

Born Sophie Augusta Fredericka, a German princess from Anhalt-Zerbst, Catherine II (1729–1796), better

known as Catherine the Great, became the wife of the heir to the Russian throne, the future Peter III, in 1745. In 1762, however, she staged a coup d'etat, dislodging her unpopular husband and taking over the throne. Shibanov accompanied the empress on her 1787 trip to the Crimea together with Prince Grigory Potemkin, who commissioned the artist to paint this portrait from life in commemoration of the event. He depicts Catherine without excessive pomp, aging as she was at fifty-eight, with white hair visible from beneath her hat, but dressed in official costume and decorated with the three highest orders of the Russian state. Despite the empress's well-known fussiness about her portraits, she herself ordered numerous reproductions of Shibanov's painting, which must have depicted her as she wished to be seen: in a manner that was not excessively idealized, but one that represented her as a reserved humanist, an enlightened monarch, and the embodiment of the "philosopher on the throne" as she described herself. —MC

66. FEDOT SHUBIN (1740–1805)
Portrait of Catherine II, 1783
Marble, h. 63 cm

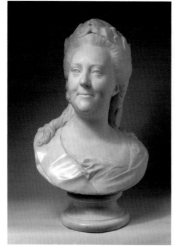

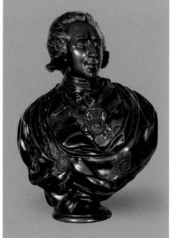

66

67

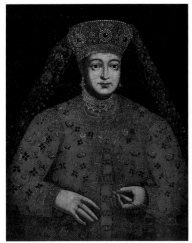

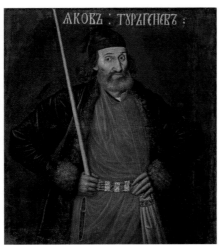

68 69

before Catherine's death, he held up to thirteen key positions in the government of the Russian Empire simultaneously. It seems that power and public status made him extremely arrogant. He entrusted most of the actual work to his secretaries and considered it his true calling to decide on the general issues of the life and politics of the state. His abuse of power and his policies, especially in foreign affairs, brought much harm to the Russian empire. Shubin brilliantly illustrates Zubov's empty gloss and his narcissistic self-assurance. —MC

68. UNKNOWN ARTIST
Portrait of Tsarina Marfa Matveevna, Born Apraksina,
Second Wife of Tsar Fedor Alexeevich, early 1680s
Oil on canvas, 89 x 70 cm
State Russian Museum, St. Petersburg
(plate 45)

This painting is an example of a *parsuna*, a word derived from the Latin *persona* and used to describe a particular kind of portrait made in Russia from about the second half of the seventeenth until the beginning of the eighteenth century. *Parsunas* represent a transition from the traditional

conventions of icon painting to a more illusionistic and individualized depiction of specific sitters. The figure here is shown against a flat, black background. Her body also appears flattened, with elbows awkwardly moved apart as if to display more of her richly decorated clothing. At the same time, the artist clearly seeks to create the illusion of three-dimensionality with his modeling of the woman's hands and the contours of her face. Marfa Apraksina was the second wife of Tsar Fedor Alexeevich (who ruled between 1661 and 1682) and this image was most likely made during her marriage in 1682, which lasted only two months before her husband died. She spent the remaining thirty-three years of her life as a widow. —MC

69. UNKNOWN ARTIST, Armory Chamber School
Portrait of Yakov Turgenev, ca. 1694
Oil on canvas, 105 x 97.5 cm
State Russian Museum, St. Petersburg
(plate 44)

This painting is one of the best-known examples of the *parsuna*, a uniquely Russian style of portraiture that reflects a combination of traditional techniques of icon

painting with a growing tendency toward greater naturalism and individualized depiction. It shows Yakov Turgenev (16?–1695), a key member of the entertainment society at the court of Peter the Great, a troupe mockingly nominated "The Most Madcap, Most Drunken Synod of Fools and Jesters Presided Over by the Prince-Pope." This portrait was made around the time of Turgenev's wedding, an event that turned into a wild three-day celebration at the court. Turgenev died shortly thereafter. As in traditional icon painting, the subject here is flattened and stands against a neutral dark background with his name inscribed at the top of the image. Yet the texture of Turgenev's clothing is conveyed with successful illusionism: the velvet of his coat, the fur on its edging, and the silk of his caftan and belt are almost tangible. The sitter's face is represented with a naturalism and expressiveness unprecedented in Russian art: there are wrinkles on his forehead and the raised eyebrows and lowered corners of his mouth display the sarcasm and disillusionment of an older man who has chosen the role of court buffoon at the end of his life. —MC

70. IVAN VISHNYAKOV (1699–1761)
Portrait of Sarah Eleonora Fairmore, ca. 1749
Oil on canvas, 138 x 114.5 cm
State Russian Museum, St. Petersburg
(plate 52)

71. IVAN VISHNYAKOV (1699–1761)
Portrait of Wilhelm George Fairmore, second half
of the 1750s
Oil on canvas, 135 x 109 cm
State Russian Museum, St. Petersburg
(plate 53)

Between 1739 and 1761 Vishnyakov served as the director of the painting workshop at the Chancellery of Construction, overseeing all decorative painting in the imperial residences of St. Petersburg. At the same time, he restored and painted icons as well as producing portraits. This pair of pendant paintings, usually considered to represent his best work, shows the two children of Count William Fermor (1702–1771), a British emigrant and General-in-Chief who led numerous military campaigns in the Russian army between the 1730s and 1750s. The children's bodies are painted in a rather simple, even slightly distorted manner: the girl's arms are disproportionately elongated to enable them to rest on the wide folds of her dress and the boy's right hand is somehow lost in the large and exquisitely decorated cuff of his jacket. Nevertheless, the technical shortcomings of the figure painting here are entirely compensated for by the extremely refined and richly detailed decoration of the dress of the subjects and the harmonious and delicately balanced palette. Vishnyakov's artistic talent is further apparent in his sensitivity to the figures' surroundings: the girl's fragility and refinement, for instance, is underscored by the delicate landscape behind her, while the boy's firmness and resolve are reaffirmed by the geometric edges of the furniture and the tiles that frame him. The overall effect of these portraits is one of elegance and sophistication. —MC

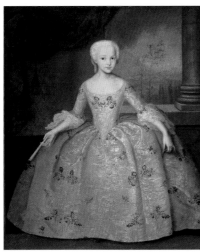

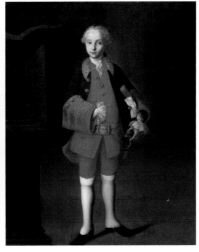

70 71

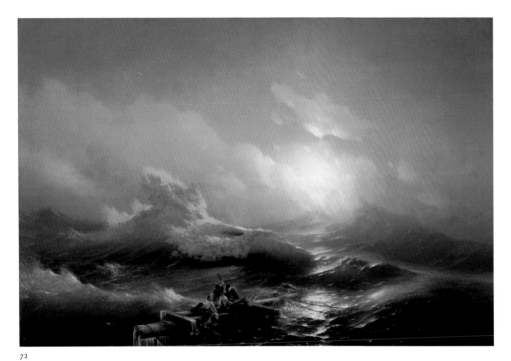

72

THE COMING OF AGE OF RUSSIAN ART: FIRST HALF OF THE 19TH CENTURY

72. IVAN AIVAZOVSKY (1817–1900)
The Ninth Wave, 1850
Oil on canvas, 221 x 332 cm
State Russian Museum, St. Petersburg
(plate 100)

Aivazovsky was born in the Crimea into an impoverished family of Armenian merchants. With the aid of people who noticed his talent, he managed to attend the Academy of Arts in St. Petersburg, where he focused on landscape painting and seascapes in particular. In 1837 he won the Major Gold Medal and embarked on a trip across Western Europe. He spent considerable time in Italy and had exhibitions in Rome, Venice, Naples, Paris, Amsterdam, and London, where he garnered the appreciation of J. M. W. Turner, who had been painting tumultuous seascapes for several decades by that time. Aivazovsky belonged to the Academies of Stuttgart, Florence, Rome, and Amsterdam, and received the French Legion of Honor. In 1844, he returned to St. Petersburg and achieved the rank of Academician. After joining the staff of the General Navy Headquarters, he accompanied the Russian fleet to such far-flung locales as Turkey, Greece, Egypt, and America. His working method involved making extensive sketches, which he used, along with his memory, to create his paintings in remarkably short periods of time. One of his greatest masterworks is *The Ninth Wave*, which like Théodore Géricault's 1819 *Raft of the Medusa*, captures man's struggle to survive against the force of the sea. The title refers to a common seamen's expression meaning a single wave larger than the others, which here threatens to engulf the tiny people clinging to their makeshift vessel. Aivazovsky's use of light creates a glistening yet foreboding seascape. The intense

light in the center of the clouds functions as a divine radiance symbolizing the eternal qualities of hope, faith, and salvation. Initially in the Russian gallery of the Imperial Hermitage, it was one of the first works to be acquired by the Alexander III Russian Museum (now the State Russian Museum) upon its founding in 1897. —VH

73. FEDOR ALEXEEV (1753–1824)
View of the Palace Embankment from the Peter and Paul Fortress, 1794
Oil on canvas, 70 x 108 cm
The State Tretyakov Gallery, Moscow
(plate 69)

Alexeev founded the Russian school of cityscape painting. He studied at the Academy of Arts in St. Petersburg between 1766 and 1773 and spent five subsequent years on a state grant in Venice. Here he studied decorative painting with Giuseppe Moretti and Pietro Gaspari, but was mainly fascinated by the work of the Venetian painter Canaletto. Upon his return to St. Petersburg, Alexeev worked as a set decorator in a theater school (1779–1786), while establishing his reputation with numerous copies of paintings in the Hermitage collection by Canaletto,

Bernardo Belotto, Hubert Robert, and Joseph Vernet. He then began to make his own *vedute*, a genre comprising topographically accurate and detailed panoramic cityscapes and other views. *View of the Palace Embankment from the Peter and Paul Fortress* won him the title of academician in 1794. It shows the corner of the Peter and Paul Fortress on the immediate left; across the river, the view is framed by the Marble Palace on the right and the Summer Garden on the left. It is a very tranquil scene, showing the Neva River with a surface of almost mirror-like smoothness. —MC

74. FEDOR ALEXEEV (1753–1824)
Cathedral Square in the Moscow Kremlin, 1800–02
Oil on canvas, 81.7 x 112 cm
The State Tretyakov Gallery, Moscow
(plate 70)

In 1800, at the request of Paul I, the council of Academy of Arts in St. Petersburg asked Alexeev to paint cityscapes of Moscow, the pre-Petrine capital of Russia. The artist worked there until the spring of 1802, creating visual records that some ten years later acquired the status of precious historical documents, as a major fire during the Napoleonic invasion destroyed most of the city's old wooden architecture. This majestic view of the Cathedral Square at the heart of the Kremlin shows the red porch of the Hall of Facets on the left, and next to it, the Cathedral of the Assumption, the oldest and largest church on the square; in the center of the image is the Bell Tower of Ivan the Great, which also marks the center of Moscow, and on the very right can be seen the corner of the Archangel Cathedral. A number of other important historic buildings are visible behind the Kremlin wall. The artist chose a lowered viewpoint in order to monumentalize the buildings and increase the width of the panoramic view. From 1803 until his death Fedor Alexeev taught the class in perspective painting at the Academy of Arts in St. Petersburg, counting Silvester Shchedrin and Maxim Vorobiev among his best pupils. —MC

75. KARL BRIULLOV (1799–1852)
Portrait of Countess Julia Samoilova, 1832–34
Oil on canvas, 269.2 x 200.7 cm
Hillwood Museum and Gardens, Washington, D.C., Bequest of Marjorie Merriwether Post, 1973
(plate 90)

Briullov was the first Russian painter to gain an international reputation, earning membership in the academies of

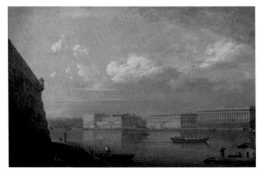

73

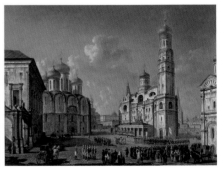

74

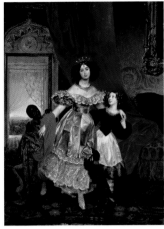
75

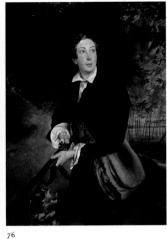

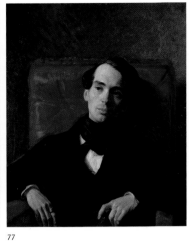
76

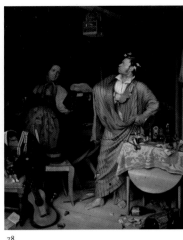
77

78

Bologna, Milan, Parma, and Florence, and the Grand Prix at the Paris Salon of 1834. Upon winning the gold prize for painting and graduating from the Academy of Arts in St. Petersburg in 1821, he went to Italy on a stipend from the Society for the Promotion of the Arts. During his thirteen-year stay, Briullov met and fell in love with Countess Julia Samoilova (1803–1875), who had left Russia in part due to Tsar Nicholas I's disapproval of her lavish lifestyle following her separation from her husband, Count N. Samoilov. At her villa near Milan, she hosted many cultural luminaries, including the Russian writer Ivan Turgenev and the Italian opera composer Giovanni Pacini, with whom she had an affair and whose two daughters she adopted. Giovaninna Pacini is represented in this portrait as she adoringly greets her mother, who wears a stunningly rendered blue satin dress, tiara, and gold belt adorned with cabochons. A black page catches the red cashmere shawl falling off her right arm. Samoilova's face and expression recall the contemporaneous work of Jean-Auguste-Dominique Ingres, who was in Italy from 1806 to 1824. As in Briullov's other portraits, 120 of which he painted while in Italy, this one possesses a theatricality that contributed to comparisons with the work of Anthony van Dyck. Indeed, both the theater and Samoilova played a role in Briullov's most famous painting *The Last Day of Pompeii* (1833). Pacini's opera *The Last Day of Pompeii*, staged at La Scala in 1827, had a strong influence on Briullov, and Samoilova was the model for several figures in the painting. When he showed it for the first time in 1834 at La Brera in Milan, it became an instant sensation, earning him the appellation "Great Karl," as well as the admiration of the hero of the Romantics, Sir Walter Scott. —VH

76. KARL BRIULLOV (1799–1852)
Portrait of Alexei Tolstoy in His Youth, 1836
Oil on canvas, 134 x 104 cm
State Russian Museum, St. Petersburg
(plate 89)

Briullov returned to Russia from Italy in 1835, and he taught at the Academy of Arts in St. Petersburg from 1836 to 1848. Shortly thereafter, he painted the portrait of Alexei Tolstoy (1817–1875), who became a noted poet and playwright. Tolstoy was born in St. Petersburg to Count Konstantin Tolstoy and his wife, Anna Perovskaya,

the illegitimate daughter of Catherine the Great's prominent courtier Count Alexei Razumovsky. His parents separated shortly after his birth, and consequently he was raised by his mother and uncle, Alexei Perovskii. His uncle was a well-known author of the period who published under the name of Anton Pogorelskii and split his time between Moscow and a country estate in the Cherligov province of Ukraine. Briullov painted the young man at age nineteen, as he prepared to go hunting with his dog. This picture was widely produced as an engraving. Mikhail Botkin, the noted collector and patron of the arts, was struck by the remarkable likeness of the painting to the sitter. Tolstoy's talents as a writer had become evident by the age of six, and at age ten he met Johann Wolfgang von Goethe during a trip to Weimar with his mother and uncle. He did not begin to publish in earnest until the 1850s and did so while holding down a government job. At that time, he invented the author Kozma Prutkov—modeled on an official in Tsar Nicholas I's government—whose fables, epigrams, and sayings painted a portrait of an arrogant, stupid member of contemporary Russian society. By the 1860s, he quit his job and moved to the country, where he wrote historical novels, poems, and plays, among them *The Death of Ivan the Terrible* (1866). —VH

77. KARL BRIULLOV (1799–1852)
Portrait of the Writer Alexander Strugovshchikov, 1840
Oil on canvas, 80 x 66.4 cm
The State Tretyakov Gallery, Moscow
(plate 88)

This portrait of Alexander Strugovshchikov (1808–1878) shows the writer and translator lost in thought in a manner characteristic of other Romantic portraits painted during this time. Strugovshchikov translated into Russian major works by such prominent German Romantic writers as Friedrich von Schiller and Johann Wolfgang von Goethe, including the latter's *Faust*. Beginning in 1840, he succeeded Nestor Kokolnik, whose highly romanticized portrait Briullov painted in 1836, as publisher of *The Gazette of Fine Arts* in St. Petersburg. The long fingers of the bent hand and the casual pose reflect the influence of Anthony van Dyck's *Self-Portrait* of 1622–23, which Briullov would have seen in the collection of the Royal Hermitage and which had an impact on Briullov's

numerous self-portraits. Like his self-portraits, this work focuses tightly on the seated figure, and emphasizes the broad forehead, thus referring to the sitter's inherent intellect and creativity. Strugovshchikov's troubled gaze suggests an inner conflict. The moderate scale of the work, coupled with the lack of a dramatic, lush setting, contrasts with Briullov's more festive portraits, such as the one of Countess Samoilova seen here. —VH

78. PAVEL FEDOTOV (1815–1852)
The Newly Decorated Civil Servant (An Official the Morning after Receiving His First Decoration), 1846
Oil on canvas, 48.2 x 42.5 cm
The State Tretyakov Gallery, Moscow
(plate 98)

Fedotov turned to painting as a full-time occupation late in his life. Having finished military school, he had served in the Life-Guards Regiment in St. Petersburg until 1843, when he resigned. He then began taking classes at the Academy of Arts in St. Petersburg. Fedotov was largely self-taught, learning as much by copying works in the Hermitage as he did in the academy. He particularly valued Dutch seventeenth-century genre painting, the social satire of the English eighteenth-century artist William Hogarth, and the prints of the contemporary French artists Honoré Daumier and Paul Gavarni. *The Newly Decorated Civil Servant (An Official the Morning after Receiving His First Decoration)* is Fedotov's first genre painting; it was preceded by a sepia drawing (1844, State Tretyakov Gallery) where the same subject is parodied in a considerably more grotesque way. The painting's protagonist poses as a monument to himself, a heroic statue wrapped in a dirty dressing gown instead of a Greek toga. His audience is made up only of his cook, who looks mockingly at her master while handing him a worn-out pair of boots, and a soldier peering with surprise from underneath a table. The room is in total disarray, bearing traces of the previous evening's drinking bout. At once comic and deplorable, this scene effectively exposes the empty nature of officialdom. The pictorial space is boxlike and theatrical, with the tilted floor bringing the scene close to the viewer's space. The overabundance of objects scattered everywhere, and the characters' expressive poses and gestures create a clear but overwhelming narrative. —MC

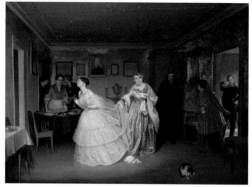

79

79. PAVEL FEDOTOV (1815–1852)
The Major's Proposal, ca. 1851
Oil on canvas, 56 x 76 cm
State Russian Museum, St. Petersburg
(plate 99)

The Major's Proposal is one of two versions painted by Fedotov. The first, made in 1848 and now in the collection of the State Tretyakov Gallery, earned him admission to the Academy of Arts in St. Petersburg and is often considered his most accomplished painting. The viewer witnesses a moment immediately preceding the meeting of an aging impoverished officer of aristocratic descent and a merchant's daughter, whom he intends to marry in order to solve his financial difficulties. Just as the matchmaker walks in announcing the arrival of the potential groom, the young woman attempts to rush out of the room, while her mother catches her by the dress. The version shown here, painted a few years after the first, illustrates the profound transformation of Fedotov's art within a short period of time. It is now substantially more austere, with a greater emphasis on the tragic rather then the comic aspects of the subject. While the poses are still expressive and the setting still highly theatrical, Fedotov shifted the focus from external appearances to the psychological aspects of the event. By restricting the number of narrative details, toning down decorative elements, and relying more heavily on contrasts between light and dark, the artist increased the inner tension and the narrative and emotional complexity of the work—as he did in his late paintings generally—while also giving the viewer greater interpretative freedom. —MC

80. ALEXANDER IVANOV (1806–1858)
Study for *The Appearance of Christ to the People*,
ca. 1837
Oil on canvas, 53.5 x 74.5 cm
State Russian Museum, St. Petersburg
(plate 91)

This study is closest to the final version of the painting, Ivanov's *magnum opus* of monumental dimensions (540 x 750 cm), which is now at the State Tretyakov Gallery in Moscow and is undoubtedly one of the most famous works of Russian nineteenth-century art. Ivanov worked on it for over twenty years, from 1837 to 1857, in Italy, where he spent most of his productive life. The canvas merges a number of episodes from the Gospels, showing simultaneously St. John's prophetic sermon, his baptism of

the people, and the appearance of Christ. The emphasis here is not so much on the miracle itself, but rather on the variety of reactions of different people to the transformative powers of this event. Ivanov sought to create an ethnographically accurate panorama of human life and psychology and to express it in a direct and convincing manner, avoiding traditional classical stylization. —MC

81. ALEXANDER IVANOV (1806–1858)
Nude Boy, study for *The Appearance of Christ
to the People*, 1840
Oil on canvas, 47.7 x 64.2 cm
State Russian Museum, St. Petersburg
(plate 92)

This sketch was made on the outskirts of Rome as part of Ivanov's preparation for his monumental *Appearance of Christ to the People*. On one level it is an accomplished painterly study of a nude body *en plein air*. At the same time, this and other similar images of youth had a deeper symbolic meaning for the artist. In his search for representational symbols that could speak to the viewer directly, Ivanov juxtaposed the freshness and immediacy of youth with the idea of eternal and immutable nature. By insisting on this contrast, Ivanov breaks away from the romantic understanding of the inseparability of human interiority and the forces of nature. —MC

82. ALEXANDER IVANOV (1806–1858)
Model of Assunta, in the Pose of Christ, study for *The
Appearance of Christ to the People*, 1840s
Oil on paper, mounted on canvas, 47.5 x 37.1 cm
The State Tretyakov Gallery, Moscow
(plate 93)

This female figure served as one of the studies for the depiction of Christ in the finished composition. Ivanov often used female models in his studies for the painted figures of men. The turn of Assunta's head in relation to her torso is repeated in the figure of the Messiah. Her eyes and eyebrows as well as her nose are also closely mimicked in Christ's male face. Ivanov searched for a pose for Christ that would reveal the qualities that made him more than human. He made one more study of a female model, this time without hands, and in the final painting Christ appears with his hands folded. Ivanov's numerous sketches and preparatory drawings for his *magnum opus* often became finished drawings and paintings in their own right, which is undoubtedly the case here. —MC

83. ALEXANDER IVANOV (1806–1858)
Head of St. John the Baptist, study for *The Appearance of Christ to the People*, 1840s
Oil on paper, mounted on canvas, 51 x 44 cm
The State Tretyakov Gallery, Moscow
(plate 94)

Ivanov attributed great importance to each figure in his monumental painting, looking for a unique expressive pose and gesture for every one of over thirty human figures in the final painting. The figure of St. John the Baptist is undoubtedly the central one, creating a visual, narrative, and symbolic connection between the characters in the painting and Christ. His oratorical gesture

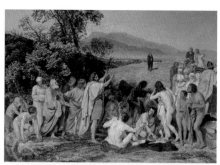

80

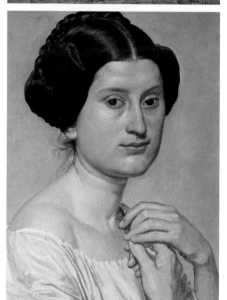

81

82

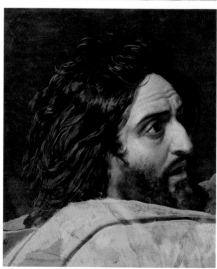

83

84

85

86

points to the coming figure of Christ, and his influence on the others in the painting is the greatest. This sketch shows the resoluteness of St. John's facial expression. The turn of his head and his upward glance testify to his leadership and spiritual aspirations. His mouth is open—he is the only talking figure in the painting. —MC

84. ALEXANDER IVANOV (1806–1858)
Figure of a Rising Man; Head of a Faun; Head of Old Man Rising, study for *The Appearance of Christ to the People,* 1833–57
Oil on paper, 50 x 62 cm
State Russian Museum, St. Petersburg
(plate 95)

This study demonstrates the extent to which Ivanov relied on sculptural classical models for the modeling of bodily postures and facial expressions of the human figures in his

monumental painting. The head of the old man on the left combines the features of the sculptural head of a substantially younger Faun on his right and a much more weather-beaten old man at the bottom of the page. Here, age seems to be only a relative factor, as Ivanov integrates the features of a young Faun into the representation of an old man, and thus imbues his figure with a meaning that goes beyond physical appearance. The painter's comments at the bottom of the sketch are written in Italian, revealing the degree of his assimilation into the country where he spent most of his productive life. —MC

85. ALEXANDER IVANOV (1806–1858)
Olive Tree, Aricca Valley, study for *The Appearance of Christ to the People,* 1846
Oil on canvas, 61.4 x 44.4 cm
The State Tretyakov Gallery, Moscow
(plate 96)

Beginning in 1846 Ivanov used *camera lucida* in his work on landscapes, as he strove to reveal nature in its objective reality. For him nature was a means of expressing a sense of timelessness and immutability, of the weight and authority of history and a symbol of the transcendence of human limitations. His landscape studies always carry a connection to a specific place that is itself charged with history. An olive tree, depicted here, becomes a natural symbol, one that is readily comprehensible without the mediation of the conventions of the classical tradition. As both an inalienable part of the Italian landscape and one of the longest-living trees, the olive tree stands for long life and hope. Ivanov monumentalizes the tree by depicting it in a close up, seen from below and hovering above the valley. —MC

86. ALEXANDER IVANOV (1806–1858)
Water and Stones near Palaccuolla, study for *The Appearance of Christ to the People,* early 1850s
Oil on canvas, 45 x 61.2 cm
State Russian Museum, St. Petersburg
(plate 97)

This study was painted in Italy, near the thirteenth-century Franciscan Monastery Palaccuolla, situated on the outskirts of Rome near Lake Albano. It is during work on such open-air studies that Ivanov developed his pioneering system of outdoor painting. Ivanov sought to discern and reveal what he took to be the symbolism inherent in nature—hence the monumentalization and almost photographic precision of his landscape studies. Here the monumental effect is achieved through a close-up view of the stones, the wet surfaces of which become a rich ground for the study of the complex play of light and shadow. —MC

87. OREST KIPRENSKY (1782–1836)
Portrait of Colonel Evgraf Davydov, 1809
Oil on canvas, 162 x 116 cm
State Russian Museum, St. Petersburg
(plate 75)

Orest Kiprensky was one of the leading Russian artists of the early nineteenth century, and he achieved international recognition for his work. The illegitimate son of the

landowner Alexei Dyakonov, Kiprensky was raised by the serf Adam Schwalbe. Dyakonov freed his son from servitude and helped him to be admitted to the Academy of Arts in St. Petersburg in 1788; he graduated in 1805 with the Gold Medal. While he was trained as a history painter, one of his earliest and defining successes was his portrait of his adopted father, Schwalbe, which demonstrated the introspective hallmarks of Romantic portraiture. This approach was also evident in Kiprensky's *Portrait of Colonel Evgraf Davydov,* whose military career represented the kind of adventurous, daring exploits characteristic of the Romantic hero. For a long time, it was thought that the subject of this painting was a cousin of Davydov (1775–1823), Denis, who like Evgraf, was a hero of the war against Napoleon (known as the War of 1812). Evgraf later achieved the rank of Major General and was finally discharged from military service in 1813. Many have remarked on the similarity of this portrait to the work of Jacques-Louis David and Théodore Géricault, but Kiprensky could not have seen these French artists' work by 1809. He was, however, influenced by the paintings of Rembrandt, Peter Paul Rubens, and Anthony van Dyck on display at the Hermitage. —VH

88. OREST KIPRENSKY (1782–1836)
Portrait of Daria Khvostova, 1814
Oil on canvas, 71 x 57.8 cm
The State Tretyakov Gallery, Moscow
(plate 73)

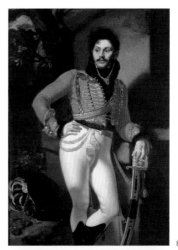

87

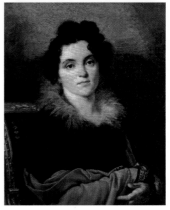

88

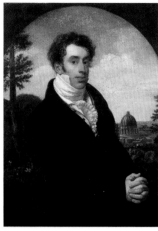
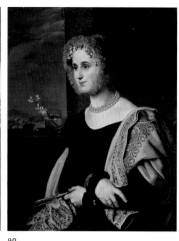

89 90

Painted in the period following the War of 1812, this stunning early portrait served as a pendant to Kiprensky's picture of the sitter's husband, V. S. Khvostov. Khvostov exudes reflective seriousness, as he clutches his jacket and glances toward an undefined space outside the canvas. He wears a cross medallion on his neck and stands before a lush drapery. Khvostova wears a similarly reserved expression. But in contrast to her husband, she looks directly at the viewer and assumes a more natural pose, thereby appearing less detached, but no less introspective. Her elegant fur collar and loosely draped shawl reveal her stature, as well as Kiprensky's talent for painting textiles. —VH

89. OREST KIPRENSKY (1782–1836)
Portrait of Prince Alexander Golitsyn, ca. 1819
Oil on canvas, 97.3 x 74.5 cm
The State Tretyakov Gallery, Moscow
(plate 77)

Kiprensky left Russia for Western Europe in 1816 and spent seven years in Italy. He chose Prince Alexander Mikhailovich Golitsyn (1772–1821) as the subject of his first Italian portrait. Golitsyn came from one of the most prominent Russian noble families and in the early 1810s served as staff master to Grand Duchess Ekaterina Romanov, the favorite granddaughter of Empress Catherine II (Catherine the Great) and the sister of Tsar Alexander I. Golitsyn worked for the grand duchess in the Tver province, where her husband Duke Peter of Oldenburg was the governor; her salon was the center of artistic life in the region. Kiprensky initially met Golitsyn in Tver but painted this portrait in Italy a number of years later. Golitsyn came to Italy in search of a cure for tuberculosis, a disease that caused his untimely death in 1821. The prince, who was an art collector, commissioned several portraits of himself while living in Italy. Kiprensky's painting represents Golitsyn as a foreign traveler contemplating the Roman landscape from a point above the city. The sitter's elegant clothing indicates his aristocratic social standing, even as the formality of his dress contrasts with the landscape in which he is situated. An arch framing the scene visually echoes the dome of St. Peter's Basilica in the distance, itself a reflection of Golitsyn's solid, vertical presence, which denotes his elevated stature. Various accounts indicate that the landscape painter

Silvester Shchedrin worked on this painting with Kiprensky; indeed, the representation of the dome calls to mind Shchedrin's rendition of St. Peter's in his famous *New Rome: St. Angel's Castle* (1824, cat. no. 92). The conflation of Golitsyn with this major symbol of the original seat of Christianity is further emphasized with the pietistic clasping of his hands. Kiprensky was also in touch with one of Golitsyn's more prominent relatives, Prince Alexander Nikolaevich Golitsyn, whose ascendancy to power was inextricably linked with the notion of a universal Christianity based in Russia that would merge Protestantism, Catholicism, and Orthodoxy. Alexander Nikolaevich had been, by the time Alexander Mikhailovich's portrait was painted, Tsar Alexander I's procurator of the Holy Synod, president of the interdenominational Russian Bible Society (RBS), and the tsar's minister of education and spiritual affairs, a unique and highly powerful post; from 1838–41 he served as chairman of the State Council. In the thirteenth chapter of the epilogue to Leo Tolstoy's *War and Peace* (1863–69), set during the time of Russia's War of 1812, it is noted that Alexander Nikolaevich and the RBS had practically become the government. —VH

90. OREST KIPRENSKY (1782–1836)
Portrait of Ekaterina Avdulina, 1822
Oil on canvas, 81 x 64.5 cm
State Russian Museum, St. Petersburg
(plate 74)

Kiprensky painted this portrait, widely considered one of his best, during a stay in Paris. Ekaterina Avdulina (1788–1832) was the granddaughter of the wealthy nobleman Savva Yakovlev and the wife of General Major Alexei Avdulin, a member of the Imperial Guard, as well as the Society for the Promotion of the Arts. At the time this portrait was made, the Avdulins were living in Paris, but in St. Petersburg society, they were noted for their formal balls, which were attended by such luminaries as the writer Alexander Pushkin, the subject of Kiprensky's famous 1826 portrait. Many scholars have noted the similarity between Kiprensky's representation of Avdulina and both Leonardo da Vinci's *Mona Lisa* of 1503–06 and Titian's 1536–37 *Portrait of Eleonora Gonzaga della Rovere*. Avdulina bears the slight, closed-mouth smile of Mona Lisa and sits adjacent to an open window of an interior

like Eleonora Gonzaga, but unlike either of those subjects, she does not make eye contact with the viewer. Rather, she engages in introspective reflection characteristic of Romanticism. Kiprensky reveals a familiarity with Dutch still lifes as well in his treatment of the flowers and vase. As the art historian Dmitry Sarabianov has noted, the fallen petals suggest the precarious balance Avdulina must maintain between her inner life and the demands of her duties. —VH

91. NIKIFOR KRYLOV (1802–1831)
Winter Landscape (Russian Winter), 1827
Oil on canvas, 54 x 63.5 cm
State Russian Museum, St. Petersburg
(plate 83)

Krylov was one of Alexei Venetsianov's first pupils and one of the first to become a member of the Academy of Arts in St. Petersburg. He came from a petty bourgeois family, and at a young age he was a traveling artist working primarily in churches as an icon painter. Venetsianov discovered Krylov in 1823, and by 1825 had taken him to St. Petersburg to introduce the young artist to the collections of the Hermitage. In addition to Venetsianov's tutelage, Krylov took a drawing class at the Academy of Arts. He traveled to a village on the Tosno River in order to paint *Winter Landscape (Russian Winter)*, which he showed along with a series of his portraits in 1827 at one of the academy's public exhibitions. He received much critical acclaim for this landscape, which, like the work of his teacher, captures the daily life and labor of the villagers. It also suggests a kinship with the sixteenth-century paintings of the Dutch artist Pieter Brueghel the Elder, although certainly Krylov's work is less populated and

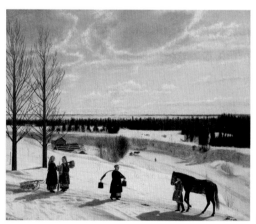

91

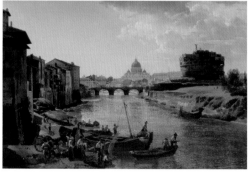

92

more reverent in its approach to the subject. This simple scene of Russian peasants that emphasizes both the countryside and the lower class, departs radically from the type of subject matter and style that dominated the Academy of Arts in the 1820s. —VH

92. SILVESTER SHCHEDRIN (1791–1830)
New Rome: St. Angel's Castle, 1824
Oil on canvas, 44.7 x 65.7 cm
The State Tretyakov Gallery, Moscow
(plate 87)

Shchedrin belonged to a family of artists. His father, Fedosii, was a famous sculptor, professor, and assistant rector at the Academy of Arts in St. Petersburg. His uncle Semyon was credited with the establishment of landscape painting in Russia and, according to his nephew, with introducing young Silvester to the Hermitage, where the boy fell in love with the work of the eighteenth-century Italian painter Canaletto. He entered the Academy of Arts in 1800 and studied with noted landscape painter Fedor Alexeev. He graduated with honors and a gold medal, but his study abroad had to be delayed until 1818 due to the War of 1812 with Napoleon. Shchedrin gained wide recognition for *New Rome: St. Angel's Castle,* and he ultimately made approximately ten versions of this subject. In contrast to many paintings of Rome, this one does not focus exclusively on the architecture, ruins, or other signs of the city's history. While he did include the dome of St. Peter's Basilica and the medieval St. Angel's Castle, he also depicted Rome as a living entity, in large part by including the vital presence of the fisherman along the Tiber River. He also employed a formal technique to underscore this point. Rather than using the brown tones so prominent in most painting, he used an innovative range of colors in gray and silvery tones that permitted him to better

93

94

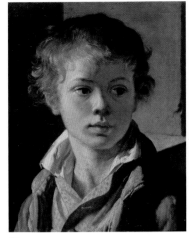

95

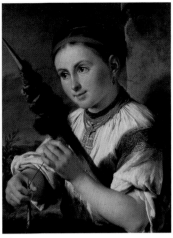

96

capture the quality of light he was seeking. He shared this concern with light with such contemporaries as the British artist John Constable, and the French artist Camille Corot, who Shchedrin may well have met in Italy. —VH

93. SILVESTER SHCHEDRIN (1791–1830)
Terrace on the Sea Coast, 1828
Oil on canvas, 45.4 x 66.5 cm
The State Tretyakov Gallery, Moscow
(plate 85)

Shchedrin spent a good deal of time in Naples, and *Terrace on the Sea Coast* exemplifies the mythic Italy of the Russian imagination, an idyllic haven for beauty in which human life coexists harmoniously with nature. He produced numerous paintings of vine-wrapped terraces overlooking the sea, in which he further experimented with warm colors and tones and the naturalistic treatment of light. He skillfully painted the play of light and shadow throughout the terrace, as well as glowing sunshine illuminating the sparkling water below. This painting reflects his interest in using diagonal compositions to impart a sense of dynamism into the work. Shchedrin frequently used a splash of vivid color, such as the red cap of the standing male figure, to provide a focal point for his paintings of Naples. —VH

94. GRIGORII SOROKA (1823–1864)
Fishermen, second half of 1840s
Oil on canvas, 67 x 102 cm
State Russian Museum, St. Petersburg
(plate 84)

Soroka may have been Alexei Venetsianov's most gifted student. A serf by birth, he studied with Venetsianov from 1842 until his teacher's death in 1864. In spite of Venetsianov's efforts to buy his freedom, Soroka remained in servitude until Tsar Alexander II declared the end of serfdom in 1861. His peaceful, idyllic *Fishermen* captures the beauty of the Russian countryside, and specifically of the village of Spasskoe in the district of Kozlovo. This and other landscape paintings by Venetsianov were suffused with light, which he regarded as a sign of God's benevolence. The timelessness of this representation reflects the artist's desire to create an image of paradise through his art

that contrasted with the misery of earthly life. Sadly, he committed suicide in 1864. —VH

95. VASILY TROPININ (1776–1857)
Portrait of Arseny Tropinin, ca. 1818
Oil on canvas, 40.4 x 32 cm
The State Tretyakov Gallery, Moscow
(plate 80)

Tropinin was born into serfdom. His master, the general Irakly Morkov, sent him to study at the Academy of Arts in St. Petersburg, only to call him back to his estate before he had graduated out of fear that admirers of the young painter's talent would request his freedom. Tropinin worked as a pastry cook and a footman on his owner's estate while also receiving numerous commissions for portraits, for which he was becoming increasingly well known. In 1823 Tropinin was granted freedom and, after submitting a series of paintings to the Academy of Arts, was admitted to its ranks. Tropinin's portrait of his son Arseny was made during his service. It is a typical Romantic work, capturing the freshness and openness of the child through the dramatic contrast between light and shade, the delicacy of his facial features, and his loose golden curls. —MC

96. VASILY TROPININ (1776–1857)
Spinner, 1820s
Oil on canvas, 60.3 x 45.7 cm
The State Tretyakov Gallery, Moscow

As someone born into serfdom and granted freedom when he was already in his forties, Tropinin often painted peasants whom he knew well. Idealized portraits of peasant women at work, spinning, doing embroidery or lace making, were among his favorite subjects in the 1820s. Typically for Tropinin's representation of peasants, this image combines elements of portraiture and genre scene. The young woman is presented in a setting typical for a Romantic portrait—half-length, turned in three quarters and set against an expressive landscape. Her hands are prominent, as often in Romantic portraits, yet they hold the tools of her trade, and she is actually spinning thread. She looks conspicuously Russian, with her rounded face and a traditional peasant hairstyle, an embroidered cotton shirt and a Russian Orthodox cross

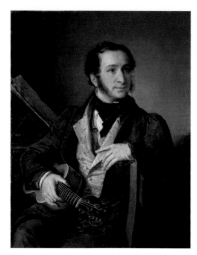

97

around her neck. Tropinin's style here has changed: the brushwork is almost invisible and the surface is now smooth and polished. —MC

97. VASILY TROPININ (1776–1857)
Portrait of Pavel Mikhailovich Vasiliev, 1830s
Oil on canvas, 95 x 75 cm
State Russian Museum, St. Petersburg
(plate 78)

This is one of Tropinin's mature works, painted after he settled in Moscow permanently in the mid-1820s and began to enjoy wide acclaim and popularity as a free painter. He made portraits of his contemporaries from all walks of life: writers, merchants, businessmen, and common people. Pavel Mikhailovich Vasiliev (1798–1854), an accountant at the offices of the Moscow Imperial Theater, is here depicted in an intimate setting, as a music lover seated with a guitar and a music stand. Despite the presence of genre elements in this portrait, it is the figure's interiority that is emphasized. The shallow space and the blank, evenly dark background bring forth the figure of the sitter, who looks diagonally to the side with the light dramatically illuminating his dreamy and inspired face. —MC

98. ALEXEI VENETSIANOV (1780–1847)
Reaper, 1820s
Oil on canvas, 30 x 24 cm

State Russian Museum, St. Petersburg
(plate 81)

Venetsianov was born in Moscow to a merchant family from Greece. In the early 1800s, he worked as a civil servant and studied painting in his free time, but in 1802, he moved to St. Petersburg. There he enrolled as an external student at the Academy of Arts and spent time in the Hermitage, where he fell under the influence of seventeenth-century Dutch genre and landscape paintings and such French artists as Louis Le Nain, Jean-Baptiste Chardin, and especially François-Marius Granet, whose *Choir of the Capuchin Church in Rome* of 1818 he particularly admired. For a brief time, he lived and studied with the portraitist Vladimir Borovikovsky. In 1810, the board of the Academy of Arts awarded Venetsianov the title of Distinguished Associate on the basis of his portraiture. In 1819 he purchased a small estate in the Tver province, where he founded an art school for commoners and serfs, many of whom he liberated; however, he still maintained serfs of his own. Venetsianov became the first painter to dedicate himself to Russian rural and peasant life. In works such as *Reaper*, the influence of icons and religious painting is evident. The sentimentality of Venetsianov's depiction of the young woman's sweet face reflects Borovikovsky's influence. While the specific features of the reaper make this a portrait, the iconicity of the representation also invokes icons of the Mother of God. The golden crop behind her is suggestive of the gold ground characteristic of Russian icons. —VH

99. ALEXEI VENETSIANOV (1780–1847)
On the Harvest: Summer, mid-1820s
Oil on canvas, 60 x 48.3 cm
The State Tretyakov Gallery, Moscow
(plate 82)

On the Harvest: Summer is one of Venetsianov's finest works. In contrast to his contemporaries Karl Briullov and Orest Kiprensky, Venetsianov did not try to adhere to academic rules and techniques. Like most of his paintings, this one is suffused with a gentle, natural light. As indicated by the title, he tried to capture the seasonal conditions in this and other contemporaneous works such as *In the Fields. Spring* of 1827, which, together with *On the Harvest: Summer*, forms a kind of diptych about the cyclical life of the peasant. Here, there is little spatial

differentiation between the platform on which the peasant in red is seated, the field populated with laborers, and the clear, blue sky. This serves to emphasize the close connection between humans and nature, as well as to invoke the flatness characteristic of icons. The sickle and the traditional dress of the peasant women impart a specific, nationalist referent, but Venetsianov presents them as universal figures by occluding their faces. The peasant in the foreground nursing her baby functions as a sort of secular Madonna and underscores the artist's belief that the mother and child symbolized the continuation of the human race and a bastion of moral strength. While this idyllic, idealized scene invites contemplation of such larger issues, it also captures the dignity and beauty of farm labor represented by the workers in the field, as well as the peacefulness of rest represented by the nursing mother. —VH

100. MAXIM VOROBIEV (1787–1855)
Neva Embankment near the Academy of Arts: View of the Wharf with Egyptian Sphinxes in the Daytime, 1835
Oil on canvas, 75 x 111 cm
State Russian Museum, St. Petersburg
(plate 86)

Vorobiev began at the Academy of Arts in St. Petersburg in 1798 in the architectural faculty and graduated in 1809 as a landscape painter. He became an academician in 1814 and a member of the academy's faculty in 1815. He eventually rose to the rank of honored professor and his students included the famed Ivan Aivazovsky. Vorobiev specialized in the painting of landscapes, seascapes, architectural monuments, and war scenes. He devoted particular emphasis to light and atmosphere, as is evident in *Neva Embankment near the Academy of Arts: View of the Wharf with Egyptian Sphinxes in the Daytime*. The focal point of this painting is the two sphinxes that were installed on the granite pier opposite the academy in 1834. These massive sculptures, discovered by French archaeologists on a dig near Thebes in the early nineteenth century, bear the visage of the Egyptian Pharoah Amenhotep III, the ninth king of the Eighteenth Dynasty. His reign marked the pinnacle of ancient Egypt's political power and cultural achievements, and the presence of the two sphinxes—each weighing twenty-three tons—underscored the importance of the academy. —VH

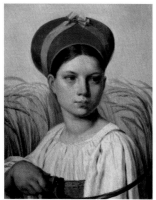

98

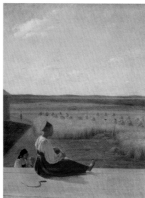

99

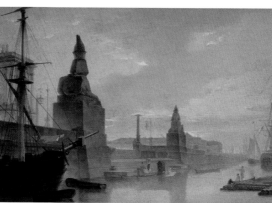

100

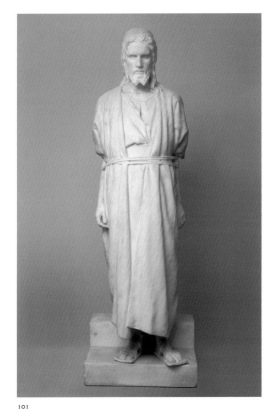

101

ART AND SOCIETY: SECOND HALF OF THE 19TH CENTURY

101. MARC ANTOKOLSKY (1843–1902)
Ecce Homo: Christ before the People, after 1892
Marble, h. 100 cm
State Russian Museum, St. Petersburg
(plate 135)

Antokolsky began his artistic career working on church iconostases. He was the first Jewish student admitted to the Academy of Arts in St. Petersburg, where he made friends with Ilya Repin and met both Ivan Kramskoy and the famed art critic Vladimir Stasov. In the late 1860s, he became associated with the academy of Berlin and later gained membership in the Paris and Urbino Academies. In 1870, he participated in the first exhibition of the Wanderers (Society of Traveling Art Exhibitions), but by 1871 he left Russia to live abroad. Nonetheless, he became the most prominent Russian sculptor of the second half of the nineteenth century and is perhaps best known for his penetrating, monumental sculpture of Tsar Ivan the Terrible, which earned him the title of academician. A few years later he produced the first version of *Ecce Homo: Christ before the People*, which was in bronze. As was his custom, he made versions in various mediums, including this marble one completed after 1892. This sculpture was one of Antokolsky's most successful depictions of a historical figure with defining attributes, in this case the ropes binding Christ's arms as he stood in judgment before Pontius Pilate and the people. Many of the other Wanderers—chiefly Kramskoy and Nikolai Ge—produced major paintings of Christ that stressed his doubt

and suffering. Antokolsky's representation is distinguished by an emphasis on Christ's Semitic features and the strength of his faith and determination. Antokolsky recognized the contradictory aspects of his sculpture: "I have put myself in the position that both Christians and Jews will be against me. The Jews will say, 'Why do you do Christ?' and the Christians will say, 'What sort of Christ has he done?'" This depiction of Christ as a Jew would later have an influence on the artist Marc Chagall. —VH

102. NIKOLAI GE (1831–1894)
The Last Supper, 1866
Oil on canvas, 66.5 x 89.6 cm
The State Tretyakov Gallery, Moscow
(plate 134)

Ge was born into a noble family of French origin. His mother died when he was a baby, and he was raised on his father's estate by a serf nurse, who the artist credited with teaching him compassion for others' sorrows. Initially a student of physics and math, he entered the Academy of Arts in St. Petersburg in 1850. He studied historical subjects and portraiture and revered the work of Karl Briullov. In 1857, he received the Major Gold Medal and embarked on a six-year course of study abroad that took him to Germany, Switzerland, France, and ultimately to Italy. In Italy, he completed his 1863 original of *The Last Supper*, now in the collection of the State Russian Museum. Both that version and the smaller replica of 1866 shown here employ an unusual iconography, focusing on the moment of Judas's departure from the banquet. Ge represents Judas as separated from his fellow disciples, who regard him with suspicion, hence emphasizing the discord soon to be caused by the revelation of his betrayal of Christ. Judas is enveloped in an otherworldly darkness that sets him apart from his colleagues, and he casts a long, dark shadow on the wall above the table. His physical separation underscores Ge's message that differing philosophies can lead to conflict. Although the writer Fedor Dostoevsky allegedly disapproved of the 1863 version, it earned Ge the title of academician, and Tsar Alexander II purchased the work for his collection. —VH

103. NIKOLAI GE (1831–1894)
Conscience: Judas, 1891
Oil on canvas, 149 x 210 cm
The State Tretyakov Gallery, Moscow
(plate 136)

Ge was deeply impressed by the teachings of Leo Tolstoy, who stressed the importance of the individual conscience

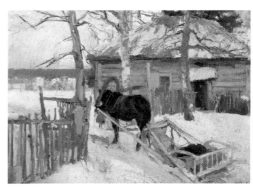

104

and moral reflection. He explored this topic in *Conscience: Judas* and other late paintings, which centered on the events at the end of Christ's life and especially the Crucifixion. The isolated, conflicted figure of Judas seen in *The Last Supper* (1866, cat. not. 102) returns again, but this time he is even more physically detached from his fellow disciples, who can be seen as diminutive figures further down the road. Enveloped in darkness and wrapped in shroudlike clothing, Judas finds himself on a path taken by many, that of the traitor. Ge does not pass judgment on Judas, but presents him as a faceless everyman tormented by his conscience and aware of the evil of his actions. In a certain way, he resembles the ancient warrior knight at the crossroads, forced to decide which path he will take, a subject revived at this same time in *Knight at the Crossroads* (1878, cat. no. 126), a work of Ge's contemporary Victor Vasnetsov. A distinguishing aspect of *Conscience: Judas* and other of Ge's late work is its innovative formal language. The sickly, otherworldly green locates this work among the most experimental Symbolist paintings of the day, while his expressionistic brushwork anticipates the modernist revolutions of the early twentieth century. —VH

104. KONSTANTIN KOROVIN (1861–1939)
In Winter, 1894
Oil on canvas, 37.2 x 52.5 cm
The State Tretyakov Gallery, Moscow
(plate 124)

Korovin is the foremost representative of Impressionism on the Russian soil. He studied at the Moscow School of Painting, Sculpture, and Architecture with the established landscape painters Aleksei Savrasov and Vasily Polenov. He was also a member of the art colony in the village of Abramtsevo that brought together, under the patronage of Savva Mamontov, some of the most innovative artists of

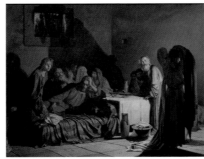

102

103

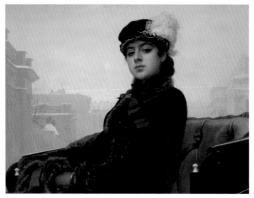

105

the time, whose interests centered on Russian national artistic traditions. In the 1880s and 1890s Korovin traveled extensively in Europe, where he responded especially strongly to French Impressionism. *In Winter* combines a traditionally Russian subject matter with a modern painterly technique. Korovin depicts an unmistakably Russian scene: a snow-covered village with a log house, a lopsided fence, and a horse harnessed into a sleigh. Yet it is the surface of the painting and the effect of its colors that account for its striking effect. Korovin emphasized the texture of paint, applying it in thick pronounced strokes, and avoided linear contours altogether. The palpable materiality of paint is strengthened by the predominance of a blinding white that yields in places to the more earthly grays and culminates with the black of the horse in the painting's center. —MC

105. IVAN KRAMSKOY (1837–1887)
Unknown Woman, 1883
Oil on canvas, 75.5 x 99 cm
The State Tretyakov Gallery, Moscow
(plate 119)

Unknown Woman was both one of Kramskoy's most famous and most controversial pictures. It exemplifies his ability to make a painting almost indistinguishable from a photograph. Like Edouard Manet's *Olympia* (1863), *Unknown Woman* boldly makes eye contact with the viewer. While Kramskoy's woman is fully clothed in a fashionable dress with fur muff and feathered hat, she was nonetheless recognizable as a lady of ill repute. The noted art critic Vladimir Stasov reportedly described her as "a coquette in a carriage," and Pavel Tretyakov would not purchase the work on the grounds it was immoral. Ironically, in 1873 Kramskoy persuaded the writer Leo Tolstoy to sit for what many consider to be one of the best portraits made of him, which the artist painted at the request of Tretyakov. At precisely that time, Tolstoy was working on *Anna Karenina* (1873–76), whose central character, a member of St. Petersburg high society, scandalously becomes pregnant by her lover, leaves her husband, and ultimately commits suicide. It is known that the novel's character of the artist Mikhailov is based on Kramskoy, and many have subsequently argued that *Unknown Woman* belies the influence of *Anna Karenina*. Kramskoy himself never offered an explanation of the painting's source or content. The woman has also been interpreted as an example of the amorality of the city, and

some have seen her reflected in the Russian Symbolist poet Alexander Blok's 1906 poem *Unknown Woman*, which describes a lone woman out at night "swathed in silk" and wearing a "hat with its funereal plumes." Her association with the metropolis as well as her evident elegance and beauty later led to her transformation into a model to be admired and emulated. In the Soviet period, her image adorned necklaces and boxes of chocolates. —VH

106. ARKHIP KUINDZHI (1842–1910)
After the Rain, 1879
Oil on canvas, 102 x 159 cm
The State Tretyakov Gallery, Moscow
(plate 125)

Twice rejected by the Academy of Arts in St. Petersburg and essentially self-taught, though he was encouraged and influenced by Ivan Kramskoy, Kuindzhi stands strikingly apart from his contemporaries. He is most admired for his use of highly unorthodox colors, for his delight in turning the commonplace into something enigmatic and even poetic, and for his radical simplification of details. *After the Rain* is a typical example of Kuindzhi's striking use of color and light and his dramatizing of the everyday. The work is characteristically Romantic in its use of overcast skies, a low horizon line, and a strong contrast between light and dark. Yet it also has a number of qualities that make it a forerunner of Symbolist painting, such as the deep green intensified to the point of unnaturalness and the drama that seems overtly theatrical. The bright ray of sunlight spotlights the human dwelling, which towers on a hill surrounded by infinite nature. —MC

107. ARKHIP KUINDZHI (1842–1910)
Patches of Moonlight, 1898–1908
Oil on canvas, 39 x 53.5 cm
State Russian Museum, St. Petersburg
(plate 126)

Although small in size, *Patches of Moonlight* feels monumental due to its powerful composition and highly generalized forms. Kuindzhi never worked from sketches or studies, but always composed his paintings from memory. His landscapes are constructions of the mind, verging on the fantastic and the symbolic. Here tree branches are covered with such thick layers of snow that they become almost anthropomorphic, increasing the enigmatic nature of the work. The circular composition creates a sense of self-contained space with an almost centrifugal tension within it. Kuindzhi's work was undoubtedly far ahead of its time, a precursor to the bold color schemes and abstract designs of the Symbolists and the avant-garde. Kuindzhi's two closest students, the Symbolist Nicholas Roerich and the Socialist Realist painter Arkady Rylov, exemplify the range of his influence on subsequent painting in Russia. —MC

108. ARKHIP KUINDZHI (1842–1910)
At Night, 1905–08
Oil on canvas, 107 x 169 cm
State Russian Museum, St. Petersburg
(plate 127)

One of the last significant works made by the artist, *At Night* verges on abstraction, striking a balance between linearity and expanses of large, almost flat areas of color. The strongly pronounced line of the horizon cuts across the entire stretch of the canvas, while a sense of depth is created by the curve of the river that cuts in at a sharp diagonal. Yet an overall effect of the composition is that of profound calm and silence, which is achieved through the radical simplification and generalization of form and through an overall compositional balance. The enigmatic appeal of the painting is also due to its highly unusual lighting—the foreground is dark while the light is coming from the farthest distance at the horizon, drawing the viewer in. —MC

109. BORIS KUSTODIEV (1878–1927)
Shrovetide, 1916
Oil on canvas, 61 x 123 cm
The State Tretyakov Gallery, Moscow
(plate 188)

106

107

108

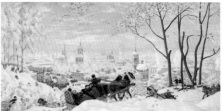

109

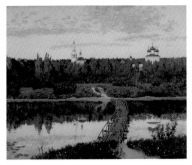
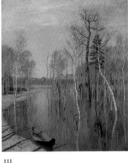
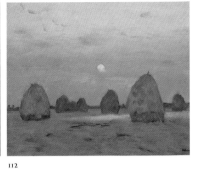

110 111 112

Maslenitsa (or Shrovetide in its Catholic equivalent) is a traditional Russian holiday that goes back to pre-Christian times. It is a weeklong celebration bidding farewell to the winter and welcoming the spring, accompanied by feasting on traditional Russian foods, especially *bliny* (or pancakes), symbols of the round golden sun. Other indispensable attributes of the Pancake Week merrymaking were tobogganing, riding the merry-go-round, and enjoying folk theater performances in show booths at the fair. With the advent of Christianity the holiday week was integrated to precede Lent. Kustodiev's celebration of Russian folk traditions contains a number of indispensable attributes—abundant snow, traditional dress and decorations of the sleighs and the horses, and of course numerous churches among the vast expanses of the land. He paints with loose, impressionistic brushstrokes and uses bright colors in a style that imitates traditional decorative arts and verges on the primitive. —MC

110. ISAAK LEVITAN (1860–1900)
Quiet Dwelling, 1890
Oil on canvas, 87.5 x 108 cm
The State Tretyakov Gallery, Moscow

Levitan had the good fortune to study at the Moscow School of Painting, Sculpture, and Architecture (1873–75) with such masters of landscape painting as Vasily Perov, Aleksei Savrasov, and Vasily Polenov. He traveled more extensively in Europe than most of his contemporaries and was familiar with artistic developments in France, Italy, Germany, and elsewhere. His painterly style, with its loose expressive brushstrokes and thick, abstracted patches of color, is a stark departure from the naturalism of Ivan Shishkin or the socially grounded landscapes of Perov. His landscapes are most aptly characterized as lyrical, and *Quiet Dwelling* is a typical example. It is a quintessentially Russian landscape, with its golden evening light and the cupolas of the church in the background. The elegiac and harmonious view is open and accessible, as the bridge across the river offers a visual passageway from the viewer's space to the monastery. —MC

111. ISAAK LEVITAN (1860–1900)
Spring: High Water, 1897
Oil on canvas, 64.2 x 57.5 cm
The State Tretyakov Gallery, Moscow
(plate 133)

One of Levitan's best-known paintings, *Spring: High Water* depicts the long-awaited arrival of spring after months of bitterly cold winter. The sun reappears and snow slips from trees and hills and swells the rivers, resulting in the common spring floods. Levitan's image expresses the joys and hopes of the Russian spring as the shining bright blue surface of the water, interspersed with the white of birch trees, feels almost interchangeable with the bright blue sky and the rare white clouds in it. The shimmer of the reflections, the thin curving trunks of the birch trees, and the overall lightness of the palette create a sense of elusiveness and transience. Human presence, as is often the case in Levitan's works, is felt only indirectly, through the floating boats and distant houses. —MC

112. ISAAK LEVITAN (1860–1900)
Twilight: Haystacks, 1899
Oil on canvas, 59.8 x 54.6 cm
The State Tretyakov Gallery, Moscow
(plate 132)

Toward the end of Levitan's life, his work became more abstracted and his colors more intensely expressive. In *Twilight: Haystacks* linear contours are almost entirely eliminated while the sense of spatial recession is highly elusive. Expressiveness is achieved through the direction of brushstrokes and through contrasts between fields of almost unmodulated color. Levitan uses the same subject matter as Claude Monet, who painted a series of haystacks near Giverny during the 1890s. Although Levitan was undoubtedly familiar with the work of the Impressionists, scholars have found no indication that he was aware of this particular series. Levitan's use of color here brings him closer to the Symbolists or to that other Russian innovative landscape painter, Arkhip Kuindzhi. In the late 1890s Levitan showed his best works in all three of the Munich Secession exhibitions; *Twilight: Haystacks* was exhibited there in 1899. —MC

113. MIKHAIL NESTEROV (1862–1942)
Taking of the Veil, 1898
Oil on canvas, 178 x 195 cm
State Russian Museum, St. Petersburg
(plate 146)

Taking of the Veil depicts a procession in a Russian convent. A young woman, who is about to take vows to become a nun, is accompanied by older nuns. All the women's heads are bent in gestures of humility, suggesting a solemn and sad occasion. The scene takes place in a springtime landscape that promises renewal and contrasts with the quiet restraint visible on the nuns' faces. The painting forms part of a cycle devoted to the lives of Russian women that was inspired by the novels of Pavel Melnikov-Pechersky about the Old Believers in Russia. In 1898 Nesterov was admitted to membership in the Academy of Arts in St. Petersburg for this painting. —MC

114. VASILY POLENOV (1844–1927)
Dreams (On Top of a Mountain) (from the *Life of Christ* series), 1890–1900s
Oil on canvas, 151 x 142 cm
State Russian Museum, St. Petersburg
(plate 137)

In the 1880s Polenov, already a leading landscape painter, turned to evangelical subjects, largely inspired by the writings of Joseph Ernest Renan on the life of Christ. The image of Christ that Polenov created corresponded to his own Christian ideals. He repeatedly traveled to the Near East, Egypt, and Greece in order to reconstruct the landscapes and historical settings of Christ's time, including dress, temples, dwellings, and roads, with an almost archaeological accuracy. At the same time, the painter avoided Christian iconographic canons. *Dreams (On Top of a Mountain)* depicts a moment during Christ's forty-day wandering in the desert of Judea. By showing Christ lost in dreams, as the painting's title suggests, Polenov invites the viewers to follow his protagonist and suspend their sense of time and place. The artist's choice to depict Christ on a mountain top allows him to show a vast surrounding landscape, which underscores the monumentality and peacefulness of the scene and gives it a universal quality. The composition itself invites viewers to project their feelings and thoughts beyond the figure of Christ onto the timeless nature that surrounds him. Unlike Ivan Kramskoy's earlier painting on the same subject (*Christ in the Desert*, 1872, State Tretyakov Gallery), Polenov avoids using Christ's name in the title, making his subject more universal and open to interpretation. —MC

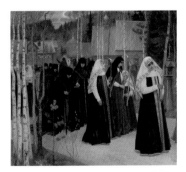

113

114

115 117 118 120

115. VASILY POLENOV (1844–1927)
The Moscow Courtyard, 1902
Oil on canvas, 55.2 x 44 cm
State Russian Museum, St. Petersburg
(plate 131)

After receiving the Grand Gold Medal from the Academy of Arts in St. Petersburg, Polenov traveled on a stipend to Germany and Italy in 1872–73 and to France in 1873–76. In 1876 and 1877, as a war artist, Polenov took part in the Balkan wars against the Turks. In 1877 he settled in Moscow, where he met the Wanderers and turned largely to landscape painting. He showed *The Moscow Courtyard* (1878, The State Tretyakov Gallery) at the Sixth Traveling Exhibition, and it became a landmark for the artist and for Russian landscape painting as a whole. The version shown here is a replica made by the artist twenty-four years later. Its fundamental difference from the earlier image is the absence of human figures, which transforms what was a mixture of genre and landscape into a more timeless and nostalgic image for the old city of Moscow before it was irreversibly transformed by industrialization. —MC

116. ILYA REPIN (1844–1930)
Barge Haulers on the Volga, 1870–73
Oil on canvas, 131.5 x 281 cm
State Russian Museum, St. Petersburg
(plate 104)

Repin first saw barge haulers during a boat trip along the Neva River in St. Petersburg. He was strongly impressed by the ragged people strapped to the boat that they pulled against the river tide. Their labor, cheaper than that of the horses, reflected the social and economic conditions of the time: in 1861 serfs were freed but were not given land and many of them found themselves utterly destitute and without the means to make their living. Repin made special trips to the Volga River, where he studied and observed the life of the haulers. He filled *Barge Haulers on the Volga* with men of various disposition, character, and fate, each of them modeled on concrete individuals. The artist shows not only their tremendous suffering but also their endurance and moral strength. He monumentalizes labor through the frieze-like organization of the figures and the viewpoint from below, which makes the haulers tower above the background of water and sky. —MC

117. ILYA REPIN (1844–1930)
Portrait of Nadya Repina, 1881
Oil on canvas, 66 x 54 cm
Radischev Art Museum, Saratov
(plate 121)

Nadezhda (Nadya) Repina (1875–1931) was the second of the artist's three daughters. She worked as a pharmacist's assistant in a number of hospitals in St. Petersburg. From 1910 onward, she lived at Penaty, her father's estate, suffering from severe mental illness. The composition of this portrait is an S-curve, formed by the girl's body and her tilted head and continued by the shape of the pillow. Her tanned skin and dark hair contrast sharply with the delicate pink of her dress and the white of the pillow. The shallow space of the canvas makes this painting into an intimate and tender portrait of a child who just opened her eyes. —MC

118. ILYA REPIN (1844–1930)
Portrait of Pavel Tretyakov, Founder of the Tretyakov Gallery, 1883
Oil on canvas, 98 x 75.8 cm
The State Tretyakov Gallery, Moscow
(plate 112)

Pavel Tretyakov (1832–1898) was a rich Moscow merchant who became the main patron of emerging Russian artists in the second half of the nineteenth century as he sought to assemble a systematic collection that would reflect the history of the best Russian painting. Since it was common knowledge that Tretyakov's collection was meant to become a national gallery, he enjoyed enormous respect in the art world; acquiring his patronage was a great honor and a major career boost for emerging artists. Tretyakov met Repin in 1872, acknowledged his talent upon seeing *Barge Haulers on the Volga* (1870–73, cat. no. 116), and became not only his major patron but also his devoted friend. He commissioned Repin, along with Vasily Perov and Ivan Kramskoy, to create portraits of the best Russian men of their epoch. Although perhaps not overtly intended as such, this portrait of Tretyakov himself undoubtedly deserves a place among their ranks. —MC

119. ANDREI RYABUSHKIN (1861–1904)
A Merchant Family in the Seventeenth Century, 1896
Oil on canvas, 143 x 213 cm
State Russian Museum, St. Petersburg
(plate 145)

The son of a peasant icon painter, Ryabushkin studied at the Moscow School of Painting, Sculpture, and Architecture (1875–82) with Vasily Perov and Illarion Prianishnikov and then at the Academy of Arts in St. Petersburg (1882–90) with Pavel Chistiakov. He received a stipend to go abroad, but chose instead to travel across the Old Russian towns. His art is centered on the life of pre-Petrine Russia of the seventeenth century, emphasizing traditional customs, architecture, and costumes. *A Merchant Family in the Seventeenth Century* is one of his central programmatic works, painted as part of a projected (but unrealized) series depicting generalized images of different strata of seventeenth-century Russian society. It is a formal but intimate portrayal, with the figures positioned very close to the picture plane and staring in a dignified way directly at the viewer. Ryabushkin evokes folkways not only through traditional costumes and elements of wood-carving visible on the poles behind the figures, but also by employing the stylistic conventions of icon painting, such as the neutral flattened background, frontal and static poses of the figures, and bright saturated colors. —MC

120. VALENTIN SEROV (1865–1911)
Portrait of the Artist Konstantin Korovin, 1891
Oil on canvas, 111.2 x 89 cm

116

119

The State Tretyakov Gallery, Moscow
(plate 123)

One of the most brilliant and versatile portraitists of Russia's Silver Age, Serov often adjusted the style of his representations to the personality of his sitters. Judging by the impressionistic technique of this work, with its thick, expressive brushstrokes and rough blurred contours, it could well have been painted by Konstantin Korovin himself. Except for the clearly delineated face and the concentrated gaze of the sitter, the rest of the painting has the rough, unfinished quality of a sketch. Especially striking is the painter's right hand: this key instrument of a master is barely indicated by a thick black contour placed on top of a light brown blotch. Serov clearly takes his liberties with the permission of the sitter, who was his good friend and whose aesthetic program was very close to Serov's own. Korovin is shown in a highly informal pose and in an intimate setting; he is a modern painter, whose individuality and creative independence are placed before his professional and public roles. This portrait is a self-conscious argument against the formality, seriousness, and sociopolitical engagement of the Wanderers. —MC

121. IVAN SHISHKIN (1832–1898)
The Oaks of Mordvinovo, 1891
Oil on canvas, 84 x 111 cm
State Russian Museum, St. Petersburg
(plate 117)

Shishkin made sketches for *The Oaks of Mordvinovo* in the forest of Countess Mordvinova near St. Petersburg. By 1891 he was an accomplished artist whose one-man show with over 600 works opened in the Academy of Arts in St. Petersburg. Pavel Tretyakov had been buying his paintings since 1869, and since 1870 Shishkin regularly showed with the Wanderers. Mighty oak trees growing in open areas are a typical subject of Shishkin's paintings. In his later works, however, he moves away from his earlier photorealistic style toward a greater preoccupation with light and a more lyrical perception of nature. Here the abundant foliage of the oaks provides a rich surface for working out the play of sunlight. Shishkin's style in his later

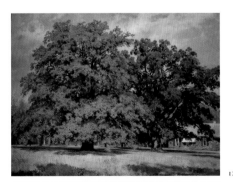

121

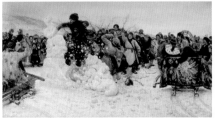

122

years becomes more abstracted and even somewhat impressionistic, yet his drawing remains precise and his vision grounded in the tangible material world. —MC

122. VASILY SURIKOV (1848–1916)
Capture of a Snow Fortress, 1891
Oil on canvas, 156 x 282 cm
State Russian Museum, St. Petersburg
(plate 122)

Unlike most of Surikov's history paintings, *Capture of a Snow Fortress* is rooted in his childhood memories and refers to Russian history only indirectly. "Capture of a snow fortress" was a popular Siberian game that took place on the Day of Forgiveness, the last day of Maslenitsa, or Shrovetide, a traditional holiday that precedes Great Lent. The players divided into two groups: one attacked the fortress and the other defended it. A horseman had to burst through the gates and knock down a snow divider. The Cossacks probably established this tradition to commemorate their conquest of Siberia in the late sixteenth century. Yet a reenactment of a military conquest on the Day of Forgiveness undoubtedly held special meaning for the Siberian peoples. In addition to its historical and religious associations, Surikov's painting is a joyful celebration of the boldness of national character and the inventiveness of the Russian folk traditions. —MC

123. PAVEL TRUBETSKOY (1866–1938)
Moscow Cabman, 1898
Bronze, h. 24 cm
State Russian Museum, St. Petersburg
(plate 147)

Paolo Trubetskoy was born in Italy, near Lago Maggiore, the son a Russian prince, Pavel Trubestkoy, and an American singer, Ada Winans. He didn't receive a systematic art education, but took sculpture lessons in Milan, where he was strongly associated with the Milanese avant-garde movement *scapigliatura*, which was applied to sculpture by Trubetskoy's teacher Giuseppe Grandi and later by Medardo Rosso. Trubetskoy came to Russia in 1897 and soon began to teach at the Moscow School of Art, Sculpture, and Architecture. *Moscow Cabman*, his first work executed in Russia, reflected his first impressions of his father's homeland. Trubetstskoy has been called an Impressionist in sculpture, because of the visible and expressive traces of modeling he left on the sculpture's surface. An immediate and unpretentious record of the artist's impressions, this sculpture contradicts expectations of monumentality and grandeur usually associated with this medium. *Moscow Cabman* enjoyed tremendous popularity at the 1899 World of Art exhibition, where it was seen by many as a true poetic image of Russia. In 1900 Trubetzkoy was awarded a Grand Prix at the World Exhibition in Paris for this and two other sculptures. —MC

124. PAVEL TRUBETSKOY (1866–1938)
Maria Botkina, 1901
Bronze, h. 47.5 cm
The State Tretyakov Gallery, Moscow
(plate 149)

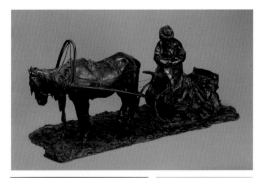

123

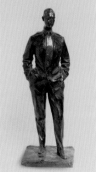

124 125

Artist Maria Botkina (1870–1959) was the daughter of the famous physician and professor Sergei Petrovich Botkin, and the sister of Sergei Sergeevich Botkin, also a physician and professor of medicine, who married the oldest daughter of the art collector Pavel Tretyakov. Botkina stands very straight in a dignified manner, yet she is also alert, leaning slightly forward and placing part of her weight on the umbrella. The sculpture's base, fluid and with visible traces of modeling, gives the sculpture an incredible plasticity that counteracts the rigid and heavy nature of the medium and activates its interaction with the surrounding space. The texture of the base is echoed in the woman's hairdo and hat, giving a sense of dynamism and lightness to her entire figure, as well as a sense of unity to the sculpture as a whole. Trubetskoy was best known for this kind of portrait: statuettes that invariably captured the personality of his sitters in an elegant and unpretentious way. He was extremely prolific and made portraits of numerous well-known figures. —MC

125. PAVEL TRUBETSKOY (1866–1938)
Portrait of Grand Duke Andrei Vladimirovich, 1910
Bronze, h. 56 cm
State Russian Museum, St. Petersburg
(plate 148)

In 1906 Trubetskoy moved to Paris, where his studio quickly became an international meeting-place for the most distinguished artists, diplomats, and intellectuals of the day. Grand Duke Andrei Vladimirovich Romanov (1879–1956), who was the son of the Grand Duke Vladimir Alexandrovich and nephew of Tsar Nicholas II, was a frequent visitor. This sculptural portrait is clearly an informal one, judging especially by the sitter's relaxed posture and casual dress. The grand duke appears to have been caught unawares, lost in thought. His figure is dynamic, as his body is slightly thrust forward and his left

leg is placed in front of the right. Pronounced folds on his suit, echoed by the uneven surface of the pedestal, further underscore the spontaneity of the image, brilliantly illustrating Trubetskoy's motto of "depicting life in its fleeting grace." This portrait was included in a large retrospective of his work held in the American Numismatic Society and the Hispanic Society of America in 1911. Although Trubetskoy's stay in Russia was rather short—he worked in Paris (1906–14, 1921–32), the United States (1914–21), and Italy (1932–38)—his work had a profound impact on the subsequent development of Russian sculpture. —MC

126. VIKTOR VASNETSOV (1848–1926)
Knight at the Crossroads, 1878
Oil on canvas, 147 x 79 cm
Museum of History and Art, Serpukhov
(plate 144)

In 1878 Vasnetsov's work changed radically from genre painting in the tradition of critical realism to a painting style steeped in folktales and the Russian historical epos. This version of *Knight at the Crossroads*, the first that the artist executed, is also one of the first paintings in his new style. Its subject is taken from the medieval Russian epic *Ilya Muromets and the Robbers*. It depicts a critical moment when the hero arrives at a deserted field strewn with human remains. An inscription on the stone reads, "if you go straight you will not survive, there is no way for anyone walking, riding, or flying." While rooted in the national past and folk wisdom, this painting also had an immediate contemporary relevance, echoing Russia's humiliating defeats and enormous losses during the Russo-Turkish war of 1877–78, and the intelligentsia's subsequent dismay at the country's social and political situation. —MC

127. VASILY VERESHCHAGIN (1842–1904)
Mortally Wounded, 1873
Oil on canvas, 73 x 56.6 cm
The State Tretyakov Gallery, Moscow
(plate 129)

Vereshchagin is often considered the most accomplished Russian battle painter, having taken an active part in Russian military actions at numerous occasions throughout his life. *Mortally Wounded* was painted in Munich in 1873 from the sketches the artist made of the defense of the Samarkand fortress during his travels in Turkestan (in 1869–73). Vereshchagin shows the process of death in an unusual way, by capturing the moment of desperation of a man who is doomed to die within minutes. He drops his rifle and, holding the bleeding wound, his face distorted

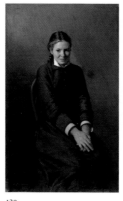

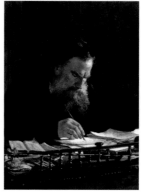

129 130 131

with pain, instinctively rushes away from the battlefield, only to fall down within a few steps. The white sand suspended in the air conveys the sense of the southern heat while also isolating the figure of the soldier in the foreground and forcing the viewer to concentrate on his inner state of pain and despair. —MC

128. VASILY VERESHCHAGIN (1842–1904)
Defeated: Service for the Dead, 1878–79
Oil on canvas, 179.7 x 300.4 cm
The State Tretyakov Gallery, Moscow
(plate 128)

Vereshchagin made *Defeated: Service for the Dead* in response to the Russo-Turkish war of 1877–78, in which Russia supported the liberation of the Slavs in the Balkans from the rule of the Ottoman Empire. Vereshchagin, who was himself seriously wounded in that war, here depicts a scene he had witnessed: almost an entire regiment had perished after being ordered to conduct an unprepared attack in open terrain. A boundless field is strewn with dead and anti-heroically naked male bodies and mutilated body parts. The painterly language is laconically expressive: the palette is reduced to two shades, gold-brown and blue-gray; the horizon line is lowered in a dramatic diagonal, darkened on the right by an approaching storm. A powerful unmasking of the inhuman nature of war and the absurdity of the losses it inevitably brings, this painting provoked great discontent from the tsarist government, which sought to ban it from exhibition. —MC

129. NIKOLAI YAROSHENKO (1846–1898)
Female Student, 1880
Oil on canvas, 85 x 54 cm

State Russian Museum, St. Petersburg
(plate 120)

Yaroshenko frequently used young female students as models for his portraits. In 1878, the Bestuzhev Higher Courses for Women were established, which the artist's wife attended. Following her studies, she remained active in the school's development and cultivated friendships with young students. Yaroshenko became a member of the Society for Traveling Art Exhibitions (also known as the Wanderers) in 1875, and took over its leadership in 1876, after the death of Ivan Kramskoy. The style of *Female Student*, which conveys the psychology of the sitter through a natural, yet expressive, pose and a simplified background, is typical of the Wanderers. A critic writing about this portrait, which was included in the eighth Wanderers' exhibition of 1880, observed, "One cannot find a single visitor to the exhibition who wouldn't smile looking at this embarrassed face." —MC

130. NIKOLAI GE (1831–1894)
Portrait of the Writer Leo Tolstoy, 1884
Oil on canvas, 96 x 71 cm
State Russian Museum, St. Petersburg
(plate 110)

In 1876, Ge purchased the estate of Pliski in Chernigov Province in Ukraine. By 1880, after a hiatus, he returned to making art and focused almost exclusively on biblical subjects. In 1882, he met the writer Count Leo Tolstoy (1828–1910), and he became an advocate for the writer's quasi-religious philosophy. By that time Tolstoy had officially broken with the Russian Orthodox Church and become an advocate of his own moral-philosophical theories. He encouraged people to live according to the

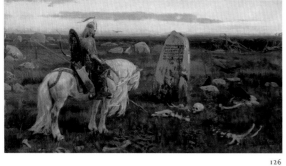

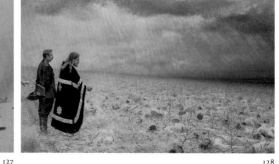

126 127 128

132 133

dictates of their conscience and to seek individual perfection through their own, personal efforts. In addition, he both preached and practiced a simple life of labor and repudiated material possessions. Ge rather romantically represents Tolstoy as a writer at work in his Moscow study, pen in hand, papers strewn about his desk, spotlight on his forehead, the site of his creative genius. The author was working on his manuscript for *What I Believe*, which was published in 1885. The dark colors and simplicity of setting portray the famed author as a sort of latter-day monk or prophet. —VH

131. ALEXEI KORZUKHIN (1835–1894)
Before the Confession, 1877
Oil on canvas, 108 x 160 cm
The State Tretyakov Gallery, Moscow
(plate 103)

Korzukhin was among the fourteen painters who left the Academy of Arts in St. Pertersburg in 1863, after refusing to paint the subject proposed by the academy's council for their graduation. Although he was one of the founding members of the St. Petersburg Artel of Artists in 1864, and one of the co-signers of the 1874 charter of the Society for Traveling Art Exhibitions, Korzukhin never fully shared the aesthetic approach and political views of the Wanderers. In 1877 he left the society having never participated in its exhibitions. Korzukhin often worked on religious subjects in a highly naturalistic style. *Before the Confession* depicts the interior of the Nikolsky Cathedral in St. Petersburg. Each figure in the group of eighteen represents a contemporary social type rather than an individual. Among those waiting to confess is a haughty-looking aristocratic woman dressed in black. Gazing resolutely and almost provocatively at her is a poor boy. Next to him, a simple and sincerely pious woman, wearing a modest, checkered shawl and a traditional Russian headscarf, waits patiently. An earlier version of this painting is now in the collection of the Tver Art Gallery. —MC

132. IVAN KRAMSKOY (1837–1887)
Portrait of the Painter Ivan Shishkin, 1873
Oil on canvas, 110.5 x 78 cm
The State Tretyakov Gallery, Moscow
(plate 115)

Born into the family of a provincial state clerk, Kramskoy was, by the age of 15, apprenticed to an icon painter and then served as a retoucher in a photographer's studio. He

entered the Academy of Arts in St. Petersburg in 1857. In 1863, he was among a group of fourteen students who were dismissed from the academy for refusing to paint the assigned mythological subject for the diploma. Kramskoy and the others formed an artists' commune known as the St. Petersburg Team of Artists, and he taught such future luminaries as Ilya Repin at the school of the Society for the Promotion of Arts. In 1869, the Academy of Arts made him an academician, and he travelled to Berlin, Dresden, Munich, Düsseldorf, Antwerp, Paris, and Vienna. Upon his return, he began to regularly paint portraits of cultural and scientific personalities for the Moscow collector Pavel Tretyakov, who became a major supporter of the group Kramskoy helped to found in 1870, the Society for Traveling Art Exhibitions, or the Wanderers, which sought to bring contemporary art to Russians living outside Moscow and St. Petersburg and to provide a forum for artists to sell their work. This portrait of the noted landscape painter and fellow Wanderer Ivan Shishkin evokes a famous self-portrait by Gustave Courbet, *Bonjour Monsieur Courbet* of 1854, which presents the bearded artist, staff in hand and bag on his back, on his way to paint *en plein air*. Kramskoy's depiction literally roots Shishkin in the Russian landscape that was his constant subject. Standing against a sun-drenched backdrop—a reflection of the artist's preference for painting daytime scenes—Shishkin appears monumental, yet at the same time he nearly blends in with the trees, thus living up to his nicknames, which included the "forest tsar" and the "lonely oak." —VH

133. IVAN KRAMSKOY (1837–1887)
Forester, 1874
Oil on canvas, 84 x 62 cm
The State Tretyakov Gallery, Moscow
(plate 118)

Kramskoy, along with other Wanderers, played a major role in the transformation of portraiture in Russia by taking as their subjects not only well-known personalities, but also others whom society often ignored. From 1872 to 1874, Kramskoy worked on a peasant series. In contrast to the work of the early-nineteenth-century artist Alexei Venetsianov, who idealized his peasant subjects and tended to treat them as timeless archetypes infused with religious significance, Kramskoy presents the *Forester* as an individual. The man's weathered face, simple clothing, and lengthy beard clearly indicate that he lives in the countryside, works outdoors, and belongs to the lower class. Similar to Venetsianov, Kramskoy stresses the dignity of his subject, and the artist's mastery of photorealism underscores his

objective approach to portraiture. While some of these portraits placed the peasant in the landscape, this and other major works in the series locate the subject against a dark backdrop similar to those in photo studios. Kramskoy's emphasis on the forester's vibrant, yet cautious eyes suggest an acute awareness as well as an active inner life. —VH

134. VLADIMIR MAKOVSKY (1846–1920)
A Party, 1875–97
Oil on canvas, 108.5 x 144 cm
The State Tretyakov Gallery, Moscow
(plate 107)

The title of this painting, *A Party*, contains a pun, as the Russian *vecherinka* may be understood and translated as either "party" or "evening gathering," implying an assembly of greater purpose. The latter is undoubtedly the case here, as what we are witnessing is a clandestine gathering of the revolutionary intelligentsia. While a solitary figure at a table on the left conveys the heavy thinking and melancholy underlying the activity, the right side of the canvas is devoted to the young activists of the movement who are obviously supported by older sympathizers behind the table. The young people's determination is underscored by the strong light while the duration of their meeting and the degree of agitation involved may be derived from the numerous cigarette butts scattered on the floor. —MC

135. VLADIMIR MAKOVSKY (1846–1920)
Convict, 1879
Oil on canvas, 76.5 x 113 cm
State Russian Museum, St. Petersburg
(plate 106)

Among the urban intelligentsia, the 1870s coincided with the height of a "going to the people" movement. Preoccupied with the social and political problems pervading Russian society in the late nineteenth century, Makovsky became a member of the Wanderers in 1872. Highly dramatic scenes of arrests, imprisonments, and exiles provided a rich source for the group's psychologized subjects. The figure of the social revolutionary is heroicized in *Convict*, not least through the sympathetic gestures of the peasants and the understanding restraint of the soldiers surrounding him. It would have been clear to contemporary viewers that the man had been convicted for political activities against tsarist rule and condemned to a term in prison or a long exile to Siberia. —MC

134 135

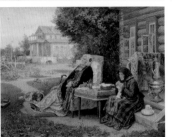

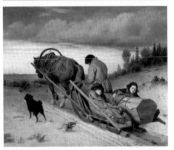

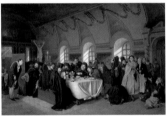

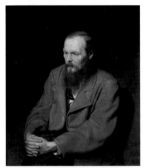

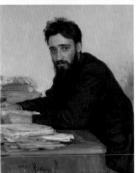

freedom of mobility, they were left without land to live off. The grayness of the autumn cityscape, with its last falling leaves, may be symbolic of the lack of prospects for this couple, and their isolation from each other speaks eloquently of urban alienation. As was often the case with the Wanderers, Makovsky painted several replicas of this painting, and it was widely reproduced in engravings. —MC

137. VASILY MAXIMOV (1844–1911)
All in the Past, 1889
Oil on canvas, 72 x 93.5 cm
The State Tretyakov Gallery, Moscow
(plate 109)

According to the artist's daughter, *All in the Past* was conceived as early as 1866, during Maximov's trip on the Volga, when he visited Princess Golenishcheva-Kutuzova. An old lady, whose aristocratic background is apparent in her dress and manners, sits by the porch of her house, lost in dreams (probably of her glorious past), while her peasant housekeeper knits next to her on the steps. This work is a social commentary on the fate of the impoverished gentry and the imminent decline of their estates in the late nineteenth century. It is also a general meditation on old age and the transience of human existence. Maximov painted several replicas of this work. —MC

138. VASILY PEROV (1833–1882)
A Village Funeral, 1865
Oil on canvas, 45.3 x 57 cm
The State Tretyakov Gallery, Moscow
(plate 101)

From 1862 to 1864, Perov studied in Paris on a fellowship from Academy of Arts in St. Petersburg, but he returned before the end of his term, feeling the responsibility to depict the life of his native country based on direct personal experience. *A Village Funeral*, the first painting he made upon returning to Russia, quickly put Perov in the forefront of the new movement of socially active art. He portrayed the life of the destitute directly and without embellishment, confronting the viewer with human suffering in the most prosaic way. The widow's silhouette, her bent head and drooping shoulders, speak eloquently of her sorrow. The children also seem frozen by their grief, and their cheeks are pale despite the cold air. The horse's own exhausted slow motion echoes the grief and perhaps symbolizes the difficult future that awaits the widowed woman and orphaned children. —MC

139. VASILY PEROV (1833–1882)
A Meal, 1865–76
Oil on canvas, 84 x 126 cm
State Russian Museum, St. Petersburg
(plate 102)

Perov made a number of paintings with anticlerical themes, exposing the corruption of the church and the priesthood. He began *A Meal* in 1865 and did not finish it until 1876. It depicts a scene in the refectory of a Russian Orthodox monastery and exposes the contemptible mores of the monastery's inhabitants: the inequality among themselves, their greed, gluttony, and indifference to the poor, their servility to the rich. The hypocrisy of

their faith is exposed through the crucifix that presides over a feast that is anything but pious. Perov's depiction is highly narrative and literal; the figures' gestures, poses, and faces are especially expressive. Yet the bright rays of light that stream through the window may be heralding the possibility of change. —MC

140. VASILY PEROV (1833–1882)
The Last Tavern by the City Gate, 1868
Oil on canvas, 51.5 x 65.8 cm
The State Tretyakov Gallery, Moscow
(plate 105)

The road, and movement into the unknown, is central to *The Last Tavern by the City Gate*, just as it is in *A Village Funeral* (1865, cat. no. 138), extending substantially the work's narrative as well as its symbolic power. The subject itself is charged with meaning: the last tavern at the city gates suggests the unpredictable vast open space beyond. The viewer is invited to relate to the narrative through the eyes of the young woman sitting in one of the sleighs, who is looking out suspiciously, covering her mouth with her hand. Perhaps she is anxiously awaiting her husband, who is drinking in the tavern. An atmosphere of numbness and melancholy is here underscored by the contrast between the static, undefined process of waiting and the road running away into the distance; it is further enhanced through psychological details, such as the setting sun, crows in the sky, and the guarded pose of the dog. —MC

141. VASILY PEROV (1833–1882)
Portrait of the Writer Fedor Dostoevsky, 1872
Oil on canvas, 99 x 80.5 cm
The State Tretyakov Gallery, Moscow
(plate 111)

136. VLADIMIR MAKOVSKY (1846–1920)
On the Boulevard, 1886–87
Oil on canvas, 53 x 68 cm
The State Tretyakov Gallery, Moscow
(plate 108)

On the Boulevard depicts a scene of social destitution, in which a young man wearing a peasant shirt and playing an accordion—perhaps a migrant factory worker who has lost his job—appears alienated from his young wife, who shrivels from despair holding tight to her child wrapped in a quilt. This couple exemplifies the fate of thousands of newly urbanized peasants who flooded the cities after the abolition of serfdom in 1861. While former serfs had gained

In the early 1870s, Perov, together with Ivan Kramskoy, Nikolai Ge, and others set out to develop a new kind of portraiture that was to record their most prominent contemporaries. This portrait of Fedor Dostoevsky (1821–1881), usually seen as one of Perov's best works in this genre, was commissioned by Tretyakov for his portrait gallery. The dark, flat background and the brightly lit forehead draw attention to the sitter's self-absorption and intense intellectual activity. Dostoevsky's nervously clenched hands separate him from the viewer's space. When the work was first shown at the Second Traveling Exhibition in 1872 the critics immediately saw it not only as a likeness of a single individual, but as an expression of the consciousness of the time. The writer's sympathy for the suffering and the oppressed and his concern over the fate of the "small man" in Russian society brought him close to the revolutionary intelligentsia of the 1860s and 1870s. —MC

142. ILYA REPIN (1844–1930)
Portrait of Vsevolod Mikhailovich Garshin
(1855–1888), 1884
Oil on canvas, 88.9 x 69.2 cm
The Metropolitan Museum of Art, New York,
Gift of Humanities Fund Inc., 1972
(plate 113)

143

144

146

Repin had an active social life—he was a member of several informal salons held by members of the liberal intelligentsia, writers, journalists, scholars, and artists. Vsevolod Garshin was the best-known member of one of these circles, having made a mark with sensitively told stories about the suffering of the downtrodden. He was also Repin's close friend; he revered the painter as a socially committed, independent artist and had written enthusiastically about his paintings as early as 1877. Garshin posed for several of Repin's paintings, including the figure of the revolutionary in his famous *They Did Not Expect Him* (1884–88, State Tretyakov Gallery) and the figure of the mortally wounded tsarevich in *Ivan the Terrible and His Son Ivan* (1885, State Tretyakov Gallery). —MC

143. IVAN SHISHKIN (1832–1898)
Rye, 1878
Oil on canvas, 107 x 187 cm
The State Tretyakov Gallery, Moscow
(plate 116)

Ivan Shishkin studied at the School of Painting, Sculpture, and Architecture in Moscow (1852–60) and at the Academy of Arts in St. Petersburg (1856–60). He also spent three years abroad on a government grant, in 1862–65, studying at the academies in Munich, Prague, and Düsseldorf. It is during that time that Shishkin developed his predilection for precise, almost photographic depictions of landscapes, with a strong preference for forests. *Rye* is considered to be one of the best-known works by Shishkin and is often seen as an expression of Russian national character. Nature here is dignified and monumentalized as a vast panorama opens up that is filled with golden rye and towering mighty pine trees. The balance between the strong horizontals of the horizon line and the verticals of the trees gives the painting a sense of monumental scale, while the gently leaning ears of rye give it a strongly pronounced human dimension. A dried-out trunk placed between the trees further reminds us of the temporality of things and shows that nature is not being idealized. Shishkin is admired for his precise draftsmanship and his "monumental naturalism." —MC

144. FEDOR VASILIEV (1850–1873)
Wet Meadow, 1872
Oil on canvas, 70 x 114 cm
The State Tretyakov Gallery, Moscow
(plate 114)

Fedor Vasiliev was one of the most gifted landscape painters of the 1870s. He died of tuberculosis at the early age of 23, yet his works demonstrate a strong and highly developed talent. *Wet Meadow* was painted in the Crimea, where the artist spent the last two years of his life trying to cure his rapidly progressing disease. The landscape, however, is that of central Russia, reconstructed from memory and studies. As often in Vasiliev's work, this painting captures a changing moment in nature: a rain has just passed and the setting sun begins to reappear between the clouds, creating a strong contrast of light and shadow and reflecting playfully off the surface of the pond and the moisture on the grass. The palette is dominated by deep greens and blues that give the painting depth and stability. —MC

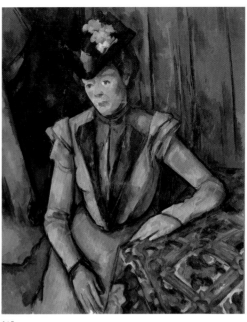

145

FRENCH MODERNIST MASTERWORKS: THE COLLECTIONS OF SERGEI SHCHUKIN AND IVAN MOROZOV

145. PAUL CÉZANNE (1839–1906)
Lady in Blue, ca. 1900
Oil on canvas, 90 x 73.5 cm
State Hermitage Museum, St. Petersburg
(plate 157)

Lady in Blue comes from the collection of Sergei Shchukin, which included seven paintings by Cézanne. Shchukin bought his first Cézannes in 1903, long before the artist was widely recognized in Europe. Starting in 1907, Shchukin's house in Moscow was open to the public on Sundays, and it became filled with artists, critics, and art aficionados. The importance of Cézanne's work for the development of modern Russian painting cannot be overestimated. Ivan Morozov, in turn, considered Cézanne his favorite artist, and had acquired eighteen of his major works beginning in 1907, the year of the painter's posthumous exhibition at the Salon d'Automne in Paris. The figures in Cézanne's portraits are often likened to objects in his still lifes, as they suggest the same sense of solidity and timelessness. The model for this painting remains unidentified. She appears wearing the same dress and hat in Cézanne's *Lady with a Book* (1900–04), now in the Phillips Collection in Washington, D.C. —MC

146. ANDRÉ DERAIN (1880–1954)
The Wood, 1912
Oil on canvas, 116.5 x 81.3 cm
State Hermitage Museum, St. Petersburg
(plate 158)

After Henri Matisse and Pablo Picasso had become the leading painters in his collection, Sergei Shchukin also became passionate about the work of Derain, whose

reputation at that time was at its peak. Between 1912 and 1914 Shchukin bought as many as sixteen of the artist's canvases, all of them from Daniel-Henry Kahnweiler. *The Wood* was painted in Paris at the end of 1912. It represents Derain's so-called "gothic" style, reflecting a direct engagement with the work of Paul Cézanne (as did all of his landscapes between 1908 and 1914), but transformed by Derain's own static, robust, and somewhat decorative style. In sharp contrast to the artist's earlier bright Fauvist colors, here the palette is restricted to tones of brown, green, and gray. Contours are sharply linear and dramatic shading defines the sculpted natural forms. The overall effect is somber, almost completely static in an eerie way, anticipating Derain's later, more painterly style. —MC

 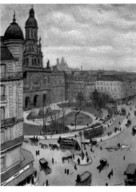

149 150 151

147. NARCISSE DÌAZ DE LA PEÑA (1807–1876)
Landscape with a Pine Tree, 1864
Oil on panel, 21.5 x 33.5 cm
State Hermitage Museum, St. Petersburg
(plate 154)

Dìaz de la Peña was a prominent member of the Barbizon school. Like all the Barbizon artists, he painted regularly in the forest of Fontainebleau, and the view depicted in *Landscape with a Pine Tree* is probably located in its immediate vicinity. This painting is characteristic of Dìaz de la Peña's late work, in which calm natural light in expanses of open space replaced his earlier dramatic use of light and shadow in his representations of the woodland thicket. The horizontal emphasis of the composition suggests the vastness of the space, while the sense of perspectival recession is reinforced by the trees in the middle ground. Characteristically for a Barbizon painter, Dìaz de la Peña depicts nature without unnecessary adornment, but nevertheless imbues it with strong metaphorical undertones. The solitary human figure is set right in the center of the painting, but appears strikingly small in contrast to the vast expanses of nature surrounding him. This painting comes from the collection of Mikhail Morozov, the elder brother of Ivan Mozorov. —MC

148. PAUL GAUGUIN (1848–1903)
Conversation (Les Parau Parau), 1891

147

148

Oil on canvas, 70.5 x 90.3 cm
State Hermitage Museum, St. Petersburg
(plate 156)

Conversation (Les Parau Parua) was one of the first two works by Gauguin that Ivan Morozov purchased from the Parisian art dealer Ambroise Vollard in 1907. Just a year later he already owned eight outstanding works by the painter. Sergei Shchukin had also assembled, between 1904 and 1910, what he called an "iconostasis" of sixteen of the finest works by Gauguin, which covered an entire wall in his dining room from floor to ceiling. The inscription *Parau Parau* can be translated as "words, words" or "gossip." A later version of this painting, with the figures set further into the background, is now in the collection of the Yale University Art Gallery. Gauguin's work had a strong impact on the artists of the Russian avant-garde, who admired his bold colors and primitive style. Mikhail Larionov's *Village Bathers* (1909, cat. no 176) is one example of an openly declared affiliation with Gauguin. —MC

149. KONSTANTIN KOROVIN (1861–1939)
Portrait of Ivan Morozov, 1903
Oil on canvas, 90.4 x 78.7 cm
The State Tretyakov Gallery, Moscow
(plate 152)

Varvara Morozova, the mother of Ivan Morozov (1871–1921) and his older brother Mikhail, chose Korovin, a promising but then still unknown painter, to serve as art instructor to her sons. Korovin was a daring innovator who experimented with the use of color and paint and by the late 1880s developed his own style, strongly affiliated with French Impressionism, using thickly applied paint and broad expressive brushstrokes. He introduced the Morozov brothers, both of whom were to become major art collectors, to Russian and Western European art and influenced their predilection for modern French painting. Under Korovin's guidance, Ivan Morozov developed his modest talent for landscape painting. Korovin's landscapes were among the first acquisitions of Morozov, who occasionally used the painter's advice regarding art purchases. By the early 1900s Korovin was a well-established painter and Morozov a successful Moscow merchant who had taken over the family's firm and bought a lavish mansion on Prechistenka Street. *Portrait of Ivan Morozov* depicts a mature and confident businessman. Korovin and Morozov shared a deep appreciation of artistic experimentation, and the pictorial expressiveness of this painting lies in its broad

dynamic brushstrokes, a motley background, which contrasts sharply with the unmodulated black and white of the sitter's suit. —MC

150. CHRISTIAN CORNELIUS KROHN (1882–1959)
Portrait of Sergei Shchukin, 1915
Oil on canvas, 97.5 x 84 cm
State Hermitage Museum, St. Petersburg
(plate 153)

This is one of three existing finished painted portraits of Sergei Shchukin (1854–1936), one made by D. Melnikov (1915) and two by Krohn, a little-known Norwegian artist who studied with Ilya Repin in St. Petersburg and exhibited with the Jack of Diamonds group during the second decade of the twentieth century. Shchukin had few portraits of himself made, and apart from a second full-length portrait by Krohn (1915) and the one by Melnikov, the only other extant portraits of him are a small caricature by Pablo Picasso (ca. 1907) and a charcoal drawing by Henri Matisse (1912). Matisse planned to complete a painted portrait of the collector, but his work was interrupted by the sudden death in October 1912 of Shchukin's brother Pyotr. Krohn's pictorial vocabulary can clearly be related to the most recent developments in modernist painting. This portrait uses bright, saturated colors, thick contours, and a completely flat background. The collector's facial features are simplified, giving his head a somewhat wooden aspect. —MC

151. ALBERT MARQUET (1875–1947)
Place de la Trinité in Paris, ca. 1911
Oil on canvas, 81 x 65.5 cm
State Hermitage Museum, St. Petersburg
(plate 160)

A close friend of Henri Matisse, Marquet is often associated with the Fauves. Several of his paintings from around 1905 are highly representative of the vivid colors and loose brushstrokes characteristic of their style. Yet he soon abandoned this approach in favor of a more subdued palette and strongly defined outlines. Marquet was highly sensitive to light and atmospheric conditions; here he captures the mood of a rainy day in Paris. An almost static effect is achieved through the use of broad brushstrokes and blocky colors. The composition is grounded by pronounced outlines yet is also dynamic and engaging: a strong receding diagonal going from the lower left corner to the upper right is counteracted by the powerful vertical

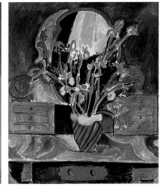
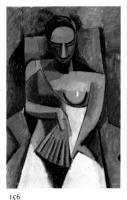
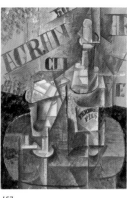

152 153 154 156 157

pull of the repeated silhouettes of a residential building and two churches, L'église de la Trinité and the silhouette of Sacré-Coeur in the background. While this particular painting came to the Hermitage from the collection of the St. Petersburg-based Swiss businessman Georg Haasen, Sergei Shchukin was also a great admirer of Marquet's work and owned nine of his paintings. —MC

152. HENRI CHARLES MANGUIN (1874—1949)
Morning at Cavalière, 1906
Oil on canvas, 81.5 x 65 cm
State Hermitage Museum, St. Petersburg
(plate 161)

Sergei Shchukin acquired *Morning at Cavalière* from the Salon d'Automne in 1906. It is characteristic of Manguin's Fauvist period during the spring and summer of 1906, which he spent on the shores of the Mediterranean. He often painted in the area around Cavalière, working early in the morning and frequently depicting a female figure in the landscape. Manguin's favorite model was his wife Jeanne, who appears carrying the same umbrella in another similar painting titled *Jeanne with an Umbrella at Cavalière* (1906), now in Kunsthalle Bielefeld. Also known under the titles *Morning* and *Woman Sitting by the Shore of the Gulf of Cavalière*, *Morning at Cavalière* shows the early light of morning, with a predominance of sky-blue tones and the golden yellow of the rising sun. The gnarled trunks of the trees block the view of the bay, thereby creating an effective tension within the composition. —MC

153. HENRI MATISSE (1869—1954)
Girl with Tulips, 1910
Oil on canvas, 92 x 73.5 cm
State Hermitage Museum, St. Petersburg
(plate 164)

From 1906 Sergei Shchukin was to become one of Matisse's main patrons, acquiring thirty-seven outstanding paintings within eight years, including the now famous *Dance* and *Music*, which he commissioned from the artist in 1909. Shchukin's request for more large paintings with allegorical subjects resulted in Matisse's 1911 visit to Russia. The painter's encounter with indigenous icons was to have a tremendous impact on his work. Shchukin often quoted Matisse, who, while standing in front of icons in the Tretyakov Gallery, was heard to pronounce: "I spent ten years searching for what your artists have already discovered in the fourteenth century. It is

not you who need to come to us to study, but it is us who need to learn from you." Shchukin bought *Girl with Tulips* in 1910 from the Salon des Indépendants, where it was the only canvas by Matisse on view. Here, Jeanne Vaderin, or Jeannette as Matisse called her, is depicted with the artist's characteristic bright, unmodulated colors, thick contours, and flattened space. —MC

154. HENRI MATISSE (1869—1954)
Vase of Irises, 1912
Oil on canvas, 117.5 x 100.5 cm
State Hermitage Museum, St. Petersburg
(plate 165)

Sergei Shchukin had bought his first Matisse still life because he saw it as representing a critical reaction to Cézanne's artistic experiments, yet he soon began buying Matisse's art for its own innovative qualities. The artist's works had a separate room devoted to them in Shchukin's house. The collector acquired *Vase with Irises* only a few months after it was made. According to his own account, Matisse painted this bouquet of blue irises when he was confined to his hotel room in Morocco during a rainy period. The actual colors in the painting, however, are far from naturalistic, reflecting instead the hues of Moroccan decorative schemes. This work involves a complex interaction between bold disjointed colors and flattened surfaces; it requires an intense interpretative engagement from the viewer. —MC

155. CLAUDE MONET (1840—1926)
Poppy Field, late 1880s
Oil on canvas, 60.5 x 92 cm
State Hermitage Museum, St. Petersburg
(plate 155)

Monet painted fields of poppies quite frequently during the 1870s and 1880s. *Poppy Field* is distinguished by an overall absence of detail, bold brushstrokes, and the use of strongly contrasting colors, dominated by red and blue. A dynamic composition results from the tension between the apparent motion of certain elements in opposing directions. This sense of movement is suggested primarily by the orientation of the brushstrokes: the field of poppies leans sharply to the left, while the clouds appear to move to the right and the vertical trees mediate between them. This painting belonged to Mikhail Morozov, whose collection of modern French paintings was to form the basis of the collection of his younger brother Ivan. Sergei

Shchukin also amassed an important group of Monets; between 1898 and 1904 he acquired thirteen of the artist's finest canvases, including the study for *Le Déjeuner sur l'Herbe* (1865), *Rouen Cathedral* (1894), and *Waterlilies* (1899). —MC

156. PABLO PICASSO (1881—1973)
Woman with a Fan, 1907—08
Oil on canvas, 150 x 100 cm
State Hermitage Museum, St. Petersburg
(plate 162)

It is believed that Sergei Shchukin was introduced to Picasso by Henri Matisse, who brought his Russian patron to Picasso's Bateau Lavoir studio in Paris in September 1908. In 1909 Shchukin bought his first painting by Matisse's main rival for the leadership of the avant-garde: *Woman with a Fan*, an early Cubist work. In Shchukin's collection it was called *After the Ball*, a title probably invented by the merchant himself. He remembered that it took him a while to learn to appreciate this painting, and that at first he could not find a place to hang it, as its rough geometric intrusiveness created a strong dissonance with the rest of his collection. He ended up putting it in a dark corridor near the entrance where no other paintings were displayed. Gradually, he learned to appreciate Picasso's art and acquired about fifty of the artist's works before 1914.

157. PABLO PICASSO (1881—1973)
Table in a Café (Bottle of Pernod), 1912
Oil on canvas, 46 x 33 cm
State Hermitage Museum, St. Petersburg
(plate 163)

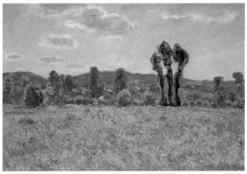

155

Sergei Shchukin had a strong preference for Picasso's early works and generally shied away from his later Analytic Cubist pictures and collages. (However, Ivan Morozov, who owned only three works by Picasso, had acquired his famous *Portrait of Ambroise Vollard*, a masterpiece of Analytic Cubism, not long after it was painted in 1910.) *Table in a Café (Bottle of Pernod)*, purchased by Shchukin from Daniel-Henry Kahnweiler after 1912, was an exception in his collection. Although painted in oil, the work contains some of the key effects of collage. Here Picasso teasingly reveals the mechanisms for creating the pictorial illusion of three-dimensional textured volumes in space. He deliberately confuses light and shade, flatness and recession, exposing our predilection for establishing meaning through opposition. His sharpest pun is the introduction of stenciled letters, which brings the viewer's attention back to the pictorial surface; despite their familiarity, the meaning of the words they make is not easy to decode. Picasso's collage was instrumental for the development of abstraction in Russia by such key avant-garde figures as Kazimir Malevich and Vladimir Tatlin. —MC

158. MAURICE DE VLAMINCK (1876–1958)
Small Town on the Seine, ca. 1909
Oil on canvas, 81.3 x 100.3 cm
State Hermitage Museum, St. Petersburg
(plate 159)

Vlaminck, who had no formal training, began to study painting in 1899. He first exhibited in 1905 at the Salon des Indépendants and in 1906 at the Salon d'Automne, where, together with André Derain, Henri Charles Manguin, and Henri Matisse, he was derisively labeled a *"fauve"* (wild beast). The Paul Cézanne retrospective of 1907 in Paris had a profound impact on Vlaminck; he became more interested in the structure of his compositions and began to restrict his palette to the greens, blues, and ocher favored by Cézanne. This affinity is clearly evident in the subject, palette, and composition, as framed by two trees, of *Small Town on the Seine*. Vlaminck's intense interest in Cézanne's landscapes lasted until about 1910, the same year in which Sergei Shchukin acquired this painting from Daniel-Henry Kahnweiler's gallery in Paris. Although this painting was titled *Small Town by a Lake* when it entered Shchukin's collection, the water in it is most likely the Seine near Bougival, where Vlaminck worked in 1909–10. —MC

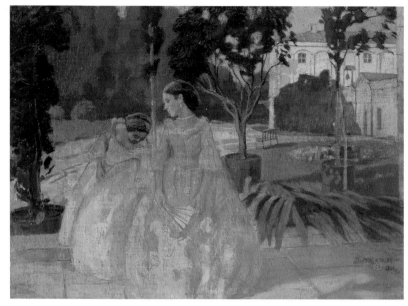

159

ACKNOWLEDGING TRADITION AND BREAKING NEW GROUND: EARLY 20TH CENTURY

159. VIKTOR BORISOV-MUSATOV (1870–1905)
Gobelin, 1901
Tempera on canvas, 103 x 141.2 cm
The State Tretyakov Gallery, Moscow
(plate 151)

In *Gobelin* the vibrancy of the Impressionist brushstroke in Borisov-Musatov's earlier work is transformed into the purely decorative effect of a matte surface, reminiscent of medieval tapestries. Not incidentally, the title of this painting refers to the famous French tapestry manufacturers, whose name came to stand for tapestries themselves. The surface of Borisov-Musatov's painting appears uniform, with pigments rubbed into the canvas so that its grainy texture shows through. The world in his images becomes a kind of dreamland, with static disjointed figures and an almost complete lack of narrative. Borisov-Musatov was a prominent representative of the Symbolist movement in Russian art, having formed a circle of artists in his native Saratov before coming to study in the main art schools of Moscow and St. Petersburg and then going on to Paris. He spent three winters there between 1895 and 1898 and absorbed the leading modern artistic trends. He particularly admired the murals of Pierre Puvis de Chavannes, and in its decorativeness, flattened space, and predominant interest in the ethereal effects of color and light, Borisov-Musatov's work is reminiscent of such Nabi artists as Pierre Bonnard, Maurice Denis, and Eduard Vuillard. —MC

160. MARC CHAGALL (1887–1985)
The Soldier Drinks, 1911–12
Oil on canvas, 109.2 x 94.6 cm
Solomon R. Guggenheim Museum,
New York 49.1211
(plate 171) 49.1211

The Soldier Drinks was made in Paris, where Chagall lived between 1910 and 1914. He had a studio at La Ruche in Montparnasse and was acquainted with a number of modernist painters and poets. While stylistically this painting reflects the latest experiments of the Parisian avant-garde, such as the Cubist treatment of space and the bright colors of Fauvism and Orphism, the iconography is Chagall's own. It depicts a space between reality and dream in which the soldier's memory of his wife is perhaps manifested in the form of a small dancing couple in the foreground. The painter later said that this image was evoked by his memories of tsarist soldiers during the Russo-Japanese war of 1904–05. Its setting is indeed conspicuously Russian, as indicated by the soldier's uniform, a samovar on his table, and an *izba* (traditional wooden house) visible through the window. —MC

161. JOSEPH CHAIKOV (1888–1939)
Blacksmith, 1927
Plaster with cement powder, h. 49 cm
The State Tretyakov Gallery, Moscow
(plate 210)

Chaikov studied sculpture in Paris in the studio of Boris Aronson, at the Ecole Nationale des Arts Decoratifs (1910–12), and at Ecole des Beaux-Arts (1912–13). Between 1922 and 1923, he lived in Berlin and participated in the Novembergruppe's exhibitions and in the First Russian Art Exhibition in 1922. Following his return to Russia, he taught sculpture at VKhUTEMAS (Higher State Artistic and Technical Workshops) in Moscow, one of the centers of Constructivism. *Blacksmith* shows a strong stylistic proximity to Italian Futurism and especially to the Cubist sculptures of Alexander Archipenko. Its massive blocklike forms are enhanced by geometrical contours. The worker is here elevated to the status of a machine, which at the time meant unquestionable monumentalization. —MC

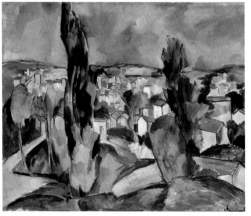

158

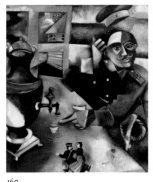

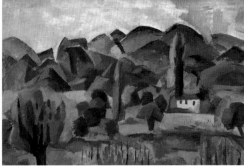

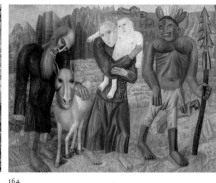

160 162 163 164

162. ROBERT FALK (1886–1958)
Landscape: In the Mountains, 1916
Oil on canvas, 81 x 118 cm
Ivanovo Regional Art Museum
(plate 189)

The composition of *Landscape: In the Mountains* is clearly inspired by Paul Cézanne. It has a slightly elevated viewpoint, the trees in the middle ground create an illusion of spatial recession, and the hills in the background close off the horizon line and make the picture plane tilt forward toward the viewer. Falk's use of color, however, is closest to the sensibility of the Fauves. The landscape is dominated by patches of bright red, yellow, and deep green that are applied freely and expressively without being closely tied to the representational details. One of the founding members of the Jack of Diamonds group, Falk probably showed this work in its 1916 exhibition in Moscow under the title *Landscape (Crimea)*. From 1928 until 1937 Falk lived in Paris, and upon his return to the USSR he lived in isolation. He was faithful to his aesthetic principles and became a highly influential figure for the postwar generation of nonconformist artists. —MC

163. PAVEL FILONOV (1883–1941)
German War, 1915
Oil on canvas, 176 x 156.3 cm
State Russian Museum, St. Petersburg
(plate 192)

Filonov developed an analytic painting system in the early 1910s. The main principle of his working method was "*sdelannost*," a neologism that translates as "madeness" or "craftedness." *Sdelannost* involved a difficult process of revealing all the properties that lead to extraordinarily detailed, crystalline, iridescent, and seemingly unstructured painterly textures. Despite its apparent similarity to Analytic Cubism, Filonov's approach is fundamentally distinct. His focus lay not in the formal components of painting, but rather in the visible world, which he sought to decompose into its most minute and fundamental parts and to record the results on such canvases as *German War*. He believed his method to be purely scientific, accessing the very essence of things, and thus he called his style "double naturalism." —MC

164. PAVEL FILONOV (1883–1941)
The Flight into Egypt (The Refugees), 1918
Oil on canvas, 71.4 x 89.2 cm
Mead Art Museum, Amherst College,

Gift of Thomas P. Whitney, Class of 1937
(plate 191)

Filonov's modernism is rooted in Russian folk art and in medieval icon and fresco painting. *Flight into Egypt (The Refugees)* is one of several works that the artist painted on Biblical subjects, including *Peasant Family* (1914), *Three around the Table* (1914–15), and *Magi* (1914), all of which are in the State Russian Museum. *Flight into Egypt* follows closely the graphic image Filonov used as a cover for his 1915 illustrated neologistic poem *The Chant of Universal Flowering (Propeven o Proposli Mirovoy)* on the theme of World War I. The painting combines the style of popular woodcuts (*lubki*)—apparent in the flattened, stylized figures in the foreground—with that of the artist's own analytical painting, evident in the rich texture and faceted quality of the space containing the figures. Given the tumultuous state of Russia just after the revolution and its withdrawal from World War I, this painting may have had an allegorical meaning at the time it was made. —MC

165. ANNA GOLUBKINA (1864–1927)
Pilgrim, 1903
Wood, h. 42 cm
State Russian Museum, St. Petersburg
(plate 173)

Golubkina came to Moscow from Zaraisk, first taking classes from Sergei Volnukhin, then continuing her studies at the Moscow School of Painting, Sculpture, and Architecture and the Academy of Arts in St. Petersburg. In the late 1890s she worked in Paris, in the studio of Filippo Colarossi, and periodically visited the studio of Auguste Rodin, from whom she received professional advice. *Pilgrim* is typical of Golubkina's early style, with its highly expressive posture and contrasting finishes of the carved surface. The smooth face of the old woman creates a sense of warmth and deep introspective concentration as it emerges from underneath the rougher surface of her headscarf. The woman's head contrasts even more sharply with her chest and shoulders, which bear large traces of the carving knife, adding to the overall emotional intensity of the work. Golubkina claimed that she asked this pious woman to pose when she encountered her going on a pilgrimage in her native town of Zaraisk. —MC

166. ANNA GOLUBKINA (1864–1927)
Old Woman, 1908
Marble, h. 40.5 cm
The State Tretyakov Gallery, Moscow
(plate 172)

Made out of marble, *Old Woman* is more stylized and emotionally reserved than *Pilgrim* (1903, cat. no. 165), responding to the Symbolist sensibilities of the Russian Silver Age. Golubkina learned to work in marble during her last trip to Paris in 1903–04, and she felt that it gave her work a much greater power and strength. Here the sculptor returned to the subject of old age, but rather than portraying its emotional side, as in her sculpture *Old Age* (1898; State Russian Museum) or the wooden *Pilgrim*, she emphasized its timeless and symbolic aspect. The work's frontal viewpoint and a symmetrical, almost triangular, face make it appear static and abstracted. The traditional peasant scarf on the woman's head is folded in such a way that her bust recalls the Egyptian statues of sphinxes. There is no indication of her body, only the face is visible against the rough texture of her headscarf. Human presence in this work is no longer humble, as it is in *Pilgrim*, but powerful and monumental, and it is legible on a number of metaphorical levels, as was typical for Symbolist works. —MC

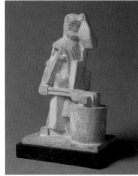

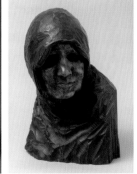

161 165 166

167 168

167. NATALIA GONCHAROVA (1881–1962)
A Girl on a Beast (from the *Harvest* series), 1911
Oil on canvas, 167 x 128.5 cm
Kostroma State Unified Art Museum
(plate 182)

For Goncharova, modern art always remained inextricably linked to ancient traditions. In her own attempt to find the modern essence of some of the oldest forms of artistic expression, Goncharova turned not only to shop signs and popular woodcuts (*lubki*) but also to Scythian art and religious subjects. Her nine-part series *Harvest*, made in the year when her career had reached its peak, represents a powerful combination of the artist's interest in religious ecstasy (the subject of the polyptich is apocalyptic) and the wisdom and expressiveness of folklore. *A Girl on a Beast* is an extraordinary synthesis of Goncharova's versatile pictorial language, as large flat areas of saturated colors are given dynamism by the intersecting diagonal lines that break the pictorial space in a violent way. These lines are reminiscent of Cubist planarity, while their thickness makes them resemble the spatial dividers of cloisonné. —MC

168. NATALIA GONCHAROVA (1881–1962)
Self-Portrait with Yellow Lillies, 1907
Oil on canvas, 77 x 58.2 cm
The State Tretyakov Gallery, Moscow
(plate 168)

In *Self-Portrait with Yellow Lillies*, Goncharova's first programmatic manifesto, she depicted herself as an independent and self-sufficient artist. She took up oil painting around 1905; the Post-Impressionists, and especially Vincent van Gogh, strongly influenced her early style. Traces of their impact are clearly visible in the thick impasto and dynamic, expressive brushstrokes. Already by 1907 Goncharova had developed her own primitive style, working in parallel to her husband, Mikhail Larionov. This self-portrait looks traditional, with the artist standing in a reserved posture in front of her canvases and the solemn three-quarter turn of her head; yet it is her right hand, exaggerated and heavy, a far cry from feminine refinement, that betrays Goncharova's real affiliation: her search for radical innovation grounded in a serious investigation of the expressive essence of Russian peasant culture. —MC

169. NATALIA GONCHAROVA (1881–1962)
Cats (rayist percep.[tion] in rose, black, and yellow), 1913
Oil on canvas, 84.4 x 83.8 cm
Solomon R. Guggenheim Museum,
New York 57.1484
(plate 183) 57.1484

Cats (rayist percep.[tion] in rose, black, and yellow) is the finest example of Goncharova's Rayonist painting. Larionov, who invented Rayonism in 1912, explained that its purpose was to depict what we see in a literal way by painting the sum of rays as they are reflected from the object being depicted. Goncharova's representation of cats (or a single cat, as Russian scholars have recently argued) verges on abstraction, dissolving the divisions between figure and ground in an expansive solid space. The division between line and color is also blurred here, as lines merge into planes of color defining spatial recessions and the volume of the ostensibly solid bodies of the cats. The bright yellow may be suggestive of the intensity of light, which, at least in theory, is the main agent in Rayonist painting. —MC

170. VASILY KANDINSKY (1866–1944)
Sketch for Composition II, 1909–10
Oil on canvas, 97.5 x 131.2 cm
Solomon R. Guggenheim Museum, New York
45.961
(plate 186) 45.961

Sketch for *Composition II* features Kandinsky's favorite and recurring motif of a horseman, which was also used on the covers of his theoretical manifesto *Concerning the Spiritual in Art* (1911) and the *Blue Rider Almanac* (1912), which he edited with Franz Marc in Munich. The rider symbolized Kandinsky's crusade against stale aesthetic conventions and the possibility of achieving a more spiritual future through the transformative powers of art. Beginning in the 1910s, the rider also stood for the Horseman of the Apocalypse from the Book of Revelation. In the sketch shown here, as in a number of later paintings by Kandinsky, the horseman symbolically divides the canvas into the epic destruction on the left and the paradise of salvation on the right. Kandinsky's bright colors and linear style retains vestiges of his earlier works based on Russian folktales. —MC

171. VASILY KANDINSKY (1866–1944)
Painting with White Border, May 1913
Oil on canvas, 140.3 x 200.3 cm
Solomon R. Guggenheim Museum, New York,
Gift, Solomon R. Guggenheim 37.245
(plate 185) 37.245

In an essay also titled "Painting with White Border," Kandinsky explained that he had painted the spirit of the city of Moscow as a highly abstracted trio of horses. This explanation is characteristic of the artist's gradual introduction of abstraction, through which he gave viewers visual clues to the narratives underlying his imagery. The horses, whose abstracted heads appear in the upper-left corner of the painting, are pulling a carriage placed near its center. The artist's path to abstraction during his years in Munich (1896–1914), as well as his belief in spiritual content, set him apart from younger painters in Russia, who used geometric forms and approached nonrepresentational painting in more rational, systematic ways that were largely based on the conceptual breakthroughs of transrational poetry and Cubism. —MC

172. PYOTR KONCHALOVSKY (1876–1956)
Family Portrait, 1911
Oil on canvas, 179 x 239 cm
State Russian Museum, St. Petersburg
(plate 178)

169

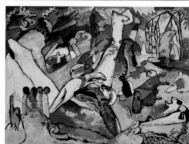

170

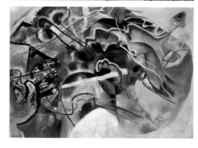

171

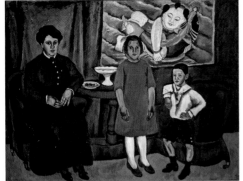

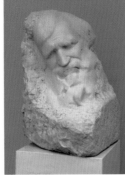

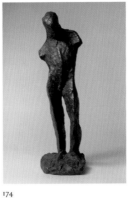

172

173

174

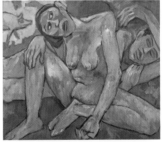

175

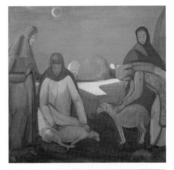

176

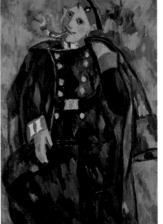

177

Konchalovsky was among the founders of the Jack of Diamonds society in 1911 and participated in all its shows until 1927. *Family Portrait* depicts the artist's wife Olga (1878–1958), daughter Natalia (1903–1988), who became a writer, and son Mikhail (1906–2000), who became a painter. Konchalovsky created a deliberate, strong overall sense of staginess and artificiality in the composition through the use of shallow space, the rigid frontal postures of the figures, and their exaggerated stares. This general sense of affectation contributes to the deliberate debasing of painting that members of the Jack of Diamonds held in common. The presence of a Chinese print in the background further emphasizes the artificiality of the painted space and creates a gently mocking contrast to the traditional red of the girl's dress and the rouge on the woman's cheeks. —MC

173. SERGEI KONENKOV (1874–1971)
The Thinker, after 1905
Marble, h. 56 cm
State Russian Museum, St. Petersburg
(plate 143)

Born into a peasant family, Konenkov received a solid academic education, first at the Moscow School of Painting, Sculpture, and Architecture (1892–96) and then in the Academy of Arts in St. Petersburg (1899–1902). In 1897 Konenkov traveled to Italy, France, and Germany, and he was familiar with modern artistic trends. He greatly admired the work of Auguste Rodin, and the title of this sculpture is probably an homage to this French master. Konenkov claimed to have modeled his *Thinker* on the worker Ivan Kuprin, who also posed for Konenkov's more traditional full-length sculpture *Stonecutter* (1898) and whose wisdom and dignity greatly impressed the sculptor. A close affinity with Auguste Rodin is also evident in Konenkov's expressive use of the contrast between the inanimate, inert, and unpolished piece of stone, and the sculpted human form that emerges from it. The tilt of the man's head and his knitted brow further underscore his self-conscious power and depth. This is one of Konenkov's relatively few early works in marble, as from the early 1910s he increasingly turned to the carved wooden sculpture for which he is renowned. —MC

174. BORIS KOROLEV (1884–1963)
Standing Male Figure, 1914
Bronze, h. 49 cm

State Russian Museum, St. Petersburg
(plate 202)

Between 1910 and 1914, Korolev studied at the Moscow School of Painting, Sculpture, and Architecture and traveled extensively, visiting England, Italy, France, Germany, and Austria. In Paris he worked briefly in the studio of Alexander Arkhipenko and was inspired by the language of Cubism. He may also have been familiar with the work of Pablo Picasso. While the pose of this bronze figure closely resembles classical *contraposto*, its volumes are highly abstracted and the surface is left rough, reminding the viewer of the modeling process. The truncated arms are another reference to classical sculptures (as we know them), yet the geometric sharpness of the edges has a violent, industrial feeling. The pronounced vertical line along the man's body and the shape of his abstracted head complete the impression of an uncanny, mutilated body in armor that is in keeping with the historical moment of its execution. —MC

175. PAVEL KUZNETSOV (1878–1968)
Shearing Sheep, ca. 1912
Tempera and pastel on canvas, 77.5 x 81.5 cm
State Russian Museum, St. Petersburg
(plate 166)

Kuznetsov studied in the Moscow School of Painting, Sculpture, and Architecture from 1897 to 1904 under the guidance of Valentin Serov and Konstantin Korovin. He was associated with the Russian Symbolists and throughout the 1910 exhibited with the Blue Rose and the World of Art groups. In this period, he made a series of paintings based on his impressions from travels through the steppes of Central Asia. *Shearing Sheep* is a Symbolist fantasy of the idealized East as a site of harmony, simplicity, and the eternal. Kuznetsov used flattened, generalized forms and muted colors that are dominated by a calm blue tone. The composition is static and its lines smooth, creating an atmosphere of timelessness within this depiction of a mundane task. —MC

176. MIKHAIL LARIONOV (1881–1964)
Village Bathers, 1909
Oil on canvas, 89 x 109 cm
Kovalenko Art Museum, Krasnodar
(plate 175)

While Larionov began painting in his distinct neoprimitive style in 1907, *Village Bathers* still shows his intense

engagement with the leading styles of modern European painting. The subject-matter itself, the primitivizing treatment of the figures, and the prevalence of purple clearly point to Paul Gauguin, whose numerous works were on view in the Sergei Shchukin collection. Bright patches of color, especially the orange and the green, echo the work of the Fauves, while the edginess of the figures and the broken brushstrokes show some affinity with German expressionists. Larionov showed this work at the first Jack of Diamonds exhibition held in Moscow in the winter of 1910–11, which also included works by Robert Falk, Natalia Goncharova, Pyotr Konchalovsky, Alexander Kuprin, Aristarkh Lentulov, and Ilya Mashkov. But by the end of 1911 Larionov and Goncharova left the group and embraced a radically different orientation, which culminated in the *Donkey's Tail* (1912) and *Target* (1913) exhibitions. —MC

177. MIKHAIL LARIONOV (1881–1964)
Soldier (Smoking), 1910–11
Oil on canvas, 100 x 72.5 cm
The State Tretyakov Gallery, Moscow
(plate 170)

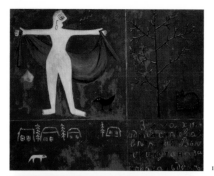

178

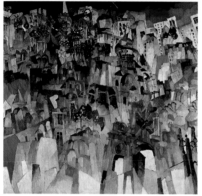

179

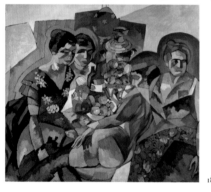

180

In the spring of 1912 Larionov showed thirty-seven works at the provocative exhibition *Donkey's Tail* in Moscow. Thirty of them were devoted to the life of soldiers, many made during the artist's own military service. His earliest biographer, Ilya Zdanevich, claimed that Larionov was inspired by soldiers' barracks graffiti. Many of Larionov's depictions of soldiers contain these drawings and writings. *Soldier (Smoking)* is among the earliest of these works, yet Larionov's primitivism is already strikingly apparent in the flattening of the figure and his awkward posture, and especially in the exaggerated tilt of his head, which makes him look like a straw doll more than a disciplined servant of the state. —MC

178. MIKHAIL LARIONOV (1881–1964)
Winter (from the *Seasons* series), 1912
Oil on canvas, 100 x 122.3 cm
The State Tretyakov Gallery, Moscow
(plate 181)

The *Seasons* series in many ways represents the culmination of Larionov's primitive style. The pictorial plane is entirely flattened and contour alone defines volume. Line,

that trace of the painter's hand, looks more like the scratch of graffiti than the touch of a brush. Each of the four paintings is divided into four parts, in which a female figure symbolizes each season, and text describes its qualities. *Winter* looks almost archaic, with clear sources not only in popular woodcuts (*lubki*) and shop signs but now also in prehistoric art and children's drawings. The color scheme is highly reductive and dominated by the earthy brown that speaks almost literally of the debased grounded quality of the image. Larionov reduced pictorial language to the bare bones of its expressive potential, thus revealing the capacity of painting to speak to the viewer directly and powerfully without need for illusionism. (The text in the lower right corner reads, "Winter cold snowy windy wrapped in the snowstorms chained by ice.") —MC

179. ARISTARKH LENTULOV (1882–1943)
Moscow, 1913
Oil on canvas, 179 x 189 cm
The State Tretyakov Gallery, Moscow
(plate 180)

In 1911–12 Lentulov traveled to Italy and France, where he studied with Henri Le Fauconnier and undoubtedly became acquainted with all the leading trends of modern French painting. One of his most accomplished works, *Moscow* shows the influence of Cubism, but also of Umberto Boccioni and Robert Delaunay. The pictorial space of Lentulov's painting is almost vertical: the sense of spatial recession is minimal and buildings of various shapes, patched together from fragments of color, are stacked almost on top of each other from the bottom to the top, evoking the dynamism and density of the city. An homage to Delaunay and his colorful and highly abstract Parisian window series is inserted in the form of the Eiffel Tower on the top left side of the painting. Yet the space of *Moscow* is powerfully dominated by the traditional Russian red and the colorful onion-shaped cupolas of Russian Orthodox churches. —MC

180. ARISTARKH LENTULOV (1882–1943)
Women and Fruit (panel from diptych), 1917
Oil on canvas, 142.5 x 159.5 cm
Pozhalostin Regional Art Museum, Ryazan
(plate 179)

It is often said that in the work of the members of the Jack of Diamonds group human figures become indistinguishable from still lifes. It is certainly the case in *Women and Fruit*, which shows four models, one of them nude, with her behind provocatively turned toward the viewer, seated around a table with a Russian samovar and surrounded by bright decorative motifs of fruit in vases, pillows, and flowers. This painting is the left part of a diptych and thus it is not surprising that three of the women are gazing toward the right, creating a bridge to the second part of the composition, which shows three more women in a very similar setting. While the treatment of volume in space is overtly Cubist, the decorative bright patchwork inspired by Russian traditional motifs is the signature of Lentulov's mature style. He avoids all shading and suggests three-dimensionality through color juxtapositions alone. —MC

181. KAZIMIR MALEVICH (1878–1935)
Morning in the Village after Snowstorm, 1912
Oil on canvas, 80.6 x 81 cm
Solomon R. Guggenheim Museum,
New York 52.1327
(plate 187) 52.1327

Morning in the Village after Snowstorm was painted in the period when Malevich experimented with several modernist painterly styles simultaneously. It combines the Cubist analysis of space with the Futurist mechanized forms of the bodies. This painting could be Malevich's response to the style of Fernand Léger, whose exhibition he may have seen in Moscow in February of 1912. At the same time, the artist depicts a distinctly Russian subject—peasants carrying buckets of water in the snow-covered streets of a village—in keeping with the language of primitivism developed and practiced by Mikhail Larionov and Natalia Goncharova with whom Malevich was associated at the time. —MC

182. KAZIMIR MALEVICH (1878–1935)
Suprematism, 1915
Oil on canvas, 87.5 x 72 cm
State Russian Museum, St. Petersburg
(plate 195)

Malevich hung *Suprematism* underneath and slightly to the right of his *Black Square* at the 0-10 exhibition held in St. Petersburg in 1915, in which the artist first revealed

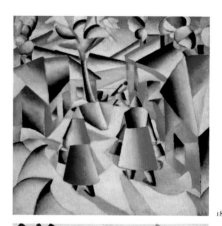

181

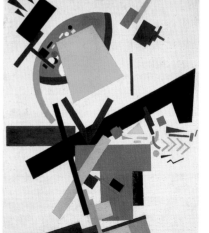

182

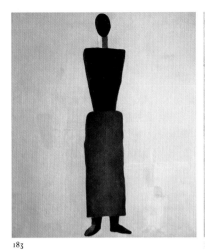
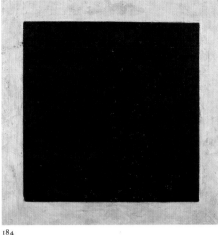
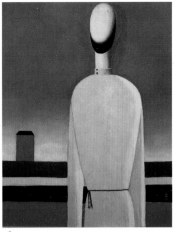

183 184 185

to the public his breakthrough painterly language of Suprematism. Filled with numerous forms of varying colors and shapes, this busy painting contrasts sharply with the minimalism of the *Black Square* and demonstrates that, from its inception, the visual language of Suprematism was not as reductive as many believe. Originally shown under the title *Painterly Masses in Movement, Suprematism* demonstrates that Malevich understood forms abstractly and manipulated their shapes and colors in order to create an effect of movement on a seemingly neutral white background, which was, in fact, highly symbolic. For Malevich, the white background signified infinite cosmic space. —MC

183. KAZIMIR MALEVICH (1878–1935)
Female Figure, 1928–29
Oil on canvas, 126 x 106 cm
State Russian Museum, St. Petersburg
(plate 203)

After his return from Germany in 1927, Malevich developed a pictorial language that oscillates between abstraction and representation. While many art historians have seen the artist's return to figuration as a retreat in the face of external ideological pressure, another interpretive approach considers this style as a critical commentary on the capacity of figuration to reveal the limitations of its own pictorial language. With works such as *Female Figure*, Malevich entered into a dialogue with the advocates of illusionism and demonstrated that one *can* show a figure and still draw the viewer's attention to the capacity of painting to encompass *more* than the visible world. The female figure exists in a timeless space, and her form is made up of flat areas of unmodulated color. On the back of the stretcher Malevich inscribed "Supranaturalism," confirming his simultaneous engagement with and transcendence of naturalistic depiction. —MC

184. KAZIMIR MALEVICH (1878–1935)
Black Square, ca. 1930
Oil on canvas, 53.5 x 53.4 cm
State Hermitage Museum, St. Petersburg
(plate 194)

This is the fourth and last version of the landmark *Black Square* (originally entitled *Black Quadrangle*) that Malevich exhibited at the *0-10* exhibition in Petrograd in 1915, when he inaugurated Suprematism. Designated by the artist as "a reigning royal infant," the original *Black Square* was hung high up in a corner, like an icon presiding over dozens of other abstract works filled with geometric shapes on white backgrounds. This painting bluntly announced the end of representation and the advent of new, superior, and limitless possibilities for painting, which was now liberated from what Malevich designated as its "enslavement by forms of nature." Malevich painted a second version of his square in 1923 for the Venice Biennale, and a third one in 1929 for his one-man show at the State Tretyakov Gallery in Moscow. He probably made this last version for the room of his works at the 1932 exhibition *Artists of the R.SFSR in the Last Fifteen Years* held in the State Russian Museum in St. Petersburg. —MC

185. KAZIMIR MALEVICH (1878–1935)
Complex Premonition (Torso in a Yellow Shirt), ca. 1932
Oil on canvas, 98.5 x 78.5 cm
State Russian Museum, St. Petersburg
(plate 201)

Even more than *Female Figure* (1928–29, cat. no. 183), Malevich's *Complex Premonition (Torso in a Yellow Shirt)* flirts with illusionism, but quickly subverts it. It is difficult to tell whether the figure is turned away from or facing the viewer. And the horizon line, which initially functions to ground our eye in the perspectival distance, becomes, upon closer inspection, a grouping of four flat stripes in solid bright colors. The figure's peasant attire—a long shirt tied with a string—has led a number of art historians to interpret this work literally, as the artist's lament for the fate of Russian and Ukrainian peasants during the famine of the early 1930s, which was the result of forced collectivization. While an element of social critique may indeed be present, the work also expresses the artist's more generalized anxiety. This is evident in the inscription on the back of the canvas, which reads, "Composition came together from the feeling of void, solitude, and hopelessness of life." —MC

186. ILYA MASHKOV (1881–1958)
Still Life: Fruit on a Dish, 1910
Oil on canvas, 80.7 x 116.2 cm
The State Tretyakov Gallery, Moscow
(plate 177)

Mashkov studied at the Moscow School of Painting, Sculpture, and Architecture (1900–10) under Valentin Serov and Konstantin Korovin. He showed at the Golden Fleece exhibitions in 1909–10 and in 1911 became one of the cofounders of the Jack of Diamonds exhibiting society. Still lifes quickly became the "calling card" of the Jack of Diamonds painters, and Mashkov was one of their major proponents, depicting giant fruit in a painterly style that combined the bright and expressive colors of the Fauves with compositional devices derived from Paul Cézanne. Compared to works by the French painter, however, the composition of *Still Life: Fruit on a Dish* is substantially simpler, the tabletop is tilted unambiguously, and the volume and shape of the fruit are clearly delineated. In 1924 Mashkov joined the Association of Artists of Revolutionary Russia (AKhRR), a conservative group that advocated a return to nineteenth-century modes of realism, and from the mid-1920s onward his style remained strictly representational. —MC

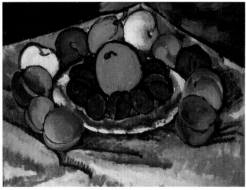

186

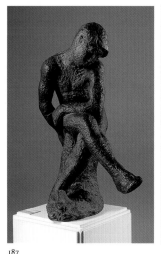

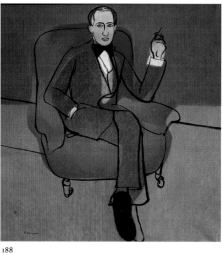

187

188

189

the background, signals the artist's ongoing, if partial, adherence to the traditions of realism. —MC

187. ALEXANDER MATVEEV (1878–1960)
Sitting Boy, 1909
Bronze, h. 117 cm
The State Tretyakov Gallery, Moscow

Born in Saratov, Matveev studied painting there from 1896 to 1899, becoming a member of the artistic circle associated with the Symbolist painter Viktor Borisov-Musatov. The Saratov school later constituted the core of the Symbolist Blue Rose group. Matveev's Symbolist sensibilities are most apparent in the works he made between 1907 and 1912 in the art and ceramics studio of Pyotr Vaulin in the village of Kikerino, near St. Petersburg. *Sitting Boy*, modeled after a teenager who worked at a local factory, is an image of youth, freshness, and regeneration. The boy's pose has a fluid quality, and his head is tilted dreamily. This bronze, along with a number of other works by Matveev, was part of a park ensemble at the summer residency of Yakov Zhukovsky in Kuchuk-Koi in the Crimea. A bronze cast of it is installed on the grave of the artist at the Novodevichy Cemetery in Moscow. —MC

188. PYOTR MITURICH (1887–1956)
Portrait of Arthur Lourié, 1915
Oil on canvas, 102 x 101.5 cm
State Russian Museum, St. Petersburg
(plate 190)

This painting is one of the most accomplished works of Miturich, who is also known as the husband of Vera Khlebnikova, the sister of the transrational (*zaum*) poet Velimir Khlebnikov. It depicts Arthur Lourié (1892–1966), a composer and close friend of the poet Anna Akhmatova. The memoirs of contemporaries have preserved the story of the creation of this portrait. Miturich visited the artist Lev Bruni in apartment no. 5 at the Academy of Arts in St. Petersburg, then a key meeting place for the artists, poets, and critics of the Left. Bruni was in the process of painting Lourié's portrait. Miturich asked for a canvas and a palette and completed this portrait within an hour. Its bold display of linear painting over flat areas of color is reminiscent of the work of Henri Matisse, while also anticipating the techniques employed by American Pop artists some fifty years later. —MC

189. MIKHAIL NESTEROV (1862–1942)
Portrait of the Artist's Daughter, 1906
Oil on canvas, 175 x 86.5 cm
State Russian Museum, St. Petersburg
(plate 169)

Nesterov depicted his oldest daughter, Olga Shreter (1886–1973), a number of times. This full-length portrait in a horse-riding dress is considered the best of these works. The painting is based on a sketch Nesterov made on the Belaya River outside of Ufa, his hometown in the Ural Mountains. It is subtitled "an Amazon," implying the independent nature of the woman whose tall, elegant figure is framed by a landscape at sunset. Nesterov further monumentalized his daughter by depicting her from a slightly low viewpoint and by establishing a high horizon line. The delicate, elegiac mood of the landscape underscores the woman's quiet, introspective expression and her balanced pose. The harmony of people and nature is typical of Nesterov's portraits as well as his religious works. —MC

190. KUZMA PETROV-VODKIN (1878–1939)
On the Shore, 1908
Oil on canvas, 128 x 159 cm
State Russian Museum, St. Petersburg
(plate 176)

Petrov-Vodkin developed a distinct style that reconciled the classical tradition with contemporary interest in the flattened perspective and stylized forms of Early Renaissance art and in the medieval frescoes and icons of Russia. He studied with Abram Arkhipov and Valentin Serov in Moscow, with the painters of the Munich Secession, and in various private studios in Paris, including that of Pierre Puvis de Chavannes. Upon Petrov-Vodkin's return to Russia in 1909, he exhibited with the World of Art group and for decades remained strongly influential in Russian and Soviet art. Painted in Paris, *On the Shore* is an example of the artist's early Symbolist style, which is characterized by flattened space, decorative outlines, and generalized forms. The classicizing folds of the women's dresses and their idealized faces are reminiscent of the stylistic characteristics of Puvis de Chavannes's murals. Yet the detailed, illusionistic depiction of pebbles, which contrasts sharply with the abstracted outlines of the mountains in

191. KUZMA PETROV-VODKIN (1878–1939)
Morning, 1917
Oil on canvas, 161 x 129 cm
State Russian Museum, St. Petersburg
(plate 204)

Petrov-Vodkin singled out three main colors—red, blue, and yellow—for his symbolic painterly language. According to the artist's aesthetic system, the interplay of these colors within pictorial space expressed the philosophical image of the universe. One key source of his pictorial language was his careful study of the old frescoes in Russian monasteries, especially the sixteenth-century frescoes by Dionysii in the Ferapont Monastery. The ground in *Morning* is tilted toward the picture plane at a forty-five degree angle that flattens the scene and brings it closer to the viewer's space. Depicted from a low vantage point, the woman and child appear monumental and

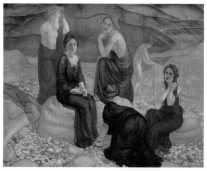

190

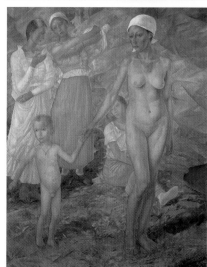

191

192

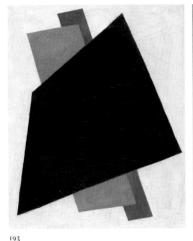

193 194 196

slightly elongated. Their static poses further imbue a simple genre scene with a quality of timelessness reminiscent of Russian icons. —MC

192. KUZMA PETROV-VODKIN (1878–1939)
Herring, 1918
Oil on oilcloth, 58 x 88.5 cm
State Russian Museum, St. Petersburg
(plate 205)

Herring is characteristic of Petrov-Vodkin's style, which created a balance between the modernist pictorial idiom and conventional illusionism. In keeping with compositional approaches that go back to Paul Cézanne, the table-top is tilted toward the viewer and its surface consists of slightly faceted planes. The modernist tradition also figures in the artist's choice of oilcloth for the painting's support, a material that recalls the puns of the Cubist collages. Yet in striking contrast, the objects on the table are illusionistically rendered. Bread, potatoes, and herring—staples in Russia during the privation of the first post-revolutionary years—are singled out and monumentalized. The disjointed space around the table, and the fragment of a boy's head with closed eyes, give the painting an uncanny quality similar to the future work of the Surrealists. —MC

193. LIUBOV POPOVA (1889–1924)
Painterly Architectonics, 1916
Oil on canvas, 88.7 x 71 cm
The State Tretyakov Gallery, Moscow
(plate 193)

One in a series of non-objective works that Popova made between 1916 and 1918, *Painterly Architectonics* demonstrates her knowledge of Cubism as well as her affinity for the visual language of Kazimir Malevich's Suprematism and the principles of Vladimir Tatlin's *Counter-Reliefs*. In the winter of 1916, when this painting was made, Popova was associated with the Supremus group, and her use of large geometric forms dynamically positioned on a white background is clearly indebted to Malevich. Yet the word "architectonic" in the painting's title points in a different direction, as does the strong overlap of the planes and their solid, unmodulated colors. These effects ground the forms and emphasize texture and tectonic qualities akin to

Tatlin's experimental layering of materials in his *Counter-Reliefs*. Yet Popova quickly developed her own expressive language, and by 1921 became a key protagonist in the formulation of the fundamental principles of Constructivism. —MC

194. ALEXANDER RODCHENKO (1891–1956)
White Circle, 1918
Oil on canvas, 89.2 x 71.5 cm
State Russian Museum, St. Petersburg
(plate 198)

White Circle is from Rodchenko's series *Concentration of Color*, which he showed at the Tenth State Exhibition in Moscow in 1919. Although the impetus for the arrangement of geometric forms against a white background clearly came from Kazimir Malevich, Rodchenko sought to challenge the Suprematist pictorial system at its core. He broke the angular dictate of the square with circles, which are clearly static rather than moving in space. Instead of being dissolved, as in the work of Malevich, the edges of the circles are highlighted by contrasting colors. Moreover, the white background in Rodchenko's work is visibly textured, its materialism opposing the ethereal cosmic white in Malevich's work. Rodchenko was interested in the physical properties of color, form, and spatial illusion. He experimented with texture, bringing together pictorial elements in a constructive, rather than a painterly, unity. —MC

195. ALEXANDER RODCHENKO (1891–1956)
Triptych: Pure Red Color, Pure Yellow Color, Pure Blue Color, 1921
Oil on canvas, three panels, 62.5 x 52.5 cm each
Private collection, Moscow
(plate 197)

Triptych: Pure Red Color, Pure Yellow Color, Pure Blue Color was Rodchenko's declaration of the end of painting. It marked the last point in his investigation of the traditional pictorial components of color and surface plane. The three monochrome panels self-consciously fuse these pictorial elements for the first time. In his manuscript "Working with Mayakovsky," written in 1939, Rodchenko explained this iconoclastic gesture by stating, "I reduced painting to its logical conclusion and exhibited three canvases: red, blue, and yellow. I affirmed: it's all over. Basic colors. Every plane is a plane and there is to be no representation." These were logical steps in the abandonment, by Rodchenko and a number of other artists on the Left, of the aestheticism of easel painting. These artists' subsequent engagement in Constructivist and Production art sought to bring "art into life," finding new art forms that would address the masses directly, actively shaping the new Soviet reality. —MC

196. OLGA ROZANOVA (1886–1918)
Non-Objective Composition (Suprematism), ca. 1916
Oil on canvas, 85 x 60.5 cm
State Russian Museum, St. Petersburg
(plate 200)

In her 1917 article "Cubism. Futurism. Suprematism," written for the journal *Supremus*, Rozanova stated that Suprematism abandoned real forms in painting because their conventionality stifled color. She believed Suprematism liberated color, allowing it to dictate expression directly through its inherent properties. Fittingly, Varvara Stepanova described Rozanova as a "painter of color" who understood the visible world through color. Indeed, Rozanova identified the painting method of her last years as *tsvetopis* (color painting). In *Non-Objective Composition (Suprematism)*, she eliminated all illusion of three-dimensionality and gave over all expression to large, highly saturated planes of color. She avoided lines and contours altogether, letting blank canvas show at the junctures between the planes. Rozanova applied paint very thinly, seeking to create a translucent effect in order to convey color's immateriality. Her work is a clear forerunner of Mark Rothko's Color Field paintings. —MC

195

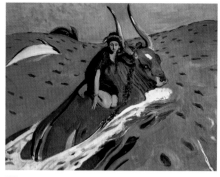

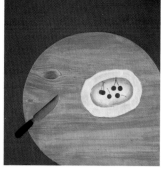

197

198

197. VALENTIN SEROV (1865–1911)
The Rape of Europa, 1910
Tempera on canvas, 71 x 98 cm
The State Tretyakov Gallery, Moscow

The style of *The Rape of Europa* exemplifies Serov's departure, in the last years of his life, from both realist and Impressionist painterly conventions. Instead, this work shows the artist's growing interest in Henri Matisse's use of color and the decorative stylization of Art Nouveau. Serov depicts a scene from an often-illustrated Greek myth, when Zeus, in the guise of a bull, abducts the Phoenician princess Europa and carries her on his back across the sea to Crete. Dolphins come to the surface to greet the god, and he turns his head to look at the young woman with tender eyes that betray his true nature. The abstracted, almost flat, expanse of the sea, with its stylized waves, and the uniform blue tone of the water and sky, create an atmosphere of serenity and harmony, while a patch of white paint around the bull's body gives the composition tension and dynamism. A final, larger version of this painting is now in a private collection in Moscow. —MC

198. DAVID SHTERENBERG (1881–1948)
Still Life with Cherries, 1919
Oil on canvas, 68 x 67 cm
State Russian Museum, St. Petersburg
(plate 206)

Shterenberg studied at the Ecole des Beaux-Arts in Paris between 1906 and 1912, establishing close ties with the painters Amedeo Modigliani and Chaim Soutine and the poet Guillaume Apollinaire. In 1917, he returned to Russia to head the Art Section of Narkompros, remaining in arts administration for the remainder of his career. In Russia he was known for his still lifes, of which *Still Life with Cherries* is a typical example. The painting creates a striking balance between naturalism and abstraction. The tabletop is shown from above, parallel to the picture plane. The table's wooden surface is depicted illusionistically, but its distorted right side completely fills the painting's bottom-right corner. The objects on the table—a knife, plate, and cherries—are lifelike and contrast sharply with the flat, gray background. Through such juxtapositions, Shterenberg's work acknowledges a modernist visual language without rejecting representation or illusionism. —MC

199. VLADIMIR STENBERG (1899–1982)
Spiral, 1920
Metal on wood base, h. 19 cm; base h. 8 cm
The State Tretyakov Gallery, Moscow
(plate 199)

Spiral is one of the earliest examples of Constructivist spatial constructions. Stenberg, his brother Georgi Stenberg, Karl Ioganson, Konstantin Medunteski, and Alexander Rodchenko became the founding members of the First Working Group of Constructivists, which was established in March 1921. The group abandoned easel painting as a bourgeois art form in favor of new, expedient technological forms that would be useful for the young Soviet society and would respond to the needs of the new collective viewers of art. Stenberg's *Spiral* illustrates the Constructivists' interest in industrial materials and their formative principles. In this work, Stenberg studied the development of line in three dimensions by positioning two curved pieces of metal in space and by tying them to a wooden pedestal, which itself forms an integral part of the piece. While undoubtedly in dialogue with Vladimir Tatlin's work with materials in his *Counter-Reliefs* and Rodchenko's spatial constructions, Stenberg clearly developed his own Constructivist trajectory. —MC

200. VLADIMIR TATLIN (1885–1953)
Counter-Relief (Material Selection), 1916
Wood, iron, and zinc, h. 100 cm
The State Tretyakov Gallery, Moscow
(plate 196)

Tatlin developed his *Counter-Reliefs* in order to demonstrate the effects that the inherent properties of materials—such as texture, surface, weight, and pliability—have on their expressive qualities. Initially inspired by Georges Braque's and Pablo Picasso's three-dimensional Cubist collages, which he may have seen firsthand in Picasso's studio in Paris in 1914, Tatlin progressed quickly, and by 1915 he had broken with representation and with two-dimensional support altogether. Collage, however, is only one basis of Tatlin's radically new artistic vocabulary. Its second component is the Russian avant-garde's long-standing preoccupation with *faktura* (texture), which it traced back to the wooden support of the icons. The third crucial element that made possible Tatlin's breakthrough into abstraction was his lifelong admiration for the *zaum* (transrational) poet Velimir Khlebnikov, who liberated the expressive content of language from the constraints of its conventional forms. —MC

201. NADEZHDA UDALTSOVA (1885–1961)
Restaurant Table, study for *Restaurant*, 1915
Oil on canvas, 71 x 53 cm
The State Tretyakov Gallery, Moscow
(plate 184)

A study for the painting *Restaurant* (1915, State Russian Museum), *Restaurant Table* is more elaborate and fresh than the final work. In 1912–13, together with Liubov Popova, Udaltsova studied in Paris with Henri Le Fauconnier and Jean Metzinger. Upon her return to Moscow, she worked in Vladimir Tatlin's studio and continued to perfect her command of the complex pictorial idiom of Cubism. In 1915, the year Udaltsova painted this work, Vladimir Tatlin emerged out of Cubism to create his *Counter-Reliefs* and Malevich showed his abstract Suprematist works. In contrast, Udalstova's painting remained firmly entrenched in a Cubist vocabulary of broken planes, suggestive fragments of form, and a highly reductive palette. The Latin rather than Cyrillic letters painted on the canvas refer to Parisian life and art, further confirming the artist's

199

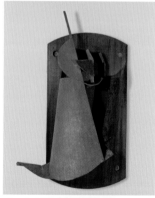

200

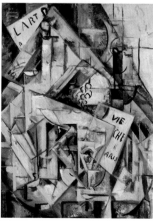

201

continued affiliation with the capital of Cubism. But in *Restaurant*, which incorporates a version of this study into its left-hand side, Udaltsova's style is closer to Russian Cubo-Futurism than to French Cubism. —MC

202. MIKHAIL VRUBEL (1856–1910)
Egyptian Woman, 1891
Majolica, h. 32.5 cm
The State Tretyakov Gallery, Moscow
(plate 140)

Egyptian Woman was produced by Vrubel during a stay on the estate of the wealthy industrialist Savva Mamontov, which was called Abramtsevo. Vrubel produced relatively few sculptures during his career, but most of them had a connection with Mamontov. In addition to *Robert and the Nuns* of 1896, a dynamic sculpture made for Mamontov's Moscow home, Vrubel worked on a series of small, ceramic works at Abramtsevo, in which he experimented with glazing in different colors and finishes. Mamontov facilitated the artist's work in this medium by building him a kiln and workshop on the estate. The sitter for *Egyptian Woman* was Mamontov's young daughter Vera (1875–1907), who was also the subject of Valentin Serov's masterwork *Girl with Peaches* of 1887. According to Aline Isdebsky-Pritchard, Vrubel dubbed this sculpture *The Secret*, as it was a representation of Vera whispering to her friend. It was one of two versions of this subject. In the one shown here, Vera wears a simple, knotted head covering and neck scarf, while in the other, she sports a wreath of flowers on her head. As he did in his paintings, Vrubel emphasized the figure's eyes, which almost seem to bulge out of the young girl's head. This treatment also serves to emphasize a resemblance between the sculpture and figures from ancient Egyptian art. —VH

203. MIKHAIL VRUBEL (1856–1910)
Portrait of Savva Mamontov, 1897
Oil on canvas, 187 x 142.5 cm
The State Tretyakov Gallery, Moscow
(plate 138)

Savva Mamontov (1841–1918) was a powerful Moscow industrialist who dedicated much of his time and money to the visual arts, theater, and music. Mamontov's Abramtsevo, an estate with an eighteenth-century house located on the outskirts of Moscow, served as an artists' colony from the 1870s to 1890s; besides Vrubel, the artists who stayed there include Victor Vasnetsov, Konstantin Korovin, Isaak Levitan, Mikhail Nesterov, Vasily Polenov, Ilya Repin, Valentin Serov, and Vasily Surikov. Vrubel's depiction of Mamontov, one of his most celebrated portraits, differs substantially from Repin's casual 1880 portrait, in which the industrialist leans on his arm and wears a slight grin and a peasant-style smock. Vrubel portrayed Mamontov as an imposing, powerful, wealthy man seated on a thronelike chair. The broad, loosely rendered, flat fields of color creating his proper black suit and white dress shirt demonstrate the artist's command of the reductive means of modernism. The reclining sculpture on the ledge above Mamontov echoes his pose and emphasizes his formality and rigidity. Its presence refers to both Mamontov's interest in sculpting—he briefly studied with Mark Antokolsky—and his personal commitment to the arts. The intensity of the eyes, characteristic of Vrubel's work, as well as the strong black of the suit, formally suggest a connection between Mamontov and one of the artist's signature "demons," which were inspired by Mikhail Lermontov's poem "The Demon" (1842). —VH

204. MIKHAIL VRUBEL (1856–1910)
Sea King, 1897–1900
Majolica, 52.3 x 40 cm
The State Tretyakov Gallery, Moscow
(plate 141)

205. MIKHAIL VRUBEL (1856–1910)
Mizgir, 1898
Majolica, h. 47 cm
The State Tretyakov Gallery, Moscow
(plate 142)

In the summer of 1899–1900, Vrubel began work on a series of ceramic sculptures based on two folk operas by the composer Nikolai Rimsky-Korsakov: *Snegurochka* (*Snow Maiden*, 1882) and *Sadko* (1898). This choice of subjects reflects Vrubel's enduring fascination with imaginative tales and folklore, and he created up to ten versions of his diminutive yet highly expressive figures. *Sea King* was a leading character in *Sadko*, a Novgorod *bylina* (a traditional epic poem), which tells the story of a poor minstrel named Sadko who bets Novgorod merchants that he can catch golden fish in Lake Ilmen (a northern lake noted for its fine pearls). A sea princess, Volkhova, helps him to complete this task, and he wins a fleet of ships. On a later trip, Sadko and his crew face a storm and decide to make a human sacrifice to the Sea King to obtain their safety; Sadko is chosen by lot. He impresses the Sea King by playing his *gusli*, an ancient Russian folk instrument similar to a harp, and a party ensues. Meanwhile, St. Nicholas intervenes to save the sailors from the tempest, orders Sadko home, and transforms Volkhova into the river Volkhov of Novgorod. Vrubel represented the highly abstract, threatening face of the Sea King in a series of both platters and sculptures as a convoluted mass, with deep-set, angry eyes, hair and beard composed of wavelike weeds and fishes, and a flat nose; in other words, far from human in form.

Mizgir is at the center of the tale of Snegurochka, the Snow Maiden, who was the daughter of King Winter and Fairy Spring, and was fated to die upon her first contact with the sun or upon falling in love. Snegurochka defied her parents and left her woodland home to live in a village among mortals. The songs of the shepherd Lel warmed her numb heart, and she fell in love with Mizgir, a Tatar merchant already engaged to someone else. Mizgir, represented by Vrubel in a confident pose, elegant, medieval dress, and beard, abandoned his fiancée for Snegurochka, and her mother bestowed upon her daughter the power to love. Upon proclaiming her love to Mizgir, the sun melted the Snow Maiden, and she drifted away into the heavens. —VH

206. MIKHAIL VRUBEL (1856–1910)
Portrait of N. I. Zabela-Vrubel, the Artist's Wife, in a Summer "Empire" Dress, 1898
Oil on canvas, 124 x 75.7 cm
The State Tretyakov Gallery, Moscow
(plate 139)

In 1896, Vrubel, then forty, married Nadezhda Zabela (1868–1913), twenty-eight. Zabela was a popular prima donna in Savva Mamontov's private opera, which was founded in 1885 following an 1883 decree that released ballet, theater, and opera from state control. Mamontov commandeered many luminaries for his opera, among them the singer Fedor Shalyapin and the composer Nikolai Rimsky-Korsakov, and he had the outstanding

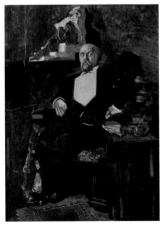

203

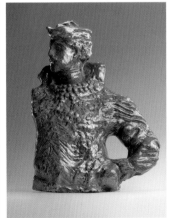

202

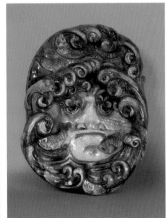

204

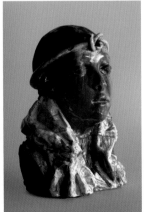

205

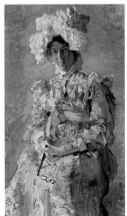

206

artists staying at his Abramtsevo estate design the sets and costumes for the productions. Vrubel painted numerous portraits of his wife, most of which portrayed her in theatrical guise, as, for example, his 1900 painting *Swan Princess*, in which he depicted her as the heroine of the Rimsky-Korsakov opera *Tsar Sultan*. In the highly decorative depiction shown here, Zabela-Vrubel wears a frilly, Empire-style dress designed by her husband and poses with a lorgnette that both refers to her own associations with theater and represents her as a lady of fashion. This is one of Vrubel's most Impressionist works, in terms of the light palette, loose brushwork, and overall *plein air* feel. This representation emphasizes the central place of artifice in his wife's life, as she constantly assumed new roles, both on the stage and in their personal life. The only section of the work that is painted with formal precision is the face, which seems to peak out of the flowerlike bonnet and dress that threaten to engulf the figure. —VH

207. MIKHAIL VRUBEL (1856–1910)
Lilacs, 1900
Oil on canvas, 160 x 177 cm
The State Tretyakov Gallery, Moscow
(plate 150)

From the beginning of his career, Vrubel painted studies of flowers and included them as vital elements of his larger works such as the 1890 painting *Seated Demon*, one of his signature compositions related to the theme of "demons" and inspired by Mikhail Lermontov's poem "The Demon" (1842). Also in 1890 he made an incredibly powerful sculpted head of a demon, now in the State Russian Museum, which is dominated by a mass of snaky black hair out of which peers a starkly white, frightened pair of intense eyes. The figure in *Lilacs*, often said to be the soul or spirit of the flowers that surround her, bears a striking resemblance to the sculpted demon. Engulfed by the natural world around her, she appears as a pale, tentative, otherworldly figure inhabiting the boundary between the real and imaginary, a subject that fascinated Vrubel. This girl did not appear in early studies for the work, which showed only lilacs, a fact that has led some to postulate that Vrubel had seen Claude Monet's *Lilacs at Argenteuil* of 1873 in the collection of Sergei Shchukin. Certainly the heavy impasto of the work suggests the influence of Vincent van Gogh, with whom Vrubel was sometimes compared, both for the singularity and expressionism of his work and because he ultimately died in an insane asylum. —VH

207

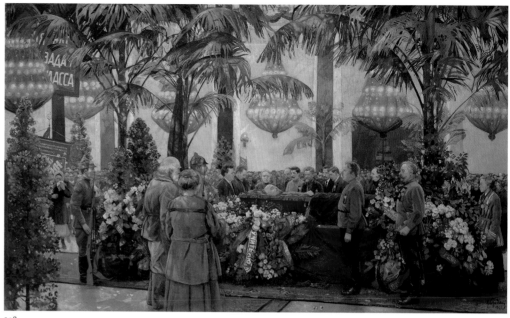

208

ART AND IDEOLOGY: LATE 1920S–1930S

208. ISAAK BRODSKY (1883–1939)
At the Coffin of the Leader, 1925
Oil on canvas, 124 x 208 cm
State Historical Museum, Moscow
(plate 215)

One of the leading painters of Socialist Realism, Brodsky studied under Ilya Repin at the Academy of Arts in St. Petersburg and painted in a traditional academic style throughout his life. In 1925 he became a member, and shortly thereafter the leader, of the Association of Artists of Revolutionary Russia (AKhRR), an organization that advocated traditional realist style and remained the main opponent of the avant-garde throughout the twenties and early thirties. Brodsky's specialty was portraits of revolutionary leaders in staged, often pseudo-historical settings that served to impose upon the masses a particular version of Soviet revolutionary history. *At the Coffin of the Leader* shows Vladimir Lenin's funeral in a conventional theatrical setting, with his wife Nadezhda Krupskaia and potential successors standing closest to the coffin. The viewer is positioned as an onlooker, and is invited to identify with one of the older peasants witnessing the scene from the foreground. —MC

209. ISAAK BRODSKY (1883–1939)
V. I. Lenin in the Smolny, 1930
Oil on canvas, 198 x 320 cm
State Historical Museum, Moscow
(plate 214)

The first well-known portrait of Vladimir Ilyich Lenin (1870–1924), *V. I. Lenin in the Smolny* shows the leader at the Smolny Institute for Young Ladies of the Nobility, from which he directed the revolutionary uprising. Brodsky based the figure of Lenin on a photograph, as he often did, and carefully staged the highly narrative setting:

a second empty chair conveys the democratic nature of Lenin and of the revolution itself, inviting the viewer to join the leader. The photographic realism of the image made it into a historical document, a fake one of course, but one that was nonetheless highly credible and popular. This painting, like many later works of Socialist Realism, was widely disseminated both through official institutional channels and by the artist himself, who signed numerous copies made by his collaborators. Although often considered the first Socialist Realist work, this painting was made before the term was put into circulation or defined in visual terms with any precision. —MC

210. ALEXANDER DEINEKA (1899–1969)
Defense of Petrograd, 1927
Oil on canvas, 210 x 238 cm
Central Museum of the Armed Forces, Moscow
(plate 213)

One of the most successful paintings of Deineka's entire career, *Defense of Petrograd* depicts the resolve of the city's workers to defend Bolshevik power during the first postrevolutionary years. After completing his studies at VKhUTEMAS (Higher State Artistic and Technical Workshops), Deineka worked for years as a graphic artist. The strength of his painterly style lies precisely in its

209

laconicism and graphic quality. The most expressive aspect of this painting is its rhythmic composition, an effect created by the extreme reduction of details, the repetition of poses, and the determined linearity of the workers' profiles. The solid linear structure of the bridge further underscores the psychological commitment of the figures. It also divides the composition into two distinct parts, assuring its circularity: the slow progress of the wounded soldiers above turns into the confident energetic march of the figures below, whose movement reads from left to right and seems to continue beyond the boundaries of the frame. —MC

211. ALEXANDER DEINEKA (1899–1969)
Collective Farm Worker on a Bicycle, 1935
Oil on canvas, 120 x 220 cm
State Russian Museum, St. Petersburg
(plate 222)

In 1935 Deineka traveled to France, Italy, and the United States to gather material for his work. At the end of the same year he had a solo show in Moscow that included more than a hundred works. Along with numerous paintings and sketches of Western life, he also showed this depiction of the Soviet version of modernity. *Collective Farm Worker on a Bicycle*, hailed by critics of the day as a successful example of Socialist Realism, is strikingly modernist in style, with its large flattened areas of bright colors and a picture plane that is strongly tilted forward. A truck visible in the background and the shiny bicycle—still rare commodities in the Soviet countryside—would easily have been read by contemporaries as desired symbols of modernity. The bright-red dress of the peasant woman and her elegant white shoes portray her as a prosperous and emancipated citizen. Although hardly compatible with contemporary Soviet reality, this painting represents a sincerely positive vision of Socialist achievements. —MC

212. ALEXANDER DEINEKA (1899–1969)
Future Pilots, 1938
Oil on canvas, 131.5 x 160 cm
The State Tretyakov Gallery, Moscow
(plate 218)

After Valery Chkalov's famous nonstop flights across Russia in 1936 and to the United States via the North Pole in 1937, enthusiasm for flight in the Soviet Union became synonymous with pride for the country's Socialist

achievements. Soviet boys dreamed of becoming pilots, just as, in the sixties, they would dream of becoming cosmonauts. Deineka records this fundamental social reality by depicting an airplane hovering above the expanse of sea that opens in front of three young boys. He painted *Future Pilots* on the shores of the Black Sea in Sevastopol. Deineka's strong predilection for the nude male body, young or adult, has clear sexual overtones in a number of his paintings. The subject of sexuality, however, was taboo in Soviet public life. In 1938 Deineka also created a series of mosaics on the subject of flight for the ceiling of the Mayakovskaia subway station in Moscow. —MC

213. VASILY EFANOV (1900–1978)
An Unforgettable Meeting, 1936–37
Oil on canvas, 270 x 393.5 cm
The State Tretyakov Gallery, Moscow
(plate 219)

As of 1934 Joseph Stalin began to be depicted as a warm, paternalistic figure who cared about ordinary Soviet people. The Stalin cult also stressed and inculcated the idea of the citizens' own immense love and appreciation for the leader, the Communist Party, and the state. To strengthen that bond, in the mid-thirties a series of highly publicized meetings were held, in which Stalin and other Party leaders met with exemplary workers and peasants. Efanov's *An Unforgettable Meeting* depicts one such occasion, at which Stalin honors a female worker at a reception in the Kremlin, praising her for her hard work and social activism. Flowers at the edge of the table extend warmth and hospitality to the viewer and the gigantic size of the canvas magnifies the intensity of emotion. Stalin is here shown acting with the unanimous support of the main Party leaders and of Vladimir Lenin's widow Nadezhda Krupskaia; together they legitimize his authority. —MC

214. SERGEI GERASIMOV (1885–1964)
A Collective Farm Festival, 1937
Oil on canvas, 234.5 x 372 cm
The State Tretyakov Gallery, Moscow
(plate 223)

A paradigm of Socialist Realism of the late thirties, *A Collective Farm Festival* celebrates the advent of the bright Socialist future in the Soviet countryside. Painted for the All-Union Agricultural Exhibition, it depicts a peasant holiday celebration on a sunny summer day. Figures are arranged in a theatrical manner against the backdrop of an

212

213

214

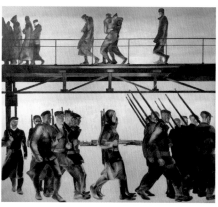
210

211

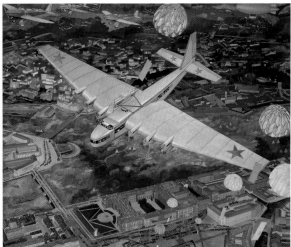

215 216

State Russian Museum, St. Petersburg
(plate 212)

Labas was a member of the Society of Easel Painters (OST), whose artistic program included the creation of a painterly style that would adequately reflect the Soviet Union's rapid industrialization. In *The Train Is Coming* the approaching train that cuts swiftly through the brownish cityscape is an iconic sign of the machine's power. Yet the color scheme chosen by the artist also suggests a disturbing aspect of this enthusiasm for the machine: the pitch-black train cuts through a gray and brown landscape under a blue sky, which, strangely, does not add any brightness to the city. The work's composition and its ambivalence toward technology are reminiscent of J. M. W. Turner's *Rain, Steam and Speed—The Great Western Railway* (1844, National Gallery, London). —MC

218. SARAH LEBEDEVA (1892–1967)
Portrait of Valery Chkalov, 1936
Bronze, h. 36 cm
The State Tretyakov Gallery, Moscow
(plate 217)

Valery Chkalov (1904–1938) was a legendary Soviet test pilot who tested more than seventy new types of airplanes and invented several figures of aerobatics. In 1936 he was given the country's highest award—Hero of Soviet Union—for the longest nonstop flight between Moscow and Petropavlovsk Kamchatsky in the Russian Far East. He was Joseph Stalin's personal favorite and the hero of all Soviet boys. In 1937 Chkalov became world famous when he completed the first nonstop flight from Moscow to Vancouver by way of the North Pole, covering a distance of 8,504 kilometers (5,284 miles). The circumstances of his sudden death in 1938, ostensibly during an unsuccessful landing, are still not fully understood. Lebedeva's expressive sculpture not only bears a close resemblance to the pilot but also conveys an overall impression of a courageous and determined man. In 1958 Lebedeva was awarded the silver medal for this sculpture at the International Exhibition in Brussels. —MC

idyllic landscape that bears signs of modernity: a bicycle, still a rare commodity in Soviet villages at the time, and a high-voltage tower in the background. A former student of Konstantin Korovin, Gerasimov painted in a broadly impressionistic style, which was well within the visual canon of Socialist Realism of the late thirties. Despite its crude technique, the painting proved highly popular and influential and was even awarded a silver medal at the 1937 Exposition Universelle in Paris. In the same year Gerasimov was given the prestigious title of Distinguished Art Worker of the Russian Federation. —MC

215. PAVEL KORIN (1892–1967)
Three, 1933–35
Oil on canvas, 190 x 110 cm
The State Tretyakov Gallery, House-Museum of
Pavel Korin, Moscow
(plate 225)

Trained as an icon painter, Korin was inspired to work on a monumental scale by his experience of painting the interior of the Church of Intercession of the Virgin in Moscow. Despite the Soviet atheism of the twenties and thirties, Korin continued to depict religious subjects, working under the direct patronage of the influential painter Mikhail Nesterov and the well-known writer Maxim Gorky. *Three* is one of thirty-three preparatory works produced by the artist for his unfinished magnum opus *Requiem: Farewell to Russia* (1926–59). It is a tribute to three generations of female spirituality, showing an old but authoritative Mother Superior in the center, a middle-aged, reserved-looking nun on the right, and a younger, passionate-looking nun on the left, whose refined hands betray her aristocratic background. Dressed entirely in an ascetic black, the figures are monumentalized with a close-up and lowered viewpoint. This painting represents quite a contrast to the typically cheerful works of the official Soviet art of the period. —MC

216. VASILY KUPTSOV (1899–1935)
ANT-20 "Maxim Gorky", 1934
Oil on canvas, 110 x 121 cm

State Russian Museum, St. Petersburg
(plate 216)

In 1934, the Soviet aircraft designer Andrei Tupolev built the ANT-20, a single-unit Soviet demonstration plane, which was named the "Maxim Gorky" in honor of the fortieth anniversary of the Russian writer's first literary work. At the time of its production, the plane was the biggest in the world: it had eight engines, weighed forty-two tons, and could transport up to eighty-eight people. Unfortunately, the life of this miracle of Soviet engineering was very short: on May 18, 1935, it crashed after an impact with an accompanying fighter plane. *ANT-20 "Maxim Gorky"* is an exalted celebration of flight in its different forms: in addition to the Maxim Gorky, three more planes and a dirigible are visible in the sky, along with numerous parachutists, who are about to land in the historical center of St. Petersburg, which is visible in detail below. This geographical setting betrays the artist's fantasy, as the ANT-20 flew only above Moscow. —MC

217. ALEXANDER LABAS (1900–1983)
The Train Is Coming, 1929
Oil on canvas, 98.3 x 75.8 cm

219. SERGEI LUCHISHKIN (1902–1898)
The Balloon Flew Away, 1926

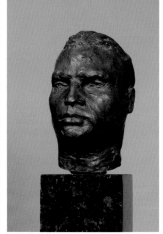

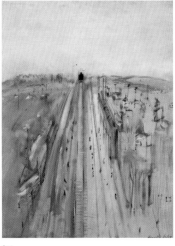

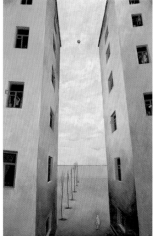

217 218 219

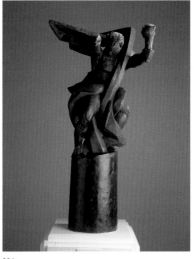

220

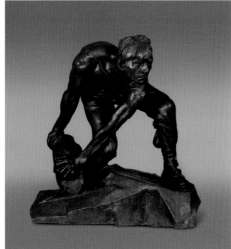

223

Oil on canvas, 106 x 69 cm
The State Tretyakov Gallery, Moscow
(plate 211)

The Balloon Flew Away is Luchishkin's best-known work. It combines an elegiac dreaminess with a rather grim perspective. The pictorial space is claustrophobic, sandwiched between two apartment buildings and a tall fence behind. The main protagonist in this almost deserted scene is a little girl in a bright blue dress watching her red balloon disappear into the sky. The psychological impact of the image is enhanced by the use of what Luchishkin called "spherical perspective," one that makes the spectator's viewpoint coincide roughly with that of the girl. Upon closer inspection, a few additional figures are visible in the windows: two are preoccupied with the window frames, one is peering out, and one is seen hanging, dead, from the ceiling. Such bleak depictions of Soviet life were not unusual in Luchishkin's work of the twenties: he had also exhibited a painting, later destroyed, that showed the starvation of peasants in the Volga region. —MC

220. VERA MUKHINA (1889–1953)
The Flame of Revolution, 1922–23
Bronze, h. 104 cm
The State Tretyakov Gallery, Moscow
(plate 208)

Best known for her monumental *Worker and Collective Farm Woman*, which was shown at the International Exposition in Paris in 1937, Mukhina, like most ambitious Russian artists, was initially interested in French modernism. Between 1912 and 1914, she studied in Paris with Antoine Bourdelle, Henri Le Fauconnier, and Jean Metzinger, and was well acquainted with such modernist sculptors as Jacques Lipchitz and Ossip Zadkine. *The Flame of Revolution* is a project for an unrealized monument to the revolutionary Yakov Sverdlov that was to stand on the Moscow square bearing his name. Mukhina's original conception is based on the legendary Greek Stymphalides (birds with female heads), which she subsequently turned into a winged female figure that personifies the sweeping forces of the revolution. The forward movement of the figure, which is expressed by its pose

and the rendering of its fabric, is further underscored by the diagonally cut pedestal. —MC

221. YURI PIMENOV (1903–1977)
New Moscow, 1937
Oil on canvas, 139.5 x 171 cm
The State Tretyakov Gallery, Moscow
(plate 221)

Pimenov's *New Moscow* is a hymn to the reconstructed city center and to the liberated Soviet woman. He puts the viewer on the back seat of a luxury convertible car driven by a woman with a modern short haircut (still considered daring at the time) along one of the central streets of Moscow. The edge of Sverdlov (now, Theater) Square appears on the right of the image, and the House of Unions with red flags on its facade and the tall gray building of the Supreme Soviet stand along the right side of the road. The impressionistic quality of the brushwork and the shimmering colors give the painting lightness and elegance. This depiction of the city just after a summer rain, with transparent air and clean streets, creates an overall effect of freshness and renewal, which the artist intends his viewers to read on both a literal and a metaphorical level. —MC

222. KLIMENT REDKO (1897–1956)
Uprising, 1924–25
Oil on canvas, 170.5 x 212 cm
The State Tretyakov Gallery, Moscow
(plate 207)

Redko began his artistic education in the icon-painting school of the Kievo-Pecherskaya Lavra in Kiev (1910–1914) and completed it at the VKhUTEMAS (Higher State Artistic and Technical Workshops) in Moscow (1920–1922), the center of radical artistic experimentation at that time. In the early twenties, Redko developed a style he called "electro-organism" and later "luminism" that reflected his fascination with technology and science and his idea that light was "the highest expression of matter." *Uprising* was painted soon after Vladimir Lenin's death. This striking work combines Redko's interest in the expressive qualities of light and

abstracted geometric form and his growing involvement with representation. An intense radiance spreads outward from the figure of Lenin toward his Communist Party comrades and onto the Red Army soldiers who fill the streets of revolutionary Petrograd. Although the figures are depicted naturalistically, the space of the painting is radically flattened and the city is abstracted into a uniform repetitive grid. —MC

223. IVAN SHADR (1887–1941)
Cobblestone—Weapon of the Proletariat, 1927
Bronze, h. 125 cm
The State Tretyakov Gallery, Moscow
(plate 209)

Shadr received an extensive education, first at the Art School in Ekaterinburg (1901-06), then in Paris with Auguste Rodin and Antoine Bourdelle (1910–11), and finally in Rome (1911–12). After the revolution of 1917, he made a number of statues of workers and peasants as well as monuments to Communist leaders, including Karl Marx, Karl Libknekht, and Vladimir Lenin. In 1924 Shadr was given the honor to make a death cast of Lenin's face. *Cobblestone—Weapon of the Proletariat* is an impressive example of realist sculpture, which successfully renders the tension of the man's body, his dynamic pose, and his determined facial expression. Further expressiveness is achieved by the contrast between the rough surfaces of the stone base and the stone the worker is about to lift, and the smooth surface of his body. In 1926 Shadr traveled extensively in Europe, especially in Italy where Michelangelo's *Slaves*, in particular, may have inspired him. —MC

221

222

224

OFFICIAL AND UNOFFICIAL: 1940S–1980S

224. GRISHA BRUSKIN (b. 1945)
Boy with a Small Flag (from the *Birth of the Hero* series), 1990
Stainless steel, 142.2 x 83.8 x 40.6 cm
Courtesy Marlborough Gallery, New York
(plate 245)

Bruskin graduated from the Department of Decorative and Applied Arts at the Moscow Textile Institute in 1968. In the late 1970s and early 1980s, he initiated work on two major painting series, *The Fundamental Lexicon* and *Alefbet*, in which he divided the canvases into grids, each cell of which contained a figure and text. The former series is centered on the Soviet system of signs and contains what appear to be official plaster sculptures carrying a signature object, while the latter consists of supernatural figures based on Bruskin's own interpretation of themes in the Torah and Kabbalah and intended to give visual form to the symbolism in these texts. *Boy with a Small Flag* is related to *The Fundamental Lexicon*. In his childhood, Bruskin repeatedly encountered plaster sculptures of the heroes of Soviet ideology in parks, on buildings, and in public squares. These prototypical figures, among them athletes, war heroes, and young pioneers, functioned in much the same way as heroic sculptures from antiquity and the Renaissance. As the artist has noted, these mythic figures of the Soviet pseudo-religion "were telling us: 'Be like us.' . . . They were Gods." For him, these sculptures underscored his difference from this ideal, and they represented a particular brand of Soviet kitsch distinct from high art. In the eighties he made a series called *Birth of the Hero* that consisted of fifteen small figurines in bronze with a white patina. Some evoked the stock figures of

Soviet art and held an object or sign in one of their hands; others were derived from Judeo-Christian myth. He later produced a series of twelve related life-size and over-life-size figures in stainless steel. *Boy with a Small Flag* belongs to this series and is both a generic figure of a Young Pioneer (similar to the Boy Scouts) holding a flag reading *"Troop 10"* and a self-portrait of the artist. The flowerbed invokes their mode of display in the Soviet Union; it is meant to symbolize the Soviet Paradise, itself a mythic construct. Bruskin therefore transported the image from his childhood and the Soviet cultural referent into the realm of high art, to him "the empyrean of another Paradise."—VH

225. ERIK BULATOV (b. 1933)
Krasikov Street, 1977
Oil on canvas, 150 x 198.5 cm
Jane Voorhees Zimmerli Art Museum, Rutgers, The State University of New Jersey, New Brunswick, The Norton and Nancy Dodge Collection of Nonconformist Art from the Soviet Union
(plate 239)

Bulatov studied at the Surikov Institute of Art in Moscow in the 1950s. In the mid-sixties he and other members of his circle of artist friends, which included Ilya Kabakov and Oleg Vassiliev, became acquainted with the early-twentieth-century avant-garde artist Robert Falk and the graphic artist and painter Vladimir Favorsky. They introduced the younger generation to ideas and approaches distinct from the more rigid official style of art known as Socialist Realism. Bulatov has noted that despite the fact that urban and suburban landscapes were dominated by slogans, portraits, and posters, Soviet artists rarely depicted these visual expressions of political clichés and ideology in Socialist Realist paintings. He took a keen interest in painting the social space of his immediate environment, as for example in *Krasikov Street*, which shows a Moscow street inhabited by a handful of people walking on a side-walk and a smattering of cars and buses moving along the street itself. A huge white billboard set on a strip of grass depicts Lenin confidently striding forward into an inde-terminate space. His pose echoes that of the Soviet pedes-trians, who pay no attention to the monumental figure of Lenin that dominates their surroundings and, indeed, seems to dwarf both the trees and apartment buildings in the distance. Like American billboards advertising prod-ucts for sale, Soviet propaganda images were omnipresent and consequently they often blended into the landscape, becoming virtually invisible to their intended audience. Bulatov forces the viewer to perceive what the people in the painting do not, namely the public expression of Soviet ideology. At the same time, in representing the three women in distinctive dresses, he underscores the fact that, even within a Communist state, there was some room for personal expression. —VH

226. IVAN CHUIKOV (b. 1935)
Window No. 13, 1979
Enamel on wood, 113.5 x 106 cm
Jane Voorhees Zimmerli Art Museum, Rutgers, The State University of New Jersey, New Brunswick, The Norton and Nancy Dodge Collection of Nonconformist Art from the Soviet Union

Like Ilya Kabakov and Erik Bulatov, Chuikov studied art at the Surikov Institute of Art in Moscow in the 1950s. In the mid-seventies, he served as an important source of information on international contemporary art by trans-lating and reading aloud articles— from such leading Western art magazines as *Flash Art*, *Studio International*, and *Artforum*—to friends, including Valeriy Gerlovin, Rimma Gerlovina, Vitaly Komar, Alexander Melamid, and Leonid Sokov. By the late sixties he began a signature conceptual series centered on the form of the window. With this body of work, Chuikov interrogated and deconstructed the tra-ditional definition of painting as a window onto the world or a faithful representation of reality. This was an especially relevant issue in relation to Socialist Realism, which demanded the use of a realistic style and prioritized paint-ing. Chuikov's windows, painted on wooden surfaces, materially reveal their status as objects, and the three-dimensional grids on the surface visually evoke an actual window. In using enamel paint, Chuikov rendered the sur-faces glossy, yet opaque. The forms painted on these pan-els—typically clouds and trees—consequently appear abstract and schematic. In *Windows No. 13* the extremely flat image of a landscape lacks perspective; it is unclear if it is located inside or outside the window. The artist's win-dows exist in a state between painting and sculpture, illu-sion and mimesis, and abstraction and representation. This conceptual limbo firmly challenged the definition of painting as a window onto reality, especially as defined by Soviet ideology and Socialist Realism. —VH

227. ALEXANDER DEINEKA (1899–1969)
Defense of Sevastopol, 1942
Oil on canvas, 200 x 400 cm
State Russian Museum, St. Petersburg
(plate 224)

During the Great Patriotic War (as World War II is known in the Soviet Union) Deineka, exempted from the draft so that he could continue painting, first worked in Moscow

225

227

226

when the Germans came dangerously close in 1941, and later made trips to frontlines in the south. In 1942 he saw a photograph of Sevastopol, his favorite port city in the Crimea where he had often worked, almost completely destroyed by German bombing raids, and decided to create an imaginary record of battles in that city. Deineka claimed that he lived through the events while working on *Defense of Sevastopol*, which, although not as pictorially accomplished as many of his earlier works, is nevertheless a powerful expression of the intensity and tragedy of war. The same riverbanks on which youths dreamed of flight in the artist's early paintings, are now seen encircled by red flames and scattered with dead bodies. —MC

228. RIMMA GERLOVINA (b. 1951) and
VALERIY GERLOVIN (b. 1945)
Stones, 1977
Stones, cardboard, fabric, and sixty-two cards with Russian and English text, 24.8 x 16.5 x 9.5 cm
International Foundation of Russian and Eastern European Art (IntArt), New York

Gerlovina graduated in 1973 from Moscow State University, where she studied literature and philosophy, and Gerlovin graduated in 1967 from the Art Studio of the Moscow Art Theater. In 1971, they began working together on a collaborative body of conceptual work that includes performance, photography, poetry, books, and objects. In 1974, Gerlovina produced a series of cubes made of fabric and paper with texts consisting of statements and poetic lines; for example, "Imagine this white cube in a red sphere" and "Don't open it or it will fly away." The placement of instructional, imaginative, and provocative statements within these playful boxes constituted a truly innovative aesthetic in the Soviet Union at that time. While it seems related to Fluxus projects of the sixties, the Gerlovins were totally unaware of that international group until 1979. The Gerlovins played a leading role in producing a unique form of the artist's book, which did not take aesthetics as its primary goal and was part of a trend called *samizdat* or self-published books. As the artists themselves have noted, these books served as "portable objects of mass reproduction" that circumvented official censorship and delivered intense messages about creative problems and values. The unique copies of these books passed from person to person, and became the subject of discussion and reflection among artists and intellectuals. *Stones* is related to the Gerlovins' other language-based pieces and consists of a box of 160 stones and sixty-two cards with text on two sides, one in Russian and the other in English. They selected stones because they are "the most enduring item in nature," and they gave each stone its own story, sometimes linked to that of other stones: "#85 twin of #86; #124 is lost without further notice." By disrupting the expected, they seek to encourage thinking from another point of view. The humor, even absurdity, of some of the statements effectively delivers the artists' often metaphysical messages to the spectator. In 1977, the same year this work was made, the Gerlovins produced some of the most pioneering performance art in the Soviet Union. Photographic documentation of these pieces and other works smuggled out of the country were shown at the Eastern European Biennale in Venice in 1977. The Gerlovins immigrated to the United States in 1980. —VH

229. FRANCISCO INFANTE-ARANA (b. 1943)
Regularity D (from the *Projects for the Reconstruction of the Firmament* series), 1965–67
Tempera, gouache, and casein on paper, 50 x 32 cm
Collection of the artist

230. FRANCISCO INFANTE-ARANA (b. 1943)
Wave (from the *Projects for the Reconstruction of the Firmament* series), 1965–67
Tempera, gouache, and casein on paper, 50 x 32.2 cm
Collection of the artist

231. FRANCISCO INFANTE-ARANA (b. 1943)
Star (from the *Projects for the Reconstruction of the Firmament* series), 1965–67
Tempera, gouache, and casein on paper, 50 x 32.1 cm
Collection of the artist

Infante-Arana was born to a Russian mother and a Spanish father who fled Spain in 1936 during the Civil War. He attended high school at the Surikov Art Institute in Moscow, and in 1962 he graduated from the Moscow College of Decorative and Applied Arts. In the early sixties, he met both Lev Nusberg and Nonna Goriunova, his wife and artistic partner to this day. In 1962, Nusberg, Infante, and three other young artists founded the artists' group known as Dvizhenie (Movement). The group continued in the Russian avant-garde tradition of Constructivism by producing kinetic art, a mode being explored across Europe in the sixties. In their environments, performances, and objects, the group's members investigated the relationship between art and technology. While part of the Movement group, Infante-Arana also developed his independent work, which focused on the notion of infinity and the form of the spiral. He avidly studied mathematical forms and philosophical concepts and was influenced by such artists as Alexander Calder, Nicolas Schöffer, Robert Smithson, and Victor Vasarely. Taking both nature and geometry as points of departure, in 1965 he began to produce *Projects for the Reconstruction of the Firmament*, a series of sixty works in which he devised a conceptual arrangement of the stars as a geometric system or a reconstruction of the heavens; three panels from this series are seen in the exhibition. Infante-Arana has admitted that his visual schemas are analogous to other "sky-interpretation systems" such as the zodiac, as well as to the reconstructive spirit of Constructivism. But he considers that his work embodies an element of the absurd and is not meant as a "pictorial representation of a new stellar distribution"; in this sense, it is less strictly utopian than the visions of the historic Russian avant-garde. —VH

232. VIKTOR IVANOV (b. 1931)
In the Café Greco, 1974
Oil on canvas, 185 x 205 cm
The State Tretyakov Gallery, Moscow
(plate 234)

Ivanov studied at the Surikov Institute of Art in Moscow in the late forties, and he received his diploma with a painting titled *Stalin, Educator of Military Leaders*. Following Joseph Stalin's death in 1953, Ivanov and other

228

229

230

231

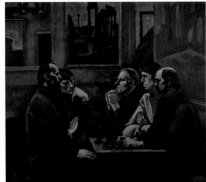

232

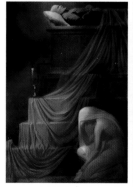

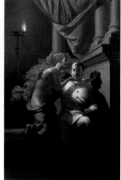

artists of his generation continued to work officially and in a realist style, but they began to explore more personal themes rather than the repetitive stock subjects of Socialist Realism under Stalin. "Severe Style" is a term often applied to their work, which lacked the extreme optimism of Soviet art of the thirties, and was characterized by both a simplified style and a certain monumentality. Ivanov was drawn to social subjects with tragic undertones, and he considered the Wanderers of the nineteenth century, and Vasily Surikov in particular, to be important influences. This is evident in the painting *A Family in 1945* (1958–64), which was criticized for presenting an overly pessimistic picture of postwar life as embodied by a family seated around a dinner table. *In the Café Greco* reflects a trend in Soviet art of the early seventies that Ivanov himself identified, namely "an interest of the artist in his own persona." Ivanov painted himself and four fellow artists sitting at a table in the Café Greco in Rome—from left to right are Gelii Korzhev, Petr Ossovski, Efrem Zverkov, and Dmitry Zhilinsky, with Ivanov himself shown clutching a wine glass. These five were among the most accomplished artists of their generation. This painting testifies to their status, as they had the rare opportunity to travel outside the Soviet Union to Italy on a study trip arranged by the Union of Artists. Many of them looked to Italy for artistic inspiration; Zhilinsky, for example, was influenced by Italian Renaissance art, while Ivanov admired the work of the realist painter Renato Guttoso, who had come to Russia in the fifties. The café itself played a significant role in Russian art history and therefore provided a tangible link for these artists to Russian artists and writers of the nineteenth century who had used the café as a gathering place; among them were the painters Karl Briullov and Alexander Ivanov as well as the writer Nikolai Gogol, who is said to have worked on his 1842 novel *Dead Souls* there. This painting thus depicts a modern-day circle of artists simultaneously reflecting on the past, as represented by the ancient ruins visible through the window and the paintings hanging on the walls, and contemplatively pondering the present. —VH

233. ILYA KABAKOV (b. 1933)
Answers of the Experimental Group, 1970–71
Enamel on fiberboard, 147 x 376 cm
The State Tretyakov Gallery, Moscow
(plate 237)

Kabakov graduated in 1957 from the Surikov Art Institute in Moscow. Along with his friends Erik Bulatov and Oleg Vassiliev, he met the early twentieth-century avant-garde artist Robert Falk and the graphic artist and painter Vladimir Favorsky, both of whom exposed him to new ways of thinking about art. Kabakov's profession as an illustrator of children's books helped him to refine the combination of word and image that would become a defining aspect of his work. In contrast to many of his contemporaries, who referenced official art, he focused on the everyday life of the Soviet citizen. Kabakov has noted that he finds words necessary to explain fully his ideas, attributing this in part to the discussions among his friends concerning the connection of various objects to reality. The ensuing explanations, comments, and dialogues assumed equal importance to the object under consideration. Already in 1969, Kabakov began to articulate the concept of *Answers of the Experimental Group* in a drawing in which written identifications are shown together with a schematic representation of a house. In his subsequent paintings diagrammatic imagery is either absent altogether, as with the one exhibited here, or replaced by an actual three-dimensional object such as a coat hangar. Kabakov utilized the gridlike structure and formal strategies of signboards and standardized charts and chose colors derived from those used in official or public places, including the communal apartments typical of the Soviet Union. The text of *Answers of the Experimental Group* consists of statements attributed to fifty-two specific names, which nonetheless have an anonymous, generic, open-ended character; for example "Lidia Samokhvalova: He usually comes on holidays." Through this and related works, Kabakov underscored the rote sterility of public speech in the daily life of the Soviet citizen. —VH

234. VITALY KOMAR (b. 1943) and ALEXANDER MELAMID (b. 1945)
Lenin Lived, Lenin Lives, Lenin Will Live (from the *Nostalgic Socialist Realism series*), 1981–82
Oil on canvas, 183 x 148 cm
Collection of Jörn Donner, Helsinki
(plate 241)

Komar and Melamid both graduated from the Stroganov Institute of Art and Design in 1967. In 1972, they invented the term "Sots Art," a linguistic merger of Socialist Realism and Pop art. Their collectively produced paintings, installations, and photographic works combined the visual vocabulary of Soviet propaganda and mass culture with visual strategies culled from Socialist Realism. The resulting art ironically commented upon and critiqued official culture. In 1976, while still living in Russia, Komar and Melamid had their first show at Ronald Feldman Fine Arts in New York, and in 1978, they immigrated to New York. By the early eighties, they had developed a nostalgic attitude toward their childhoods and the Soviet culture that had once dominated their daily existence. The result was their *Nostalgic Socialist Realism* series (ca. 1980–84), more than two dozen paintings in which they reconstructed and parodied some of the central myths and ideological messages of the Soviet Union. The title of *Lenin Lived, Lenin Lives, Lenin Will Live* is taken from a slogan by the poet Vladimir Mayakovsky, which proclaimed that despite the fact that Vladimir Lenin died in 1924, he continued to exert a vital presence and legacy. This notion was quite literally embodied by the Lenin Mausoleum on Red Square, where his embalmed body remains on display to this day. *Lenin Lived, Lenin Lives, Lenin Will Live* depicts Lenin's lifeless corpse atop a podium that is connected to a pump containing liquid—an allusion to the mysterious, miraculous substance that sustains his body. Lenin's ghostly face is illuminated by a bright light, and the pillow underneath his head acts as a halo, thereby referring to his status as a Communist icon or deity, both in life and death. The intense red drapery falls in a pattern that evokes the shape of the Mausoleum itself, which served as a platform for the party leadership during ritualistic celebrations of Soviet power held on Red Square. The kneeling, mourning female figure in the lower right calls to mind female allegorical figures from throughout art history, in particular Evgeny Vucetich's 1967 sculpture *Sorrows of the Motherland* located on the Plaza of Grief at the war-memorial complex of Stalingrad (now Volgograd). Thus she stands for the nation's sorrow at Lenin's death, as well as its worship at his tomb. At the same time, her nudity literally strips bare the grotesqueness of Lenin as a relic, as well as the failure of the Communist project. —VH

235. VITALY KOMAR (b. 1943) and ALEXANDER MELAMID (b. 1945)
The Origins of Socialist Realism (from the *Nostalgic Socialist Realism series*), 1983
Oil on canvas, 183.5 x 122 cm
Jane Voorhees Zimmerli Art Museum, Rutgers, The State University of New Jersey, New Brunswick, The Norton and Nancy Dodge Collection of Nonconformist Art from the Soviet Union

234 235

236 237 238

The Origins of Socialist Realism, from Komar and Melamid's 1980–84 series Nostalgic Socialist Realism, depicts Joseph Stalin seated in a candlelit space, holding a pipe in his left hand, and resting his right hand on the back of a semi-nude female figure. The woman gently cups Stalin's chin in one hand as she traces his shadow with the other. Stalin and the woman are located on a bench adjacent to a massive stone base topped with three stone columns and a billowing red curtain. The theatricality and artifice of the image suit the painting's subject, namely the origin of the official style of painting in the Soviet Union beginning in the 1930s. The principle iconography comes from Pliny the Elder, who recounted the legend of the Corinthian maid Dibutade outlining the profile of her lover. Joseph Wright of Derby painted this tale in 1783–84, as did the Scottish artist David Allan, whose 1775 portrayal includes an oil lamp uncannily close to the one in Komar and Melamid's picture. The woman's bold, red hair invokes both Mary Magdalene and the femme fatales of paintings by Edvard Munch and the Pre-Raphaelites. She imparts a sexual charge to the work, which is undercut by Stalin's seeming lack of interest in her, and also serves as an allegorical figure, representing Socialist Realism and the strivings of Soviet artists to capture the image of the very leader who imposed that official style. In an ironic twist, the image of Stalin's shadow lacks Socialist Realism's crisp precision and idealization. The low, flickering light slyly suggests that Soviet art under Stalin was anything but illuminating. —VH

sented by Velimir Khlebnikov, who experimented with neologisms and identified significance in the shape and sounds of letters. Like many of her contemporaries, she also took an interest in the work of the literary group of the twenties and thirties known as OBERIU, and its main animator Daniil Kharms, whose short stories followed an absurdist, surreal logic. These sources call into question traditional narrative structures as well as the boundary between imagination and reality. This approach, coupled with the avant-garde's explorations of the communicative possibilities inherent in visual language, informs Kopystianskaia's art. Her series of word-covered landscapes on canvas embody a simple beauty evocative of the Japanese and Chinese ink painting tradition. The texts are all found or ready-made and come from classic literary sources including the writings of Anton Chekhov, Fedor Dostoevsky, Leo Tolstoy, and Ivan Turgenev. The Landscape shown here is one of the artist's so-called folded works from the series, made by handwriting a text in black tempera on fabric prepared in a manner analogous to canvas and painted with oil in the selected color. Kopystianskaia chose this medium because she lacked access to canvas of a high enough quality to achieve the desired effect. The folding process occludes portions of the text and hence alters its message and meaning. The end result is a new text based on chance that can be read, but like Futurist or OBERIU literature is fragmentary, absurd, and often senseless. Kopystianskaia has also used these works as the basis for performances in which the texts are read out loud and recorded. —VH

fused these diverse sources in the series Museum, which he initiated in 1984 and which consists of installations, paintings, photographs, and video. Construction I belongs to this series. For this work, Kopystiansky meticulously copied a series of French, Dutch, and Danish realist paintings that belong firmly to a bourgeois aesthetic that was anathema to the Russian avant-garde. Although he does not consider the identity of the works important and regards the combination as the chance result of his intuition, the original painting of the nude woman reflected in a mirror is by Danish artist Christopher Eckersberg, probably painted in the 1830s. The canvas placed on the floor and serving as a base for the structure is Paul Cézanne's Girl at the Piano (The Overture to Tannhauser) (ca. 1868), from the collection of Ivan Morozov and now in the State Hermitage Museum, and the canvases acting as rolled columns are unidentifiable landscape paintings. Construction I is related to, but quite distinct from, appropriation art of the eighties in the United States as exemplified by the art of Mike Bidlo and Sherrie Levine. Rather than pure copies exploring the concept of authorship, these paintings deconstruct the original meaning of the paintings in part through their juxtaposition with other works—as in a museum—and in part by transforming them into the building blocks of a freestanding, independent object. In other works from this series, Kopystiansky used paintings as the basis for such useable objects as chairs. Thus, the end result of his work represents a unique creation and not merely an appropriation. —VH

236. SVETLANA KOPYSTIANSKAIA (b. 1950)
Landscape, 1985
Oil and fabric mounted on fiberboard, 181 x 130 cm
Jane Voorhees Zimmerli Art Museum, Rutgers,
The State University of New Jersey, New Brunswick,
Gift of the artist

Kopystianskaia graduated from the School of Architecture at the Polytechnic Institute Lvov in the Ukraine. Along with her husband and frequent artistic partner, Igor, she became an important member of the unofficial art scene in Moscow. Her conceptually oriented work is fundamentally rooted in text, which she used as the primary material for a series of countless works she titled Landscape. These text-based paintings reflect her awareness of the primacy accorded to literature and writers within Russian culture. She has cited as key influences on her work the tradition of Russian Futurist poetry as repre-

237. IGOR KOPYSTIANSKY (b. 1954)
Construction I, 1985–86
Oil on canvas, 167.5 x 152.5 x 160.5 cm
Jane Voorhees Zimmerli Art Museum, Rutgers,
The State University of New Jersey, New Brunswick,
The Norton and Nancy Dodge Collection of
Nonconformist Art from the Soviet Union

Kopystiansky graduated from the Lvov Institute of Applied Arts in the Ukraine in 1977. In 1980, he and his wife Svetlana, also an artist, were living in Moscow when they saw the art of the Russian avant-garde for the first time at the historic exhibition Paris-Moscow 1900–1930. Both of them were drawn to the tradition of Constructivism. Kopystiansky was also attracted to Marcel Duchamp's notion of the readymade, or the redefinition of an ordinary object in the context of art. He

238. GELII KORZHEV (b. 1925)
Raising the Banner, 1957–60
Oil on canvas, 156 x 290 cm
State Russian Museum, St. Petersburg
(plate 228)

This is the central panel from Communists, Korzhev's best-known triptych, which functioned as the painted manifesto of the Severe Style of the 1960s. Although officially dedicated to the events of the revolution, this painting clearly reflects the emotional impact of World War II, which began to be portrayed more dramatically during Nikita Khrushchev's "thaw," when Soviet art moved away from the ostentation and pomposity typical of the art of the Stalinist era. Characteristic features of the Severe Style include monumental scale, an unusual and dramatic viewpoint, and a cinematic cropping that compels the

viewer to extend the composition beyond the frame. Korzhev enhances the dynamism of the composition with the intersecting diagonal lines of the flagstaff and the tramway lines. The strength of this image also lies in the stark realism of the figures and the predominance of earthy tones, which bring out the bright red of the flag. —MC

239. GELII KORZHEV (b. 1925)
The Traces of War (from the *Burnt by the Flame of War* series), 1963–64
Oil on canvas, 200 x 150 cm
State Russian Museum, St. Petersburg
(plate 230)

The confrontational nature of *The Traces of War* from Korzhev's series *Burnt by the Flame of War* (1962–67) can be attributed to the materiality of its coarse grainy surface and its enormous size for its subject matter. The image of a soldier who lost an eye in World War II is an honest look at the disfiguring consequences of a catastrophic event. The painting is also a testimony to the heroism of the Soviet soldier, expressed here through an anonymous and thus easily generalizable portrait. The military uniform is historically accurate, while the close-up view of the soldier against a flat, simple background echoes the format of a photograph made for identification. *The Traces of War* succeeds in blurring the boundaries between a representation of individual suffering and an allegory of the ubiquity of suffering in the Soviet Union as a result of the Great Patriotic War. —MC

240. ALEXANDER KOSOLAPOV (b. 1943)
Malevich Sold Out, 1989
Acrylic on canvas, 112 x 152 cm
Jane Voorhees Zimmerli Art Museum, Rutgers,

The State University of New Jersey, New Brunswick, The Norton and Nancy Dodge Collection of Nonconformist Art from the Soviet Union

Kosolapov attended secondary school at the Surikov Institute of Art in Moscow along with Igor Makarevich and Leonid Sokov. In 1968, he graduated from the Stroganov Institute of Art and Design, where he studied monumental sculpture. In the seventies, he began using mixed media, and he often created unfamiliar combinations of materials and images that resulted in witty, ironic works. In upending traditional associations in order to elicit a reaction from the viewer, he followed in the tradition of Dadaism and the OBERIU, a group of Soviet writers from the twenties who stressed anarchic humor, appropriation, and parody. In 1975, Kosolapov immigrated to the United States, where he became a leading artist in the Sots Art movement in New York. This term, coined by Vitaly Komar and Alexander Melamid in Russia in 1972, denotes a style that mined popular Soviet culture and combined it with Socialist Realist tropes and icons to ironic effect. Kosolapov developed an especially fertile series of works that exploited parallels between American and Soviet mass culture. In particular, he was impressed by the Marlboro Man, whose iconic status also attracted the attention of the American artist Richard Prince, who took him as the subject of a project in the early-to-mid-eighties called *Untitled (Cowboy)*. Kosolapov has noted that to him, the Marlboro Man represents the last American hero, who is always westward bound. This American pop culture icon made the artist reflect upon Kazimir Malevich's status as a cultural hero whose art had in many ways become subordinate to the myth of the man. Like other members of his generation, Kosolapov responded to the complex legacy of Malevich in a series of works, a number of which fused his name with the graphics and logo of Marlboro cigarettes. In *Malevich Sold Out*, Kosolapov employs Malevich's three primary colors—red, black, and white—which also happen to be the colors of the Marlboro package. The abstract, geometric composition is related to, yet also quite distinct from, Malevich's signature style. Kosolapov uses the text on the canvas to convey his ironic message. On the one hand, Malevich's work is rare in the West, and a sought-after commodity; consequently, it is more or less "sold out." On

the other hand, many artists of Kosolapov's generation felt that Malevich had sold out to the Soviet regime and that his absolutist vision for art was little different than the government's totalitarianism. —VH

241. ALEXANDER LAKTIONOV (b. 1910)
Letter from the Front, 1947
Oil on canvas, 225 x 154.5 cm
The State Tretyakov Gallery, Moscow
(plate 226)

Laktionov was the favorite student of Isaak Brodsky at the Academy of Arts in Leningrad between 1932 and 1938. Soon afterward he became known as a champion of traditional academic painting, working in a style that was highly illusionistic and painstakingly finished, so much so that he was accused of excessive naturalism and had trouble receiving commissions until his breakthrough with *Letter from the Front*, for which he was awarded the Stalin Prize. The painting depicts a group of the residents of a small town who have gathered on a porch illuminated by bright morning sunlight, to listen to a boy reading good news from the front. Filled with lyricism and appealing to the albeit short-lived relief and optimism of the first postwar years, it became one of the most popular Soviet images of the forties. Laktionov painted copies of this work almost every year until the end of his life. It remains a textbook image familiar to most Russians. —MC

242. IGOR MAKAREVICH (b. 1943)
Triptych: Portrait of Ivan Chuikov, 1981
Oil on wood, 212 x 137 x 8 cm
State Russian Museum, St. Petersburg
(plate 248)

243. IGOR MAKAREVICH (b. 1943)
Triptych: Ilya's Wardrobe (Portrait of Ilya Kabakov), 1987
Mixed media, 209 x 75 x 60 cm
State Russian Museum, St. Petersburg
(plate 250)

244. IGOR MAKAREVICH (b. 1943)
Triptych: Portrait of Erik Bulatov, 1988
Compregnated wood and acrylic resin,

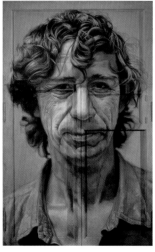

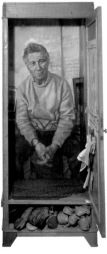

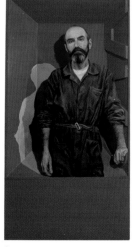

242 243 244

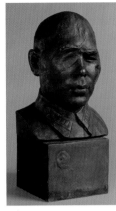

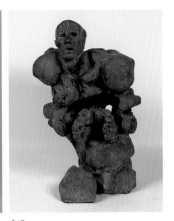

245

246

247

200 x 105 x 22 cm
State Russian Museum, St. Petersburg
(plate 251)

Makarevich graduated from the department of art at the All-Russian Institute of Cinematography in 1968. He earned his living illustrating books, painting lampshades, and designing sets for theater and for television movies. In the early sixties, he was influenced by a group of poets and artists, among them Eduard Shteinberg. In the seventies, he produced large, hyperrealistic paintings, including the remarkably powerful *Death of the Communards* (1977), based on a photograph of fifteen French Communards in their coffins. At the same time, he experimented with photography, creating a series in which he gradually transformed and analyzed his own face in a manner that evoked such disparate work as Austrian artist Arnulf Rainer's contemporaneous self-portrait photographs and Japer Johns's mid-fifties paintings incorporating plaster casts. In the late seventies, Makarevich and his wife Elena Elagina became active in a performance art group known as the Collective Actions group (1976–89). Makarevich fostered important friendships with other leading conceptual artists in Moscow, including the three artists represented in these three portraits. Sometimes referred to as the *Stationary Gallery of Russian Artists*, this triptych consists of three freestanding works made over a seven-year period that incorporate aspects of their respective subjects' signature styles. Using his faculty for near photographic realism, Makarevich painted a monumental rendition of the face of Ivan Chuikov on a large wooden surface made in imitation of a window with a relief frame. In this, he mimics Chuikov's oft-repeated motif of the window rendered as both painting and object. Ilya Kabakov was particularly revered by the younger Conceptualists, and Makarevich's portrait honors him by invoking one of his earliest works, the album known as *Sitting-in-the-Closet Primakov* (1972–75), which chronicles the life of a fictional character who never leaves his closet. He also included shoes, photos, a map, and a plaque with inscription in this work. Taken together, these objects reflect Kabakov's use of everyday materials and language, creating an environment similar to those of Kabakov's installations. Makarevich's portrait of Erik Bulatov places that artist on a panel in the foreground of a boxlike object. This object and the golden shadow Bulatov casts emphasize his location in space. Bulatov is surrounded by the Soviet red that he has described as "warm," "penetrating,"

"unique," and an embodiment of "home." The walls of the box contain parts of inscriptions, thereby invoking the artist's own combination of text, realist images, and space.—VH

245. ANDREI MONASTYRSKY (b. 1949)
Canon/Gun, 1975
Tempera, paper, and cardboard, 56 x 56 x 62 cm
The State Tretyakov Gallery, Moscow
(plate 238)

Monastyrsky is a poet, visual and performance artist, and theoretician. He was influenced by his study of philology and existentialism as well as by his admiration for the American composer John Cage. In the late sixties, Monastyrsky produced surrealistic poetry with drawings and graphic, conceptual books in a style akin to that developed by modernist poets of the early twentieth century. In fact, he and some of his friends who were poets and artists, among them Rimma Gerlovina and Valeriy Gerlovin, made collective poetry in a method similar to the "exquisite corpses" produced by the Surrealists; each participant would read one line by a colleague and then add two of his or her own. In the seventies, Monastyrsky made a series of interactive objects, among them *Canon/Gun*. These works are closely related in intention to art produced in Western Europe and the United States in the sixties that shifted focus away from the artwork as the unique creation of the artist and sought to elicit the active participation of the viewer in its completion. Like other conceptual artists, Monastyrsky offered the spectator written information or instructions that introduced the parameters of the action in which they were about to engage. For *Canon/Gun*, he used very simple materials—paper, cardboard, and tempera—and the result was an ephemeral, homemade-looking object that hung on the wall and consisted of a black box with a tube protruding from the left. The participant was told to look into the box and turn the device with his or her left hand, and as a result the sound of a bell was emitted from the "canon." The market for this art was very limited in the West, and nonexistent in the Soviet Union. As Ekaterina Degot has pointed out, Monastyrsky's objects allowed him to give "material form to mental constructs," an approach he also employed in actions he staged outside Moscow in the out-of-doors, along with his six fellow members of the Collective Actions group that he founded in 1976.—VH

246. VERA MUKHINA (1889–1953)
Portrait of Colonel Bari Yusupov, 1942
Bronze, h. 49.5 cm
The State Tretyakov Gallery, Moscow
(plate 229)

In addition to monumental sculptures, Mukhina made bust portraits of specific individuals. During the war years, she focused on military heroes and commanders. The sculpture shown here portrays Colonel Bari Yusupov, a World War II artilleryman who was wounded in the head and partially lost his eyesight. For his heroic deeds during the war, he was awarded one of highest orders in the Soviet Union—the Order of Lenin, which appears on the base of the sculpture. The colonel is realistically portrayed, with multiple scars on his head and a missing eye. Without excessive drama, the artist shows the ugly face of war and conveys the strength of the war-hero's spirit. —MC

247. ERNST NEIZVESTNY (b. 1926)
The Prophet, 1966
Bronze, 93 x 56 x 66 cm
Jane Voorhees Zimmerli Art Museum, Rutgers,
The State University of New Jersey, New Brunswick,
The Norton and Nancy Dodge Collection of
Nonconformist Art from the Soviet Union

Neizvestny initiated his studies in 1946 at the Academy of Arts in Riga, Latvia, and in 1955 graduated from the Surikov Art Institute in Moscow. He had been discouraged from pursuing a career as a sculptor as a result of a series of wounds he received in World War II, which were so extensive that at one point a field doctor mistakenly pronounced him dead. His personal experience of pain and suffering, of the human body ripped asunder, had a discernible impact on his art. Neizvestny gained notoriety in 1962 when, during an exhibition commemorating the thirtieth anniversary of the Moscow Section of the Union of Artists, he had a heated screaming match with Nikita Khrushchev that simultaneously earned him international prominence and problems at home; he emigrated to the United States in 1976. Nonetheless, he continued to make works on paper and sculptures, much of which was directed toward what he considers to be a focal point of his oeuvre, the *Tree of Life*, which he defines as a zone where man and nature coexist and all humankind is protected and peaceful. The figure of the prophet stands at

248

249

ground for a floating cross, which is composed of everyday cards. Thus the work is grounded in reality rather than another realm beyond. The two handprints in the lower center refer to the absence of the artist Anatolii Zverev (1931–86), a close friend who had died in the year Nemukhin began the work. —VH

249. BORIS ORLOV (b. 1941)
Imperial Totem, 1989
Painted aluminum, 254 x 139.7 x 91.4 cm
Collection of Alexandre Gertsman, New York
(plate 243)

Orlov studied sculpture at the Stroganov Institute of Art and Design, where he became acquainted with fellow students Francisco Infante-Arana, Alexander Kosolapov, and Leonid Sokov. In the early seventies, he worked alongside a group of friends—including Kosolapov and Sokov—who were among the most radical in unofficial artistic circles; together they contributed to the development of Sots Art, which looked to Soviet visual culture and, to a certain extent, American Pop art for inspiration. In the mid-seventies Orlov began to work on sculptures and mixed-media works based on portraits of Roman emperors and the heroes of the Soviet Union, in particular sailors and military officers. The heads of the sculptures assumed the forms of those on classical busts and contrasted with the shoulders and upper bodies of the subjects, which were rendered in an abstract, simplified manner and adorned with medals, ribbons, and, in some instances, rounds of ammunition. Gradually, Orlov eliminated the heads, and these symbols of military might and heroic achievement became the focus of his sculptures, which he mounted on cylindrical bases. He made his faceless "totems," like *Imperial Totem*, out of aluminum, thus reflecting the coldness of military culture as exemplified by tanks, guns, and other military gear, as well as medals awarded for valor in battle. Orlov's metallic medium is contrasted with vividly colored enamel paint that not only invokes the palette and slickness of officialdom and ceremony, but also that of carved wooden folk art. This anthropomorphic object comments upon the reduction of the individual to the sum of decorations, slogans, and other emblems of the state in the imperial system of the Soviet Union. At the same time, the depiction of the ideographic symbols of the war machinery invokes the work of the American artist

the center of this tree. Neizvestny has cited Alexander Pushkin's 1826 poem "The Prophet" as a major inspiration. Indeed, the poem has eerie parallels with the artist's biography; it recounts the story of a pilgrim ripped apart by an angel, only to be reborn as a prophet charged by God to reach out to others with his work. The tortured face of *The Prophet* invokes the work of the Russian avant-garde artist Pavel Filonov as well as Norwegian artist Edvard Munch's iconic *The Scream* of 1893. The hole in the center of his body simultaneously expresses psychological and physical pain, a point further emphasized by Neizvestny's characteristic deformation and exaggeration of the figure. —VH

248. VLADIMIR NEMUKHIN (b. 1925)
Black Card Table (Dedicated to Anatolii Zverev), 1986–87
Oil, playing cards, and wood veneer on canvas,
100.1 x 100.7 cm
Jane Voorhees Zimmerli Art Museum, Rutgers,
The State University of New Jersey, New Brunswick,
The Norton and Nancy Dodge Collection of
Nonconformist Art from the Soviet Union

Educated in Moscow, Nemukhin initially studied with Pyotr Sokolov, a former student of Kazimir Malevich. During this time, he saw the art of the early twentieth-century Russian avant-garde in books owned by Sokolov. In

1942 Nemukhin was expelled from the Surikov Institute of Art and in 1946 completed his studies at the Studio School of the House of Unions. He worked as an illustrator and art editor, but it was his first encounters with contemporary American and Western European abstraction at the Sixth World Festival of Youth and Students held in Sokolniki Park in the summer of 1957 that "opened another path" for him and led in 1959 to his focus on abstract painting. He found a kinship with a like-minded group of artists who gathered around Oskar Rabin in Lianozovo; they held exhibitions in apartments and played an important role in the unofficial art scene in the 1970s. Like members of the Abstract Expressionist movement, Nemukhin developed a signature style; his was exemplified by a use of playing cards as a central motif embedded in otherwise non-objective, often expressionist surfaces. Cards have a lengthy and loaded history in Russian art and literature, ranging from Alexander Pushkin's 1834 short story "The Queen of Spades," which was later transformed into an opera by Pyotr Tchaikovsky, to the early-twentieth-century artists' group Jack of Diamonds to Olga Rozanova's series of paintings of playing cards painted in 1915. In *Black Card Table*, Nemukhin combined his cards with another favorite motif, the card table, both of which refer to the intensity and chance nature of game play. Indeed, in this work Nemukhin toys with elements of Malevich's Suprematism. The black square, rather than a white surface, serves as a

250

251

252

253

254

Robert Indiana, who, in turn, found inspiration in the early-twentieth-century paintings of fellow American Marsden Hartley. —VH

250. VIKTOR PIVOVAROV (b. 1937)
Plan for the Everyday Objects of a Lonely Man (from the Projects for a Lonely Man series), 1975
Enamel on fiberboard, 171 x 130 cm
Jane Voorhees Zimmerli Art Museum, Rutgers,
The State University of New Jersey, New Brunswick,
The Norton and Nancy Dodge Collection of
Nonconformist Art from the Soviet Union

251. VIKTOR PIVOVAROV (b. 1937)
The Daily Regime of a Lonely Man (from the Projects for a Lonely Man series), 1975
Enamel on fiberboard, 171 x 130 cm
Jane Voorhees Zimmerli Art Museum, Rutgers,
The State University of New Jersey, New Brunswick,
The Norton and Nancy Dodge Collection of
Nonconformist Art from the Soviet Union

252. VIKTOR PIVOVAROV (b. 1937)
Plan for the Dream of a Lonely Man (from the Projects for a Lonely Man series), 1975
Enamel on fiberboard, 171 x 130 cm
Jane Voorhees Zimmerli Art Museum, Rutgers,
The State University of New Jersey, New Brunswick,
The Norton and Nancy Dodge Collection of
Nonconformist Art from the Soviet Union

253. VIKTOR PIVOVAROV (b. 1937)
Plan for the Sky for a Lonely Man (from the Projects for a Lonely Man series), 1975
Enamel on fiberboard, 171 x 130 cm
Jane Voorhees Zimmerli Art Museum, Rutgers,
The State University of New Jersey, New Brunswick,
The Norton and Nancy Dodge Collection of
Nonconformist Art from the Soviet Union

254. VIKTOR PIVOVAROV (b. 1937)
Project for the Living Space of a Lonely Man (from the Projects for a Lonely Man series), 1975
Enamel on fiberboard, 171 x 130 cm
Jane Voorhees Zimmerli Art Museum, Rutgers,
The State University of New Jersey, New Brunswick,
The Norton and Nancy Dodge Collection of
Nonconformist Art from the Soviet Union

Pivovarov graduated from the art department of the Moscow Institute of Polygraphy in 1962. Professionally, he worked as a book illustrator, and he gained official recognition for his work on children's books. His experience in this field influenced his art, in which he combines image and text in conceptual works often centered on fictional characters. From 1975 to 1982, he produced twelve albums that explored the challenges of daily existence in the Soviet Union, as seen through stories revolving around a type of character that has sometimes been described as a Soviet everyman; Pivovarov shared this approach with his friend and colleague Ilya Kabakov.

He simultaneously worked in a larger, painted format in which text served as a crucial companion to visual representation, as in his *Projects for a Lonely Man* series. Similar

to the albums, the story or message here does not follow a traditional narrative structure; however the individual panels do build upon and relate to one another. Working in a series is therefore a key feature of this and other works by the artist from this period. Pivovarov devised a conceptual blueprint for how the "lonely man" of the title might conduct his life. In *The Daily Regime of a Lonely Man*, he uses a clock to suggest how each hour might be passed—for example breakfast from 7:30–8:00 AM, work from 3:00–6:00 PM, tea from 9:00–9:30 PM, and sleep from 12:00–7:00 AM. *Plan for the Dream of a Lonely Man* consists of a schematic drawing suggesting what this fictional person ought to dream about on any given day of the week. *Plan for the Everyday Objects of a Lonely Man* presents a diagram detailing the uses for such quotidian objects as a table, which is designated for reading, writing, eating, or simply sitting and looking out the window. The implicit regimentation of this plan reflects the control exerted over the private sphere of Soviet citizens. In this world, there is virtually no place for the individual personality or independent thought. Perhaps the best feature of this seemingly large, yet empty and alienating space is the view out the window onto the world beyond. This potential passageway or conceptual way out stood at the heart of the vision articulated in this and other works by Pivovarov and a number of the artists associated with Moscow Conceptualism in the seventies and eighties. —VH

255. ARKADY PLASTOV (1893–1972)
Reaping, 1945
Oil on canvas, 197 x 293.5 cm
The State Tretyakov Gallery, Moscow
(plate 227)

Painted during the first summer after the end of World War II, *Reaping* shows the peasants' peaceful daily toil. Plastov himself was of peasant origin and lived in the village most of his life; not surprisingly, the subjects of the majority of his paintings are devoted to rural life and the *kolkhoz* (collective farm). The grass and flowers in the foreground of *Reaping* are painted with rich texture and the bright, broken brushstrokes characteristic of the Impressionism, which was to come under harsh criticism from government officials in the late forties. This painting, along with *Harvest* (1945, cat. no. 256), was awarded the Stalin Prize of 1946, the highest honor for an individual painting at the time. —MC

256. ARKADY PLASTOV (1893–1972)
Harvest, 1945
Oil on canvas, 167.5 x 219 cm
The State Tretyakov Gallery, Moscow

A genre scene in the tradition of nineteenth-century painting, *Harvest* depicts an old man eating with his grandchildren during a break in haymaking. Although this painting clearly shows an image of return to peaceful renewal after the war, it also has a subtext that would have been easily legible to contemporary viewers: by showing only the very old and the very young, Plastov points to the enormous cost of the war. The bold expressive brushstrokes, rich colors, and composition, which sets the scene as a close-up within the larger context of peasants

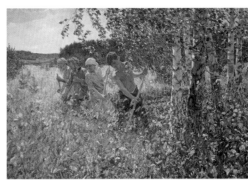

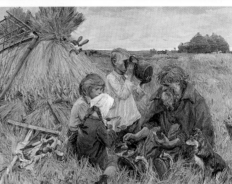

255

256

257

working in the field, account for an intimate and yet monumental quality that made this image widely popular and gained it and *Reaping* (1945, cat. no. 255) the Stalin Prize of 1946. —MC

257. VIKTOR POPKOV (1932–1974)
Builders of the Bratsk Hydroelectric Power Station, 1960–61
Oil on canvas, 183 x 300 cm
The State Tretyakov Gallery, Moscow
(plate 232)

Representing the epitome of the officially sanctioned Severe Style that dominated Soviet postwar painting, *Builders of Bratsk Hydro-Electric Power Station* brought Popkov immediate recognition as one of the leaders of this aesthetic. The subject of heroic labor was central to the iconography of Socialist Realism from its inception in the 1930s. The painting treats this subject in a manner characteristic of the late 1950s and early 1960s. The large scale of the work emphasizes its public nature; forms are simplified and colors are bright and modulated only slightly. Popkov achieved a direct and stark impression by placing the figures on a light ground against a black

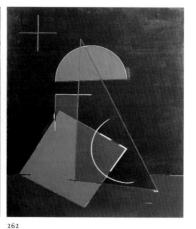

258

259

262

background. The viewpoint from below monumentalizes the figures, an effect that is especially apparent in the tall, muscular worker who stands on the right in a white suit and a bright red shirt, radiating power and self-confidence. —MC

258. VIKTOR POPKOV (1932–1974)
Father's Overcoat, 1970–72
Oil on canvas, 176 x 120 cm
The State Tretyakov Gallery, Moscow
(plate 235)

A foremost representative of the so-called Severe Style, Popkov retreated from the public and social orientation prescribed by Socialist Realism toward an introverted and individualized world of memories and private feelings. *Father's Overcoat* is a self-portrait of the artist trying on the overcoat of his father, killed during World War II, and thereby establishing a symbolic connection with him. In the painting's background, he quotes the reddish silhouettes of peasant female figures from his own *Widows* series, painted during the 1960s. Silent dreamlike figures, still mourning their dead husbands, are based on the artist's observations of village life in the north, and they evoke the fate of Popkov's own mother, a Russian peasant whose husband died in the war. The composition of the painting is flattened and the artist's figure and his palette directly address the viewer, inviting them to join the artist's private space of a tragedy that, as it quickly becomes clear, is shared by many. Sadness and melancholy are pervasive and presage Popkov's own untimely and absurd death two years later, when he was shot by mistake by security guards. —MC

259. OSCAR RABIN (b. 1928)
Passport, 1964
Oil on canvas, 70 x 90 cm
Private collection, New Jersey
(plate 236)

Rabin was orphaned at the age of four, but was adopted by the artist Yevgeny Kropivnitsky, who introduced him to the art of the historic Russian avant-garde. In the late 1940s, he studied first at the Academy of Arts in Riga, Latvia, and then at the Surikov Institute of Art in Moscow, from which he was expelled for "formalism," a term applied to work that exhibited formal innovation and especially modernist tendencies. Rabin's interest in German Expressionism is evident in his paintings, which often had highly articulated surfaces, flattened objects, and grotesque figures. While he worked in a realist mode, his approach radically contradicted the bright, photographic, positive images that dominated official Socialist Realist works of the time. Like his Pop art contemporaries in the West, Rabin painted such quotidian objects as newspapers and Stolichnaya vodka labels. But these were not the products of a booming consumer culture; rather, they were the everyday objects and detritus of a bleak Soviet reality. In paintings like *Passport* Rabin revealed the degree to which bureaucracy and official culture dominated the daily life of the individual. This multifaceted self-portrait of the artist includes a painted representation of a typical passport photo of his face as well as the standardized data found in identity cards such as name, date of birth, nationality, and signature. On the line for nationality he lists Latvian, and in parentheses he adds the Russian word for Jew. Rabin made a second version of this painting in 1972, in which he indicated his date of death despite the fact he was still very much alive. Both works are significant historical documents of the Soviet period, when all citizens had to carry identification cards, few were issued passports, and even fewer ever had the chance to leave the country unless they intended to emigrate, as Rabin did in 1978 when he was stripped of his Soviet citizenship. —VH

260. MIKHAIL ROGINSKY (1931–2004)
Buffet, 1981–82
Acrylic on paper, 150 x 169 cm
International Foundation of Russian and Eastern European Art (IntArt), New York
(plate 246)

Roginsky graduated in 1951 from the Department of Scenography of the Moscow Art School Named in Memory of 1905. He went on to work as a stage designer, as well as an unofficial artist. Roginsky found inspiration in the paintings of Edward Hopper and Ben Shahn, which he saw in 1959 at the *Exhibition of American Painting and Sculpture* held at the Sokolniki Park in Moscow. In the work of Hopper in particular, he recognized a more informal approach than that of Socialist Realism, especially in the American artist's depiction of urban scenes and commonplace objects from contemporary everyday life. Beginning in the early sixties, Roginsky painted quotidian subjects ranging from toilets to the metro, in a flat, sometimes expressionist manner similar to that used by Western Pop artists of that decade. He painted the most characteristic and banal objects that dominated Soviet daily life, but he did not offer ironic commentary or criticism of Soviet culture. His work was distinguished from that of his contemporaries abroad by his context; these were not the stuffs of overly abundant consumer culture but rather the standardized communal products of the Soviet era. Roginsky immigrated to Paris in 1978. In the early eighties, he painted from memory a number of other works on the theme of Moscow life, including *Buffet* (1981–82). In this work, he uses loose brushwork and flat forms to render the depersonalized worker and three anonymous customers in a buffet which, according to the sign, is part of the restaurant "North," open from 9:30 AM to 6:30 PM. He breaks up the monotony of the scene—represented by the dominant use of purple—with the bright colors of both the wall behind the female server and the trio of sodas she dispenses. —VH

261. TAIR SALAKHOV (b. 1928)
Portrait of the Composer Kara Karaev, 1960
Oil on canvas, 121 x 203 cm
The State Tretyakov Gallery, Moscow
(plate 231)

Salakhov, an artist from Azerbaijan and currently vice-president of the Russian Academy of Arts in Moscow, depicts here his fellow countryman, the composer Kara Karaev (1918–1982). With its simplified forms and minimal details, this work is a typical example of the Severe Style of the 1960s. The painting has a pronounced linearity, and the outlines of the piano, the stool, and the figure's

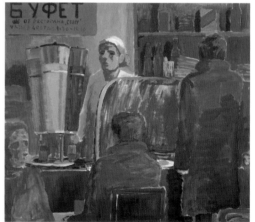

260

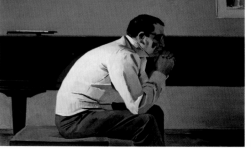

261

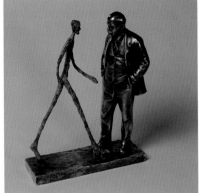

263 264 265

profile have a stark and direct effect. The strong emphasis on the horizontal dimension, created by the lines rendering the piano, stool, and plinth, and by the cropping of the piano, gives the impression that the image extends beyond its frame. The flattened space in the background conveys an intimate impression, while the bright, even color of the composer's clothes magnifies the impact of his thoughtful presence. —MC

262. EDUARD SHTEINBERG (b. 1937)
Composition, 1987
Oil on canvas, 120 x 97 cm
State Russian Museum, St. Petersburg

Shteinberg received his art education largely from his father Arkady, who graduated from the experimental art school VKhUTEMAS (Higher State Artistic and Technical Workshops, in operation 1920–30), and was a student of David Shterenberg. Consequently, Shteinberg became familiar with the Russian avant-garde, but he only saw this art for the first time at the end of the fifties in the collection of George Costakis. He became especially interested in Kazimir Malevich, and even placed a picture of the artist in his studio. Shteinberg went through a long white period, which not only reflected the influence of Suprematism and the Italian metaphyical school—perhaps best exemplified by Giorgio Morandi—but also the writings of the early-twentieth-century Russian Orthodox theologian Pavel Florensky, who regarded white as the color of light, symbolizing holy transfiguration. Shteinberg felt a primarily abstract, geometric formal language was best suited to the exploration of humankind's relationship to the cosmos, and he adopted six principle shapes: the cross, circle, prism, triangle, square, and sphere. Like Malevich, Shteinberg believed that these abstract elements had metaphorical significance; the rectangle, for example, suggests death, loss, and a yearning for God. In the eighties Shteinberg turned to a darker palette dominated by browns, reds, and greens, all the while maintaining his neo-Suprematist visual vocabulary. *Composition* represents this period in his work, during which he conceptually shifted his focus from heaven, sybolized by his use of white, to the earth.—VH

263. MIKHAIL SHVARTSMAN (1926–1997)
Untitled, 1982
Oil on panel, 99.2 x 75.3 cm

Jane Voorhees Zimmerli Art Museum, Rutgers,
The State University of New Jersey, New Brunswick,
The Norton and Nancy Dodge Collection of
Nonconformist Art from the Soviet Union

Shvartsman graduated from the Stroganov Institute of Art and Design in Moscow and worked as a designer, illustrator, and monumental painter. Unlike many of his contemporaries, he has tended to work in hermetic isolation, an approach in keeping with his decision in the 1960s to turn his attention to the artistic tradition of the Middle Ages, which in Russia was the age of the icon. He sought to re-create a mystical, transcendental role for painting, to define new religious symbols that would allow art to serve as a vehicle for speaking to God. To achieve his goal, he began to paint his works on panel in emulation of icons. He defined his approach by inventing the term "hierature" to denote spaces in which religious thought and aesthetics intersect. While his works sometimes include schematic human faces, most often they are abstract, architectonic paintings, such as *Untitled*. In this and related pictures, he smoothly applied multiple layers of oil paint in a manner that imparts a distinct tactility to his panels. The notion of touching a work was central to icons; thus Shvartsman's formal method suggests that his paintings are also holy objects. His dark palette seems more connected to old masters than to icons, but he succeeded in creating a subtle inner light that shines forth from the surfaces of his works. —VH

264. LEONID SOKOV (b. 1941)
The Meeting of Two Sculptures, 1986
Bronze, 48.9 x 40.2 x 16.9 cm
Solomon R. Guggenheim Museum, New York, Gift,
John Schwartz 92.4030
(plate 244)

Sokov graduated from the Stroganov Institute of Art and Design in 1969. As a student, he looked to the work of Aristide Maillol and Auguste Rodin as models for his sculpture. In his official job as a member of the Union of Artists, Sokov produced park statuary, especially of animals, and he mastered the technique of welding and forging at a foundry under his direction. By 1970, he had already begun his activity as an unofficial artist, and he worked especially closely with Alexander Kosolapov and Boris Orlov. Sokov and his friends found inspiration in Pop art, Socialist Realism, and the icons of Soviet mass

culture, and they were among the artists who developed Sots Art in the seventies and eighties. Within this trend, Sokov was distinguished by his focus on relief and sculpture, which often represented Soviet leaders, particularly Lenin and Stalin. He produced quite a number of works in crude wood, and many of them had simple, kinetic mechanisms that transformed them into Sots toys. *The Meeting of Two Sculptures* is one of Sokov's most famous works. Here he placed two iconic figures from twentieth-century art history on the same base, Vladimir Lenin and Alberto Giacometti's *Walking Man* (1948). While many sculptures of Lenin depicted him in mid-stride, Sokov's highly skilled representation shows him with feet firmly planted on the base and with a slightly furrowed brow. Giacometti's emaciated, modernist man places his foot in Lenin's space, and his right hand reaches toward the Soviet leader, who keeps his hands in his pockets. The two figures represent the face-to-face confrontation not only of two sculptures, but also of two styles: Socialist Realism and modernism. The juxtaposition invokes the dialectical pair of avant-garde and kitsch as articulated by noted American critic Clement Greenberg in his 1939 article "Avant-Garde and Kitsch." Sokov's use of bronze, however, suggests that both traditions belong to the realm of high art. The sculpture also seems to pose a question central to Sokov's own art: What happens when these two seemingly disparate styles meet on the same ground?—VH

265. OLEG VASSILIEV (b. 1931)
Ogonyok No. 25, 1980
Oil on canvas, 122 x 91.7 cm
Jane Voorhees Zimmerli Art Museum, Rutgers,
The State University of New Jersey, New Brunswick,
The Norton and Nancy Dodge Collection of
Nonconformist Art from the Soviet Union
(plate 242)

Vassiliev graduated from the Graphic Arts Department of the Surikov Art Institute in Moscow in 1958. Along with his friends Erik Bulatov and Ilya Kabakov, he became acquainted with the early-twentieth-century avant-garde artist Robert Falk and the graphic artist and painter Vladimir Favorsky. For thirty-three years, he made his living working as an illustrator of children's books in collaboration with Bulatov. The two artists also supported one another in their unofficial art. Vassiliev looked to a wide range of sources, among them the work of Russian artists Valentin Serov, Isaak Levitan, and Ivan Shishkin, whose treatment of light, which was similar to that of the German Romanticists, had a discernible influence on him. He also had an interest in Constructivism, and he described his paintings as visual structures. Using color, form, and light, he explores the space and what he has called the "energy flow" inherent in the painting. In *Ogonyok No. 25*, he painted the June 1975 cover of one of the oldest Russian weekly illustrated magazines, *Little Light*. His presentation of this subject reflects his stated interest in examining the "interactions between space-surface-light and depicted object," which here is an official Communist Party meeting. At the center of the image stands a podium emblazoned with the seal of the Soviet Union. Intense lights coming from each corner culminate in a blazing spotlight in the center of the podium that completely obliterates the speaker, General Secretary

Leonid Brezhnev (1906–1982), who is surrounded by delegates on both sides. Thus actual light, the source of seeing and perceiving the visual world, becomes the focus rather than the leader, who was generally depicted in sources such as *Ogonyok* as the light or deity of the Soviet system. Through his choice of title and referent Vassiliev ironically implies that the Soviet leadership and system were not a beacon to the world, but rather no more than a little light. —VH

266. VLADIMIR YANKILEVSKY (b. 1936)
Triptych No. 14: Self-Portrait (Memory of the Artist's Father), 1987
Mixed media, 195 x 360 cm
State Russian Museum, St. Petersburg
(plate 249)

Yankilevsky graduated from the Moscow Polygraphic Institute in 1962. During that same year, he participated in a semi-official exhibition of artists affiliated with the studio of the artist Eli Beliutin, who taught Yankilevsky first at the Polygraphic Institute and later at a school founded by the older artist. This exhibition drew the attention of the foreign press, and as a consequence Yankilevsky was among a select few asked to show their work in *Thirty Years of Moscow*, which had already opened at the Manezh exhibition hall off Red Square. On December 1, 1962, Nikita Krushchev visited the exhibition and unleashed his vitriolic disapproval of the

form and content of the work shown by Yankilevsky and his friends, chief among them the sculptor Ernst Neizvestny. Yankilevsky's work demonstrates the influence of the machine aesthetic as pioneered by Marcel Duchamp and Francis Picabia, as well as the biomorphism and primal forms developed by Paul Klee, Joan Miró, and Pablo Picasso, whose work he had seen at a monographic exhibition in Moscow in 1956. In addition, Yankilevsky has explored issues of gender in surrealistic, sexualized representations in which male and female figures exchange body parts or simply are fused together. By 1961, he had begun to produce mixed-media works that combine painting and relief in a triptych format. In these triptychs, he often explored the obliteration of individual identity by representing three-dimensional clothed figures with their backs turned to the viewer. In obscuring the sculpted people's faces, Yankilevsky alludes to the dehumanization implicit in modern culture. He also employed this approach in the central panel of *Triptych No. 14: Self-Portrait (Memory of the Artist's Father)* in which a male figure, dressed in a trench coat and winter hat, clings to a handlebar in a subway as he reads a newspaper. The tangible presence of this man, further underscored by the actual briefcase beside his feet, contrasts with the abstract representations of a male silhouette in the left and right panels. The figure on the left is white and has a series of colored lines running through his midsection, while the figure on the left is black with white and gray lines in the same position. These positive/negative mirror images suggest the binaries of birth and death; the central panel stands for the life journey that occurs between these two defining moments. In juxtaposing real space with imaginary or symbolic space, Yankilevsky achieved his goal of presenting "the simultaneity of various existential states in one work," and created a moving tribute to his father. —VH

266

267

267. DMITRY ZHILINSKY (1927–1965)
Gymnasts of the USSR, 1965
Gesso and tempera on plywood, 270 x 215 cm
State Russian Museum, St. Petersburg
(plate 233)

Gymnasts of the USSR is, in essence, a group portrait of famous Soviet sportsmen, all of whom, together or individually, won medals in World Championships and Olympic Games. In order to create this monumental portrayal, Zhilinsky adapted techniques employed in traditional Russian frescoes and early Renaissance murals; he painted with tempera on board, flattens perspectival space, and minimizes modeling. The viewpoint is so elevated that the picture plane is naturally sharply tilted forward. Only one figure in the foreground is looking directly out at the viewers, drawing them into the pictorial space. Other figures are displayed in a freeze-like static manner, without real interaction or narrative. A total lack of shadow and the use of bright localized colors, dominated by white, red, and brown, create a strong sense of decorative monumentality. Despite its use of modernist techniques, then still prohibited in the Soviet Union, this painting won high praise in contemporary official art circles and was awarded a Silver Medal of the Soviet Academy of Arts in Moscow in 1966. —MC

268

OPENING NEW SPACES: 1980S TO THE PRESENT

268. SERGEI BUGAEV AFRIKA (b. 1966)
Industrial Unconscious II, sketch for Mir: Made in the XX Century, 2000
Steel and photography on enamel, 319 x 165 cm
State Russian Museum, St. Petersburg
(plate 253)

Bugaev, who is sometimes known as Afrika, left home at fourteen to join a rock band and in the 1980s belonged to a number of different musical groups in Leningrad (now St. Petersburg), among them Aquarium, Kino, and Popmechanics. By the mid-1980s he began associating with Timur Novikov and the New Artists group (founded 1982) and made paintings in a Neo-Expressionist style. In his visual art, he has often turned to found materials, and his artistic influences range from the Russian avant-garde of the early twentieth century to the mass media of the Stalin era to Andy Warhol, John Cage (whom he met in Leningrad in 1988), and Joseph Beuys. Bugaev passionately collects objects that he preserves and organizes in his studio, among them vernacular wooden doors, Lenin memorabilia, and varied textiles. *Industrial Unconscious II* is a sketch for *Mir: Made in the XX Century*, an installation shown at the Russian Pavilion of the Venice Biennale in

1999. For this work, Bugaev drew on Soviet photography of 1920s and 1930s industrialization, such as that seen in *USSR in Construction*, the Stalin-era journal that was translated into multiple languages and distributed internationally as propaganda for Stalin's successive five-year plans. Taken together, the small panels comprising *Mir: Made in the XX Century* reflect the cold, metallic order of industry, the hope of progress through science and modern industry, and the repetitive, stock imagery of the Soviet era that nonetheless embodies a poetics uniquely its own. In order to transfer the photographic images to small, metal plates, the artist undertook an arduous process that involves the exposure of film on a glass plate, the application of a compound of powder and a special substance to produce a jellylike material on the surface, the submerging of the plate in water to loosen the image and transfer it to a double-layered enamel plate, and the baking of that plate to complete the process. In many respects, such a multistep method has much more in common with the craftsmanship of icon painters, as Olesya Turkina has argued, than the processes of most modern-day artists. In the final work for the Venice Biennale, Bugaev engulfed the viewer with walls filled by his photographic plates and a floor composed of imageless plates. In the center of the room he hung a huge metal sphere—evocative of the Russian word *mir*, which means both "peace" and "world" and is also the name of the well-known Russian space station. And within this conceptual globe, he placed a video monitor playing footage of electroshock therapy being performed in a Crimean psychiatric hospital. A haunting score by the English composer Brian Eno accompanied the installation in Venice, which represents the traumatic collision of the individual with ideology and collective experience. —VH

269. ERIK BULATOV (b. 1933)
Melting Clouds, 1982–87
Oil on canvas, 260 x 200 cm
State Russian Museum, St. Petersburg

269

270

Bulatov has often turned to photographs, postcards, and magazine illustrations as initial sources for his paintings. In *Melting Clouds*, the influence of Alexander Rodchenko's photographs is evident. Rodchenko pioneered the use of strange angles and viewpoints such as the earth-to-sky one employed in Bulatov's painting. Indeed, this work strongly evokes the Soviet photographer's *Pine Trees in Pushkin Park* (1927). In contrast to Rodchenko's composition, which is dominated by trunks and tree tops, Bulatov's painting stresses the open, blue sky dotted with a handful of clouds. In the mid-seventies and eighties, clouds became an oft-repeated motif in his work. Bulatov became used to depicting nature in his job as an illustrator for, among other things, botanical books. In general, Bulatov paired the clouds with bold, painted text in a style similar to that used in official propaganda, as, for example, in his painting in which red lettering spelling the words *Glory to the CPSU* (1975) nearly fills a bright, blue sky. *Melting Clouds* differs from the other variations on this theme in its lack of text. This firmly places the focus on the open space of the sky. Many of Bulatov's contemporaries, and Ilya Kabakov in particular, reflected on the enclosed, confining space that defined the existence of the Soviet citizen. In this and other paintings by Bulatov, open space more broadly connoted a zone of freedom. This painting also reflects Bulatov's command of a photorealistic style as well as the central importance accorded to light in his oeuvre. —VH

270. VLADIMIR DUBOSSARSKY (b. 1964) and
ALEXANDER VINOGRADOV (b. 1963)
Troika, 1995
Oil on canvas, 240 x 600 cm
XL Gallery, Moscow
(plate 254)

Both Dubossarsky and Vinogradov were educated in Moscow, studying at the Moscow Art College in the early eighties and graduating from the Surikov Institute of Art in 1995. They began to collaborate with one another in 1994. Their approach differed from the predominant modes of Moscow conceptualism and radicalism, the latter of which was characterized by aggressive, hooligan tactics. Dubossarsky and Vinogradov have noted that their work differs from that of Vitaly Komar and Alexander Melamid and other Sots artists because they do not ironically comment on ideology and Soviet clichés; in this sense, their work reflects in a postperestroika sensibility. While their realist painting style and scale clearly owe a debt to Socialist Realism, their subject matter is rooted in the culture of capitalist excess and popular trends represented especially by the culture of celebrity as depicted in the media. Similar to Socialist Realist artists, they portrayed a sort of universal paradise, but their global arcadia is grounded in pop culture through film, political, and music stars as well as beautiful, often nude women. The large scale of their paintings, which are often installed to fill entire galleries, projects a cinematic character, like viewing frames of a movie. *Troika* presents a classic Russian theme: the troika, a carriage or winter sleigh pulled by three horses. The subject, celebrated by the writer Nikolai Gogol in his 1842 novel *Dead Souls*, has been depicted frequently in Russian art since the nineteenth century—including both fine art and lacquer

271

boxes—as an emblem of freedom and the unrestrained joy of leisure time. These positive associations are reflected in another *Troika* painting by Dubossarsky and Vinogradov, which shows an ecstatic nude baby at the reigns and is set during spring. Painted in saccharine Technicolor, the work contains a rainbow, doves, rabbits, and two other happy babies, one of whom clasps a model airplane. In contrast, the *Troika* shown here is dark and foreboding. In place of frolicking bunnies and doves, this snowy winter scene includes agitated, barking wolves, a sky full of bats with sharp teeth bared, and a satanic, winged gargoyle with exposed penis and defined nipples. The person in the sleigh, who appears to be nude under an open fur coat, defensively but blindly fires a machine gun in the direction of the flying monster. Taken together, the elements of these monumental *Troika* paintings present two opposing scenes: paradise and hell. —VH

271. ILYA KABAKOV (b. 1933)
The Man Who Flew into Space (from the Ten Characters Series), 1981–88
Wood, rubber, rope, paper, electric lamp, chinaware, paste-up, rubble, and plaster powder, 96 x 95 x 147 cm
Musée Nationale d'Art Moderne, Centre Georges Pompidou, Paris
(plate 255)

In 1972, Kabakov began to work in earnest on a series of albums (35 to 100 pages in length) centered around characters of his invention. He drew on his work as an illustrator of children's books, as he combined imaginative drawings and text to recount the stories of these everyday heroes. He would present the albums to his friends as sort of plays by placing them on music stands, reading them aloud, and turning the pages. He felt that these works embodied elements of literature, film, fine art, and theater. Kabakov sought to achieve a similar effect in installations such as *The Man Who Flew Into Space*, one of his most important works. As with the albums, the piece focuses on a person who is both an individual with a personal story and a kind of Soviet everyman. As a series of texts affixed to the structure of this everyman's boarded-up room explain, the former inhabitant had moved into this tiny space within a communal apartment two years prior, but little detail was known about him. He could not afford wallpaper, so he covered the space with three tiers of

272

posters. This cheap Soviet iconostasis had a top level of gods, a middle row representing everyday life, and a bottom tier of all red pictures symbolizing hell. The room contained a simple cot, as well as a series of maps, a painting of the Spasky Tower in Red Square taking off into space, and a model of his building with a metal strip. This strip represented his planned trajectory once he used his homemade catapult—reminiscent of invented flying devices from Leonardo da Vinci to Vladimir Tatlin—to escape the confines of the apartment and his life and to experience the liberation of space like an astronaut such as Yuri Gagarin. A blinding floodlight shines through an open hole in the roof. This heavenly light emanates from the very place where the man blasted through in search of a paradise beyond his daily existence. —V H

272. OLEG KULIK (b. 1961)
Cosmonaut (from the installation series Museum),
2003
Wax, mixed media, and vitrine, 165 x 175 x 60 cm
XL Gallery, Moscow
(plate 256)

Kulik is perhaps best known for his performances, photographs, and videos in which he assumes the identity of a dog by appearing nude, on all fours, and barking or growling. With that body of work—sometimes referred to as the artistic program "Zoophrenia"—Kulik explores the relationship between humans and animals, and in particular the possibility of the animal serving as an alter-ego to human beings or, as the artist has put it, "the animal as

a non-anthropomorphous Other." In 1998, Kulik also examined the border between animal and human in the series Memento Mori (dead monkeys) consisting of twelve, close-up, mugshotlike photographs of taxidermied monkeys from a museum of natural history. By presenting the images of the monkeys as individual portraits within the context of cultural institutions, he commented upon the museification of both nature and culture. With his installation series Museum, Kulik continued this theme by depicting recognizable cultural icons—Madonna, Bjork, Anna Kournikova, and Yuri Gagarin—as wax figures with generic titles (Actress, Singer, Sportswoman, Cosmonaut) displayed in glass vitrines. In contrast to wax museum figures such as those at Madame Tussaud's, which strive to present the most accurate likeness possible, Kulik's figures bear physical evidence of their artifice in the form of visible seams that read as thick, stitched scars. And unlike the wax sculptures by such artists as Maurizio Cattelan, Duane Hanson, and Ron Mueck, Kulik's figures are placed in vitrines evocative of the natural history museum and the series is called Museum, thereby making explicit his commentary on the culture of display, both in terms of celebrity and art. The literalness of the figures is contrasted with a sense of wonder and spectacle as Kulik suspends them—figures within vitrines—in the air. This is especially true of the Cosmonaut, hanging from the ceiling in a manner reminiscent of dioramas in air and space museums celebrating the achievements of the Space Age. This work stands apart from the others in its invocation of an earlier period by representing the Soviet cosmonaut or astronaut Yuri Gagarin, who, in 1961, became the first man to orbit Earth and consequently achieved international fame. Cosmonaut, like the other figures, inhabits a realm between life and death, where the icons of culture are simultaneously preserved in moments of action and imprisoned as dioramas in vitrines, forever subject to the gaze of the viewer. —V H

273. NATALIA NESTEROVA (b. 1944)
Moscow, 1989
Oil on canvas, three panels, 170 x 140 cm each
The State Tretyakov Gallery, Moscow

Nesterova studied under Dmitry Zhilinsky at the Surikov Insitute of Art in Moscow, graduating in 1968. She soon became a leading member of the left wing of the Union of Artists, producing realist works that reflected her desire to base art on nature, and not merely to imitate it. She draws on numerous artistic sources for

inspiration, including French modernism as represented by Paul Cézanne, whose painting she encountered at a young age with her grandfather; naive art as exemplified by Jean Dubuffet, Henri Rousseau, and the Georgian artist Niko Pirosmani; and Surrealism, particularly as represented by René Magritte. Nesterova has noted that she prefers subjects taken from "the flow of human life," such as leisure activities, vacation scenes, and everyday events like meals. While there is often an implicit story to her works, she does not employ traditional narrative structures. Moreover, her paintings combine elements of theater, religion, fable, and fantasy. In contrast to both official artists working in a Socialist Realist style, and unofficial artists of the Sots Art movement, politics are not addressed in her art per se. However, the collision of the personal and social is examined in such works as Moscow. In this triptych, she created a scene reminiscent of a theater set, with groups of figures in the foreground lined up along a balustrade looking onto a vista that includes a park below and a series of Stalin-era skyscrapers set against a red, expressionist sky. Nesterova did not use traditional perspective here; rather, she placed all of these spatial zones in direct relation to one another in order to underscore the relationship between the "people" and their surroundings. The vertical figures echo the vertical buildings, even as their surreal, otherworldly appearance—they are faceless, white, and covered with eyes—contrasts with the architecture, which stands for the ambitions of Joseph Stalin and his successors. Nesterova's multi-eyed people are endowed with an ability to look at their world, both literally and conceptually, from many perspectives at once. —V H

274. TIMUR NOVIKOV (b. 1958)
Airport, 1983
Paper, oil, chalk, color foil, stamp, and collage on black flannel, 237 x 237 cm
State Russian Museum, St. Petersburg
(plate 252)

Beginning in the late seventies, Novikov was a leading member of the Leningrad (now St. Petersburg) nonconformist artist scene. In the early eighties, he developed a theory of collage/montage that drew on the cinematic technique of montage as pioneered by the Soviet film director Lev Kuleshov in the twenties and the theory of inverted perspective elaborated by the Russian rocket engineer and scientist Boris Rauschenbach. Airport is one of Novikov's earliest works in which he applied collage elements cut out of magazines to his prefered medium of textiles. He attributed his choice of the textile medium to the influence of Larionov, who looked to folk arts, including textiles, as a model. Moreover, he felt it allowed him to operate on the boundary of high and low; it could function both as high art and as a tablecloth. This border also played a major role in the cubist collage technique, which Novikov invokes with the applied images as well as the letters above the control tower that read "Leningrad." The main image is that of St. Petersburg's Pulkovo Airport, set on a black cloth suggestive of the night sky. The facade of the airport has a display of what appear to be five posters, or banners showing an attractive flight-attendant, likely for the airline Aeroflot. A gigantic plane dominates the center of the work, and a bright light

273

274 275

emanating from it creates a star-like shape and focal point. This approach foreshadows Novikov's later work, in which he placed simple symbols such as a star in the middle of monochromatic textile panels. Cutouts of other planes, satellites, tanks, and buses in various sizes are spread throughout the ground of the work. The multicolored structure in the upper left calls to mind the grinders in the lower right of Marcel Duchamp's *Large Glass* of 1915–23. Like Duchamp, Novikov has brought together the realms of man and machine in a playful spatial field that is devoid of conventional perspectival devices. —VH

275. **VADIM ZAKHAROV** (b. 1959)
The History of Russian Art—From the Avant-Garde to the Moscow School of Conceptualists, 2003
Painted wood, metal, photo reproductions, porcelain, CD, DVD, and archival and printed materials, 360 x 605 x 390 cm
Museum für Moderne Kunst, Frankfurt-Am-Main
(plates 257, 258)

In 1983, Zakharov graduated from the Pedagogical Institute in Moscow. He participated in the Aptart (apartment art) movement, which emerged in 1982 and lasted until 1984. In the earliest period of Soviet nonconformist art, exhibitions took place in artists' apartments because they could not be held publicly, but by the time of Aptart holding shows in apartments had become a choice rather than a necessity. Zakharov and Yuri Albert, with whom he collaborated at that time, developed works that initiated a dialogue with the previous generation of nonconformists, including Erik Bulatov, Ilya Kabakov, and Eduard Shteinberg; this approach became a significant feature of Aptart. In 1982, Zakharov produced a performative photographic series entitled *I Acquired Enemies*. In these photos, the artist's extended right hand dominated the picture. He wrote a short text on his palm addressed to the most prominent members of the Moscow avant-garde, for example, "Shteinberg, you are made-up Malevich"; his attitude was provocative but not disrespectful per se. In 1988, Zakharov, along with Bulatov, Ivan Chuikov, Kabakov, Igor Makarevich, Andrei Monastyrsky, and others founded and contributed works to the Out of Town Museum in a dacha outside Moscow, which had been used as the site of preparations for and discussions about the actions of the Collective Actions group. This museum fit into Zakharov's strategy of "functioning in culture." In

the words of the artist, the installation *The History of Russian Art—From the Avant-Garde to the Moscow School of Conceptualists* "represents an author's subjective classification of Russian art staged as a bureaucratic drama. The work at hand parodies all efforts at classification, and yet at the same time it demonstrates the impossibility of existing outside of our culture's bureaucratic language." The installation consists of five structures or "rooms" that look like archival boxes with metal grommets. Each room is labeled on the front with the names of significant movements in twentieth-century Russian and Soviet art and with a one-word subtitle: the avant-garde is "utopia," Socialist Realism is "ideology," and so on. The avant-garde room is intersected by a huge red triangle, a reference to El Lissitzky's *Beat the Whites with the Red Wedge* (1919). The three-dimensional archive truly comes to life—with the exception of the avant-garde room, which is separated from the other rooms and whose closed door bars entry even as it emits the sound of someone sleeping—once the spectator ascends white steps to enter the rooms, which function as mini-museums or galleries displaying reproductions of major artworks from each period. The facsimiles in the Socialist Realist room include two of the most iconic paintings, Isaak Brodsky's *V. I. Lenin in the Smolny* (1930, cat. no. 209) and Alexander Gerasimov's *Stalin and Voroshilov in the Kremlin* (1938), as well as Vladimir Serov's *The Winter Palace is Captured* (1954), which shows a scruffy Lenin and a fellow comrade-in-arms in the slightly damaged Winter Palace of the Hermitage, seized during the Revolution of October 1917, and a painting by Alexander Deineka of three nude women, *Game with a Ball* (1932), evocative of the three Graces from Greek mythology. The next room, which is entered by pulling aside a black curtain, uses slides and biographical videos to present work by nonconformist artists from the 1950s and 1960s, among them, Franciso Infante-Arana, Dmitry Krasnopetsev, Vladimir Nemukhin, Oskar Rabin, Mikhail Roginsky, Igor Shelkovsky, Shteinberg, Mikhail Shvartsman, Vladimir Veisberg, Vladimir Yakovlev, Vladimir Yankilevsky, and Yuri Zlotnikov. The Sots Art room includes reproductions of Vitaly Komar and Alexander Melamid's *Don't Babble* (1972) and *Quotation* (1974), Bulatov's *Glory to the CPSU* (1975), Rostislav Lebedev's sculpture *Made in the USSR* (1979), and Alexander Kosolapov's *Russian Revolutionary Porcelain 1* (1989). The final room, Moscow Conceptual School, has four shelves of actual archival boxes of the kind that the installation

structures simulate on a monumental scale; these boxes contain biographies and information about various artists that visitors can review. Here, the concept of an archive is literalized; these are the files of culture, the artifacts for study. For Zakharov, the files could have just as easily contained information on art from another country or time, as for him they stand for "the universal striving of humankind for the utopia of the eternal Archive." —VH

The following works have been added to the exhibition in New York:

Victor Alimpiev (b. 1973) and Sergei Vishnevsky (b. 1969), *The Deer*, 2002. DVD, 00:03:40. Collection of the artist

Victor Alimpiev (b. 1973), *Sweet Nightingale*, 2005. DVD, 00:06:44. Collection of the artist

Blue Soup (Alexei Dobrov, b. 1975; Daniil Lebedev, b. 1974; Alexander Lobanov, b. 1975), *Way Out,* 2004–05. DVD, 00:08:25, Edition of 5. Collection of the artists

Olga Chernysheva (b. 1962), *Tretyakov Gallery (Tretyakovka)*, 2002–05. DVD, 00:05:00, Edition of 5. Collection of the artist

Olga Chernysheva (b. 1962), *Russian Museum*, 2003–05. DVD, 00:05:40, Edition of 5. Collection of the artist

Dmitry Gutov (b. 1960), *Demonstration*, 2000. DVD, 00:09:00, Edition of 25. Collection of the artist

Dmitry Gutov (b. 1960), *From Flat to Flat*, 2002. DVD, 00:04:00, Edition of 25, Collection of the artist

Valery Koshlyakov (b. 1962), *Moscow University*, 1995. Tempera on cardboard, 330 x 190 cm, Collection of the artist

Vlad Monroe (b. 1969), *Pirate TV*, 1989–2005. DVD, TV, and gilded wood; DVD: Edition of 20. Collection of the artist

Tatiana Nazarenko (b. 1944), *Moscow Evening*, 1978. Oil on canvas, 160 x 180 cm, The State Tretyakov Gallery, Moscow

Pavel Peppershtein (b. 1966), *America*, 2005. Oil on canvas, 150 x 450 cm, Ekaterina and Vladimir Semenikhin Collection, Moscow

Pavel Peppershtein (b. 1966), *Flag in the Landscape*, 2005. Oil on canvas, 150 x 450 cm, Ekaterina and Vladimir Semenikhin Collection, Moscow

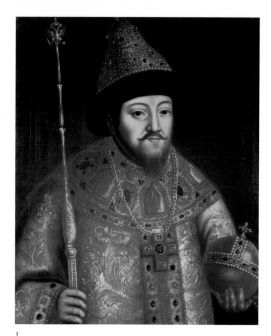

1

RUSSIA! THE MAJESTY OF THE TSARS: TREASURES FROM THE KREMLIN MUSEUM

GUGGENHEIM HERMITAGE MUSEUM, LAS VEGAS

THE TSAR AND HIS FAMILY

1. UNKNOWN ARTIST
Portrait of Tsar Mikhail Fedorovich, 18th century
Oil on canvas, 87 x 70 cm
(plate 1)

This portrait of Tsar Mikhail Fedorovich (1596–1645; reign 1613–45) must have been based on an imitation of the tsar's likeness that had been painted in the late seventeenth century by an unknown master of the Kremlin workshops. The portrait follows the rigid canons regulating the genre of ceremonial portraiture of the tsar, who was supposed to be represented with all the regalia of state. Tsar Mikhail Fedorovich is depicted in full ceremonial dress—in a *platno* (a special kind of loose, long garment that no one but the tsar was allowed to wear), with a special wide collar over his shoulders known as the *barmy* that was lavishly decorated with precious stones. The tsar is shown wearing a jewel-encrusted cross and a royal cap with fur trimming along the rim. In his hands are the scepter and orb, symbolizing the supreme power of the Russian sovereign ruler. —VC

2. *Staff*, Kremlin workshops, first quarter of the 17th century
Silver, precious stones, wood, and gold, L. 137 cm
(plate 6)

The staff had been an important attribute of the ceremonial costumes of the grand princes and then the tsars since

the early days of Old Russia. In the sixteenth and seventeenth centuries, the time when the monarchy was being consolidated and a corresponding court ceremonial established, the staff became one of the key symbols of sovereign power and status. It was not accidental, therefore, that young Mikhail Fedorovich Romanov consented to take the throne of Russia in 1613 by accepting a staff from the archimandrite of St. Hypatius Monastery in that monastery's Trinity Cathedral in the town of Kostroma. The royal staff of office shown here, from the first quarter of the seventeenth century, is most likely to have belonged to Tsar Mikhail Fedorovich. Made of wood, it is set in an embossed silver-gilt mount, with a top decorated with eagle heads. —IB

3. *Nalatnik of Tsar Mikhail Romanov*, Western Europe (?), before 1633
Satin, taffeta, and gold thread, L. 97.5 cm
(plate 7)

This is a unique specimen of Old Russian ceremonial dress and the only *nalatnik* that has survived to this day. It is a short, straight garment, unstitched at the sides and at the front, with a low neck and wide short sleeves, worn over ceremonial armor during various military ceremonies. Made of plain red satin and densely covered with silver curvilinear ornamentation arranged in intricate geometric patterns, it was known to have belonged to Tsar Mikhail Fedorovich Romanov. —IV

4. *Chain of the Grand Attire*, Western Europe, 16th century
Gold, L. 170 cm
(plate 3)

Such long gold chains were essential attributes of the ceremonial attire of medieval Russian sovereigns. As can be seen from the surviving wills of Muscovy's grand princes of the Rurik Dynasty, the earliest of which date from the first half of the fourteenth century, these gold chains were among the first items to be mentioned in the list of property and possessions that the eldest son was to inherit from a grand prince. From the mid-sixteenth century to the end of the seventeenth, such gold chains had the status of royal insignia and were used, alongside other regalia, in the ceremony of crowning the new tsar. This heavy gold chain, made of seventy-six filigree-work links of complicated shapes, is the earliest of all royal chains in the Armory collection. In the seventeenth century this chain was assigned a special status by being included in the so-called Grand Attire—a set of the most highly revered royal insignia. —IB

5. *Helmet*, Russia (?), 14th century
Steel, gold, and silver, H. 30 cm
(plate 9)

Among the numerous fine specimens of armor and weaponry that were kept in the royal treasure houses, sumptuously decorated helmets must have occupied a position of honor, since they crowned the sovereign's head during the most important military ceremonies. This helmet, entirely covered with incised silver ornamentation and featuring a beautifully executed representation of a

seven-figure Deesis (a canonical group depicting Christ flanked by saints), is a rare and truly remarkable specimen of military headgear. It is unparalleled in shape and décor. The presence on its surface of inscriptions in Greek, alongside the Russian ones, suggests that the helmet must have been made in Russia with the participation of Greek masters. It is evident that this richly decorated helmet was made for a grand prince, in all likelihood Dmitry Donskoy, under whose leadership and command Russian troops defeated the Mongols in 1380, thus beginning the process of Russia's liberation from the heavy Mongol yoke that had lasted for over a hundred and fifty years. —MM

6. *Ambassadorial axe*, Moscow, first half of the 17th century
Gold, silver, damask steel, gold, turquoise, and wood, L. 98 cm
(plate 10)

7. *Ambassadorial axe*, Moscow, first half of the 17th century
Gold, silver, damask steel, gold, turquoise, and wood, L. 99 cm
(plate 11)

In sixteenth- and seventeenth-century Russian records, ambassadorial axes are mentioned among the accoutrements of the tsar's bodyguards, known in Old Russia as *ryndas*. Despite its battle-worthy blade, this kind of axe was used exclusively as a ceremonial weapon, and the description "ambassadorial" signaled its ceremonial function. Throughout the seventeenth century, axe-bearing *ryndas* were an ever-present feature of all formal diplomatic receptions, during which they would stand—four at a time—by the tsar's throne. Ambassadorial axes were sometimes also called "gold" or "regal" axes, and it is these epithets that give

2 3

4 5

us a clear idea of their significance in the Russian court ceremonial. Both axes on display are decorated with gold-incised heraldic representations of double-headed eagles with crowns over their heads and blazons on their chests showing a unicorn on one side of the blade and a horseman slaying a dragon on the other side. The use of these motifs, reminiscent of the Russian state heraldry of the sixteenth century, suggests a broader time span during which these axes could have been made than is usually supposed. The pair of axes on display belongs to a set of four identical ambassadorial axes slightly differing in dimensions (all in all there are eight specimens of this weapon in the Armory collection). It is interesting that a weapon of this kind was not known—and did not play such an important role—in any of Russia's neighboring countries. So it would not be an exaggeration to describe the surviving specimens of ambassadorial axes as unique. —AC

8. Pendant, Moscow, late 17th century
Gold, precious stones, and enamel, 11 x 9.5 cm
(plate 5)

This gold pendant is fashioned in the shape of the Russian state emblem, the double-headed eagle with a crown over and between the two heads. The double-headed eagle was adopted as Russia's state emblem in the late fifteenth century under Grand Prince Ivan III. It is possible that the ruler of Muscovy had borrowed that image from the Byzantine Empire, where it had featured in the family crest of the Paleologos Dynasty; the Moscow ruling house considered itself to be the lawful successor to the Paleologos Dynasty after the fall of Byzantium in 1453. The pendant is decorated on the front with sparkling emeralds and blood-red rubies, while its reverse side is painted with black-and-white enamels imitating an eagle's feathering. There is no doubt that this outstanding piece of the seventeenth-century Kremlin goldsmiths' workmanship was used for the adornment of the tsar's ceremonial dress. —IB

9. Dress decorations from a kaftan of Tsar Ivan Alexeevich, Istanbul, second half of the 17th century
Gold, precious stones, enamel, and silk fabric, 80 x 8.5 cm
(plate 2)

A traditional type of decoration used to adorn ceremonial royal dress consisted of gold, gem-encrusted ornaments that were sewn along the flaps and around the hemline of the tsar's garments. Such decorations were known as zaponas, and they entered the royal treasuries from the world's most famous jewelry-making centers. The set of gold zaponas of Turkish workmanship shown here once adorned a festive kaftan of Tsar Fedor Alexeevich and later his younger brother Ivan. The beautifully decorative openwork zaponas, shaped as pomegranate blossoms or fruit and encrusted with diamonds, rubies, emeralds, and polychrome enamels, were a perfect match to the splendor that surrounded the tsar during the state ceremonies of the seventeenth century. —IV

10. Pectoral cross (front and back), Russia, last quarter of the 17th century

6, 7 8 11

Gold, precious stones, and enamel, 15.6 x 10.7 cm
(plate 8)

This highly decorative, gem-encrusted gold cross belonged to Tsar Peter Alexeevich, also known as Peter I or Peter the Great. This attribution is supported by the enameled representation of the Apostle Peter, the tsar's patron saint, on the reverse side of the cross. The center of its front side is studded with a small appliqué cross-fashioned of magnificent emeralds of varying shapes and cuts and decorated with openwork enameled foliate ornamentation. The shape and décor of the emerald cross suggest Western European workmanship of the sixteenth or seventeenth century, while the crucifix engraved on one emerald and the word "Nika" on another are undoubtedly of Russian origin and possibly also date from the late seventeenth century. —IB

11. Chain, Russia, first half of the 17th century
Gold and enamel, L. 116 cm
(plate 4)

The Kremlin Armory collection includes a number of royal chains of Russian workmanship. They are all similar in the way they are made and consist of several dozen large flat rings linked with one another. So that such chains would keep their shape, they were sewn onto silk ribbons. These chains are well known from the surviving seventeenth-century portraits of the Romanov Dynasty members, and this splendid chain is decorated with a white enameled pattern. It is mentioned in the inventory of the royal treasury compiled in the second half of the seventeenth century, which suggests that it was owned by Tsar Mikhail Fedorovich. —IB

12. St. Mikhail Malein, Moscow, first half of the 17th century
Wood, gesso, tempera, pearls, gold, niello, precious stones, and stones, 28.4 x 31.8 cm
(plate 12)

St. Mikhail Malein was the patron saint of Tsar Mikhail Fedorovich Romanov. The gold frame, or mount, of the icon is decorated with round cabochons in embossed sockets, with fine embossed patterns and niello-work ornamentation, which suggests the influence of elaborate oriental arabesques. It is characteristic of the Kremlin jewelers' style and workmanship. Before the icon found its way into the

Armory Museum, it had been in the Archangel Cathedral of the Moscow Kremlin—until the early eighteenth century the burial church of Russian grand princes and tsars. It had formed part of a separate iconostasis on the wall near the tomb of Tsar Mikhail Fedorovich. —MM

13. Our Lady of Vladimir, Russia, 16th century
Wood, canvas, gesso, tempera, silver, gold, precious stones, glass, damask, and enamel, 38 x 31.8 cm
(plate 13)

Versions of the original Our Lady of Vladimir (also known as The Virgin of Vladimir) were among the most common Russian icons, and all of them were replicas or imitations of the Byzantine icon showing the Virgin with the Christ child affectionately pressing his cheek to hers. In Byzantium this icon was known as Eleousa, which in Russian corresponds to the name Umilenie; both of these words roughly translate into English as "affectionate tenderness." The icon was sent by the Patriarch of

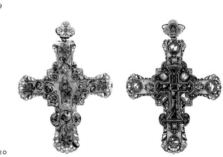

9

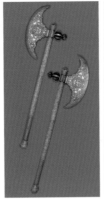

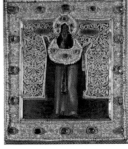
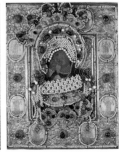

10

12 13

Constantinople as a gift for the Kiev Prince Yuri the Long Armed in 1131. In 1155 his son, Prince Andrei, moved the icon to the main city of his appanage, Vladimir. It was that city that gave the icon its second name, *Our Lady of Vladimir*, as it has since been known in Russia. In 1395 the icon was brought to Moscow, where it gained fame due to the many miracles associated with it, and it was soon turned into an object of worship throughout Russia. The *Our Lady of Vladimir* shown here is mounted in a precious frame, which, in accordance with the Russian tradition, dating back to Byzantine times, symbolizes particular reverence for the image in the icon. Standing out in the sumptuous décor of the icon are the beautiful long pendants, or *ryasny*, made of strings of pearls with enameled medallions. In Old Russia such pendants were among the most popular ornaments, and Russian women wore them attached to their headdresses. *Ryasny* were also often "presented" by women to icons of the Virgin in the hopes of securing her help and protection. —IB

14. St. John of Belgorod, Moscow, 1633
Wood, gesso, tempera, silver, gold, and fabric, 49.2 x 16.5 cm
(plate 38)

A measuring icon, *St. John of Belgorod* represents the patron saint of Tsarevich Ivan Mikhailovich, son of Tsar Mikhail Fedorovich, who was born in 1633 and died at the age of six. Measuring icons first appeared in Russia in the second half of the sixteenth century. They were so called because they were painted on the occasion of a baby's birth, and their height corresponded to the baby's head-to-toe measurement. Painted on narrow panels, these icons showed full-length images of the saint in whose name the baby was christened. The upper part of the panel traditionally featured a representation of the Holy Trinity. Each new member of the royal family received a measuring icon at birth and it accompanied him or her throughout life, being kept in the private chapel in the palace. Not even death could completely part the icon and its owner, for it would accompany the deceased into the family crypt in the Archangel Cathedral to be placed over his or her tomb. —VF

15. Child's suit of armor, Russia, second half of the 17th century

Iron, brass, and leather, helmet: H. 27 cm; cuirass: L. 31 cm; tabard: L. 44 cm
(plate 32)

This suit of armor is most likely to have been made in Russia and meant for a Russian tsarevich, a son of one of the tsars. The royal children were taught to read and write and were introduced to their country's history with the help of so-called "amusement books," something like children's encyclopedias of today. Illustrated by the court painters, they included many pictures of battles scenes and weaponry, which, together with war toys and war games, must have greatly appealed to the royal boys. Decorated with cast brass relief plates, this child's suit of armor was a very expensive toy, and was for a long time kept in the Armory. It must have been tried on by the children of Tsar Alexei Mikhailovich, among them the future Russian Emperor Peter the Great. —EY

16. Child's flintlock carbine, Russia, 17th century
Iron, steel, and wood, barrel: L. 29.8 cm; caliber: 10 mm; total: L. 47.5 cm
(plate 34)

In the Armory inventory of 1687, this miniature weapon was entered as "little carbine." And indeed, despite the musket-type butt, it is a miniature replica of the Russian seventeenth-century carbine. The fact that this remarkable piece of weaponry is among the first of the items in the royal inventory suggests that it had been crafted especially for the royal children—probably in the 1670s or early 1680s. We know from various sources of the time that in accordance with the principles of military training that formed part of the royal sons' upbringing, they would receive gifts of so-called "amusement weapons"— brightly painted toys with wooden barrels and wooden blades—as early as two or three years of age. This carbine, however, is a real and perfectly functional firearm, and the numerous scratches on the steel of its flintlock suggest that it had been fired many times. —AC

17. Child's musket, Amsterdam (?), 1650s–60s
Wood, iron, silver, steel, gold, and tortoise shell, barrel: L. 40.6 cm; caliber: 11 mm; total: L. 62 cm
(plate 35)

War toys and armament for the royal children's games— banners and drums, *partizans* (spears) and miniature cannons, pistols and guns—were made by the gunsmiths and painters of the Kremlin Armory. Apart from "amusement weapons," as wooden cannons and rifles were called, the tsar's sons would possess miniature replicas of battle and hunting weapons. Such weapons were also manufactured by professional Kremlin gunsmiths, although occasionally they could be purchased from abroad. Unfortunately we do not know when and which of the tsareviches (the tsar's sons) received this Dutch match musket. Every detail—the lock, the barrel, and the elegant stock with its tortoiseshell plating—is executed with meticulous care. The butt is shaped in the way typical of Western European muskets and has a notch for the thumb in the upper part. —EY

18. Child's saddle, Germany, 17th century
Silver, wood, velvet, copper, leather, textile, and iron, L. 39 cm
(plate 36)

19. Pair of stirrups, Germany, 17th century
Silver, H. 10.3 cm
(plate 36)

From the first years of their lives, Russia's future tsars began practicing the art of warfare. Particular importance was attached to equestrian skills. The workshops of the Kremlin Stables Office produced small saddles and matching tack for the young sons of the tsars, and those articles that have survived to this day are now in the safe-keeping of the Armory Museum. The earliest surviving document, referring to the manufacture of such saddles for Tsarevich Alexei Mikhailovich, dates from 1642. Upholstered with crimson velvet, the saddle has roller-shaped padding in the back, ensuring greater stability for the rider—a feature characteristic of Western saddles. The miniature gilded stirrups with carved decoration at the base are in tune with the gilded knob of the pommel. The saddle might have been purchased in Germany and brought to Moscow to be presented to the tsar, or it may have been fashioned in the Kremlin workshops in imitation of Western models, an explanation supported by the varicolored braiding used in the decoration, which was the same as the braiding used on Russian saddles produced by the craftsmen of the Stable Office. —OM

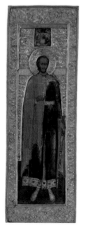

14 15 16, 17 18, 19

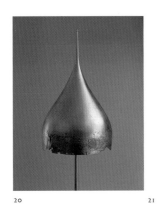

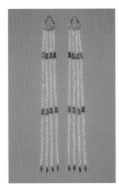

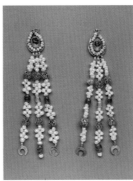

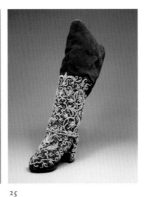

20 21 23 24 25 22

20. *Helmet of Tsar Ivan Ivanovich*, Moscow, 1557
Iron and gold, H. 18.3 cm
(plate 37)

The helmet shown here is one of the rarest specimens in the Kremlin collection of arms and armor. It is fashioned as a real battle helmet, of an elegant lancet shape and with a tall pinnacle for attaching a pennon, or long banner. Such helmets were known in Russia as *sheloms* (hence the contemporary word for helmet, *shlem*). Yet this helmet is small and was meant for a little boy. The gold-incised inscriptions in four oblong medallions on the body of the helmet indicate that it was made in July 1557, on the order of Tsar Ivan the Terrible for his three-year-old son, Tsarevich Ivan Ivanovich. The helmet also bears fragments of a gold-incised decorative pattern and figures of lions and double-headed eagles. —EY

21. *Child's halberd*, Russia, late 17th century
Iron, wood, and paint, L. 107 cm
(plate 33)

By the seventeenth century, the halberd had become virtually obsolete as a battle weapon. Nevertheless, this type of pole weapon did not fall out of fashion completely and was widely used as part of ceremonial accoutrement. The Kremlin guard was still armed with halberds in the seventeenth century. This halberd, judging by its size, was made as a child's weapon like the musket (cat. no. 16) and flintlock carbine (cat. no. 17) also shown here. It was undoubtedly used in the war games played by the young tsareviches in the late seventeenth century: the sharp tips of the little serpent-shaped axe and the beak are prudently blunted. —AC

22. *Cap of Tsarina Anastasia Romanovna*, Moscow, late 16th century
Gold and silver thread, satin, gossamer, and silk lace, H. 16.3 cm
(plate 28)

A *volosnik* (from the Russian word *volosy*, meaning "hair") is a small cap covering the back of the head and part of the forehead. It was worn by Russian married women, who were supposed to carefully hide their hair—even in the privacy of their homes. As a rule, such caps were made with bobbins or knitted with a special crochet hook out of silk and gold thread. The forehead part of the cap was made of colored fabric and decorated with embroidery.

Worn right after the wedding, the *volosnik* was therefore a kind of token accessory of marriage. At the same time, it was also an element of the traditional funeral attire. This *volosnik* had belonged to Tsarina Anastasia Romanovna, Ivan the Terrible's favorite wife, who died in 1560. —IV

23. *Pair of decorative pendants*, Russia, 16th century
Silver, pearls, and gold, L. 43.4 cm
(plate 25)

24. *Pair of decorative pendants*, Russia, 15th–16th century
Gold, silver, pearls, and glass, L. 11 cm
(plate 16)

Such long, shoulder-length pendants as the pairs shown here were part of the ceremonial headgear of Russian tsarinas and tsarevnas (the tsar's daughters or unmarried sisters). They were attached to the headdress on either side, or simply fastened to the beautiful band worn around the forehead. In the sixteenth and seventeenth centuries, such pendants were generally made of several strings of pearls entwined together. The most luxurious *ryasny* were adorned with precious stones and gold pendants. —IV

25. *Boot*, Russia, second half of the 17th century
Velvet, leather, golden cord, golden lace, cotton thread, and pearls, H. 56 cm
(plate 26)

Fashioned of dark-red velvet and lavishly decorated with pearl embroidery, this boot is an extremely rare specimen of Old Russian festive footwear. As in the rest of Europe in the Middle Ages, in seventeenth-century Russia there was nothing like the variety of footwear we know today. Boots of varying height—from ankle-high to knee-high—were the principal kind of footgear. Both women's and men's boots were made without differentiating the right and the left foot, with equally broad soles, loose-fitting tops, and steady, medium-height heels. Boots for the outdoors were made of leather; boots for indoors were made of various fabrics, either plain or patterned. Festive footwear, especially for the tsar and his family, was sumptuously decorated with pearl embroidery, precious stones, and gold braiding in the parts that would show from under the long garments. —IV

26. *Pair of ladies' shoes*, Russia, 17th century
Velvet, leather, iron, white metal, golden cord, silk cord, damask, and paillette, L. 21 cm each
(plate 27)

Such shoes were traditionally worn by Russian noblewomen in the seventeenth century. Shoes intended for members of the royal family were typically made of morocco leather, satin, or velvet and often decorated with gold embroidery, pearls and precious stones. The late sixteenth century saw the appearance of the stacked heel, and in the first quarter of the next century the heel reached 7 or 8 centimeters in height. These shoes from the Armory collection, which probably belonged to a woman from the Romanov Dynasty, were originally embroidered with pearls (now lost). The high narrow heels are stacked pieces of leather tapped with white metal plates. —NB

27. *Pectoral cross with 12th century Byzantine cameo*, Moscow, 16th century
Gold, precious stones, pearls, silver, and enamel, 8.3 x 5.5 cm
(plate 19)

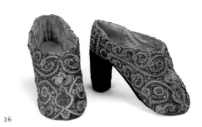

26

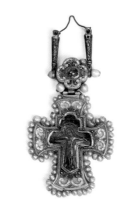

27

29

30

28

31

Buttons had a special place in the décor of Old Russian clothing, both men's and women's. The shape, size, and technique of manufacture and decoration were extremely varied. Buttons for the royal dress were made of gold, gems, or glass beads imitating precious stones. Such buttons were not only beautiful to look at but very expensive as well and sometimes cost more than the garment they adorned. The number of decorative buttons on one garment varied and was often quite large. An inventory of Ivan the Terrible's possessions lists one particular garment with sixty-eight buttons with niello-work decoration. In the sixteenth and seventeenth centuries, precious buttons were sewn not only onto clothes but onto headgear as well. There was also a special type of "necklace button" meant for fastening the collar. —IB

29. Ring, Moscow, 17th century
Gold, precious stones, and enamel, Diam. 2 cm
(plate 30)

Rings are among the most ancient kinds of personal ornaments, and high-ranking men and women in Old Russia wore rings decorated with precious stones, enamels, or niello work; such a ring would often be on every finger of each hand. Precious rings were a common gift for christenings, weddings, or name days. This elegant gold ring, with its fine decoration of gems and enameled floral motifs, could have been made to be presented as such a gift. Its precious décor and its provenance from the Kremlin treasure-house suggest that the recipient of that gift was a member of the royal family. —IB

30. Earrings, Russia, 17th century
Silver, sapphires, and gold, 6 x 2.5 cm each
(plate 29)

In Old Russia earrings were among the most popular personal ornaments and were favored by both women and men, the only difference being that men never wore earrings on both ears at the same time. The demand for earrings was very high, and they were produced in such quantities that in the sixteenth and seventeenth centuries there was a special category of silversmiths known as "earring makers." Both the shapes and the décor of earrings produced during that period were extremely varied. The simplest earring consisted of a wire ring to which several wire "rods" strung with metal, glass, or stone beads were attached. Along with this common kind of earring were far more elaborately fashioned and ingeniously decorated earrings worn by members of the nobility, the court, and the royal family. A vivid example of such ornaments is the pair of magnificent earrings on display, which had once been in the safekeeping of the Kremlin treasury. —IB

31. Casket, Solvychegodsk, late 17th century
Silver and enamel, H. 12.7 cm
(plate 18)

Caskets of varying size were used in Russia for keeping jewelry and all manner of toiletries. They were usually fashioned as rectangular boxes supported on short legs and supplied with a hipped lid on a hinge. Identical in shape, they were varied in their decoration and the materials used. The caskets produced in the seventeenth century in

the town of Solvychegodsk were made of silver and embellished with brightly colored polychrome enamels—a distinctive feature of many works by Solvychegodsk's goldsmiths. —IB

32. Plaque from the icon cover of the Holy Virgin, Russia, 17th century
Gold, precious stones, and rosin, 5.5 x 4.7 cm
(plate 24)

33. Plaque from the icon cover of the Holy Virgin, Russia, 17th century
Gold, precious stones, and enamel, W. 8.2 cm
(plate 22)

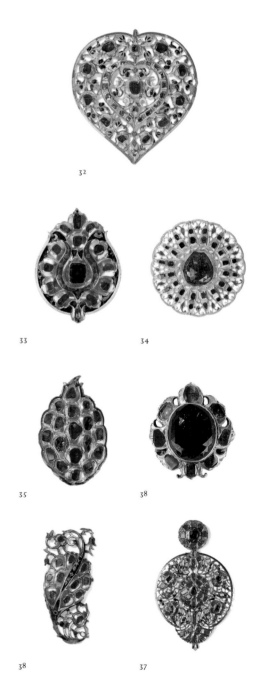

32

33 34

35 38

38 37

According to inventories of the royal family's possessions, the gold pectoral cross with the crucifix on a precious sapphire cameo was a christening gift from Tsarina Evdokia (wife of Tsar Mikhail Fedorovich) to her eldest daughter, Irina, born in 1627. The mount of the cross displays the fine artistry and taste characteristic of the Kremlin goldsmiths: the skillfully chosen colors of the enamels match the deep hue of the sapphire beautifully, while the pearl framing of the mount endows it with a kind of exquisite lightness. This cross, executed by the court masters in the second half of the sixteenth century for Ivan the Terrible, one of the last tsars in the ancient Rurik Dynasty, later became a precious possession of the founder of the new dynasty, Tsar Mikhail Fedorovich Romanov, to whom this cross symbolized the continuity of power and his blood links with the tsars of the Rurik line. —VF

28. Buttons, Kremlin workshops, first half of the 17th century
Gold, precious stones, and enamel, 5.5 x 3 cm
(plates 14, 15)

34. *Plaque from the icon cover of the Holy Virgin,* Russia, 17th century
Gold, rubies, rosin, and enamel, 6 x 3.7 cm
(plate 20)

35. *Plaque from the icon cover of the Holy Virgin,* Russia, 17th century
Gold, precious stones, rosin, and enamel, 7.8 x 8.1 cm
(plate 23)

36. *Plaque,* Russia, 17th century
Gold, precious stones, rosin, and enamel, 7.7 x 5.9 cm
(plate 21)

37. *Plaque,* Turkey, 17th century
Gold, precious stones, foil, and enamel, L. 14.2 cm
(plate 17)

38. *Plaque,* Turkey, 17th century
Gold, precious stones, and enamel 7.5 x 3.5 cm
(plate 31)

The word *zapona* was used in Old Russia to refer to types of jewelry used to decorate the ceremonial outfits of Russian tsars and the heads of the Russian church, and which also served as decorations of particularly revered icons in churches and in the domestic chapels of the royal family. The plaques shown here are splendid specimens of Russian and Turkish jewelry making. Their shapes—a pomegranate blossom and fruit, a multipetal rosette, and a large fan, among others—as well as the characteristic stylization of foliate motifs, betray an obvious oriental influence. Two of the plaques were in fact crafted in Istanbul ("Tsargrad" or "Constantinople," as it was called in Russia). Throughout the seventeenth century, Ottoman merchants, most of whom were of Greek origin, came to Moscow to sell precious fabrics and various luxury goods to the Russian court. Among their merchandise were such plaques. Their Kremlin customers gave Greek traders a warm welcome and offered generous payment for their goods, as they were people of the same faith, not to mention useful informants who brought news of the sultan's court and of his military plans. Precious ornaments were also, of course, supplied to the Russian court by royal goldsmiths, among whom there were both Russian and foreign masters. They did not only restore and repair foreign articles but produced a great deal of their own original works, often modeled on luxury goods from the East. There are numerous entries in the surviving records of the time that describe such objects. Precious stones of superior quality and remarkable beauty—like those used in the *zaponas* on display—were in those days mined in India and Southeast Asia. From there they were shipped to Istanbul, then the world's largest market for jewelry-making materials, where they were cut, mounted in precious metals, complemented with enameled décor, and exported to various countries as objects of luxury merchandise. In Moscow such articles were not only willingly purchased but also willingly received as gifts from foreign merchants and diplomats. —IZ

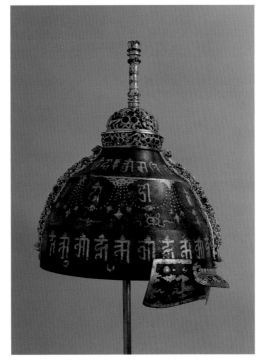

39

WAR AND THE HUNT

39. *Helmet of Tsar Mikhail Fedorovich,* Manchuria, before 1638
Iron, gold, and semi-precious stones, H. 19.5 cm
(plate 40)

The appearance of this helmet in the Kremlin royal treasury is associated with the Russian expansion into Siberia, which occurred in the seventeenth century. In the first half of the century, Russia annexed the lands east of the River Yenisei that were inhabited by Tungus tribes (contemporary name *Evenki*). This helmet arrived in Moscow, in 1638, as part of the tribute sent to the Russian tsar from the "Tungus land." The seventeenth-century Armory inventories mention velvet- and silk-lined metal plates that were attached to the lower rim of the helmet as additional protection—a typical detail of Manchurian battle helmets of the time. The surface of the helmet and its forehead plate are decorated with gold-incised ornamentation, featuring a dragon, clouds, and rain. The gilded inscription is the Buddhist mantra *Om Mani Padme Hum.* Covering the helmet's seams are openwork "combs." The openwork visor and peak are decorated with colored gems. The tube at the peak supported the plume. —IK

40. *Shield,* Kremlin workshops, early 17th century
Iron, copper, silver, fabric, steel, and gold, Diam. 54.5 cm
(plate 68)

The Armory inventory of 1686–87 contains the first reference to this remarkable *tarch*, or shield, with an attached iron "sleeve." According to that reference, the shield was covered with niello-work ornamentation and a sword blade was fastened to the sleeve (the brace for the sword

still survives today). The silver rings on the inside of the shield had a white, yellow, and black tasseled cord attached to them. There is no parallel to this shield in the entire Russian defensive arsenal registered or mentioned in seventeenth- and eighteenth-century sources. In Western European countries, shields that could be deployed both as defensive and offensive arms were mainly used when fighting in narrow trenches (hence their better-known name, "trench shields"). Apart from the blade, which prevented the opponent from coming too close, this shield could also be equipped with a pistol and a lantern for nighttime combat. The decoration of the Kremlin *tarch* is similar to quite a number of pieces of defensive armor owned by Russian tsars in the seventeenth century (for example, the Hussar armor suit, as well as some bracers and helmets). All these articles were crafted in the Kremlin workshops, although they were obviously fashioned after Western European models. —IK

41. *Shirt of mail and plates,* Russia, late 16th–early 17th centuries
Damask steel, iron, silver, gold, and leather, L. 70 cm
(plate 39)

A variant of a Persian word combination, *yushman* was used in seventeenth-century Russia to refer to a shirt of mail reinforced on the back and the chest with metal plates. According to the Armory inventory of 1686, this *yushman* entered the royal arsenal in 1655, upon the death of Nikita Romanov, cousin to Tsar Mikhail Fedorovich and, consequently, first cousin once removed to Tsar Alexei Mikhailovich. Nikita Romanov had died childless,

40

41

and his estate and possessions were divided between the royal and the patriarchal repositories, and also donated to churches and monasteries. Nearly all his weaponry went into the Kremlin Armory. This *yushman* is fortified on the chest with twenty large plates, and with fifty smaller ones on the back. The plates are decorated with gold- and silver-incised ornamentation. According to seventeenth- and eighteenth-century records, the *yushman* was supplied with shoulder plates, and the neckline was reinforced with leather straps strung through the links of the mail. —IK

42. *Rein chain*, Kremlin workshops, 17th century
Silver, gold, and metal, L. 455 cm
(plate 48)

Over 4 meters long, this heavy chain consists of two parallel lengths of cast-silver links. Each link is adorned with a carved pattern, and every other link is gilded. The middle of the chain, or collar, embraced the horse's neck like a necklace. This collar is decorated with a small gilded badge, featuring a double-headed eagle. Flanking the collar, the chains hung in symmetrical semi-circles down the horse's sides like reins, hence the name "rein chains." The two chain lengths are fastened together in several places with openwork silver balls with bells inside, which jingled when the horse was moving. In sixteenth- and seventeenth-century Russia, such "rein chains" and "jingling chains" were indispensable accessories of "Grand Horse Attire." They were used on the most special ceremonial occasions, decorating the mounts and the parade horses of the tsar and noblemen. The rattling and jingling of the silver horse chains fascinated spectators, especially foreigners, some of whom described these unusual decorations in their recollections of Russia. —OM

43. *Neck tassel*, Kremlin workshops, 17th century
Silver, glass, textile, and gold thread, L. 72 cm
(plate 55)

The use of neck tassels to decorate horses was a very old practice. The earliest tassels, which were small and made of horsehair or colored thread, served as amulets. Eventually tassels became signs of distinction for valor in battle and symbols of authority and rank. In seventeenth-century Russia, a neck tassel, or *nauz*, sometimes 70 or 80 centimeters long, was an essential element of "Grand Horse Attire." It could decorate only the tsar's or the *boyars'* (noblemen's), horses, and was used for only the most solemn and special court ceremonies. Both weaponry and horse attire from the royal treasury sometimes feature the double-headed eagle of the Russian state emblem, as well as depictions of heraldic lions and unicorns. But a *nauz* actually *terminating* in a double-headed eagle, as is evident in this example, is unique and has no parallel in any museum collection. The eagle is cast of silver, its body and outstretched wings are studded with colored glass, and the feathering is rendered by means of embossing. Instead of a single, long tassel, the *nauz* consists of nine smaller ones made of silver thread and arranged in three tiers, suspended on three silk cords. —OM

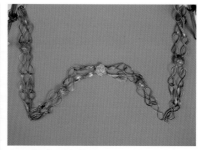

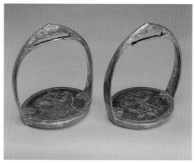

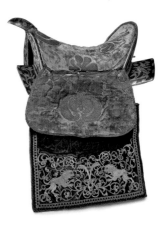

44. ANDREI PAVLOV (?)
Hussar (?) saddle, Kremlin workshops, 1677 or 1682
Silver, wood, velvet, leather, copper, galloon, textile, iron, gold, and niello, L. 47 cm
(plate 45)

The most important and most joyful feast in Orthodox Russia was Easter. During Easter Week, the tsar traditionally received gifts from his subjects. The Kremlin craftsmen—goldsmiths, armorers, and saddlers—were invariably among those bearing gifts, and they put all their talent and skill into the articles fashioned for the tsar. In the spring of 1677, the Silver Chamber masters Andrei Pavlov and Mikhail Mikhailov were engaged in decorating silver-gilt mounts. In 1682, the same masters are known to have been applying niello work to three silver-framed saddles and to several silver bridles and sabers—all presented to Tsar Fedor Alexeevich. This saddle, therefore, is probably one of the gifts received by the tsar from his silversmiths. The seat is upholstered with Italian velvet, and its rectangular flaps feature a gold and silver embroidered pattern of lions amidst foliage on a scarlet velvet background. Standing out against the niello-work background of the silver mounts is a gold-incised pattern representing grass and falcons. —OM

45. *Pair of stirrups*, Moscow, second half of the 17th century
Silver, iron, and gold, H. 17 cm each
(plate 43)

These stirrups, with slender bow-shaped sides and oval footrests, are plated with gilded silver. The stirrups' sides are engraved with fine foliate patterns, while each of the footrests features an engraved double-headed eagle. Such stirrups were fashioned exclusively for the saddles used by the tsar. —LK

46. *Flintlock gun*, Utrecht, 1640s–50s
Ebony, copper, steel, and gold, barrel: L. 70.5 cm; caliber: 16.5 mm; total: L. 103.5 cm
(plate 56)

This Dutch hunting gun is one of the most remarkable specimens of weaponry-making art. Its decoration is distinguished by a characteristically Baroque abundance of three-dimensional ornamental elements. Near the ramrod groove there is a sea-monster's head, and the butt is decorated with a macaroon in the framing of acanthus leaves. Each of the two cheek-pieces is adorned with a fantastic creature—a combination of a dolphin's head and a twisted snake's body. The butt plate features two cast figurines: a horseman with a sword fighting a dragon (possibly St. George), and a male figure in a loose full-length garment, with a sword in his hand (possibly St. Paul with his "spiritual sword"). The barrel is gilded and embellished with a stylized foliate motif on a background of tiny circles. The carbine is supplied with an Anglo-Dutch lock. The proportions of this gun are strikingly elegant, and its carved ornamentation displays skillful workmanship and exquisite finish. Through the juxtaposition of highly polished ebony and gilded surfaces, the Dutch gunsmith created a genuine masterpiece. —EY

47. *Double-barreled flintlock pistol*, Holland, 1650s–60s
Wood, iron, copper, and steel, barrel: L. 35.5 cm; caliber: 14 mm; total: L. 53.5 cm
(plate 64)

48. *Double-barreled flintlock pistol*, Holland, 1650s–60s
Iron, ebony, and copper, barrel: L. 35.5 cm; caliber: 14 mm; total: L. 53.5 cm
(plate 63)

The Armory collection includes a large array of seventeenth-century firearms outfitted with sophisticated ignition devices for the time. Among them there are multibarreled guns, breech-loading guns, revolver guns,

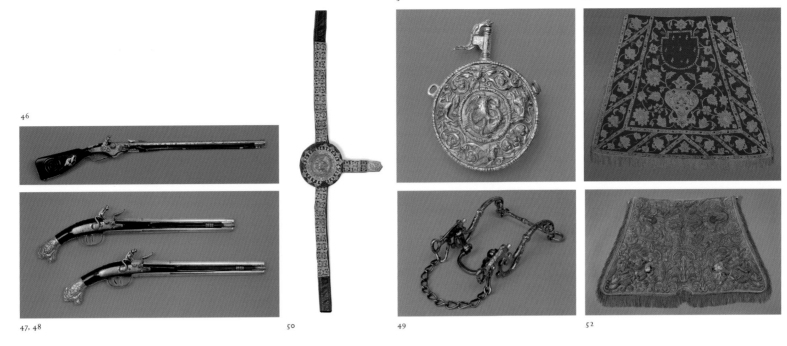

46

47, 48

50

51

49

53

52

and pistols. This variety is evidence of the great appeal that the technical innovations in Western European weaponry-making had for Russian aristocracy. Quite often specimens of advanced firearms were purchased abroad for the tsar's armories. It is known that on one such occasion, in 1657, Tsar Alexei Mikhailovich commissioned one John Gebdon ("Ivan Gebdon" in Russian sources) to purchase Dutch "two-cock" pistols (i.e., double-barreled flintlock pistols) with ebony stocks and gilded butt plates in the shape of griffin heads. Gebdon might have brought the two double-barreled Dutch pistols shown here to the tsar. Their appearance and design accurately meet the description of the tsar's commission—the only difference is that the gilded bronze butt plates are cast in the shapes of helmeted dog heads rather than griffins. The dogs' helmets are adorned with cast lizards or salamanders. —E Y

49. Curb bit, Kremlin workshops, 17th century
Silver, iron, and gold, 19 x 12 cm
(plate 50)

The progress of a ceremonial procession was slow, solemn, and orderly. The chief merit of a royal horse was not its speed but the stateliness of its movements, and its obedience to the rider or the groom who led it by the bridle. Strict control over the horse was ensured by a curb bit, with reins attached to the bridle's leather straps. The bit's curved iron mouthpiece created pressure as the reins were pulled, thus forcing the horse to move, turn, or stop. The pressure of the mouthpiece was enforced by the side extensions, to which additional reins were attached. A playful or fast horse could be curbed by fastening the jaw chain. This curb bit is not only functional but also very ornate. Its carved extensions are covered with welded silver, gilding, and carved ornamentation. —O M

50. Chest straps for a horse, Kremlin workshops, 17th century
Silver, leather, iron, and gold, W. of straps 3 cm
(plate 47)

The *paperst*, or set of breast straps, was an essential detail of horse tack. Together with the girth and the crupper, the *paperst* kept the saddle in place on the horse's back, but it also served as an ornament. Executed by Kremlin masters, this *paperst* consists of two long straps that where attached to the front of the saddle and one short strap with an embossed silver terminal featuring birds amidst foliage. The straps are decorated with openwork silver plates, every other of which is gilded. The central badge at the junction of the two straps is round, with an openwork design around the edge and an embossed representation of a fight between an eagle and a dragon. This was a common motif in Old Russian art, symbolizing the battle of good and evil. Representations of this motif can be found on other pieces of military accoutrements, including another gunpowder flask shown here (cat. no. 51). —O M

51. Priming gunpowder flask, Moscow, 1660
Silver and gold, H. 12.3 cm
(plate 65)

Like gunpowder flasks, priming flasks were indispensable to the gunman and the gun-bearing huntsman. They were smaller in size than gunpowder flasks and were meant for keeping higher-quality priming powder that was placed in the flintlock's pan of a muzzleloader as part of the charging process. This silver flask—a brilliant example of Russian court art in the seventeenth-century—is exquisitely decorated with a high-relief embossment pattern. The representation of St. George on the flask's reverse side clearly betrays Western European influence. But the animal combat scene on its front—an eagle fighting a dragon—was a popular motif in Russian decorative arts of the time, being perceived as an allusion to the history of the Byzantine Empire. According to a popular legend,

the capital of the Eastern Roman Empire was founded by Emperor Constantine on the site where he had witnessed combat between an eagle and a dragon, which he interpreted as a battle between Christian Orthodoxy and heresy. The inscription along the flask's rim reveals that its owner in the seventeenth century was an important Armory official. The spring that pressed the hinged dragon-shaped lid to the mouth of the flask is now lost, and so are the cords that were used to attach the flask to the waist-belt. —A C

52. Saddlecloth, Germany, last quarter of the 17th century
Satin, gold thread, silk thread, and glass, 80 x 50 cm
(plate 51)

A saddlecloth is a type of caparison used to cover the croup of a horse. This saddlecloth was no doubt intended for ceremonial use. It is decorated with magnificent high-relief gold embroidery, featuring pomegranate and dog-rose blossoms, tulips, and large leaves. Decorating the saddlecloth's corners are two horsemen with sabers. One is dressed in European costume, and the other in oriental clothes, with a turban on his head. In the seventeenth-century, this type of embroidery was known as "embroidery on the card," for in order to achieve relief texture, needlewomen put pieces of thick cardboard underneath the threads. —E Y

53. Caparison, Persia (?), 17th century
Broadcloth, gold thread, silk thread, fringe, and cotton fabric, 118 x 158 cm
(plate 41)

This caparison is made of red broadcloth and decorated, on three sides, with a gold-thread fringe. All functionally meaningful parts of the caparison, such as the place of the saddle and the border on all visible sides, are emphasized by the addition of a narrow band of embroidered orna-

mentation. The embroidery at the center depicts a stylized vase with two hoopoes at its base, their tail-feathers intertwined. Decorating the vase are slender plants with scalloped leaves and stylized flowers. A similar foliate pattern, arranged in parallel, slanting bands, decorates the border. Most of the embroidery is done in gold thread, with added details in blue, pink, and black silks, or in gold thread twisted with silk threads of one of these colors. The arrangement of embroidered ornamentation and the decorative emphasis on the place of the saddle suggest that this is a special caparison, which was intended to be thrown *over* the saddle or displayed on the back of an unsaddled horse. It was probably brought as a gift to the tsar from Shah Abbas of Persia by his envoy Asan-Agu in 1644. —IV

54. Pair of stirrups, Turkey, 17th century
Gold, iron, and precious stones, H. 14 cm each
(plate 46)

Russian tsars and noblemen attached great value to stirrups of Turkish workmanship. Not only were Turkish-made stirrups big, sturdy, and very decorative, but they were also convenient for the short-stirrup oriental seat and could be used with both Russian and Turkish saddles. The stirrups shown here have broad, rectangular footrests that extend at right angles from the stirrups' sides, which are shaped like triangles. The loops for attaching the stirrup straps echo the shape of the footrests. Made of forged iron, the stirrups' exterior surfaces are gilded and plated with sheet gold, embossed with an ornamental pattern, and further embellished with emeralds and rubies. Their interiors were originally lined with gold brocade, now lost. The Armory collection possesses eight pairs of gold-plated Turkish stirrups. All of them entered the royal treasury in the seventeenth century as diplomatic gifts or purchases. The most significant collection of horse tack of Istanbul workmanship brought to Muscovy by Greek merchants entered the Kremlin treasury in the 1650s, during the reign of Tsar Alexei Mikhailovich. —OM

55. Bridle, Turkey, 17th century
Gold, silver, precious stones, turquoise, glass, leather, iron, niello, and textile, W. of straps 5.3 cm
(plate 53)

56. Chest straps for a horse, Turkey, 17th century
Gold, silver, precious stones, turquoise, iron, niello, textile, and leather, W. of straps 6.5 cm
(plate 52)

This horse tack of Istanbul workmanship was presented to Tsar Mikhail Fedorovich on September 28, 1634, in the Kremlin Golden Chamber, by the merchant Onton, who had arrived in Moscow in the entourage of the ambassador to Muscovy from Sultan Murad IV of Turkey. The bridle consists of three straps: the head strap (to which a curb bit with reins was originally attached), the brow strap, and the neck strap with three carved pendants. In the center of the brow strap there is a large circular badge of embossed gold studded with rubies, emeralds, and five large green peridots. Similar, though smaller, badges decorate the places where the brow strap is attached to the head strap. The *paperst* comprises two breast straps terminating in gilded iron hooks used to fasten it to the front of the saddle, and a third strap, which was fastened to the girth under the saddle. The central badge is made of gilded silver and decorated with gems and an openwork pattern. The bridle and the chest straps are decorated in the same style. The wide leather straps are covered with two kinds of gilded silver plates: square ones, with precious stones, and narrow rectangular ones. Underneath the plates, with their exquisite carved and niello-work ornamentation, there is a gold-thread braid, which shimmers through the openwork decoration. Because of the generous use of precious metals and the superior workmanship displayed in these items, they were valued at 240 rubles, a considerable sum at the time. The gifts were taken into the Royal Stables treasury. —OM

57. Forehead ornament for a horse, Turkey, 17th century
Gold, silver, iron (nails), and precious stones, 20 x 10 cm
(plate 42)

With its embossed foliate ornament and gems (rubies and emeralds), this gold *reshma*, or muzzle, is a vivid specimen of Turkish decorative arts. Its arrival in Moscow, with a trade mission from Turkey, is recorded in a seventeenth-century source. —LK

58. Saddle, Istanbul, mid-17th century
Gold, silver, copper, iron, wood, leather, precious stones, pearls, gold thread, and velvet, L. 40 cm
(plate 44)

This golden saddle from the treasury of Tsar Alexei Mikhailovich is distinguished by its elegant form and exquisite decorations. The pointed pommel slopes down gently, flowing into the smooth curve of the seat. The rounded cantle is low, and both the pommel and the cantle are adorned with embossed gold plates, and with rubies and emeralds encircled by small pearls. These truly

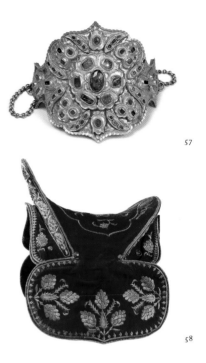

57

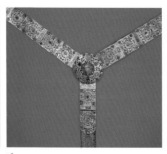

58

regal decorations are accompanied by the gold-embroidered crimson velvet with which the saddle is upholstered. The saddle might have been among those presented to Tsar Alexei Mikhailovich and his heir, Tsarevich Alexei Alexeevich, by Greek merchants in 1656. Greek merchants traveled to Moscow from Istanbul with ambassadorial missions from the sultans of Turkey. As Orthodox Christians, the merchants could persuade the tsars to accept their rich gifts into the royal treasury. —OM

59. Mace, Turkey, 17th century
Silver, copper, wood, jade, turquoise, and gold, L. 73 cm
(plate 73)

Once a formidable cavalry weapon, in the sixteenth and seventeenth centuries the mace gradually disappeared from European battlefields. But in Eastern Europe, Russia, and Turkey, the mace retained its position as a ceremonial weapon, an attribute of commanding rank, and a symbol of noble origin and wealth. In the seventeenth century, except for an array of ceremonial maces of Russian origin, maces in the Kremlin Armory were of oriental workmanship and came from Persia and Turkey. Turkish maces and other kinds of oriental cold-steel

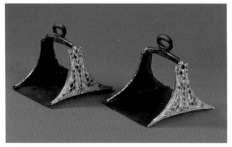

54

55

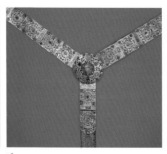

56

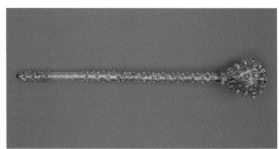

59

weapons were quite popular in Russia due to their impressive and festive decorations. —AC

60. *Dagger and scabbard,* Persia, late 17th century
Gold, precious stones, steel, wood, pearls, glass, and turquoise, blade: L. 28 cm; scabbard: L. 30.8 cm; total: L. 41.8 cm
(plate 72)

Eye-catching and sumptuously decorated, oriental arms were in perfect accord with the luxury and splendor of the Russian court's special ceremonies. The blade of this dagger is forged of damask steel, and the scabbard features a pattern of gem studs, pearls, and turquoise. —EY

61. *Saber and scabbard with belt,* Russia, early 17th century
Silver, pearls, steel, gold, niello, leather, and textile, blade: L. 87.5 cm; scabbard: L. 92.3 cm; total: L. 98.5 cm
(plate 67)

A saber was among the commonest types of cold-steel weapon used by Russian warriors in close combat. Russian armorers often forged sabers out of foreign damask-steel blades. The blade of this saber is fashioned of damask steel after a Hungarian model. The hilt and scabbard are covered with black leather and decorated with gold and silver appliqué work with niello-work ornamentation. Niello work was a very popular type of decoration used by the Kremlin silversmiths to embellish ceremonial cold steel. The silver buckles on the belt decorated en suite with the scabbard. —EY

62. *Sword and scabbard,* Poland, 17th century
Silver, steel, gold, wood, and turquoise, blade: L. 107.5 cm; scabbard: L. 112 cm; total: L. 130.5 cm
(plate 69)

The *konchar* was a popular kind of cold-steel sword used by mounted warriors in the Islamic East and in Central and Eastern Europe. Its long straight blade enabled the cavalryman to thrust at his opponent from a considerable distance. *Konchars* were often used while in pursuit of a fleeing enemy. Unlike other kinds of edged weapons, the *konchar* was attached neither to the waist-belt nor to the shoulder-belt of the horseman but to his saddle, along the length of the horse's croup. The decoration of ceremonial *konchars* had to be in keeping with the sumptuous attire of the horse. This *konchar* is mentioned in the Armory

inventory of 1686-87 and was likely made by a Polish craftsman. In addition to characteristic turquoise studs, the hilt and scabbard are engraved with a fine pattern imitating the texture of leather. —IK

63. P. ANDREEV
Quiver and bow case, Kremlin workshops, 1673
Leather, silver, gold, niello, and fabric, quiver: L. 41.5 cm; bow case: L. 72 cm
(plate 70)

In accordance with a Russian court tradition in the seventeenth century, at Easter the Armory Chamber masters presented the tsar with pieces of arms and armor, specially crafted by them for the occasion. In 1673, Tsar Alexei Mikhailovich received this *saadak* made by Master Prokofy Andreev. The word "*saadak*" was used to refer to the usual "kit" of a sixteenth and early-seventeenth-century horse-mounted archer, which consisted of a bow in a bow case and a quiver with arrows. By mid-seventeenth century, *saadaks* had been almost completely replaced by firearms as battle weapons, and remained in use only in some regiments from the eastern parts of the country. However, as a ceremonial weapon favored by Russian nobility, the *saadak* survived until the end of the century. In the sixteenth and seventeenth centuries, the royal arsenal included three *saadaks*, which were known as "the Great," "the Second," and "the Third." The decorative motifs that embellished such articles were usually inspired by the concept of Russian statehood. The decoration of this *saadak* incorporates the gold- and silver-embroidered crests of the realms, principalities, and lands, whose names were parts of the tsar's full title. Among them are the coats of arms of the Kazan and Siberian realms, and of the Novgorod, Pskov, Tver, Ryazan, and Smolensk principalities. The center of the bow case is decorated with a unique embroidered picture of the Kremlin. —IK

64. *Gunpowder flask,* Kremlin workshops, 17th century
Silver, precious stones, wood, turquoise, and gold, H. 20 cm
(plate 66)

For the military gunman or the gun-bearing huntsman who carried a muzzle-loading gun, the gunpowder flask was an essential accoutrement. This gunpowder flask is sumptuously decorated and must have been intended as a ceremonial, rather than a functional, article. It is carved of

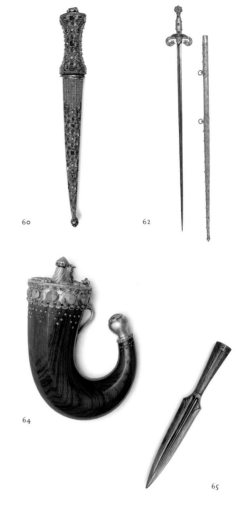

60　　　　62

64

65

wood in the shape of a twisted horn and mounted in gilded silver. Both the mount and the lid attached to it with a chain are encrusted with turquoise and small rubies. As a result of changes in the structure of court administration, this flask entered the Armory from the Court Stable Chancellery in 1736. There is every reason to believe, however, that it had been crafted by Kremlin masters in the seventeenth century and used as an accessory of the Moscow tsar's hunting outfit—hence its provenance from the Royal Stable Office, which, among other things, was responsible for the safekeeping of royal hunting gear. —AC

65. *Heavy spear,* Russia, 17th century
Steel and gold, blade: 23 x 4.5 cm, total: L. 34 cm
(plate 71)

This kind of heavy spear was known in Russian as a *rogatina*—a traditional heavy weapon used, from ancient times into the twentieth century, to hunt bears. It has a broad double-edged blade, and in Old Russia it was also employed as an infantry battle weapon. Judging by the shape of the blade, this spear (which was in the safekeeping of the royal armories) could have been used both as a battle and as a hunting weapon. Along with other kinds of arms, the heavy spear was part of the Grand Attire—the ceremonial accoutrement of the Russian

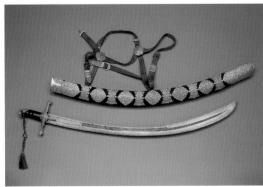

61

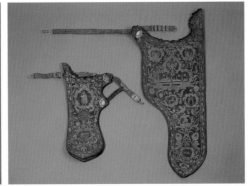

63

tsars. The items constituting the Grand Attire were essential attributes of state ceremonies aimed at demonstrating the tsar's personal valor and the military power of the realm. Among such ceremonies were state royal processions, inspections of troops, and other kinds of royal pageantry. —AC

66. Hunting flintlock harquebus, Kremlin workshops, 1692
Silver, steel, wood, bone, mother-of-pearl, and iron, barrel: L. 103.2 cm; caliber: 9 mm; total: L. 137.7 cm (plate 58)

According to the silver-incised inscription along the length of the barrel, this harquebus belonged to Tsar Peter the Great. The barrel and stock are decorated with ornamental motifs borrowed from Western European art (grotesques, macaroons, and figures in European dress). These motifs appear side-by-side with Russian double-headed eagles, unicorns, and sirens. Peter the Great's interest in arms and weaponry went back to his childhood. It is known that he enjoyed visiting the Armory and looking at the arms and weapons that were kept there. When some piece of weaponry inspired his particular interest, he would order it to be brought to the palace so that he could study it at leisure. The young tsar's youthful fascination with arms and war games gradually developed into a serious interest in the study of warfare, weapons, and fortifications, and eventually culminated in the military reforms that he initiated and carried out during his reign. —EY

67. Flintlock carbine, Kremlin workshops, 17th century
Silver, iron, gold, wood, and mother-of-pearl, barrel: L. 71 cm; caliber: 11 mm, total: L. 105.5 cm (plate 57)

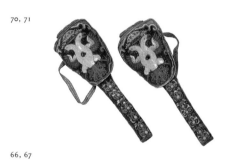

70, 71

66, 67

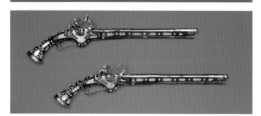

68, 69

In the seventeenth century, the term "carbine" was used to refer to relatively short, light-butted guns designed for the armament of horsemen. The carbine was worn on a leather strap, for which a special brace with a ring was attached to the left side of the stock. This flintlock carbine is a fine specimen of ceremonial weaponry. Even the purely functional details of its snaphance lock (of the Anglo-Dutch type) are exquisitely decorated and contribute to the overall festive effect. The carbine features carved images of real and fantastic animals—the frizzen, or steel, is shaped like a dolphin; the jaws of the hammer resemble a lion's head, and its lower end has a sea-monster shape, while the buffer represents a winged dragon. The flash pan is engraved with a crown. The breech is decorated with a double-headed eagle with three crowns amidst foliate ornamentation. The silver mounts—the ramrods, fore-end tip, and butt plate—are embellished with polychrome enamels over filigree ornamentation characteristic of Moscow silverwork in the seventeenth century. —EY

68. Flintlock pistol and cleaning rod, Kremlin workshops, 1680s
Iron, steel, silver, gold, wood, and mother-of-pearl, barrel: L. 45 cm; caliber: 12 mm, total: L. 64.7 cm (plate 62)

69. Flintlock pistol and cleaning rod, the Armory chamber of the Kremlin workshops, 1680s
Silver, gold, wood, mother-of-pearl, barrel: L. 45.2 cm; caliber: 12 mm, total L. 65.2 cm (plate 61)

The pistol locks are of an Anglo-Dutch type that had grown somewhat obsolete by the late seventeenth century. The pistols are decorated with carved images and engraved ornamentation. The breeches feature engraved double-headed eagles, and on the muzzles appear heraldic griffins, each with an orb in its paw. The sumptuous ornamentation of the pistols is in keeping with the aesthetic ideal of the time. There is an image of St. George Slaying the Dragon on the silver butt plates. In 1672, the image of St. George became part of the Russian state emblem, where it appeared on the breast of the double-headed eagle. The recurrence of heraldic symbols in the decoration of late seventeenth-century firearms can be accounted for by the rapid development of Russian heraldry at the time, and by Tsar Alexei Mikhailovich's great interest in it. —EY

70, 71. Pistol holsters, Moscow, 17th century
Leather, velvet, textile, pearls, precious stones, and gold thread, 40 x 20 cm (plate 59, 60)

The pistol holsters (olstras) are made of leather and covered with velvet. The key decorative motif is the relief representation of the Russian state emblem embroidered with pearls. The large emerald and the rubies adorning each holster enhance the ornamental effects with flashes of brilliant color. Holsters were attached to the saddle and hung on both sides of the horse, with a pistol in each. The holsters shown here were used by the Tsars Alexei Mikhailovich and Fedor Alexeevich. —LK

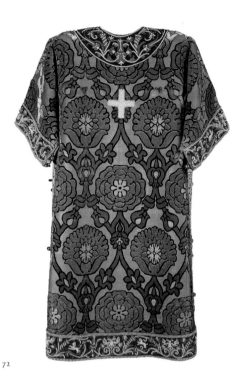

72

POWER AND FAITH

72. Sakkos of Patriarch Adrian (1690–1700), Kremlin workshops, 1691
Brocade, velvet, taffeta, satin, silver, and pearls, 135 x 139 cm (plate 85)

The sakkos, the most festive vestment of a Russian Orthodox bishop, is a long straight garment with unstitched sides, wide sleeves, and a round collar. The sakkos on display belonged to Patriarch Adrian, the last Russian Patriarch in the seventeenth century. It is made of magnificent Italian fabric. The regularly recurrent motif features a large stylized flower framed by foliate sprigs. The pattern is embroidered in silk, in the cut-loop technique, and in gilded thread, in the uncut-loop technique. The collar, the cuffs, and the hem—elements of certain sacramental significance—are made of red velvet, with double-headed eagles, unicorns, and cornucopia embroidered on them with small and medium-sized pearls and gold thread. According to surviving records of the time, the sakkos was made for Patriarch Adrian in 1691, out of a ceremonial robe that had belonged to Tsar Alexei Mikhailovich. —IV

73. Surplice, Russia, mid-17th century
Velvet, satin, taffeta, lace, gold thread, silver, pearls, and glass, 149 x 312 cm (plate 86)

The surplice is a liturgical vestment of a Russian Orthodox deacon, and the one seen here originally

comes from the vestry of the Cathedral of the Archangel Michael in the Kremlin. It is made of semi-cut velvet, featuring a recurrent motif of a pair of branches with luxurious foliage, clusters of grapes, ears of wheat, and stylized flowers framing a large iris flower and linked over it with a crown. The collar and cuffs of black velvet are decorated with a dense tendril pattern embroidered with pearls and enhanced with golden spangles. The hem is adorned with golden lace with scallops on one edge. —IV

74. Pall for the tomb of Tsarevich Dmitry, The Stroganov workshop, 17th century
Damask, taffeta, gold thread, silk thread, and pearls, 168.5 x 87 cm
(plate 98)

Tsarevich Dmitry, the youngest son of Ivan IV, was born shortly before his father's death in 1584 and assassinated in 1591 in the town of Uglich. In 1606, Dmitry was canonized, and his remains were moved to Moscow and interred in a specially made shrine in the Archangel Cathedral in the Kremlin. During ceremonial services the shrine was covered with a special pall, featuring a full-length likeness of the tsarevich in a ceremonial royal robe, with a crown on his head, a halo over it, and a necklace around his neck, where he had received the lethal blow of the dagger. The face and hands are embroidered in grayish silks with a darker shade used for modeling. Silk-thread embroidery is also used in rendering the fur collar and trimming of the tsarevich's robe. The rest of the figure is embroidered in gilded thread, with fastening stitches in colored silks. The inscription with the name, as well as the crown, the necklace, and some details of the costume are embroidered with pearls, and the text of a prayer in the border of the pall is rendered in gilded thread. —IV

75. Vessel for holy water, Kremlin workshops, 1695
Silver, gold, and niello, H. 31.5 cm; Diam. 45 cm
(plate 102)

Such vessels were used for the ritual of consecrating water. The role of a holy water vessel, as that of all other church objects and rituals, is profoundly symbolic. Consecrated holy water cleanses people of spiritual filth and strengthens their faith. And the vessel itself is a symbol of the Virgin—the purest vessel of Divine Grace giving joy to the people. Russian holy water vessels are shaped as large semispherical bowls with two handles. The vessel here is the only such vessel in the Armory collection with a detachable lid, which, when turned upside down, served as a plate for the cross. The inscription on the base of the bowl says that it was crafted by Matvei Agheev—one of the best craftsmen employed at the Armory Chamber—out of "pure *efimky*," the Russian name for Western European sterling silver coins, which originated as a popular distortion of the name "Joachim" as in "St. Joachim *taler*." Foreign silver coins were often used in Russia as the material for precious silverware, as silver was not mined in Russia until the late seventeenth century. —VF

76. Cross, Moscow, early 17th century
Silver, gold, precious and semi-precious stones, and enamel, 38.2 x 19.6 cm
(plate 101)

The altar cross performs an essential function in Orthodox worship—during the liturgy it is placed on the communion table in the altar (hence the name "altar cross," or "communion table cross" in Russian), and after the service the officiating priest picks it up to bless the congregation with it. The symbolism of the Cross, representing Christ's redeeming sacrifice for the salvation of mankind, dictates the motifs used in the altar cross decoration. The essential motif in such crosses is the figure of Christ on the crucifix in the center, with Mount Golgotha at Christ's feet, and Adam's skull underneath—in accordance with the belief that Christ was crucified on the site where the first man had been buried. Orthodox altar crosses are typically eight- or seven-armed, with two additional bars that are absent from the Catholic and other non-Orthodox Christian crosses. The short upper bar is horizontal, with Jesus's name written on it, and the lower bar is a slanting one. This lower bar is a distinctive feature of Orthodox crosses, and its most common interpretation is that its upper end points to heaven, and the lower end points to hell. —VF

77. Gospel book, Moscow, 1677–79
Gold, silver, stones, niello, pearls, velvet, watercolor, wood, and paper, 43 x 25 cm
(plate 97)

The communion table Gospel Book is one of the key liturgical objects in the Russian Orthodox service. During the liturgy and the administration of the Sacraments, the Gospel symbolizes Jesus Christ. That is why the décor of the communion table Gospel Books has always been chosen with special care. The Gospel Book here shows the Deesis—the prayer, or intercession, of the Mother of God and of John the Baptist for mankind. The Savior holds an open book with the words "Come unto me, and I will give you rest." The scroll in the hand of John the Baptist is inscribed with a prayer in which Jesus is called the Lamb of God, who took the sins of mankind upon himself. In accordance with the style of late seventeenth-century Russian art, with its meticulous representation of details of everyday life, the Evangelists are depicted in sumptuous and spacious interiors, featuring fine furniture and luxurious draperies. The carved inscription along the edge of the cover says that the Gospel Book was commissioned by Tsarevna Tatiana, daughter of Tsar Mikhail Fedorovich, and in February 1679 presented by her in memory of her late sister Irina to the New Savior's Monastery in Moscow, where seventeenth-century members of the Romanov Dynasty were interred in the family crypt. —VF

78. Eucharistic cloth, Russia, early 16th century
Pearls, silver, gold, precious stones, rubies, gold thread, silk thread, silver thread, and damask, 86 x 67 cm
(plate 88)

During an Orthodox communion service, the Eucharistic vessels are covered with a set of three special cloths. The two square cloths cover the chalice and the Eucharistic plate, or *diskos*, and the larger, rectangular cloth, known as

73

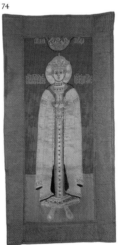

74

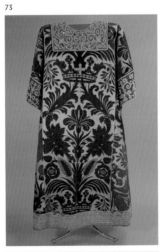

75

77

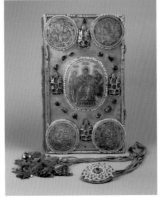

78

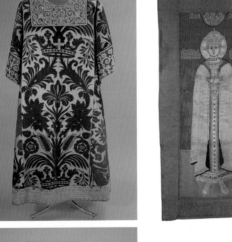

76

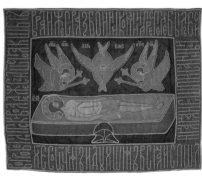

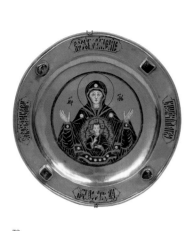

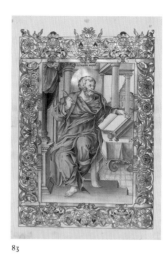

79 81 82 83 80

the *vozdukh*, is laid on top of them. The center of the cloth features an embroidered representation of Christ Entombed with a cherub and two angels flying over the coffin with flabella. The face of Christ is embroidered in flesh-colored silks, with pale-brown silks used for modeling. The sepulcher stone is embroidered with gilded threads interwoven with brown silks of various shades, while the rest is done in gilded thread with fastening stitches in blue and brown silk. The contours and inscriptions, including those around the border of the cloth, are embroidered in small and medium-sized pearls. Christ Entombed is the most common motif on liturgical objects that are directly associated with the main theme and significance of Orthodox liturgy—the Savior's sacrifice on the Cross. —I V

79. Plate, Kremlin workshops, 1664
Gold, precious stones, and enamel, Diam. 21 cm
(plate 90)

80. Eucharistic plate, Kremlin workshops, 1664
Gold, silver, precious stones, stones, and enamel,
H. 9 cm
(plate 93)

81. Spoon, Kremlin workshops, 1664
Gold, precious stones, pearls, and enamel,
L. 21.5 cm
(plate 91)

82. Spear (Eucharistic knife), Kremlin workshops, 1664
Gold, precious stones, pearls, steel, stones, and enamel, L. 24 cm
(plate 92)

These liturgical objects—plate, Eucharistic plate (*diskos*), spoon, spear—were presented to the Holy Miracle Monastery in the Moscow Kremlin by Anna Morozova, upon the death of her husband, *Boyarin* Boris Morozov (a *boyar* is the title of a hereditary nobleman). Boris Morozov was the guardian of young Tsar Alexei Mikhailovich at his ascension and a virtual ruler of the country during the tsar's minority and youth. His wife,

Anna, was a sister of Tsarina Maria, wife of the young tsar, which explains why her commissions would be attended to by the best Kremlin craftsmen. In this array of exquisitely fashioned objects, the bright shimmer of varicolored enamels is beautifully complemented by the sparkle of colorful gems. In the celebration of the Eucharist, the *diskos* is used as a receptacle of rectangular pieces of communion bread, which are arranged in a certain established order to symbolize Christ, the Virgin, the celestial angels, the prophets, the apostles, the saints, and the common mortals, both alive and dead. The *diskos* shown here features a representation of the Eucharist Lamb lying in a bowl, and two angels; the reverse side has representations of St. Gregory the Divine, St. John Chrysostom, Pope Gregory the Great, and St. Basil the Great attended by cherubim and seraphim. The *zvezditsa* (a word related to the Russian word for "star") symbolizes the Star of Bethlehem and is placed on the *diskos* and covered with a special cloth. The arched "legs" of the *zvezditsa* are adorned with openwork decorations featuring stylized flowers and gems—bright red rubies and sparkling diamonds. The junction of its arches is marked with a large rectangular emerald with an engraved cross, and the Greek letters IC XC (the monogram of Jesus Christ) and HIKA ("is winning"). The liturgical plate is used for the cutting of communion bread into small pieces for the communion of the congregation members. The plate shown here is decorated with an enameled representation of the Virgin with her arms lifted upward in prayer and with an image of Christ Emmanuel on her chest. This iconographic type of representation of the Virgin became known in Russia as The Virgin of the Sign. The so-called "spear" is used as a knife for cutting communion bread, and the spoon for giving communion to believers. —M M

83. Gospel book, Moscow, 1681
Velvet, silk, tempera, paper, and wood,
46.5 x 30 x 10.8 cm
(plate 96)

The tradition of decorating religious books with fine illumination dates back to 1681. The iconography of the Gospel illumination that developed over the centuries is based on a certain cycle of subjects and decorative genres

that is associated with each of the four Gospels. Thus, each Gospel is preceded by a portrait of the Evangelist, while every chapter opens with an elaborate ornamental headpiece and an ornate initial. The fine miniature depicting St. Mark is one of the highlights in the illumination of the printed 1681 Moscow Gospel Book. The Evangelist is shown amidst a spacious interior with a colonnade and luxurious draperies. The color scheme of the miniature, with its combination of gold and silver paints and its use of egg tempera in saturated, vivid hues, reflected the key features of seventeenth-century aesthetics—triumphant festivity and the unreserved domination of bright, vibrant color. —V F

84. Presentation in the Temple and the Apostle Peter, Moscow, 1560s
Gold, silver, tempera, gesso, wood, and canvas,
132 x 32 x 2.8 cm
(plate 74)

85. The Baptism and the Archangel Michael, Moscow, 1560s
Gold, silver, tempera, gesso, wood, and canvas,
132 x 34.5 x 2.7 cm
(plate 75)

86. The Raising of Lazarus and the Virgin, Moscow, 1560s
Gold, silver, tempera, gesso, wood, and canvas,
133 x 34.5 x 2.9 cm
(plate 76)

87. The Savior Enthroned, the Entry into Jerusalem, and the Transfiguration, Moscow, 1560s
Gold, silver, tempera, gesso, wood, and canvas,
143 x 64.5 x 2.5 cm
(plate 77)

88. The Crucifixion and St. John the Forerunner, Moscow, 1560s
Gold, silver, tempera, gesso, wood, and canvas,
134 x 33.8 x 3 cm
(plate 78)

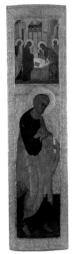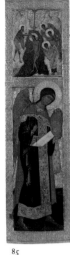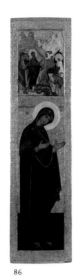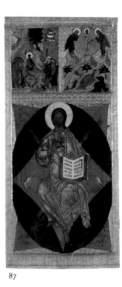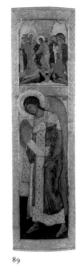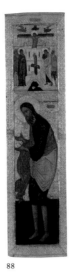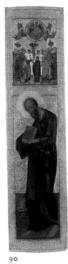

84 85 86 87 88 89 90

89. *The Descent into Limbo and the Archangel Gabriel,*
Moscow, 1560s
Gold, silver, tempera, gesso, wood, and canvas,
134 x 36.7 x 3 cm
(plate 79)

90. *The Ascension and the Apostle Paul,* Moscow, 1560s
Gold, silver, tempera, gesso, wood, and canvas,
133 x 33.5 x 2.7 cm
(plate 80)

During the 1560s, four additional chapels were added to the Russian tsars' domestic church, the Cathedral of the Annunciation. They were built over the covered galleries that surrounded the original fifteenth-century building of the cathedral and consecrated in the memory of the victories of the Russian army under Ivan the Terrible's command in the war against the Polish-Lithuanian State. The iconostasis represented in this exhibition came from the Chapel of the Entry into Jerusalem. It was a church feast that, at the time Russia received her first Tsar, was perceived as possessing special significance and was associated with the assertion of Ivan the Terrible's sovereign power.

Multitiered iconostases represent one of the most remarkable and distinctive phenomena in the legacy of medieval Russian art. In every Russian church the iconostasis is the focal point of its entire space. It separates the altar in the eastern part of the building from the rest of the church. Its role in the architectural design and character of a Russian church interior is so great that for many people, the very idea of the Orthodox Church has become inseparable from the idea of the iconostasis. The largest icons in any iconostasis are those in the Deesis tier, in the center of which is the icon of the Savior Enthroned showing Christ on the throne surrounded by celestial beings. Standing on either side of Christ are the Virgin and John the Baptist turning to Him in supplication, with Archangels Michael and Gabriel, the Apostles and other saints completing the tier on both sides of the three central figures. The tier over the Deesis usually consists of smaller icons representing the key episodes from the earthly life of Christ as described in the Gospels: the Annunciation, the Nativity, the Presentation in the Temple, the Baptism, the Transfiguration, the Entry into

Jerusalem, the Crucifixion, the Descent into Limbo, and others. In the church calendar these events are celebrated as feast days, hence the name—the Feast tier.

The iconostasis represented here consists of the Deesis and the Feast tiers, with the icons in the two tiers combined in pairs, each pair occupying one vertical panel. The iconostasis was painted by the royal Kremlin painters, whose manner was characterized by their "academic" precision in drawing, by a somewhat static character of figural treatment, and by a saturated palette dominated by various shades of blue, pink, and red. The stamped silver frames covering the background and the borders of the icon set off the colors of the paintings and enhance their solemn air. These and other surviving icons from the chapels of the Cathedral of the Annunciation are truly remarkable vestiges of Ivan the Terrible's time. —NM

91. TRETYAK PESTRIKOV AND DANIIL OSIPOV
Censer, Kremlin workshops, 1616
Gold, precious stones, stones, and niello, H. 31.5 cm
(plate 100)

A censer is a pendant liturgical vessel for burning incense. In Russia censers were fashioned in a variety of shapes. One of the types, which was common mainly in Moscow from the fifteenth to the seventeenth century, was shaped in imitation of an old Russian church, as is this censer,

executed in 1616 on the order of Tsar Mikhail Fedorovich Romanov and presented by him to the Trinity-St. Sergius Monastery. Founded around 1345 by Sergius of Radonezh and his brother Stefan, the Trinity-St. Sergius Monastery always retained a significant role as Russia's major spiritual center. The monastery, therefore, traditionally received valuable gifts from representatives of Russian nobility, from members of grand princes and royal dynasties. One of these gifts was this fine gold censer made by the court jewelers Tretyak Pestrikov and Daniel Osipov. —EM

92. *St. Nicholas,* Kremlin workshops,
ca. 16th century
Precious stones, pearls, niello, tempera, gold, gesso, and wood panel, 24 x 15.5 cm
(plate 95)

In medieval Russia icons were indispensable elements of every interior—not only of that of a church, but of every secular building as well, from a peasant hut to the royal palace. "In every Russian house," wrote a foreign diplomat who had visited Russia in the early sixteenth century, "icons are given pride of place. When one Russian comes to see another, as soon as he enters that man's house, he uncovers his head and looks around for an icon. On finding it, he crosses himself three times, one after another."

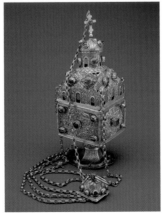

91

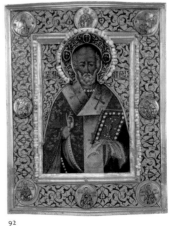

92

This small panel with St. Nicholas could have been one such domestic icon used for private worship. St. Nicholas the Miracle Worker, the patron saint of seafarers and travelers, was one of Russia's most popular saints. He was equally revered by ordinary people and by highborn members of the court. This image of St. Nicholas, judging by the skillful painting (no doubt done by a Moscow icon painter) and by its gem-encrusted gold frame with niello-work decoration, must have belonged to a member of the royal family. This assumption is further supported by the provenance of the icon from the tsars' burial church—the Archangel Cathedral of the Moscow Kremlin. —IB

93. Pyx, Russia, late 17th century
Silver and gold, 21 x 30 cm
(plate 99)

This silver-gilt pyx is fashioned in the shape of a dove—the symbol of the Holy Ghost. The body of the dove is embossed with a featherlike pattern. The hinged lid between its detachable wings covers an aperture for the Holy Sacraments—communion bread soaked in wine and dried (known in Russia as the Holy Gifts). The rings and chains on either side of the lid were used to suspend the ark. Such vessels kept Holy Sacraments intended for the sick or for a special kind of liturgy celebrated during Lent. The usual place for these vessels inside the church was either on the communion table or suspended over it. Thus, an entry in an old church inventory reads: "Over the altar there is a gilded silver dove [suspended] on a silver chain." —VF

94. *Panagia and chain*, Kremlin workshops, 17th century
Gold, precious stones, pearls, and enamel, L. 12 cm
(plate 82)

A *panagia* (translating roughly from Greek as "the Holiest") was intended as a repository for a piece of communion bread symbolizing the Holy Virgin. In the seventeenth century *panagias* were worn as pectoral signs of rank distinguishing the highest hierarchs of the Church. This *panagia*, showing the *Savior Enthroned*, is beautifully decorated with many colored enamels, both opaque and transparent, used in an effective combination with brilliantly colored gems. The bright colors distinguishing this object were characteristic of Russian seventeenth-century jewelry. —MM

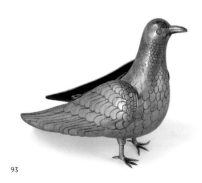

93

95. *Phelonion shoulder piece*, Kremlin workshops, second half of the 17th century
Gold, silver, velvet, canvas, precious stones, and pearls, L. 76 cm
(plate 84)

This shoulder piece has survived as a separate fragment ripped off a *phelonion*, a liturgical vestment worn by Orthodox priests. The preservation of sound fragments of frayed garments was usual practice in Old Russia, common to laymen and clerics alike. It was done not only because of the high cost of materials used in such garments—expensive imported fabrics, gilded and silk threads, pearls, and other costly luxuries—but also for the sake of preserving fine samples of exquisite embroidery. The luxurious materials used in this shoulder piece and the superb workmanship of its embroidered ornamentation suggest that it was the work of court needlewomen. —IV

96. *Pair of cuffs (oversleeves)*, Russia, 17th century
Velvet, satin, gilded thread, silver, and pearls, 18.5 x 20 cm
(plate 87)

Such cuffs or oversleeves (*poruchi*), worn by priests on their wrists during the service, are traditional elements of Orthodox liturgical vestments. The *poruchi* shown here are decorated with a stylized foliate design embroidered with pearls of different sizes. The overall color scheme, with its combination of dark-red velvet, matte-white pearls, and the glittering silver of numerous buttons, was typical of the Moscow school of decorative arts in the second half of the seventeenth century. —IV

97. *Mitre*, Russia, 17th century
Brocade, gold, taffeta, silver, niello, pearls, precious stones, and enamel, H. 22 cm
(plate 81)

The mitre is the headdress worn by Orthodox bishops at ceremonial services. From the seventeenth century onward, Russian mitres had a tall, rounded crown, divided on a cross pattern into segments by means of decorative elements. In this mitre, the cross pattern is created by "stripes" of embroidery with pearls and by rows of precious stones framed by strings of pearls. The circular gold plate at the top of the mitre features a niello-work representation of Our Lady of the Sign, and the four medallions near the rim show Archangels Gabriel and Michael and the Apostles Peter and Paul, respectively. Resplendent in its décor of precious stones and pearls and distinguished by the superior quality of workmanship in the niello-work representations, the mitre was undoubtedly produced by the craftsmen of the Kremlin workshops. —IV

98. *Dish*, Russia, 1680
Silver, gold, and niello, Diam. 42.5 cm
(plate 89)

In the Kremlin Armory collection there is a magnificent gold dish upon which Tsar Ivan the Terrible presented Maria Temriukovna, his second wife, her wedding

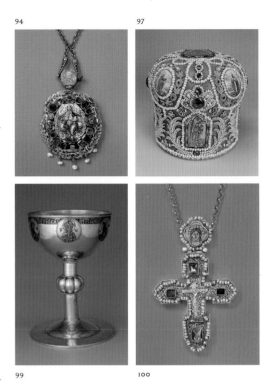

99 100

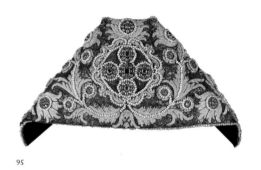

95

96

98

headdress in 1561. The dish is embossed in a shallow petal-like pattern, radiating toward the border from a focal point in the center. Decorated with niello-work ornamentation, that dish was treated as a model for imitation by several generations of Kremlin goldsmiths. As a result, the Armory collection boasts several valuable seventeenth-century dishes imitating the décor of the beautiful prototype. This dish is one in that group of items, though the Golgotha Cross in the center reveals its liturgical function. —VF

101

99. *Chalice*, Moscow, second half of the 16th century
Gold and niello, H. 22.5 cm
(plate 94)

This exquisitely decorated gold chalice comes from the domestic church of the Russian tsars, the Cathedral of the Annunciation in the Moscow Kremlin. Alongside the *diskos*, *zvezditsa*, Eucharistic plate, spear, and spoon, the chalice features among the key ritual objects used in the liturgy—the principal service of the Christian Church. The chalice serves as a vessel for wine, which during the liturgy symbolically transforms into the Blood of Christ. It is mixed inside the chalice with the pieces of communion bread that symbolize the Body of Christ. The Holy Sacraments (in the Russian tradition, the Holy Gifts), as the communion wine and bread transformed into the Blood and Body of Christ and mixed together are called, are used in the Orthodox worship for the communion of the congregation attending the service. Orthodox chalices have for centuries retained their traditional shape—a deep bowl on a tall stem. Their décor is determined by their symbolism. Along the rim of a chalice there is usually a liturgical inscription, below which there are representations of Jesus Christ, the Virgin, John the Baptist, and sometimes also of archangels and the apostles personifying the Church in heaven. —IB

100. *Pectoral cross*, Russia, early 17th century
Gold, silver, precious stones, pearls, and niello, 19.4 x 12.5 cm
(plate 83)

This pectoral cross is a truly magnificent specimen of Russian jewelry making at the turn of the sixteenth century. Fashioned of gold and covered with exquisite niello-work ornamentation, it evokes the best examples of jewelry from the sixteenth century—the heyday of niello-work technique in the works of Moscow court goldsmiths. The end of each of the four arms is adorned with a large deep-blue sapphire, and the outline of pearls around the cross provides a fine finishing touch. The cross bears no inscription revealing the identity of its owner, but its superior artistry and obvious monetary value suggest that it was crafted for a high-ranking hierarch of the church. —VF

THE ROYAL FEAST AND DIPLOMATIC GIFTS

101. *Ladle*, Kremlin workshops, 1535
Silver and gold, H. 21 cm
(plate 103)

This ladle, or *kovsh*—its smooth, graceful shape reminiscent of a floating swan or a boat—is one of the oldest types of traditional Russian tableware. It was used in Old Russia for serving mead, a popular, fragrant drink brewed throughout the country. Made with a variety of recipes and types of fruits and berries, meads differed greatly in taste and color. Ordinary Russians used plain wooden ladles, while the tsar and noblemen had ladles of gold and silver. Created in 1535, this is the earliest surviving ladle of Moscow workmanship. It belonged to Prince Ivan Ivanovich Kurbsky, a relation of Grand Prince Vasily III, father of Ivan the Terrible. Judging by its impressive size, it must have belonged to the category of serving ladles used at banquets. —IB

102. *Loving cup*, Kremlin workshops, first half of the 17th century
Gold, silver, niello, precious stones, and pearls, H. 15 cm
(plate 106)

Old Russian gold and silver tableware usually repeated the time-honored shapes of wooden and clay vessels traditionally used by ordinary people. Such cups were called "loving cups" (or *bratinas*) because they would be filled with wine or mead and passed around the table until everyone had his share. The rim of such cups would always be engraved with the owner's name, or with a saying or proverb expressing some popular wisdom. This relatively small and very decorative cup was presented to Tsar Mikhail Fedorovich from the merchant brothers Sudovshchikov. Later the tsar gave it to his wife Tsarina Evdokia, having first ordered the erasure of the original

niello-work dedication inscription made by the people who had presented him with it. The tsar may also have decided that the decorations were not sumptuous enough for his wife, because he ordered them to be augmented with strings of pearls along the rim. —MM

103. *Ladle*, Kremlin workshops, ca. 1618
Gold, silver, stones, pearls, and niello, L. 30 cm
(plate 105)

This ladle, or *kovsh*, was received by Tsar Mikhail Fedorovich from his mother. It is distinguished by an enchanting gracefulness of form and an exquisite luxuriousness of decoration. In the second half of the seventeenth century, such ladles were placed for safekeeping in the so-called Big Treasury, along with state regalia and other important accessories of the court's ceremonial holdings. They were used only during gala receptions in the Palace of Facets—the main reception room in the tsar's palace—where they served to decorate the special

102

103

stepped display shelves know as *postavets*. The displays served to impress foreign guests with the wealth of the tsar and the skill of his silversmiths. Occasionally such ladles were used for serving mead to the most honored guests. Thus a 1671 written source indicates that during a ceremonial dinner in the Cross Chamber of the Patriarch's palace "red mead" was served to the Patriarch in "three fine ladles with pearls and gems." —MM

104. Beaker, Moscow, late 17th century
Silver, gold, and niello, H. 20.1 cm
(plate 116)

Silver beakers were widely used in Old Russia long before this example was made. They can be seen in miniatures illuminating Russian manuscripts from the fourteenth century onward. The seventeenth century produced many finely decorated beakers. This beaker displays a type of decoration characteristic of jewelry made in Moscow. The niello-work pattern of miniature grass blades and tendrils serves as a perfect background for gilded stems with fantastic flowers and luxurious foliage. The foliate ornamentation skillfully incorporates fruit-pecking birds and running animals—a unicorn, deer, and ram. Alongside other precious vessels, such beakers adorned tables laid for royal feasts. Foreign guests did not spare words when describing the magnificence of royal tableware in the Palace of Facets: according to one such account, the tables "were ablaze with gold and precious stones" and were heavily laden with gold and silver plates, dishes, and beakers. —MM

105. Plate, Kremlin workshops, second half of the 17th century
Silver, gold, and niello, Diam. 30.2 cm
(plate 115)

This silver plate is a splendid specimen of Russian niello-work decoration of the seventeenth century. The floral ornamentation is complemented by the pomegranate fruit, which entered the repertory of Russian decorative motifs in the second half of seventeenth century under the influence of oriental art. The reverse of the plate is engraved with a laurel wreath framing a coat of arms. The latter features a hand holding a sword crossed by two sabers. The accompanying inscription states that the crest belonged to Bogdan Khitrovo, a *boyar* (hereditary nobleman), who for twenty-five years was in charge of the Kremlin workshops. In comparison with Western Europe, Russia saw the appearance of private family crests rather late—in the last quarter of the seventeenth century. At the beginning of the 1670s, upon Tsar Alexei Mikhailovich's invitation, Moscow was visited by the court *heraldmeister* of Emperor Leopold I of Austria. In 1673, the *heraldmeister* wrote a special treatise on heraldry that became a handbook on the subject and was used for devising family crests for Russian nobility. Bogdan Khitrovo was among the first of noblemen to have a coat of arms created for him. —MM

106. MIKHAIL MIKHAILOV AND ANDREI PAVLOV
Bowl with lid, Kremlin workshops, 1685

Silver, gold, and niello, H. 12.2 cm
(plate 107)

A *stavets*, a small cylinder-shaped or U-shaped bowl, is a type of old Russian tableware the function of which is not yet clearly established. Those designed for the tsar's or nobleman's table were fashioned of gold and silver and probably used for serving desert. Although the *stavets* shown here does not bear a date or the name of the craftsman, it was established through surviving records that it was made in 1685 by the Kremlin jewelers Mikhail Mikhailov and Andrei Pavlov. The rim of the bowl is engraved with the title of its owner, Tsarevna Sofia, elder sister to the young co-rulers, Tsars Ivan and Peter. In the first years of her brothers' joint reign, Sofia succeeded in gaining guardianship over them. However, as time went on and young Peter matured, he and his half-sister embarked on a struggle for power. As a result, in 1689 Tsarevna Sofia lost all her prerogatives and was confined in the Novodevichy Convent outside Moscow. —MM

107. HANS JAKOB BAUR I
Ewer, Augsburg, before 1635–40
Silver and gold, H. 55 cm
(plate 131)

108. HANS JAKOB BAUR I
Basin, Augsburg, 1635–40
Silver and gold, 108.3 x 89 cm
(plate 128)

Decorating this ewer and basin set is a characteristically Baroque combination of elements—shells, scallops, and exuberant floral patterns mixed with military motifs. The body of the ewer features the figures of a drummer and a soldier with a gun. Other military associations appear on the lid, and on the shallow basin is a battle scene. Set against the background of a city wall, the scene looks like a picture from life depicting a real historical event. One of the mounted warriors has a banner with the emblem of the Grand Duchy of Lithuania, which was part of Rzecz Pospolita. Historians agree that the scene represents an episode in the war between Rzecz Pospolita and Sweden. It is known that the set belonged to Krzysztof Radziwill, Grand Hetman of Lithuania and the capital city Vilnius from 1635 to 1640. Several generations of the Radziwill family served in the military for the good of their country. In 1647, Tsar Alexei Mikhailovich received a large quantity of gifts from King Wladislaw IV of Poland; the most valuable item was this luxurious washing set. —IZ

109. HERMANN VON BORDESLOE
Standing Cup, Hamburg, ca. 1600
Silver and gold, H. 98 cm
(plate 127)

This standing cup, or goblet, features bosses, figures, and various embossed compositions in cartouches and interlacing bands. The body is decorated with monkeys—allegories of the senses—and with female half-figures and cupids. On the lid, semispherical bosses alternate with relief masks, allegories of Gentleness, Hope, and the River, with anthropomorphic figures, fruits, and vases. The lid is surmounted by a splendid silver bouquet. The stem is adorned with cast figurines of winged caryatides,

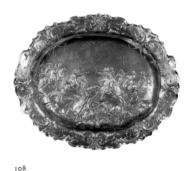

104 106 108

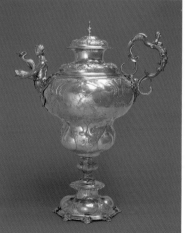

105 107 109

fantastic animals, griffins, and carved blades of grass. The tall base is chased with bosses, winged heads, grotesque masks, and clusters of fruit. The embossed inscription on the base indicates that, in 1605, the goblet was presented by the authorities of Minsk to King Sigismund III of Poland. The symbolism of the decorations suggests that the goblet might have been intended as a wedding gift. In 1647, the goblet was sent to Tsar Alexei Mikhailovich as a gift from King Wladislaw IV of Poland. —IZ

110. JOHANN BETZ
Shepherdess candlestick, Augsburg, 1675–78
Silver and nonprecious metal, H. 69.5 cm
(plate 124)

111. JOHANN BETZ
Shepherd candlestick, Augsburg, 1675–78
Silver, H. 69.5 cm
(plate 125)

This pair of cast-silver candlesticks are modeled as a shepherd and a shepherdess. Both figures wear sandals and half-length suits of armor. The shepherdess's armor is decorated with a scale pattern, and the shepherd's with luxurious acanthus leaves. Each figure is supplied with a long staff and a baby-lamb feeder, and each supports a candleholder on the head, which is shaped to imitate a wide-brimmed shepherd's hat decorated with openwork wreaths of acanthus leaves. The figures are set on tall bases, divided around the bottom into six lobes, each decorated with clusters of fruit and luxurious foliage. The base terminates in a convex bulge under the figures' feet, which is embossed with a pattern imitating ground, with stones, grass, and twigs with leaves on them. Made in the late seventeenth century, it is known that the candlesticks were still in use in the nineteenth century, decorating a ceremonial room in the Kremlin imperial palace. —AK

112. CHRISTIAN PICHGIEL
Tankard, Gdansk, 1681–99
Silver and gold, H. 26 cm
(plate 140)

The cylindrical body of the tankard is decorated with three embossed scenes showing characters from ancient mythology dressed and coiffed in accordance with seventeenth-century fashion. The first scene shows Orpheus playing the harpsichord; the second represents Eros clad in ancient armor; and the third depicts Circe, with a crown on her head and a staff in her hand, surrounded by animals. The figures appear within a landscape, with billowing clouds and trees separating one scene from another. The lid features a cast-silver figurine of a swan, with its wings raised and its neck encircled by a crown, and a two-horned thumb-piece. Cylindrical tankards with ear-shaped handles and broad bases, and with mythological and allegorical decorations, were highly typical of Gdansk silversmiths during the Baroque. —NR

113. Double standing cup, Germany, late 16th–early 17th centuries
Silver and gold, H. 38.5 cm
(plate 126)

This double standing cup features decorations in the neo-Gothic style that German silversmiths were so fond of at the turn of the sixteenth century. The cup consists of two identical vessels chased with heart-shaped and drop-shaped bosses with applied ornamentation. The plain, broad rim is emphasized with a relief ribbon plait with a small-scale pelletlike pattern. Under the plaited frieze there is a wreath of long, sinuous thistle leaves, which also appears as an openwork decoration underneath the body of the goblet. The ribbed stem rests on a base shaped like a Gothic rose. Like most of the double standing cups in the Armory collection, this example was listed in the treasury of Tsar Mikhail Fedorovich and mentioned in its 1640 inventory. —IZ

114. MASTER OF THE "MR" MONOGRAM
Pitcher, Poland, third quarter of the 17th century
Silver and gold, H. 52 cm
(plate 139)

The vessel is almost entirely embossed with clusters of fruit on loosely hanging ribbons, and with various grotesque masks and tendrils. Together these motifs form a dense, gilded pattern that stands out impressively against the pounced background. The triangular spout is chased with a mask and tendrils, and the hinged lid features a fan-shaped scallop. The lid also has a thumb-piece that resembles two horns, with a cherub's head between them and a cone-shaped decoration. Adorning the large S-shaped handle is a female head, a blazon, and a pearl-like ornament. The jug's decorations are in keeping with the Mannerist tradition. Such jugs were used in Protestant churches as liturgical vessels for communion wine. —NR

115. MASTER OF THE "IS" MONOGRAM
Flagon, London, 1619–20
Silver and gold, H. 50 cm
(plate 117)

The silver-gilt flagon with a long neck is shaped like a vase and set on a tall base. It is embossed with sea-monsters in medallions and with clusters of fruit. The sides of the flagon are decorated with lion masks in medallions and with clusters of fruit. The lions have rings in their mouths, with a heavy chain running through them. The bottom of the base is engraved with a measure of weight. The flagon was brought to Moscow, in 1620, by John Merrick's embassy as a gift from King James I of Britain for Tsar Mikhail Fedorovich. The Kremlin Armory collection contains six flagons of this shape and size, the only known examples. Popular as ambassadorial gifts in the nineteenth century, they were produced to function as magnificent display articles. Flagons intended as gifts were usually produced in sets of two. —NA

116. Bucket, Hamburg, 1619–28
Silver and gold, H. 59.3 cm
(plate 130)

Made of gilded silver, this octagonal bucket, with a tall cast-silver handle in openwork hole-pins, belongs to a group of exceptionally beautiful and rare specimens of royal luxury wares. It was purchased in 1628 at the famous auction in Archangel, to which Danish merchants brought for sale the bulk of King Christian IV's treasury. At that auction Tsar Mikhail Romanov's representatives acquired the best silver items for the new royal palace that was being

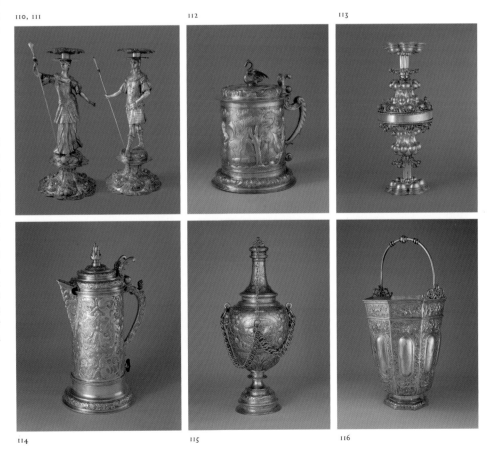

110, 111 112 113

114 115 116

117

120

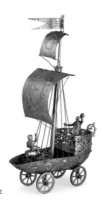

122

built in the Kremlin. The rim of this bucket is skillfully decorated with embossed animal figures, and the convex body of the piece alternates between smooth surfaces and elaborately embossed Mannerist-style ornamentation with macaroons. At the Moscow court the bucket contained the water from the Moskva River that was consecrated by the Patriarch and brought into the tsar's chambers on the Epiphany and Annunciation days. —AK

117. Dish, Amsterdam, 1647
Silver and gold, Diam. 40 cm
(plate 121)

This deep, bowl-like silver dish on a low base is embossed on the bottom with the Russian state emblem. Its simple and elegant decorations consist of a band of gadrooned patterns and a band of hollow flutes, which complement each other effectively. Gilding emphasizes the divider ribs between individual gadroons and flutes. This type of bowl and dish decoration can be found only in the Kremlin Armory collection. It is believed that this dish came to Russia as part of an ambassadorial presentation from Holland and was intended for the decoration of the tsar's *postavets*, or display shelves. The presence of the Russian state emblem supports this assumption. —NA

118. JERONIM BANG
Deer (table decoration), Nuremberg, 1588–1630
Silver and gold, H. 29 cm
(plate 135)

Shaped like a prancing deer on a low base, this table decoration may have been designed to serve as a goblet or an ewer. At the Moscow court, such elaborate vessels, modeled in the shapes of various animals—lions or wild boars, horses or bulls, swans or cranes, roosters or owls, and even snails or fabulous unicorns—served to ornament the so-called "sweet tables." These were banquet tables that were used in the tsarina's Golden or Dining Chamber to mark such occasions as the birth or christening of the tsar's child, the name-day of a member of the royal family, or a reception held in honor of a foreign royal guest. The bodies of the silver animals were filled with sweet wines; their detachable heads, as that of the deer shown here, functioned as lids. The vessel's convex base is embossed with a pattern imitating ground, with a lizard sitting near a tree stump. Beginning in the seventeenth and stretching well into the nineteenth century,

such sculptured cisterns were used as decorations for display shelves in the tsar's palace. —AK

119. HANS LAMBRECHT III
Goblet, Hamburg, 1631–52
Silver and gold, H. 73 cm
(plate 137)

This silver goblet with a lid has a solidly gilded body and a sculptured stem without gilding. The bowl, the lid, and the base are bell-shaped and adorned with high-relief ornamentation, featuring masks and other decorative elements, as well as with an embossed fruit-and-leaves motif on a pounced background. The bowl has a plain and smooth flared rim, but the edge of the lid projecting over it is adorned with pounced ornamentation. The bowl of the goblet is supported by a cherub with upraised arms. The cherub's left leg, bent at the knee, rests against a tree stump. The lower part of the bowl and the top of the base are embellished with cast-silver grass blades, and the top of the lid was surmounted by a bouquet, now lost. Such giant goblets, some taller than human height, were used to decorate the private and state apartments of the Kremlin palace. —AK

120. HANS LAMBRECHT III
Basin with Sleeping Ares (part of a washing set),
Hamburg, 1664–70
Silver and gold, 93.2 x 78.6 x 9.7 cm
(plate 123)

Decorating the border of this partially gilded silver dish is a broad floral motif. The center of the basin features an embossed figural composition representing *Sleeping Ares*. To the left of Ares are Iris, on her way from Olympus, and the Chimera in the process of turning from a lion into a wild boar. To the right of Ares is Kronos tearing apart his baby. Above them soar allegorical figures representing Love, Justice, Prosperity, and Trade. Clio, the muse of History, contemplates them all from the left-hand side of the scene. Such basins were included in luxurious washing sets that were traditional components of ambassadorial presentations to the Russian tsars. Beginning in the mid-seventeenth century, such sets were no longer in active use, having been promoted to the status of fashionable interior decorations. They would be displayed in open cupboards and on shelves or hung on walls in the chambers of the tsar's palace. —AK

121. MASTER OF THE "WINDMILL" MONOGRAM
Cupid on horseback (ewer), Nuremberg, last quarter
of the 17th century
Silver and gold, H. 39 cm
(plate 132)

Representing Cupid on a prancing horse, this ewer is part of a washing set that also included an embossed basin. The horse's body comprises the vessel proper, with the forelock concealing the aperture for pouring water into it, and the horse's mouth functioning as a spout. Cupid's naked body is draped with a ribbon, and he holds a bow and an arrow in one hand, while clutching the reins with the other. The pouncing on the horse's body imitates the animal's coat, and its tail and mane are decorated with ribbons. The tack and the hooves are gilded. The saddlecloth is decorated with a fine engraved pattern, with a gilded border along the edges. The high, oval-shaped base is embossed with a pattern imitating ground, with stones on it and a tree stump under the horse's feet. The oval medallions decorating the sides of the base feature rural landscapes. The set to which the ewer belonged arrived in Russia with a 1684 ambassadorial visit from Sweden as a gift from Carl XI to the Tsars Ivan and Peter. —AK

122. JOHANN PHILIPP STENGLIN
Ship (centerpiece), Augsburg, 1680–85
Silver and gold, H. 44.5 cm
(plate 129)

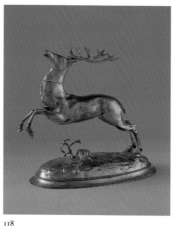

118

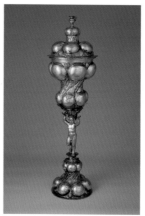

119

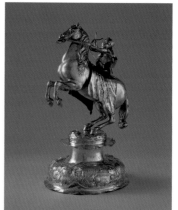

121

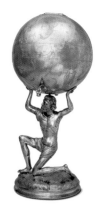

123 124 125

with an inscription stating that the jug was received as an ambassadorial gift on June 20, 1648. The size of the jug and the presence of the Russian state emblem suggest that the Amsterdam silversmith who fashioned it had been specifically commissioned to make an ambassadorial gift. Such large-scale, showy objects were used at the Moscow court for decorating the tsar's *postavets*, or special display shelves set up in reception chambers. —N A

This table ornament, shaped as a one-mast, partially gilded silver ship set on wheels, is decorated with embossed and openwork floral motifs. Adorned with a cast silver-gilt laurel wreath, the mast is rigged with a burgee and two sails of different sizes. The lower sail is engraved with a weight value in Old Russian measure (an equivalent of 1.165 grams). The rigging is made of silver openwork. The deck is decorated with a standing female figure representing an allegory of Peace, with a laurel wreath in one hand and with what looks like a fragment of a torch in the other. Opposite this figure, fastened on a thin openwork plaque, is a cast-silver barrel with a seated Bacchus atop, raising a wine goblet in his right hand. The Moscow court had a taste for such goblets and table ornaments. There is a "fleet" of a dozen silver sailing ships in the Armory collection. —AK

123. HEINRICH EICKHOFF
Tankard, Hamburg, 1688–91
Silver and gold, H. 22.5 cm
(plate 136)

The engraved decorations on this silver tankard are based on military motifs. In the early 1680s, and especially after the victory of the European allied forces in the Battle of Vienna in 1684, it became popular to extol acts of chivalrous valor. The Tsars Ivan and Peter (the future Peter the Great and his brother), twice received ambassadorial visits from royal courts of the victorious powers—Austria and Poland—in the Palace of Facets of the Kremlin. While the allegorical images decorating this tankard were perfectly intelligible to contemporaries, they are difficult to decipher today. It is possible that the three similar-looking compositions symbolize the union of the three powers—Sweden, Poland, and Russia. One of the compositions clearly features the Swedish flag, while another represents an array of weaponry possibly used by the Polish army. The motif decorating the lid may have been intended as a collective allegory of the successful military endeavor: it shows a suit of armor surrounded by trophies, a marshal's staff, and a ribbon. The letter "S" is engraved on a gilded band left of the handle. —AK

124. *Table fountain*, Vilnius, late 16TH century
Silver and gold, H. 75 cm
(plate 138)

This table fountain, a container for wine, is shaped like a celestial globe with engraved figures of gods representing planets, and with symbols of the Zodiac. The lid is engraved with a solar disk, and the two spouts resemble stylized dragon heads. The globe rests on the head of Atlas, who is kneeling on the oval base that symbolizes Earth and is decorated with large cast-silver leaves and tiny appliqué lizards. The table fountain was sent to Tsar Alexei Mikhailovich as a gift from King Jan Kazimir in 1651. Such large, eye-catching, and valuable objects were usually given pride of place on display sideboards in reception rooms. This vessel was on the *postavets* (a special arrangement of open shelves) in the Palace of Facets, among other silver items from the royal treasury, during the state banquet in honor of the coronation of Empress Catherine II the Great. —N R

125. JAN VAN DEN VELDE (?)
Jug, Amsterdam, before 1646 or 1647
Silver and gold, 80 x 23 cm
(plate 120)

The pear-shaped, smooth-surfaced *kungan*, or jug, on a tall base has a long spout and an auricular handle representing a stylized dolphin. The lid is embossed with the Russian state emblem, and the smooth surface of the body is decorated with large convex lobes with gilded straps between them. The bottom of the base is engraved

126. HENDRIKUS VAN LEEUWEN
Pitcher with lid, Amsterdam, 1665
Silver and gold, H. 34 cm
(plate 119)

The pear-shaped pitcher is partially gilded. It includes a spout and an auricular handle. The bottom is engraved with the measure of weight. In terms of its decoration, the pitcher is a rare specimen of mid-seventeenth-century Dutch silverwork. It is embossed with a pattern of large tulips and with two representations of the Russian state emblem—the double-headed eagle with three crowns over its heads. The presence of the emblem suggests that the pitcher was crafted for the Russian court, possibly as an ambassadorial gift for the tsar. Its relatively small size implies that it was intended not only as a decoration for the tsar's *postavets* (display shelves), but also as a purely functional object—a vessel for serving wine. Pitchers with long spouts, dragonhead ornaments, and auricular handles appear in Dutch still-lifes of the 1640s through the 1660s, for example, those by Willem Claesz Heda. —N A

127. HANS GEORG (JERG) LANG
Lion (ewer), Augsburg, 1645–50
Silver and gold, H. 54.5 cm
(plate 133)

The ewer is fashioned as an enormous rampant silver lion, embossed and partially gilded, with a large seashell in its front paws. The shell is covered with a slightly curved leaf that functions as a water outlet. The detachable lid comprises the lion's head. Its tongue, which is hinged inside the open fanged mouth, serves as another spout. The rim of the lid is crafted to look like long curly strands of the lion's mane. The tip of the tail curls to touch the animal's body, creating a handle. The body is pounced all

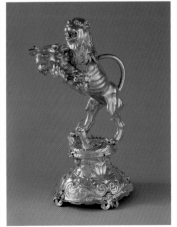

126 127

over to imitate the lion's coat, and the base is embossed with a pattern depicting ground and a knotty stump of a tree. The base rests on four legs, and its border is embossed with a rocaille motif. Such ewers often found their way into Russia as diplomatic gifts from the kings of Sweden and Denmark. —AK

128. GELB MELCHIOR
Pitcher in the shape of a female half-figure, Augsburg, ca. 1650s
Silver, nonprecious metal, and gold, H. 40.2 cm
(plate 122)

The silver pitcher has a lid, a small round base, and a cast-silver handle with embossed decoration. Partially gilded on the outside and solidly gilded on the inside, this pitcher takes the form of a female half-figure with a somewhat stern expression. The lady wears a low-cut dress with embossing that creates an impression of patterned fabric. The ribbons and lace decorating the dress are rendered by means of pouncing. A cast openwork bow provides an additional decorative element, as does the cast-silver pearl necklace. The silversmith achieved the effect of loose, wavy hair by fashioning it separately and adding it as an applied element. The lid of the pitcher represents the lady's hat, adorned with ostrich feathers and a bow similar to the one decorating the dress. The waistline is emphasized by a smooth-surfaced band between patterned surface of the bodice and skirt, the latter being adorned with a floral motif. The handle features a siren and a two-horned thumb-piece. The pitcher is one of a pair of twin pitchers brought to Tsar Alexei Mikhailovich by the 1655–56 ambassadorial visit from King Charles X of Sweden. —AK

129. MASTER OF THE "TH" MONOGRAM
Fruit Dish, London, 1663
Silver and gold, Diam. 42.5 cm
(plate 118)

The fruit dish is made of gilded silver and designed as a round dish on a short base. It is decorated with embossed flowers (poppies and tulips) and animals (a deer, dog, lion, and wild boar). The combination of floral and zoomorphic motifs was a distinctive feature of English Baroque silver. This kind of dish emerged in England as an early type of tray that was often made to pair with a two-handled bowl. In Russia, these trays were used for serving pickled berries and fruit. According to the

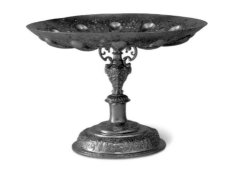

130

inscription engraved on the reverse, the fruit dish was brought to Moscow, in 1664, by Sir Charles Howard Earl of Carlisle, Ambassador of Britain, as a gift from King Charles II for Tsar Alexei Mikhailovich. —NA

130. HEINRICH BRINCKMANN I
Tazza, Nuremberg, early 17th century
Silver and gold, Diam. 28.5 cm
(plate 134)

131. HEINRICH BRINCKMANN I
Pickle bowl, Nuremberg, first quarter of the 17th century
Silver and gold, Diam. 28.5 cm

These two embossed and solidly gilded silver bowls (one of which is shown here), on cast, vase-shaped feet and tall bases, belong to a set with decorations dwelling on the change of seasons and the Zodiac motifs. The round medallions in the center of each bowl are embossed with genre scenes showing seasonal pursuits of peasants and urban dwellers. On one of the bowls, March is represented by a wandering viola player. The other bowl features July, with a peasant with a scythe, stacking hay. The figures are shown against an urban and a rural landscape, respectively, and each scene contains characteristic signs of the season: bare trees and a strong ripple on the cold river on one bowl, and haystacks on a sultry summer day on the other. The upper part of each medallion shows the corresponding Zodiac signs—Pisces for March and Leo

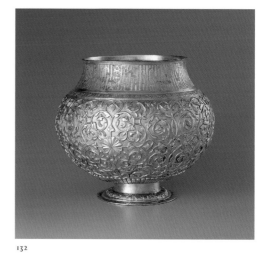

132

for late July. This set of bowls was brought in 1647 by an envoy from Sweden as a gift from Queen Christina for Tsar Alexei Mikhailovich. —AK

132. FEDOR EVSTIGNEEV
Loving cup, Kremlin workshops, second half of the 17th century
Silver and gold, H. 13.7 cm
(plate 108)

Old Russian loving-cups display great decorative variety. This vessel has a dense surface decoration featuring spiral-shaped patterns formed by relief grass blades. With a touch of acrid humor, the inscription along the rim reminds the drinker that wine leads to "the darkening of the mind," "the loosening of morals," and "the giving away of innermost secrets." —MM

133. *Bowl*, Solvychegodsk, late 17th century
Silver and enamel, Diam. 14.9 cm
(plate 111)

134. *Bowl*, Solvychegodsk, late 17th century
Silver and enamel, Diam. 16.3 cm
(plate 113)

135. *Bowl*, Solvychegodsk, late 17th century
Silver and enamel, Diam. 16.6 cm
(plate 112)

The enameled metalwork of Old Russia is represented in this exhibition by the works of Solvychegodsk silversmiths. A town in northern Russia, Solvychegodsk was famous in the seventeenth century for the exquisite painted enamels that decorated a great variety of religious and secular objects popular with the royal and the patriarchal courts. A distinctive feature of Solvychegodsk enamels is the combination of a plain white background and vividly colored enamels in a wide range of brilliant, saturated colors—yellow, orange, purple, blue, and green. Floral and foliate motifs dominated the great versatility of ornamental patterns used by Solvychegodsk craftsmen in decorating their metalwork. Many of their enameled flowers are easily recognizable—tulips, poppies, irises, cornflowers, and sunflowers. Yet the treatment of the

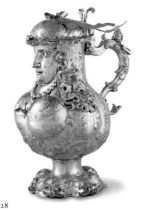

128

129

133

134

135

relief embossed pattern of wavelike scrolls with river wildlife: fish, snails, crawfish, and a fabulous siren with two tails. —IB

137. Loving cup, Kremlin workshops, first quarter of the 17th century
Silver and gold H. 28.5 cm
(plate 109)

This *bratina*, or loving cup, boasts a useful decoration: Along its rim is a carved inscription in elaborate stylized characters prescribing the appropriate occasions for drinking wine. The cup is supported by six cast-silver figurines. Its body is adorned with blazons with the name of the owner, Pyotr Tretyakov, flanked by a lion and a unicorn, as well as birds, fish, and youths in foreign dress. The decorations reveal the influence of Western European art. This is evident in the presence of the figures supporting the base and in the silver bouquet on the lid, which is similar to bouquets decorating the lids of seventeenth-century German goblets. However, these decorative elements seem perfectly allied with the characteristically Russian shape of the vessel. —MM

138. Drinking cup, Solvychegodsk, late 17th century
Silver, gold, and enamel, Diam. 8.4 cm
(plate 110)

In addition to floral ornamentation, Solvychegodsk enameled work also featured animal motifs—such as miniature birds flying amidst flowers and perching on stems, or waterfowl, like swans or ducks, in landscapes. The lion was another popular motif, particularly among silversmiths and woodcarvers. The lion is traditionally represented as a strong and proud animal "king," but in Russian art its ferociousness was often stylistically softened. Characteristic of this approach, the lion on the bowl is a kind-looking beast rather than a dangerous predator. —IB

139. Bowl, Solvychegodsk, second half of the 17th century
Silver, gold, and enamel, Diam. 15.8 cm
(plate 139)

Some specimens of Solvychegodsk enameled work feature Biblical or allegorical scenes skillfully incorporated into the ornamented background. A recurrent subject is the allegory of the Five Senses, which represents the idea of the sinfulness of the earthly world and the futility of sensual pleasures. This motif, which emerged in Western Europe in the late-medieval period, remained popular in the sixteenth and seventeenth centuries. Allegorical depictions of the Five Senses in Western European art often comprised scenes of gallant gentlemen and their ladies in a landscape or a fine interior, making music, admiring themselves in the mirror, smelling flowers, kissing, or enjoying a meal. The allegorical scenes on this enameled bowl are rendered in a concise manner, which is perfectly consonant with the shape and size of the object, and also subservient to its overall ornamental treatment. —IB

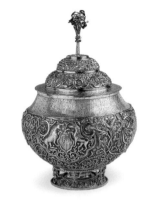

137

138

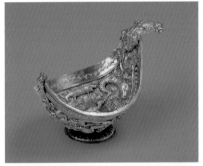

136

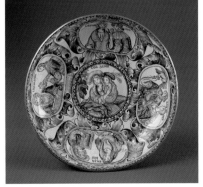

139

flowers is highly imaginative and each blossom is fantastic, unique, and almost surreally beautiful. The influence of the Baroque floral style of Western Europe is much more apparent in the works of Solvychegodsk silversmiths than in the articles produced by other seventeenth-century artistic centers in Russia. Because of their particular interest in color and natural beauty, this exuberant style strongly appealed to the silversmiths of that northern town. —IB

136. Drinking ladle, Moscow, 17th century
Silver and gold, L. 12.1 cm
(plate 104)

Designed for stronger spirits, such miniature silver ladles were common in seventeenth-century Russia. Relatively inexpensive, due to the small amount of silver used, they were popular among broad sections of the population—from the gentry to the trading class. The *korchik*'s shape repeats that of the traditional Russian ladle and, like the latter, was inspired by the graceful silhouette of a floating swan or duck. The *korchik* shown here is imaginatively decorated. Its handle is adorned with a small cast-silver lion, and the inside surface of the cup features a high-

RUSSIA! Catalogue of the Exhibition at the Solomon R. Guggenheim Museum, New York, and the Guggenheim Hermitage Museum, Las Vegas © 2005 The Solomon R. Guggenheim Foundation, New York. All rights reserved.

ISBN 0-89207-331-4

Guggenheim Museum Publications
1071 Fifth Avenue, New York, New York 10128

Design: Sarah Gephart, mgmt. design
Production: Melissa Secondino, Cynthia Williamson
Editorial: Elizabeth Franzen, David Grosz, Stephen Hoban, Edward Weisberger; Catherine Bindman, Jean Dykstra, Elizabeth Finch
English translation (Las Vegas entries): Aschen Mikoyan

Printed in Canada by Transcontinental

Available through:
D.A.P./Distributed Art Publishers
155 Sixth Avenue, 2nd floor
New York, New York 10013
Tel.: (212) 627–1999; Fax: (212) 627–9484

The hardcover edition of the companion volumes, *RUSSIA! Nine Hundred Years of Masterpieces and Master Collections*, and *RUSSIA! The Majesty of the Tsars: Treasures from the Kremlin Museum*, are also available through D.A.P./ Distributed Art Publishers.

Front cover: Fedor Alexeev, *Cathedral Square in the Moscow Kremlin*, 1800-02 (detail of cat. no. 74 [p. 20])
Back cover: Ivan Aivazovsky, *The Ninth Wave*, 1850 (detail of cat. no. 72 [p. 20])